THE ENEM
PHOTOGR
THE CONV
THE SALVA
PHOTOGR
COMES FR
EXPERIME

OF

László Moholy-Nagy,
Vision in Motion

Y OF
APHY IS
ENTION.....
TION
APHY
OM THE
NT.

OUR A
STA
WITHIN THE
O
PROF
EDUCATION T
INDIVI

IM CAN BE
ED: FROM
FRAMEWORK
F A BROAD
ESSIONAL
O OPEN AN
DUAL WAY.

Aaron Siskind and
Harry Callahan,
"Learning Photography
at the Institute of
Design"

Taken by Design

**Photographs from the
Institute of Design, 1937–1971**

**Edited by David Travis and
Elizabeth Siegel**

**With essays by
Keith F. Davis, Lloyd C.
Engelbrecht, John Grimes,
Hattula Moholy-Nagy,
Elizabeth Siegel, and
Larry Viskochil**

**The Art Institute of Chicago
in association with
The University of Chicago Press**

TAKE

DES

PHOTOG
FR
THE INS
OF DI
193

N BY
IGN

GRAPHS
OM
STITUTE
ESIGN,
37–1971

Contents

FOREWORD

The Institute of Design is one of Chicago's great cultural achievements. The design school that László Moholy-Nagy founded in Chicago in 1937 flourished not only because of his original idea of a modern visual literacy but also because that vision changed with the times and the talents the school employed. These changes produced various incarnations that were reflected in the names given to the school: the New Bauhaus became the School of Design and finally the Institute of Design. Created as an outpost of experimental Bauhaus education, the school produced leaders in the disciplines of architecture, typography, and graphic and industrial design. But our purpose here is to recognize that it also produced some of the most talented and influential photographers in twentieth-century American art.

Until now, the history of its famous photography program, which was but one of the school's many glories, has been written in the individual accomplishments of its faculty and students or scattered in neglected archives or publications long out of print. No book concentrating on photography has comprehensively recorded what the school has accomplished. Its distinguished history, replete with the names of Harry Callahan, Aaron Siskind, Arthur Siegel, György Kepes, Nathan Lerner, Art Sinsabaugh, Yasuhiro Ishimoto, Barbara Crane, Kenneth Josephson, and Ray K. Metzker, is far too rich to remain unwritten. With this catalogue and the exhibition it accompanies, we have for the first time an in-depth evaluation of how this great cultural achievement was founded and sustained. We can also recognize how it changed the course of photography and shaped our understanding of this modern medium.

With an emphasis on experimental, problem-based learning and its development of a graduate-degree program, the ID radically altered the way photography was taught and practiced. The images that were produced at the school – whether they are Moholy's photograms, Callahan's high-contrast landscapes, or Siskind's wall abstractions – set new standards for photographic exploration. The Institute of Design also educated generations of photographers who would in turn become teachers across the country, thus ensuring a lasting legacy of ID principles and pedagogy. Ask nearly any American photographer today whom he or she trained with, and you will likely be able to trace his or her education back to the Institute of Design.

It is fitting that *Taken by Design* has been initiated by The Art Institute of Chicago, for this museum has been collecting and exhibiting the work of ID photographers since the 1950s. As photographer Minor White observed in 1961, "Yearly a few arrive at the threshold of camera work. But only in Chicago does the city art museum acknowledge 'arrival' with a public exhibition." Because of this history and our recent efforts to collect, the Art Institute now boasts the most comprehensive holdings of ID photography in the country.

David Travis, Curator of Photography, recognized that the time was ripe to assess the accomplishments of the Institute of Design. The students who attended the ID in its early years were still active, but their stories and memories needed to be recorded. New scholarship on the school was starting to emerge from a variety of sources, along with images of well-known and relatively unknown ID photographers. Under his stewardship, this important exhibition has at last been realized, and his long commitment to the project is evident in the careful selection of photographs and the quality of scholarship throughout this catalogue. Elizabeth Siegel, Assistant Curator of Photography, has been an invaluable collaborator throughout the four years she spent researching and coordinating the exhibition and catalogue. Her passion and vision have shaped the project at every stage.

A remarkable team of scholars have provided their insights on the accomplishments and legacy of the Institute of Design. For their hard work and important contributions to the topic, I would like to thank Keith F. Davis, Lloyd C. Engelbrecht, John Grimes, Hattula Moholy-Nagy, and Larry Viskochil. The exhibition could not have taken place without the assistance of additional scholars and many generous lenders, all of whom are identified in the Acknowledgments.

LaSalle Bank has generously supported this project from its inception. LaSalle's partnership with the Art Institute – and with the Photography Department in particular – is a testament to their continued commitment to the city's cultural life. A Chicago institution, LaSalle Bank, which has built one of the best corporate collections of photography in the country, is also a lender to this exhibition. It is rare and wonderful to have a sponsor that is able to contribute in so many ways.

Finally, I wish to thank the student and faculty photographers of the Institute of Design past and present. The exceptional collection of images seen here and the ongoing influence of the school on American photography point to a strength of vision that is virtually unparalleled in American photographic history.

James N. Wood
Director and President
The Art Institute of Chicago

LÁSZLÓ
MOHOLY-NAGY
AN APPRECI

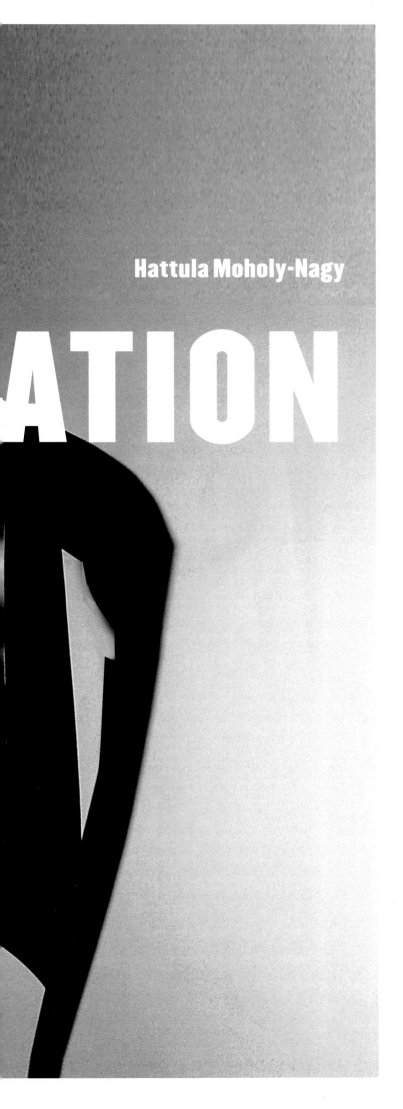

Hattula Moholy-Nagy

ATION

When László Moholy-Nagy accepted Walter Gropius's invitation to teach at the Bauhaus in Weimar, Germany, in 1923, he joined an institution whose educational philosophy was completely compatible with his own ideas of the enlightening role of art in an industrialized society. These ideas were derived in large part from the inclusive and socially oriented values of Russian Constructivism, which saw the artist as an agent in the improvement of society. Moholy could wholeheartedly accept the Bauhaus objective of educating skilled generalists who would be well-grounded in "the new unity" of art, science, and technology and would, accordingly, be able to design products to meet society's needs. The Bauhaus emphasis on learning through experimentation complemented his own desire to innovate and explore, and its focus on the student rather than the curriculum, on the learning process rather than the results, and on the value of group enterprise rather than individual endeavor appealed to his social values. Moholy's unwavering belief in Bauhaus education sustained him through nine years of strenuous effort to transplant it to another culture through the school he directed.[1]

His confidence that he could succeed in this enterprise stemmed, in part, from his own extensive transcultural experiences. He had emigrated from Hungary as a young man and had made a name for himself in Germany. Then he had lived and worked for a year in the Netherlands before establishing himself anew in England. By the time he arrived in the United States, almost two decades of experiencing other cultures and interacting with colleagues and students from many different countries had taught him to focus upon commonalities. He had also learned the value of a strong professional network through which he assembled not only his faculty, but also the extraordinarily diverse program of guest lectures, performances, and exhibitions that were regularly presented at the school. Moholy (fig. 1) genuinely liked people, one of the traits that made him such an effective teacher. He felt that everyone he met could be a potential supporter of his cause. After the New Bauhaus closed at the end of its inaugural year, he would have been unable to launch his own School of Design without the devoted help of a host of people, particularly Walter Paepcke, a member of the school's sponsoring committee and his most important link to Chicago's business community; some of his former New Bauhaus students who helped renovate and equip the building; and his faculty, who generously agreed to teach the first year without salary.

My mother, Sibyl, was his indispensable collaborator. Besides the traditional wifely chores of running the household, raising the children, and entertaining numerous guests for dinner and extended visits, she typed his manuscripts, edited his written English, and drove him wherever he had to go by car. It was Sibyl who organized and maintained the support system for the summer sessions the school held near Somonauk, Illinois. And after his death, she continued to advance his work through her numerous and eloquent lectures and publications.

Establishing his own school was a moral issue for Moholy. He felt obligated to promote the ideals he so strongly believed

in, and what better way was there to do that than by teaching? But by making this commitment he irrevocably changed his life and that of his family. Thereafter he would be constantly short of money and, more seriously, always short of time. We moved from a stately apartment on Astor Street to a comfortable, but unremarkable, floor-through on Lakeview Avenue. Moholy traveled throughout the country to promote the school and raise funds for its continuation, giving numerous lectures, film presentations, and slide shows, and participating in as many conferences and exhibitions as possible. He was at the school every day during the week and often on Saturdays. He was gone before my sister, Claudia, and I got up in the morning and he came home after we were in bed. Our time with him was Sunday, when he dedicated the morning to walking us once around nearby North Pond while our mother cooked dinner. We loved these walks with him, for they included his serial installments of the colorful adventures of a green-checkered piglet.

Although he was not tall or imposing, and possessed a somewhat high, noticeably accented voice, Moholy was an energetic presence with a warm, engaging smile. Always well-groomed and well-dressed, he was aware of how readily clothes convey social and political messages and he could expertly project information about his social position and his values. At the Bauhaus he wore red workmen's coveralls over a dress shirt

and necktie; at the Chicago school he wore a technician's white jacket over a banker's dark suit. Many still remember the black metal lunch box that he took to the school every day.

The large body of work that Moholy produced in Chicago represents an extraordinary accomplishment in view of the unending demands of the school. Exemplifying his holistic view of creative activity, his output includes paintings, drawings, sculptures, photograms, black-and-white and color camera photographs, films, many published articles, and the major statement of his educational philosophy, *Vision in Motion*, issued posthumously in 1947. Yet nowadays exhibitions and publications of Moholy's work tend to present the same familiar images from the 1920s and 1930s in a self-perpetuating series, obscuring just how versatile and innovative he was. Some of this slighting of Chicago period works, however, is due to preservation and technical problems.

With the exception of a brief hiatus in the late 1920s, Moholy always considered himself a painter. He would paint at home in increments of time as brief as fifty minutes, wrested from his long days and short weekends, producing works on canvas, opaque plastic, and transparent supports, particularly Plexiglas. Although Moholy did not invent three-dimensional painting, his Plexiglas light modulators are among its most superb examples. Plexiglas could also be bent into gleaming sculptures that

Fig. 1 László Moholy-Nagy, c. 1946. Photograph by Gordon Coster.

Fig. 2 László Moholy-Nagy lecturing in Chicago, 1946. Photograph by Arthur Siegel.

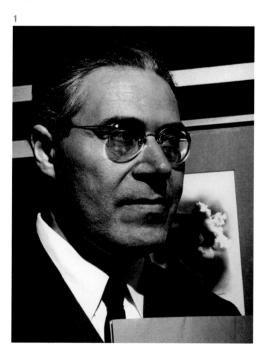

1

2

he could make at home by heating a precut sheet in our kitchen oven. But Plexiglas proved to be an unstable material and, ironically, Moholy's keen interest in its properties ensured that few of these works would survive. Today, the original beauty and transparency of most of these paintings and sculptures, which should be considered among his best, can only be appreciated in photographs.

Although Moholy took many black-and-white photographs of his family and others, he did not exhibit or publish them. His interest had turned to the potentials of color photography, which he had begun to explore in the Netherlands in the mid-1930s, and he made numerous 35mm Kodachrome slides. But because of their small format and the unsatisfactory printing methods of the times, these images are also largely unknown. Additionally, Moholy used color in several 16mm films he made to record and promote the school. Surviving films present a vivid and informative picture of its activities in the early 1940s.

Through the patience and goodwill of many individuals who taught or studied with Moholy in Chicago, I have been able to reacquaint myself with the school and, consequently, with my father.[2] A universal assessment was that Moholy was an exciting person with a remarkable ability to project excitement about the school and its goals (fig. 2). It was of overriding importance to him that the student should wholeheartedly dedicate himself or herself to acquiring an education. So disciplined himself, he placed a high value upon self-discipline in others, and students were expected to finish their projects, and to finish them on time. They were expected to learn to work in as many media as possible. A sense of the interrelationship between activities was emphasized. Students were encouraged to work cooperatively rather than competitively. Moholy was also concerned about their welfare. He arranged full or partial scholarships for a significant number of them, an act that seems surprising given the school's perpetual financial straits. Many students and faculty received photograms and artwork from him as gifts, and over the years several of them came to our apartment to celebrate our Europeanized Thanksgiving dinners with a nostalgic goose in place of the turkey.

As World War II ended, Moholy regarded the dramatic rise in enrollment at the school as a mixed blessing. The veterans were highly welcomed because they secured the school's financial future, which had been in serious doubt, but there were now too many students to know personally, and he felt that this separation had a deleterious effect on his teaching methods. He had always been deeply interested in educating the complete person. "Everyone is talented" became his best-known maxim. Every student was encouraged to discover his or her own abilities and then apply those abilities to meet the social, intellectual, emotional, and physical needs of human beings. Considerable emphasis was placed upon getting rid of preconceived notions in order to acquire the right mindset, which would naturally lead to good design. Adult students were encouraged to view the world with the wonderment of a child, free of preconceived notions that could impede a willingness to experiment or to recognize the new possibilities that might be opened up by failure. The process has been described as being stretched beyond one's limits and, accordingly, never being able to look at the world in quite the same way again.

The great achievement of the school's student-centered educational program was the gifted teachers it produced, individuals who carried its philosophy and methods into their own classrooms and their own creative work. Many of these individuals pioneered courses that have transformed design education. The impression one comes away with is that for most of its faculty and students, the school under Moholy's direction was the definitive experience of their lives. As Moholy changed the way they saw their world, so they have continued to change the perceptions of others.

An appreciation of Moholy must also take note of the distressingly brief amount of time he had to promote Bauhaus principles in America. Furthermore, circumstances could hardly have been worse, for these were the last years of the Great Depression, followed by the most destructive war in history, which drained off the money, manpower, and material he needed so acutely. His conviction and energy carried him through, but at a price: photographs show him as a good deal older than his years, and he died of leukemia at only fifty-one. Moholy had given the school its educational philosophy and his vision of what a design school could be. Had he lived longer, his ability to adapt to his circumstances might well have enabled him to integrate Bauhaus principles more firmly into American culture. He certainly never lost faith that he could ultimately accomplish this. When he was asked why the school remained in Chicago, a city famous for its conservatism, he replied, "That's why we have to be here. They need us here."

I like to imagine the special pleasure it would have given him when, in November 1999, the City of Chicago honored him with a tribute marker, which is a program that designates the residences of Chicagoans who have made important contributions to the city's history. Moholy's marker stands unobtrusively on the west side of Lakeview Avenue in front of the elephantine high-rise that replaced our old apartment building. He is in the excellent company of two other distinguished immigrants: Governor Altgeld's marker is two blocks to the north; Mother Cabrini's is two blocks to the south.

EDUCATING THE EYE

PHOTOGRAPH AND THE FOUN GENERATION AT THE INSTIT OF DESIGN, 1937–46

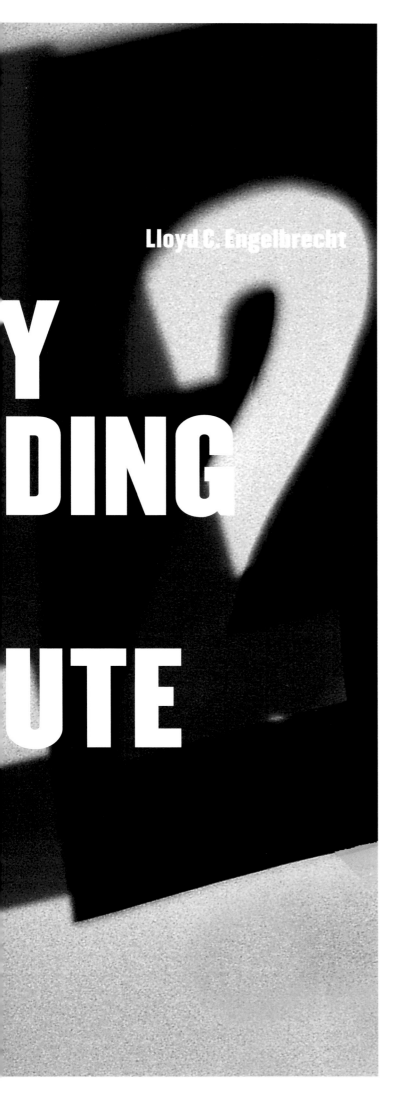

Lloyd C. Engelbrecht

In 1937 László Moholy-Nagy, a man of extraordinary personal energy and creative vitality, began a Chicago learning experiment that would revolutionize both the teaching and practice of photography. From the first small school that he directed and called the New Bauhaus, in the former mansion of Marshall Field on Chicago's South Side, through its later incarnations as the School of Design in Chicago (1939–44) and, ultimately, the Institute of Design (1944–present), Moholy guided the creation of a stimulating, experimental environment for the photographic arts. The Hungarian-born Moholy (fig. 1) used his experience in the European avant-garde as a painter, photographer, filmmaker, designer, and theorist to inspire his students to utilize the precedent-shattering creative strategies of European modernists. In addition to classes evoking the student-centered and open-ended Bauhaus spirit, the new school provided many opportunities for informal interactions between its students and a brilliant, innovative faculty. Each student's creative potential was nurtured by faculty encouragement for demanding and rigorous work directed toward probing but unforeseen results.

Not surprisingly, the impact of Moholy's radically new school shook up the study and practice of photography well beyond the confines of its classrooms and workrooms in Chicago. Photography throughout the country was effectively revolutionized by what happened under Moholy: first, photography was taught as a basic understanding of light and the manipulation of light; second, it was recognized as central to modern vision, a fundamental part of what Moholy believed it meant to say that someone was literate; third, photography was integrated into a complete art and design curriculum; and fourth, it was taught experimentally, not rigidly or dogmatically or commercially. In addition to these groundbreaking acts, what Moholy set into motion in Chicago also altered the geography of photography: prior to the opening of the New Bauhaus, photography had been dominated by artists who worked in New York or in or near the San Francisco Bay Area. Moholy's new school changed that fact as well, and Chicago took its place among the great American centers of photography.

Yet photography was not the sole aim, or even the principal aim, of the New Bauhaus and its successor schools. The outline of Moholy's original curriculum for the New Bauhaus, presented in the form of a circular diagram (fig. 2), includes photography, but only as one of six specialized workshops enumerated in an inner ring (where it is grouped with light, film, and publicity) and representing a course of study that a student would pursue during his or her second, third, and fourth years at the school. The first-year program for all students consisted of an extremely important Foundation Course, an obligatory preliminary program built upon a design workshop investigating the properties of various materials, a course in analytical drawing, and several available science classes (see figs. 3–5).[1] Clearly, the importance of photography in his own classrooms and the impact that his educational endeavors in Chicago would have on photography were unforeseen, even by Moholy. Looking back, the impact seems inevitable, since photography as taught at Moholy's

school(s) incorporated problem-based learning, the exploration of all the properties of photography, an understanding of photography as having its source in light studies, and a thorough examination of problems of form as well as experimental practices such as photograms, multiple exposures, solarization, and the use of reflection and refraction.

At the outset, however, photography was but one component in a program conceived to educate the whole person. Over the coming years, this program would change, and photography would follow its own path. By the time of Moholy's death only nine years later at the age of fifty-one, photographic education would become extremely specialized and require a different kind of training from what Moholy initially thought. Although its separation from the complete Bauhaus program may now strike us as ironic, given Moholy's firm allegiance to Bauhaus principles, this is what happened as the Institute of Design adapted to larger social and cultural forces. For the moment, however, it appeared that perhaps Moholy's most important accomplishment was his success in making the Bauhaus Foundation Course the opening wedge of an effort to replace venerable academic, or beaux-arts, training practices, characterized by encrusted exercises such as drawing from plaster casts of classical sculpture, and using established works of art as paradigms.

Moholy, Photography, and the Bauhaus

While revolutionary changes in photography and in photographic education clearly were achieved in Chicago by a number of people interacting with and learning from each other, it was Moholy who charted the course and steered the way forward. Throughout his career, Moholy's enthusiasm and his example made photography seem exciting to others and opened up new possibilities for them. He, in turn, was quick to appreciate the achievements of others and to explore the implications of their work. He brought to the task his own method of working, which was, even at the outset of his career as a photographer, far from ordinary. First of all, he did not think of photography as a passive medium. His very first photographs, for example, were two portraits meant to be superimposed.[2] Working with his first wife, Lucia (née Schulz), Moholy made his earliest photograms in their Berlin studio in 1922. His unique contribution to the photogram was clear from the outset: he conceived of it as a teaching tool, and in his very first article on photograms, entitled "Light: A Medium of Plastic Expression" and published in 1923, he articulated his notion that the technique was critical in "perfecting the eye by means of photography."[3] Significantly, he gained this insight even before he became a teacher. Over the years Moholy reiterated the importance of the photogram. In 1944, for example, he called the photogram "the key to photography, because every good photograph must possess the same fine gradations between the white and black poles that the photogram does."[4]

Moholy's judgment about photograms provides valuable clues to his aesthetic and gives us insight into arguably the most versatile artist of the twentieth century. For Moholy photography and filmmaking were part of a creative mix that included painting, printmaking, and sculpture. But he also explored artistic experiences that moved beyond existing categories, such as his

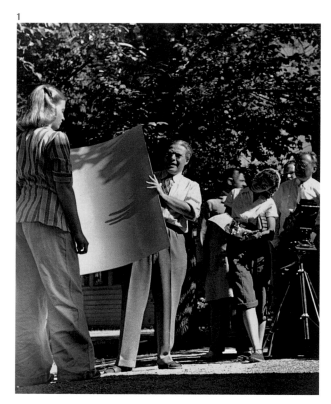

Fig. 1 László Moholy-Nagy at Mills College, Oakland, California, 1940.

Fig. 2 Curriculum diagram in the New Bauhaus course catalogue, 1937–38.

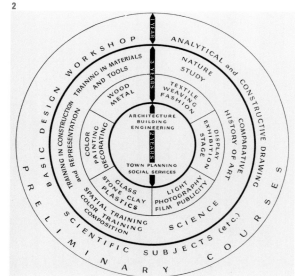

Fig. 3 Paper constructions made by students in the Basic Workshop, 1940s.

Fig. 4 Tactile chart produced in the Basic Workshop, 1940s.

Fig. 5 Student work from the sculpture class, 1940s.

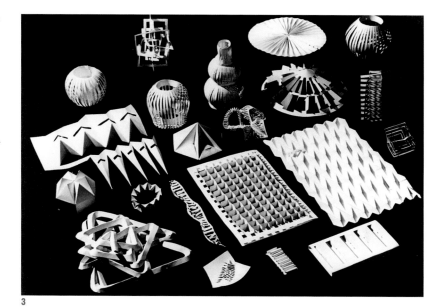

3

4

5

plans for light shows on artificial mists. He pursued graphic and industrial design, as well as exhibition and interior design; he contributed stage and costume designs for the theater and opera. Although not a professional city planner, he was nonetheless strongly involved in planning, particularly in Chicago; in addition, though he was not an architect, it was only Moholy's untimely death that prevented several schemes to collaborate on architectural commissions from blossoming into the development of an architectural practice. Along with all this he was active as a writer, educator, and lecturer in varied venues.

If Moholy's diverse endeavors were united by his concern for enriching the lives of men and women in the industrialized society of the twentieth century, another common thread in his work was his fascination with light. He created photographs through the direct manipulation of light, for example, and that same approach is evident in his paintings, some of which were based on transparent, overlapping shapes, while in others he painted and incised abstract images on clear plastic sheets to project shadows onto a white background (see fig. 6).

During his European years the two experiences that most prominently earned Moholy widespread notice in the world of photography were his years as a teacher at the Bauhaus (from 1923 to 1928), and the role he played in the international exhibition "Film und Foto," which opened in Stuttgart in 1929. Though he himself had only minimal formal education in art, Moholy nevertheless wanted to become a teacher in order to incorporate the challenges posed by modernism – and hitherto ignored by art schools – into a new kind of education. That opportunity came to him when he joined the faculty of the Bauhaus in April 1923. Founded by Walter Gropius in Weimar in 1919, the Bauhaus was a school of design, architecture, and applied arts that sought to bridge the divide between modern manufacturing techniques and traditional values of art.

To explain the crucial importance of the Bauhaus to his current and prospective students in Chicago and establish its connection to the School of Design, Moholy turned to a 1938 summation by Alfred H. Barr, director of the Museum of Modern Art in New York:

Why is the Bauhaus so important?

1. Because it courageously accepted the machine as an instrument worthy of the artist.

2. Because it faced the problem of good design for mass production.

3. Because it brought together on its faculty more artists of distinguished talent than has any other art school of our time.

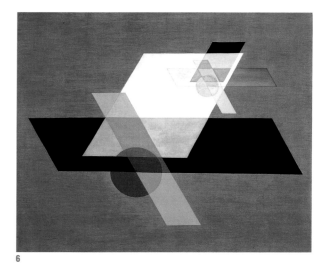

6

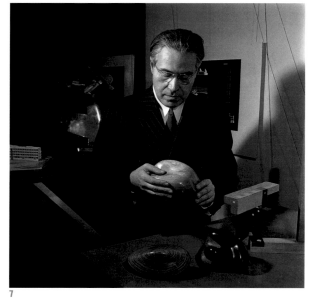

7

Fig. 6 László Moholy-Nagy, *A II*, 1924, oil on canvas, 115.8 x 136.5 cm, Solomon R. Guggenheim Museum, New York.

Fig. 7 László Moholy-Nagy, 1946.

4. Because it bridged the gap between the artist and the industrial system.

5. Because it broke down the hierarchy which had divided the "fine" from the "applied" arts.

6. Because it differentiated between what can be taught (technique) and what cannot (creative invention).

7. Because its building at Dessau was architecturally the most important structure of the 1920's.

8. Because after much trial and error it developed a new and modern kind of beauty.

9. And, finally, because its influence has spread throughout the world, and is especially strong today in England and the United States.[5]

Moholy published Barr's statement in the 1939–40 course catalogue for the School of Design and stated on the same page his own fresh approach to teaching – something that Moholy had brought from the Bauhaus to Chicago that Barr had not mentioned:

Of course, a great hindrance to self-expression is fear. One is limited by the fear that someone will laugh at him, will think him ineffective. This fear is increased by an anachronistic system which teaches the student that he must walk in the shadow of the genius of the past. In the School of Design, the student's self-expression is never compared with the work of a past "genius." On the contrary, instead of studying the master, the student is encouraged and urged to study that which the great man himself studied in his day – those fundamental principles and facts on which all design of all times is based.[6]

One of Moholy's principal responsibilities at the Bauhaus was teaching its influential Foundation Course – a first-year program required of all students to root them solidly in the fundamentals of design. After completing their Foundation Course, students elected further study in a changing variety of workshops, such as typography, pottery, weaving, carpentry, stained glass, sculpture, or stagecraft. In addition to teaching the Foundation, Moholy also directed the Metal Workshop. He co-edited with Gropius fourteen books produced by the Bauhaus, three of which were written wholly or partially by him. He also co-edited, again with Gropius, the Bauhaus magazine, and produced designs for books, catalogues, brochures, and more for the Bauhaus.

Despite the importance of photography in his own career at this time, Moholy did not teach it at the Bauhaus. He regularly had his students photograph their own work – a practice that he continued in Chicago – but courses in photography were simply not offered during his tenure at the Bauhaus.[7] One of the Bauhaus books he produced with Gropius was his own *Malerei–Photographie–Film* (*Painting, Photography, Film*), two editions of which appeared in 1925 and 1928. This book effectively challenged existing ideas about photography, although the first English-language edition did not appear until 1967.[8] Another of his Bauhaus books, *Von Material zu Architektur*, published in 1929, had a profound influence in America, especially after it appeared as *The New Vision: From Material to*

Architecture in a New York edition in 1932.[9] *The New Vision* summarized Moholy's teaching in the Bauhaus Foundation Course and his experimental and interdisciplinary approach to education.

By the time he left the Bauhaus, Moholy had emerged as a leading member of the European avant-garde, writing regularly about fine arts, film, photography, and design for a variety of journals in several countries. In addition, he worked as a photographer, filmmaker, and designer with clients in several European cities, including Berlin, Amsterdam, Brussels, and London. Assisting him were György Kepes and former Bauhaus student Hin Bredendieck, both of whom followed him to Chicago. He also achieved recognition for his work in the fine arts through large, single-artist showings in Brno, Czechoslovakia, in 1933, and in London in 1937.

Although it occurred after he had left the Bauhaus, the single event that solidified the international reputation of Moholy and the Bauhaus in photography was the German Werkbund's exhibition "Film und Foto," which opened in Stuttgart in 1929;[10] a portion of it was later seen in other European cities,[11] as well as in Tokyo and Osaka.[12] Shown in Stuttgart were more than one thousand photographs, over one hundred of which were Moholy's own images. Part of the exhibition displayed the work of schools, including the Bauhaus; this was probably the first time that the Bauhaus was brought to the attention of a broad public as a school noted for its work in photography.[13]

Moholy had helped to organize "Film und Foto," and it is notable that his role in the project included supplementing the works of professional photographers by mounting an extensive array of scientific photographs (including X-rays), many supplied by industrial firms, along with police, newspaper, and picture-agency photographs. In addition, he installed copy prints of historic photographs.[14] Close ties with industry and heavy stress on the history of photography were both to be important to the Institute of Design. The photographs shown in Stuttgart – none of which were pictorialist – buttressed Moholy's argument in *Painting, Photography, Film*, which urged the avoidance of stylistic imitation.[15]

Although films were a large component of the Stuttgart exhibition, Moholy had not as yet completed any; he would go on to make at least ten films, and he wrote extensively on cinematic theory and practice. Of the photographs that Moholy showed in Stuttgart, however, many were illustrated the following year in a book entitled *60 Fotos*, which included worm's-eye and bird's-eye photographs, as well as negative prints, photograms, and photocollages.[16] The only monograph about Moholy's work as a photographer brought out during his lifetime, *60 Fotos* had a powerful impact on many young photographers, including Henry Holmes Smith, who would later teach for Moholy in Chicago.

In his post-Bauhaus years, Moholy seemed to be having a good life and career in Europe. His work as a photographer, designer, and filmmaker had been well received in some of Europe's major cities, and his books and other writings had appeared in several languages and had made some impact.

Moreover, he was beginning to gain recognition for his work as a painter. In Berlin and later in London his circle included some of Europe's major artists, writers, architects, and designers, and he clearly found his fellowship with them to be stimulating. The one thing he lacked that was important to him was teaching. Plans for a joint educational effort with Gropius in England had not worked out, and the only teaching he actually did in Europe after leaving the Bauhaus consisted of brief guest appearances at a school in Budapest.

The New Bauhaus, 1937–38

At the time he was contacted by the Association of Arts and Industries to come to Chicago, Moholy was running a very successful design practice in London. The Association, founded by a group of Chicago industrialists in 1922, had long sought to establish a school of design and had earlier supported an "industrial art" curriculum at The School of the Art Institute of Chicago, but had withdrawn its support, dissatisfied with what it considered to be a curriculum largely irrelevant to the needs of Chicago industry.[17] By 1937 Norma K. Stahle, the executive director of the Association, had decided that she wanted a new school to be run along Bauhaus lines. Stahle wrote to Walter Gropius, who had arrived in the United States early that year to accept a position as professor of architecture at Harvard University, asking whether he would be interested in coming to the Association's planned new school. Gropius promptly replied that he intended to remain at Harvard for an indefinite period, but he recommended Moholy for the position of director, describing him as "my nearest collaborator in the Bauhaus," and adding that Moholy "is endowed with that rare creative power which stimulates the students" (see fig. 7).[18]

On May 23, 1937, Moholy received a telegram from Stahle informing him of the plan to open an "industrial design school in Fall backed by industrialists." She described it as a "modest beginning but real opportunity to establish project along lines Bauhaus," and she asked whether he would consider becoming its director. Moholy promptly cabled back that he was "highly interested."[19] Stahle then contacted some of the clients for whom Moholy had done freelance work in England, and spent two days with Gropius, questioning him about Moholy.[20] Shortly thereafter, Moholy was invited to Chicago for an interview. An appointment was offered and accepted, and a public announcement was made on August 22 that Moholy would be director of "The New Bauhaus/American School of Design" (see fig. 8).[21] Announcements soon followed in American magazines concerned with art, architecture, and design.

The New Bauhaus occupied the Marshall Field mansion, which had recently been donated for that purpose to the Association by Marshall Field III.[22] Architect Henry K. Holsman, a member of the Association's board of directors, was in charge of converting the house into a school. Moholy assisted in this effort once he was appointed director, and the character of the remodeling probably reflected his ideas and taste rather than Holsman's, since the latter tended to be conservative in expression.

The limestone-trimmed, red-brick exterior of the Field mansion, designed by Richard Morris Hunt and completed in 1873, was enhanced with a new travertine-marble frame around the entrance, with cast-aluminum letters spelling out the name of the school. A conservatory that formed part of the south side of the house was demolished, and in place of its curving glass façade a cement-block office wing was built, severely modern in appearance, containing a strikingly avant-garde office for Moholy (fig. 10). Spacious bedrooms were remodeled into classrooms. But the renovation was most dramatically seen in the circular walnut staircase, where the carved balustrade of the stairway was plastered over. Although the building was demolished long ago, the sweeping forms of the resulting spiral may still be experienced in a 1937 photograph showing Moholy with Gropius, who served as adviser to the New Bauhaus (fig. 11).

Moholy had intended that the first class in photography at the New Bauhaus be taught by György Kepes, who had been living in London (fig. 9). Kepes spent some time after Moholy had invited him to Chicago deciding whether to join the International Brigade that was aiding the Loyalist, anti-Franco forces in the Spanish Civil War. After much reflection, Kepes belatedly accepted Moholy's offer. Since Kepes was not on hand when classes opened, Moholy contracted with Henry Holmes Smith, a practicing commercial photographer, to step into the breach. He was engaged to teach one day per week during the autumn semester, and full-time in the spring semester. He also helped to get the photography program moving because he lent his own supply of materials and equipment to supplement what Moholy already had available.[23]

At the very first class in photography the students made an assemblage of objects available in the studio that day, and Smith documented the exercise with a photograph. The exercise was intended to prepare the students for the making of photograms. Nathan Lerner – then a student, later a faculty member at the school – has recounted his memory of that day: "The first problem that I remember was to take materials and try to organize them in a way that you thought would make an interesting photograph – materials that had unique characteristics of reflection, absorption, and transmission of light."[24] Smith's effort was consistent with Moholy's belief that photograms were the

8

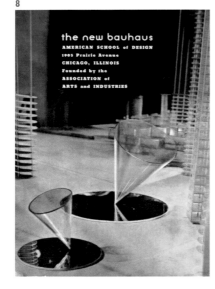

Fig. 8 Cover of the New Bauhaus course catalogue, 1937–38.

Fig. 9 György Kepes, c. 1940.

Fig. 10 Exterior view of the Marshall Field mansion, 1905 South Prairie Avenue, where the New Bauhaus was located from 1937 to 1938.

10

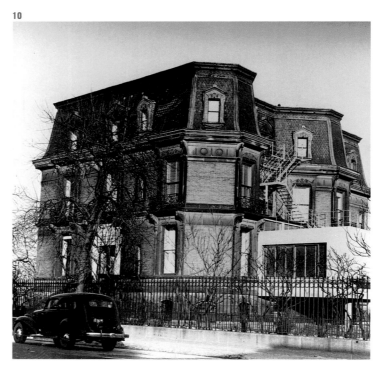

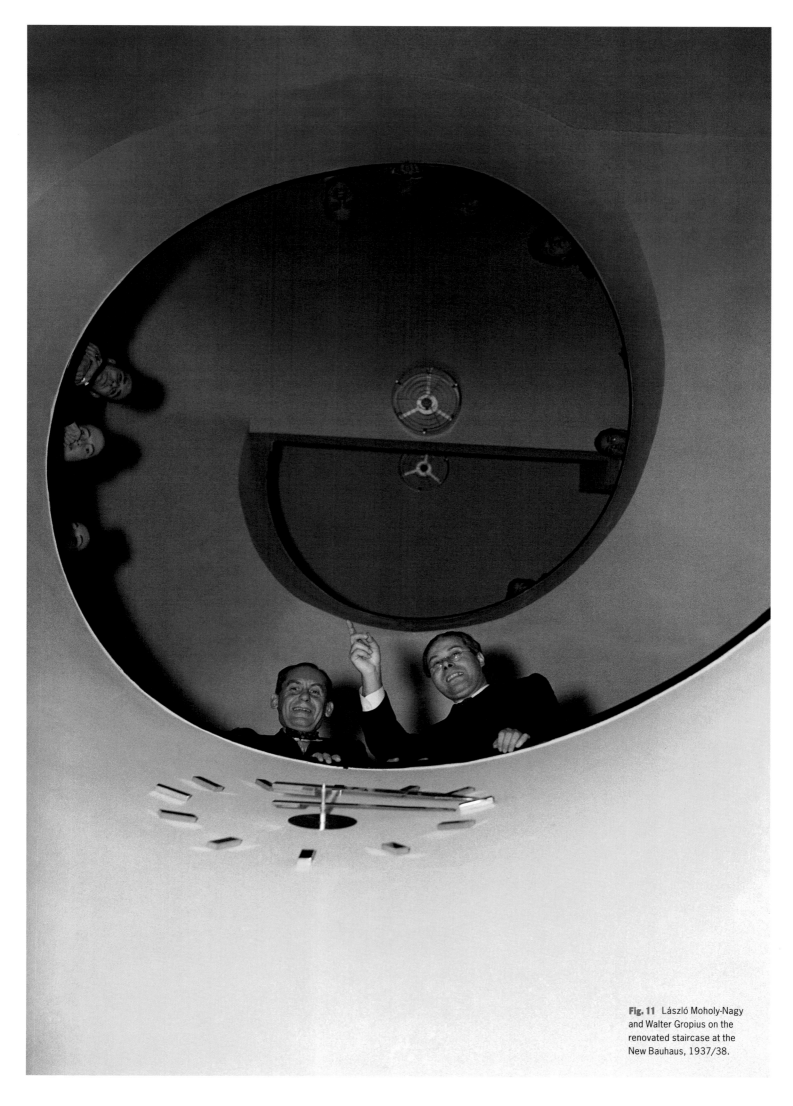

Fig. 11 László Moholy-Nagy
and Walter Gropius on the
renovated staircase at the
New Bauhaus, 1937/38.

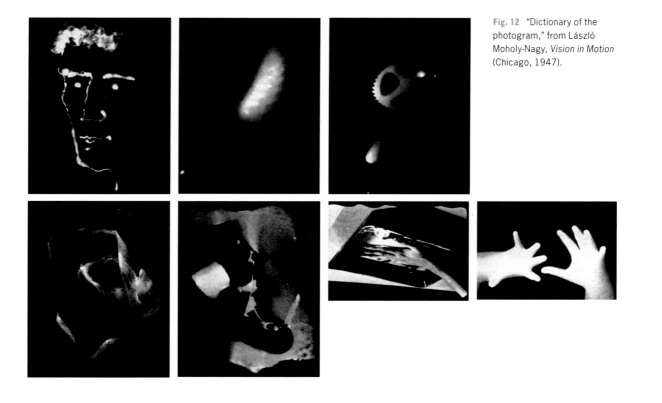

Fig. 12 "Dictionary of the photogram," from László Moholy-Nagy, *Vision in Motion* (Chicago, 1947).

key to photography and thus an important teaching tool because they allowed students to learn the infinite gradations of tonal range and to understand photography's basic property of light-sensitivity. But there was also a practical reason why they began with photograms, as Smith has explained: "Since the first days of the fall semester found us without completed dark-rooms, Moholy suggested that we start with photograms on that magic material, printing-out paper. This permits printing in bright daylight."[25] Printing-out paper, no longer readily available, allowed a photographer to use bright light sources and very long exposures. After exposure the photograms were fixed and washed, a more simple process than development.[26] The use of printing-out paper also enabled a photographer to employ moving sources of light. One could, for example, make a photogram by "drawing" on the paper with a pinpoint flashlight, as Moholy did in a portrait he later published in *Vision in Motion* (fig. 12), the posthumously published book that outlined his educational philosophy. Because they were central to Moholy's educational ideas regarding the study of light, the production of student-made photograms continued during the year, including examples made on developing-out paper.

Another exercise was based on solarization, a halo effect obtained by interrupting development and giving the film a second but short exposure. In another assignment, the students made color filters consisting of different pieces of cellophane arranged in a pattern between panes of glass. These were then used to control and modify transmitted light, much as an ordinary negative does. The exercise utilized both "color-blind" black-and-white emulsions and color-sensitive panchromatic and orthochromatic films.[27] Other problems included studies of

structure and texture, making use of such objects as leaves, insect wings, and cloth. Students were shown how to superimpose images and create multiple exposures. They made negative prints, and studied the action of prisms and distorting mirrors. They recorded overlapping rays of light, or "additive light records." Finally, they conducted "light volume studies," in which varying distances from a light source were measured by variations of brightness, or in other cases, by an increase in the area a ray of light could strike. In some of these exercises the students worked in groups, in others as individuals (see fig. 14). Related to the light volumes are "virtual volumes," made by photographing a rotating object with the camera's shutter left open so that the motion of the object defined a three-dimensional form.[28]

There were also light-modulator exercises, described by Kepes and Smith as follows:

Using white paper as the [principal] material, students design objects to work with a single light source. As the planes of paper are curved or straight, bent, or perforated, light play results which may be translated by photography into a series of black, white and gray gradations. The result is an object with a predetermined range of brightness differences which is to be rendered photographically.

They also described more advanced light-modulator exercises:

Through a more conscious articulation of light using curving planes, flat planes, perforations, etc., the student gains understanding of the way that light and objects work together to become photographic subjects.[29]

Although Kepes had a thorough training in traditional and nontraditional art, and considerable experience as an artist and

designer, he had had no prior experience as a teacher, and in fact conceived the light-modulator exercises, one of his most significant improvisations, shortly before beginning to teach in Chicago. These exercises and others, Kepes recalled, "were all improvised ideas to find a teaching method."[30] Smith has added that the light modulator was introduced "under the encouragement of Moholy-Nagy and drawing on the work of [American experimental photographer] Francis Bruguière as a model."[31]

The step-by-step construction of a light modulator from a single sheet of paper was published in *Modern Photography* magazine;[32] in addition, in *Vision in Motion* Moholy described the use of light modulators as a teaching tool, calling it, after the photogram, "the second step in learning the elements of photography" (see fig. 13).[33]

The fact that the light-modulator exercises were so valuable that they were retained as an essential part of the teaching of photography is an indication of how gifted Kepes was as a teacher. Lerner and others have emphasized the key role Kepes played in the school:

And while Moholy was the magician who made all of this possible, there was another voice just as important – Kepes, head of the Light Workshop, which included under its aegis both graphics and photography. Kepes was somehow able to take Moholy's hyperbolic zeal and organize it within a framework students could assimilate and use.[34]

For his part, Kepes acknowledged that Smith provided him "very important stimulation," and he recalled that for Smith, "Every day was for learning something new about photography."[35] Together they summarized the goals of their photography program in an end-of-the-year statement in the spring of 1938:

This is an exploratory course. Nevertheless an attempt has been made to present only material which meets one or several (preferably the latter) of the following conditions:

1 – It enables the inexperienced worker to produce pictures technically better.

2 – It is useful in the [documentary] stage of photographic work but has even increased significance in more advanced study.

3 – It can be studied without much pre-education in technical terminology and without requiring a technical background for manipulation.

4 – It involves enriching experience in this field, pointing [to] channels for additional work later, yet directs activity constantly to the same obvious task of becoming familiar with materials and means of manipulating them.[36]

Unstated here was the hope that the students would be stimulated to initiate endeavors of their own that probed unforeseen opportunities. Indeed, the record of the school shows that this is just what happened. The very first example was the "light box" invented by Nathan Lerner (fig. 15) two or three weeks after the start of the inaugural term of the New Bauhaus.[37] The light box that Lerner conceived and developed was a device for studying and expressing light in a controlled environment (see figs. 16, 17). Moholy quoted Lerner's description of it in *Vision in Motion*:

I made a box, which was open on one side and with many holes cut into all sides. These holes were used for suspending objects and also served as openings for light to enter. Over these openings, objects (wire screen, etc.) could be placed and projected on the materials inside the box With this simple device a great deal of control over light can be exercised.[38]

Lerner came to the New Bauhaus with extensive training as a painter at the School of the Art Institute. Though he had never studied photography before, he had made photographs. They grew out of his study of painting, however, and showed a painter's vision and interests, expressing psychological moods and documenting social relationships. Yet, through his teaching and his sympathetic encouragement and direction, Smith soon made Lerner aware of the possibility of expanding the means of photography.

The photographs that Lerner made with the light box show an increased and intensified sensitivity to the articulation of light and form. One of the first utilized a curved piece of paper, a rectangular block, and some dowels, articulated with light introduced through a ribbed opening.[39] Another shows the box's perforations with crisscrossed strings and two eggs dark

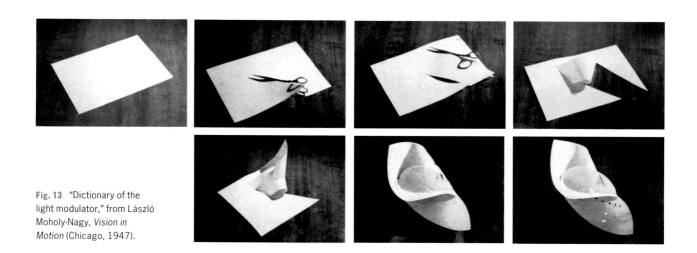

Fig. 13 "Dictionary of the light modulator," from László Moholy-Nagy, *Vision in Motion* (Chicago, 1947).

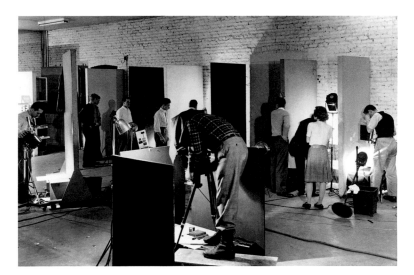

Fig. 14 Students working in the School of Design photography studio, 1940s.

against the light. Of course Lerner quickly discovered that the world is a light box: his *City Light Box*, 1945, studies clothes hung out to dry on multiple clothes lines – a real-world example of the light box's controlled lighting with paper strips and strings. In describing the broader significance of the light box, Lerner professed: "Working with it can give [any artist] a deeper insight into the visual-psychological elements that play an important role in making any picture exciting and meaningful."[40] Later, when he taught at the School of Design, Lerner stressed light-box studies. Moholy too was fascinated by the light box, and he wrote and talked about it extensively, and even illustrated Lerner's diagram of it in *Vision in Motion* (fig. 17).[41]

Lerner provides the best example of a student interacting with faculty members who also learned from him. His collaboration with Smith lasted off and on for ten years, and culminated in an encyclopedic, carefully organized written survey of photographic possibilities utilizing reflected and refracted light.[42] Meanwhile, Lerner's collaboration with Kepes resulted in the article "Creative Use of Light," which examined the history of the technical and conceptual means that "opened the way for a new form of visual expression – the use of light as a primary medium in itself."[43]

Kepes also pursued photomontage, photogram, and various other techniques. Each of the three versions of Kepes's 1937/38 portrait study *Juliet with Peacock Feather* (see pls. 30–32), for example, is a striking depiction of his wife, and each reveals how he simulated the effects of photomontage by painting on the print. Juliet Kepes herself was one of five members of the first graduating class of the School of Design in Chicago. In later years she became a very successful illustrator of children's books.

Already a photographer by the time he enrolled at the New Bauhaus in the spring of 1938, Arthur Siegel – who was to be a key player at the ID in later years – had first been attracted to the school by a lecture Moholy gave at Wayne State University in Detroit, Siegel's hometown. The lecture led to a meeting in

which Moholy examined some of Siegel's photographs.[44] Smith noted that Siegel "worked independently and was highly praised by Moholy at the year-end review of student work."[45] Siegel himself considered Moholy "a stimulating teacher" and recalled pointedly: "In six months I learned little about photography, but a world's worth of Art."[46] Siegel's *Photogram #72*, seemingly part of a series dating from his student days at the New Bauhaus, is a dazzling study of perhaps only one kitchen sieve, using multiple exposures and a moving light source, and made on printing-out paper (pl. 6).

The New Bauhaus enrolled thirty-two students in the autumn semester and fifty-two in the spring semester, plus sixteen others in a spring-semester night class. The increased enrollment in the spring semester, however, while no doubt encouraging, nevertheless put the school under stress. As Henry Holmes Smith put it, "what had been an exciting impossible task became totally unreal in its difficulty," including "Moholy's idea of having all the students attend the same class so that the experience of each could be related to all the others."[47] The school also attracted a significant number of women at a time when many nominally coeducational programs had only a scattering of female students.

Many of the students at the New Bauhaus and its successor schools had already had considerable education or experience in art or related fields. Richard Koppe, for example, who would later become a faculty member of the ID, had completed four years at the St. Paul School of Art in Minnesota before arriving in Chicago. He has observed that "Some students entered the New Bauhaus in the spirit of graduate students."[48] Recalling the diversity of students' ages (from eighteen to early thirties), Kepes noted that some were older than he.[49] Siegel called them "the most exciting group of students I've ever been with.... This small group of maybe thirty people ... was like an island in the city of Chicago."[50] Smith later remarked that one thing they had in common was that none of them had really wanted to be photographers.[51] Perhaps it was because of this fact that they

worked without preconceptions and explored the vast creative potential of photography. Indeed, they approached photography like explorers who had landed on a recently discovered planet.

Two major exhibitions brought to the New Bauhaus by Moholy during its first year indicated the artistic character he wished his school to possess. The first was a showing of abstract art, and included work by Alexander Calder, Naum Gabo, Ben Nicholson, Barbara Hepworth, Henry Moore, Piet Mondrian, and Moholy himself.[52] The second exhibition, "A Brief Survey of Photography from 1839–1937," was a selection of photographs that had been shown at the Museum of Modern Art in New York during the previous year. It was a landmark exhibition organized by Beaumont Newhall, with help from Moholy, to mark the one-hundredth anniversary of photography.[53] The show included work by Moholy,[54] who gave his views of the exhibition in a public lecture called "Development of Photography." His emphasis on the importance of the history of photography to its practice was later to be reinforced at the Institute of Design by Arthur Siegel.

Despite the increase in students during the spring semester and other apparent signs of its successful operation, the New Bauhaus shut its doors after the close of the academic year. The reasons for the closing of the New Bauhaus are complex, and to this day they are not entirely understood. The simplest explanation is that the Association of Arts and Industries – which had founded the school and supported it financially – had run out of money. Before this grim reality had become fully evident, however, a number of personal and philosophical conflicts had developed. The Association's executive director, Norma K. Stahle, and some members of its board had become dissatisfied with Moholy's operation of the school. Stahle, who had ably run the Association's affairs since its founding in 1922 and was at least nominally the assistant director of the New Bauhaus, probably felt that Moholy was not consulting with her. Stahle was committed to a modernist approach, and initially she and Moholy had gotten along very well together, but at some point the relationship had gone sour. Some of the board members thought Moholy should have taken a more direct approach to working with business and industry, while, ironically, some of the students were unhappy because they wanted more emphasis on fine arts.[55] A small number of faculty members wanted to continue to work with the Association, but that, of course, ceased to be an option when it ran out of funds. Moholy sued the Association for breach of his five-year contract,[56] and settled out of court for a sum of money, some of which he used to finance the organization of his next venture, the School of Design in Chicago. In the present context it should be stressed that the innovative achievements in photography at the New Bauhaus had no evident role in either angering or mollifying any of the dissidents.

The school enjoyed a final burst of glory in the form of the student exhibition that opened on July 5, 1938, and continued

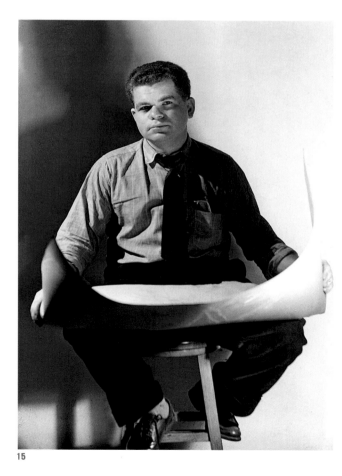

15

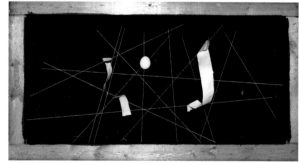

16

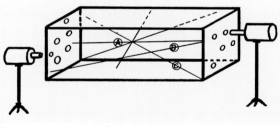

17

Fig. 15 Nathan Lerner, 1940s.

Fig. 16 Reproduction of Nathan Lerner's light box, 2000.

Fig. 17 Nathan Lerner, diagram for a light box from László Moholy-Nagy, *Vision in Motion* (Chicago, 1947).

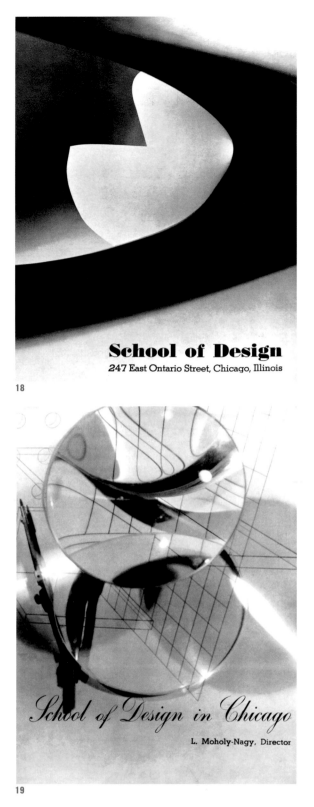

School of Design
247 East Ontario Street, Chicago, Illinois

18

School of Design in Chicago

L. Moholy-Nagy, Director

19

hand sculpture . . . life drawing . . . photo-
grams . . . biological sciences . . . stone-cut-
ting . . . architectural drawing . . . wall con-
structions . . . pigment analysis . . . posters
. . . mathematics . . . paper cuts . . . plywood
furniture . . . hand loom weaving . . . sociol-
ogy . . . clay modeling . . . mechanical draw-
ing . . . lettering . . . physical sciences . . .
light displays . . . wood cuts . . . wire bend-
ing . . . economics . . . mobile sculpture
. . . foot power weaving . . . metal cuts . . .
philosophy . . . stage sets . . .

20

Fig. 18 Cover of the School
of Design course catalogue,
1939–40.

Fig. 19 Cover of the School
of Design course catalogue,
1940–41.

Fig. 20 Detail from the
School of Design course cata-
logue, 1940–41, showing
various areas of study.

into September. A large part of the credit for the attention paid to this show is owed to Clarence J. Bulliet, a perceptive critic who published a brilliant and intriguing review for the *Chicago Daily News* that was promptly quoted by art magazines in New York and London.[57] The exhibition also received a favorable review in *Time* magazine.[58] Further recognition of the school's potential was apparent in the exhibition "Bauhaus 1919–1928," which opened at the Museum of Modern Art in New York on December 6, 1938, and included work by New Bauhaus students, Nathan Lerner among them.[59] At about the same time, a stunning new edition of Moholy's *The New Vision* appeared, issued by the prestigious New York publisher W. W. Norton, and containing still more examples of New Bauhaus student work.[60] The book did well in the trade, too: more than one thousand copies had been sold by the end of 1938.[61] Thus, while Moholy enjoyed a new round of attention to his writings and the school's creative product reaped praise from local and national press, the New Bauhaus itself closed its shop for good. It would remain Moholy's challenge to revive its intentions through the auspices of another institution.

The School of Design, 1939–44

Moholy's modest plans for the revival of the New Bauhaus began inauspiciously. Together with some of his teachers he cosigned an announcement, dated January 17, 1939, which went out to prospective students, promising to open classes "at the end of February" if sufficient enrollment could be obtained. A more confident follow-up announcement set registration for February 23, with classes to begin the next day. Eighteen day and twenty-nine night students – many from the New Bauhaus – enrolled for classes at an institution that called itself the School of Design in Chicago, located in a former bakery on the second floor of a loft building at 247 East Ontario Street on the city's Near North Side (see figs. 18–20). One of the teachers, George Barford, later recalled:

> The building … had been a commissary for a chain of Greek restaurants, and so we used the ovens that had cooked nice Greek pastries, and we stored plywood in them, and then we cleaned out the storage rooms full of meat and fish and we made darkrooms out of those.[62]

The new school was launched with very limited financial resources. Of the former board members of the Association of Arts and Industries, only Walter Paepcke, whom Moholy had approached for financial assistance, supported this new venture.[63] In addition to donating money, Paepcke and his wife, Elizabeth, also made available to the school an abandoned farmhouse and two acres of land.[64] The farm was in northern La Salle County, Illinois, just south of the small village of Somonauk.[65] Summer sessions would be held there in 1939, 1941, 1942, and in subsequent years. Paepcke's philanthropy was crucial to the continued operation of the School of Design, as it would later be to the Institute of Design. His backing meant donations from his own personal funds and those of his relatives, from the Container Corporation of America, of which he

was president, and from many Chicago businessmen whom he tirelessly prodded to give money to the school and to pay tuition for their employees to enroll as part-time students.

The school endured numerous changes in its staff, and the faculty members who returned agreed to serve without salary during the first semester – evidence of their faith in Moholy and in the school's goals. Smith, for example, departed, but Kepes continued teaching photography as part of the Light Workshop. Leonard Niederkorn, a New Bauhaus student, became his assistant for the spring semester.[66] Frank Levstik joined Kepes in the fall of 1939, and he would remain on the faculty for the next ten years. Also assisting Kepes was Lerner, still a student. Enrollment grew only slightly in the fall, numbering twenty-eight day students and fifty-three night students.[67] Throughout its existence, the School of Design remained small, as many of the students studied only part-time and at night, and often only for a year or two. Harold Allen, who was a part-time night student for just under one semester in 1940, remembered Moholy's attempts at conveying a sense of the overall activity at the School:

> [E]very night after our regular classes were finished, Moholy would call us into his offices and talk with us about half an hour, as a group, showing us what was going on in the school. Most of it was work in progress, part of a film, for instance, parts of a group of photographs somebody was making, very advanced ideas of using photography …. I was never in a class with [Moholy], but I learned a great deal from him.[68]

Another new faculty member, James Hamilton Brown, arrived in the fall of 1940 to teach night classes, and thus began a six-year tenure at the school. His emergence as a creative photographer has been observed by Lerner:

> [Brown] came to the photo workshop skilled technically, but also with a kind of vision he had derived from his commercial background. What the School did, as it did for all the students and teachers alike, was to break through preconceived attitudes and ideas. You no longer looked at what had been done, but rather at what you could do …. His images started to show his awareness of the importance of articulating tonality to create visual excitement. More importantly, we see in his work a beginning of self discovery. He starts to create a kind of warped reality which he expresses with a mastery of the medium. The works have a surreal quality …. The images are haunting.[69]

When Milton Halberstadt came from Cambridge, Massachusetts, to study on a scholarship in 1940, he was already an experienced photographer.[70] He managed the darkroom and its equipment and chemicals and also printed some of Moholy's photographs for him. Halberstadt made a number of experimental portraits, including one of Olga Kadic, his future wife, in which her face appears in multiple, distorted images, reflected from drops of water on a sheet of ferrotyped tin (see pl. 51). The best known of his portraits is a triple-exposure of a fellow student, Norm Martin, a combination of front, back, and profile. Moholy considered it an example of the kind of vision utilized by such early-twentieth-century Cubist painters as Pablo Picasso and Georges Braque. Halberstadt insisted that his por-

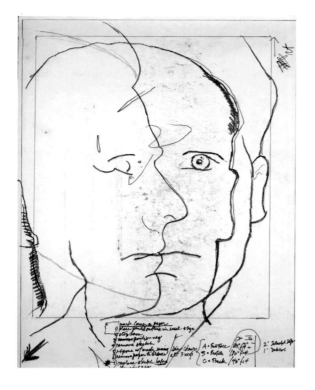

Fig. 21 Milton Halberstadt, schematic drawing for his triple-exposure portrait of Norm Martin, 1940/41. See also pl. 29.

trait of Norm Martin was basically intuitive, despite the planning that had clearly gone into his original schematic drawing (fig. 21; pl. 29).[71] Unable to enroll for a second year, because there was no scholarship money for him, Halberstadt nevertheless hung around and used the school's darkroom for processing his own work, before enlisting into the army.[72]

The impact of the School of Design went beyond what was experienced by its students, in part because Moholy proved to be highly skilled at public relations. For a small school that was at times seriously underfunded, the School of Design had a growing influence nationally, as can be seen in activities that took place in the San Francisco Bay Area during a two-year period. In April 1939 Moholy gave two slide talks on "Bauhaus Education" and "The New Vision" as a special guest at an annual convention of the Pacific Arts Association in San Francisco.[73] Margaret De Patta met Moholy during his stay there and was evidently inspired to make her own series of photograms in 1939. She also took part in a summer session that Moholy conducted with Kepes and other School of Design faculty at Mills College in Oakland, California, the following summer, 1940,[74] and studied at the School of Design that academic year (1940–41).

Moholy's invitation to teach at Mills had come from the head of its Art Department, Dr. Alfred Neumeyer. While in the Bay Area, Moholy showed photographs from July 1 to 15 as part of a series of exhibitions complementing a season-long "Pageant of Photography" that had been set up by Ansel Adams at the Palace of Fine Arts at the Golden Gate International Exposition.[75] Moholy's work was seen by an influential group of visitors, when attendees at a national meeting of the American Federation of Arts toured the Palace of Fine Arts. Not surprisingly, Moholy seems to have made the most of his time: he served as a mem-

ber of one of the Federation's discussion panels and put in another appearance, along with Adams, before the Associated Camera Clubs of Alameda County, which was hosting the annual Western Amateur Camera Conclave in Oakland.[76]

The same impetus that led Moholy to address a gathering of amateur photographers in Oakland also drove his extensive contributions to the photographic press in America. Notable examples from this period include two demonstration pieces, "Making Photographs without a Camera" and "Make a Light Modulator," as well as contributions by Kepes (see figs. 22, 23).[77] Moholy had argued consistently and repeatedly that everyone would benefit from the direct experience of making art – "everyone is talented," he often insisted.[78] These essays constitute a very practical application of his desire to teach photography. Thus, when he laid out his final thoughts on photograms and light modulators in his last published work, the posthumously issued *Vision in Motion* (1947), Moholy once more had the layman in mind, the person whom he envisioned when he frequently referred to the illiterate of the future as someone ignorant of both photography and the written word.

These very principles underlay the exhibition "How to Make a Photogram," which Moholy, Kepes, and Lerner organized at the request of Alfred Barr, director of the Museum of Modern Art, New York. The exhibition opened at MoMA in fall 1942, after an eight-city tour in 1941, before again touring through spring 1943 in venues (mostly schools) from New England to Texas. Eighteen panels illustrated photographs and photograms by faculty and students of the School of Design, and also included two examples by Man Ray.[79] The exhibition signaled that Barr – New York's increasingly influential arbiter of what was significant in modern and contemporary art – and his museum, whose cura-

tors had long ignored Chicago's painters and sculptors and almost acted as if America's second city did not exist, were finally beginning to look at something in Chicago besides its architecture.

The School of Design reached a major milestone at the end of the spring semester 1942, when it conducted a graduation ceremony for its first group of five students to complete the requirements for the bachelor's degree in design: Juliet Kepes, Myron A. Kozman, Nathan Lerner, Charles Niedringhaus, and Grace Seelig.[80] An extensive showing of student-designed furniture, complemented by a display of Moholy's paintings, was set up to mark the event.[81] By the fall of 1942 enrollment had grown to 208 students: 20 day and 188 night students.

A momentous change in the faculty occurred at the end of 1942, when Kepes accepted an offer to teach at the University of North Texas in Denton. While there he completed the text for *Language of Vision*, which made available in a stunningly well-illustrated book some of the educational strategies and accomplishments of the School of Design (fig. 24). As illustrations Kepes chose many examples of the work of School of Design faculty and students.[82] Although Kepes had not taught photography exclusively, his departure was a serious blow to the program. Fortunately, it came at a time when the School of Design was a stronger and more secure organization than it had been when Kepes taught in that seriously underfunded spring semester of 1939. It was larger and improved as well, with an increased enrollment that reflected its growing reputation. It would still face problems in its financial stability and it would shortly face a more devastating loss in the death of its charismatic director. For the moment at least, its growth was sustained and its prospects, even in wartime, seemed bright.

The Institute of Design, 1944–46

By spring 1944 Moholy and Paepcke realized that it was time for the school to take another step forward. Thus, in March, the two of them led the school through a reorganization, during which it changed its name again, becoming the Institute of Design. It also welcomed a new governing board of directors to replace the so-called Sponsors Committee that had been named in 1939 but that had never actually met, nor provided any financial support. The new board fulfilled their expected financial responsibilities, although in agreeing to back the school, they made Moholy accept that business managers would be brought in to oversee operations. Despite these changes, Moholy still held the artistic and educational reins. The difficulty in attracting students throughout the war years, however, clearly cast doubt on the viability of the school and Moholy's vision of its educational plan. After successful summer programs in 1941 and 1942 in Somonauk, for example, the 1943 summer school had been cancelled for lack of enrollees. Even a year after the reorganization, in the spring 1945 semester, the total enrollment of 212 students was not substantially different from what it had been in recent semesters, particularly in view of the fact that only twenty-nine of these students were full-time. Correspond-

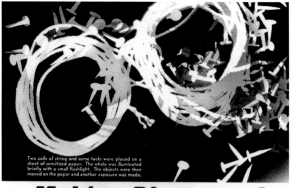

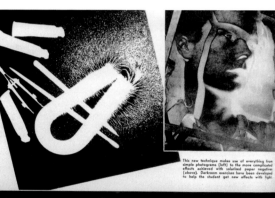

Fig. 22 László Moholy-Nagy, "Making Photographs without a Camera," *Popular Photography* 5 (December 1939).

Fig. 23 György Kepes, "Modern Design! With Light and Camera," *Popular Photography* 10:2 (February 1942). See also pl. 26.

ingly, of the sixteen members of the ID faculty, four taught full-time, two half-time, and the rest taught only one course.

One harbinger of the future for the Institute of Design was the awarding of its first graduate degree that same spring, 1945, to Robert D. Erickson, whose thesis was titled "A Child Sees." Graduate study was to become an important component of the photography program in future years, although few could have imagined it: at that very moment, the building on East Ontario was sold and the ID's lease was not renewed. The school was forced to relocate again, to second-floor quarters at 1009 North State Street – a more attractive site than the former bakery, but with less space. Ironically, the smaller facilities proved to be a problem, for, with the ending of the war, enrollment had finally begun to rise. Early in June 1945, the ID bought the former building of the Chicago Historical Society at 632 North Dearborn Street, an 1892 neo-Romanesque building designed by Henry Ives Cobb (fig. 25). Remodeling was initiated to prepare the building for the fall 1946 semester.

With its largest enrollment to date in fall 1945, numbering 461 students, the ID required a larger teaching staff, and Moholy was fortunately able to call on several former faculty members to return, including Lerner. Sadly, that fall Moholy was afflicted with the first signs of what he would soon learn was leukemia. His wife Sibyl has described periods at night when "he would sit in his chair without working, staring vacantly into space, or speaking in short, labored sentences." These were followed by "nervous skin disorders and frequent dizzy spells," before a complete collapse in November put him into the hospital for three-week stay.[83] Released on December 2, he was sent home to rest while undergoing periodic therapeutic sessions of X-ray treatments. By January it seemed, at least for a while, that he had completely recovered. With the school bolstered by the increase in students and the favorable press it had attracted, at the beginning of the spring 1946 semester, former student Arthur Siegel was brought in to head a new Department of Photography and begin a four-year photography program as a separate curriculum. The way photography was taught at the school would change radically with Siegel's appointment.

To kick off their new academic program, Moholy and Siegel conceived a six-week-long summer seminar, "New Vision in Photography" (fig. 26).[84] While this event will be discussed fully in the following essay by Keith Davis, it is important to state here that the 1946 summer seminar was a culmination of Moholy's work as a photographer and as an educator. Moholy and Siegel clearly wanted to publicize the new curriculum by staging a photographic event that would be comparable in significance to the Stuttgart "Film und Foto" exhibition of 1929, and they began by securing the participation of some of the country's most distinguished photographers and curators: Berenice Abbott, Erwin Blumenfeld, Beaumont Newhall, Paul Strand, Roy Stryker, Weegee (Arthur Fellig), and others, including some of the school's own faculty. Moholy's initial lecture, scheduled for the morning of July 8, probably echoed Stuttgart themes, as it was to include an account of "the invention of photography, its degeneration at the turn of the century, and its rejuvenation through the amateur, police photography, scientific, reportage and technology."[85] Siegel, an experienced commercial photographer and photojournalist, was doubtless primarily responsible for the list of scheduled participants that appeared in the July issue of *Popular Photography*, where some of their common experiences were described, including working for the Farm Security Administration, the Office of War Information, and *Life* magazine.[86] When asked once how he had made his choices, Siegel replied: "One, I wanted to find out what

Fig. 24 György Kepes, cover of *Language of Vision* (Chicago, 1944).

Fig. 25 Institute of Design building, 632 North Dearborn Street, where the school moved in 1946.

was going on in photography, in a way; and two, I knew a lot of these people and I wanted to bring them together to get some publicity for the program."[87] During the seminar Siegel also had to support Moholy physically during recurrences of his leukemia, by following him around with a chair into which he would collapse.[88]

Moholy was supremely pleased with the way the seminar had worked out, and hoped to make it the forerunner of an annual event, confident that its yield would be beneficial, "especially if we are able to continue it yearly with similarly enthusiastic and devoted participants."[89] Siegel has recalled that there were thirty or forty students present, that they "came from all over," and that they were of "all ages." When asked to describe how the seminar was conducted, Siegel recalled:

So, Paul [Strand] would give these lectures and then there would always be questions, you know, interchange between the people at the seminar … it really was a seminar …. I mean, there was an exchange; it was not giving a lecture and then leaving. Lots of us would eat together, and we would go out [to restaurants] … and sit and talk for a long time.[90]

Here, but a few months before his death in Chicago on November 24, Moholy had succeeded in bringing together his ID students and faculty with an internationally renowned group of photographers. Perhaps a final assessment of him may be gleaned from the report that students Max Thorpe and Jane Bell Edwards published in *Popular Photography* following the ID summer seminar. They witnessed the power of Moholy as a teacher near the close of his life, and they did so in the context of this rich assembly of master photographers:

When Moholy-Nagy stepped upon the stage you were immediately aware of a man who was a talented and creative artist. His ability to let you know that he liked humanity, was interested in you as an individual, and that he had something to tell you, all without his uttering a sound is something that one rarely encounters.[91]

Moholy did not live long enough to see the end of the ID's autumn semester of 1946, but he had already assured the future of the photography program by bringing back Arthur Siegel and, as the following essay points out, by bringing in Harry Callahan as well. Even in failing health, Moholy was reluctant to slow down. His work on *Vision in Motion* continued, but it remained unfinished when he died. Thanks to skillful editing by his widow, Sibyl, this text, which proved to be a masterful summing up of his ideas, including his photographic theories, was published in 1947 (fig. 27). A teacher to his last breath, he chose the work of his students for many key illustrations.

László Moholy-Nagy succumbed to leukemia on November 24, 1946.[92] His funeral took place at the Institute of Design on November 27; Walter Gropius delivered the eulogy.[93]

26

27

Fig. 26 Cover of the brochure for the special summer session at the Institute of Design, "New Vision in Photography," 1946.

Fig. 27 László Moholy-Nagy, cover of *Vision in Motion* (Chicago, 1947). See also pl. 4.

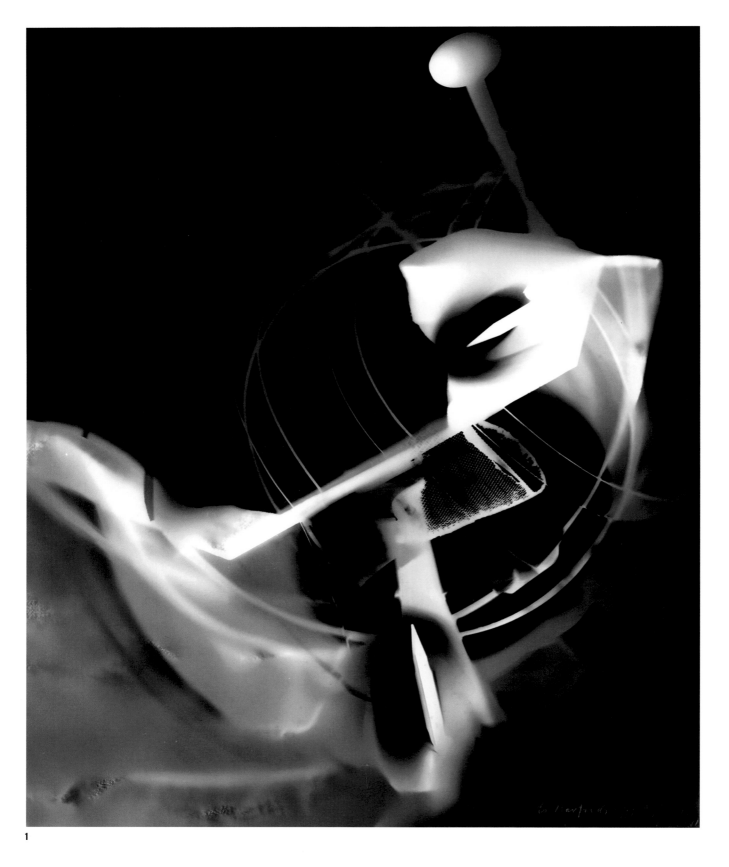

1

1 László Moholy-Nagy, *Untitled*, c. 1940, cat. 131 2 László
Moholy-Nagy, *Untitled*, c. 1939, cat. 129 3 Margaret De Patta,
Untitled, 1939, cat. 47

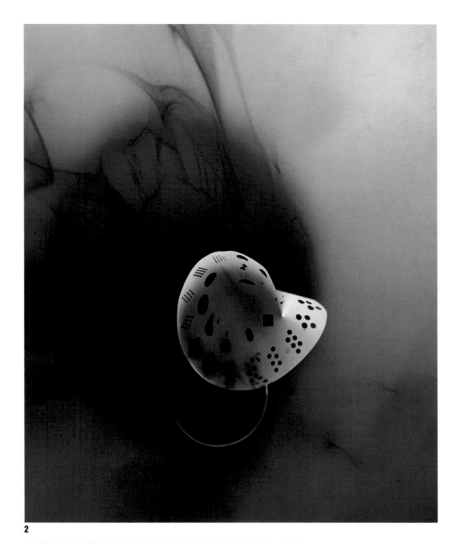

2

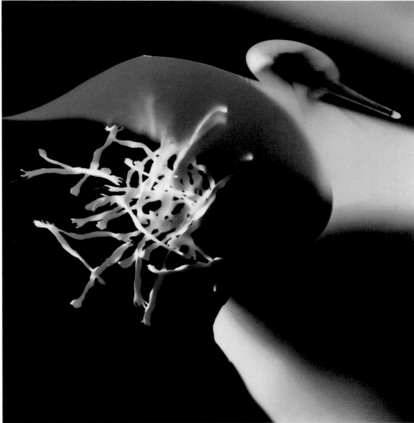

3

4

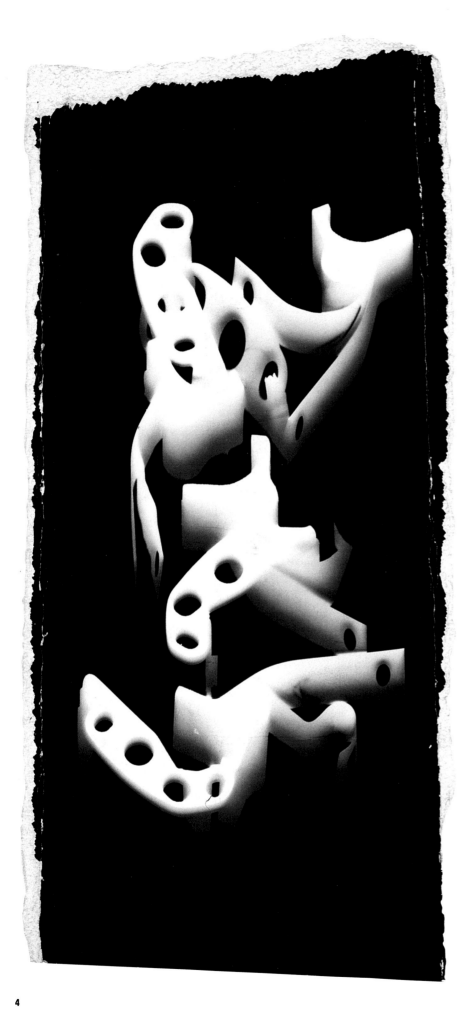

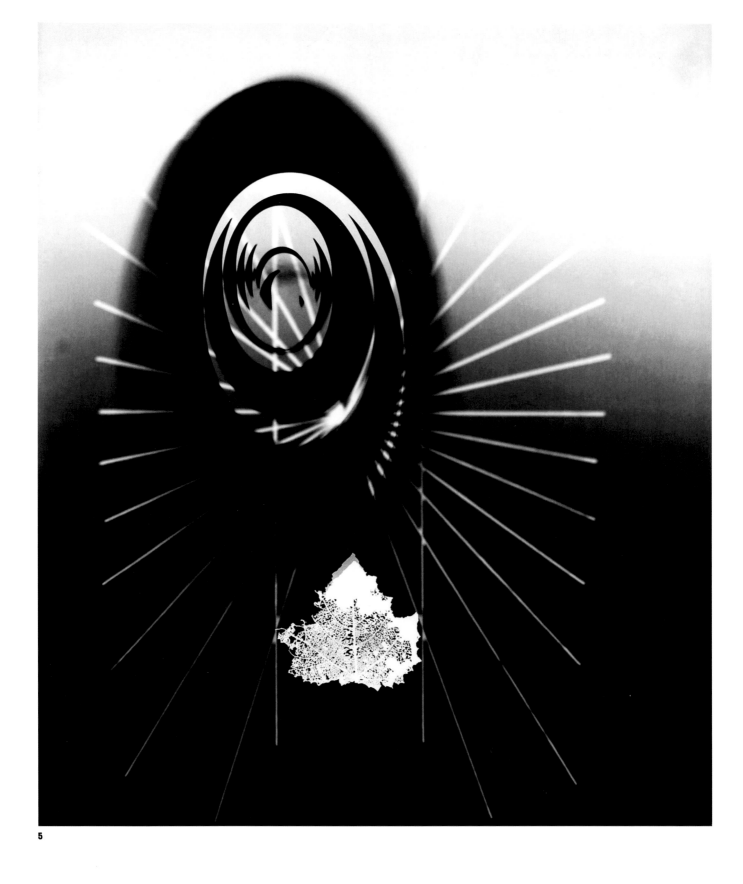

5

4 László Moholy-Nagy, *Untitled*, 1941, cat. 135 **5** György Kepes, *Untitled*, 1937/43, cat. 85

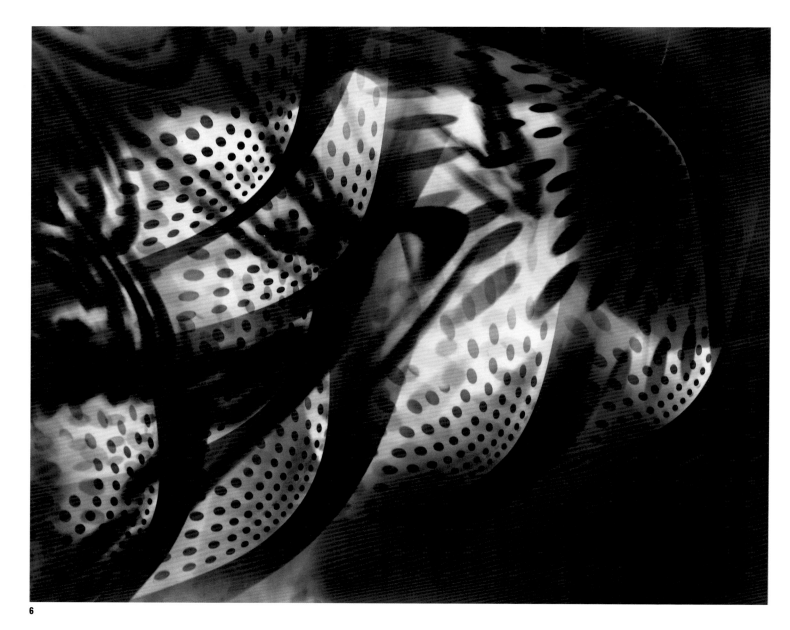

6

6 Arthur Siegel, *Photogram #72*, c. 1937, cat. 151 **7** László
Moholy-Nagy, *Untitled*, c. 1940, cat. 130 **8** Artist unknown
(student of László Moholy-Nagy), *Untitled*, c. 1940, cat. 136

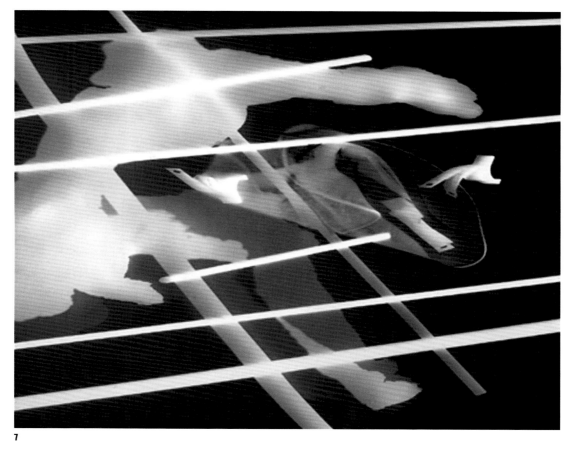

7

8

9

10

11

9 Nathan Lerner, *Light Volume, Chicago*, 1937, cat. 103
10 Nathan Lerner, *Eggs and Box*, 1938, cat. 104 11 Nathan
Lerner, *Charley's Eye*, 1940, cat. 105

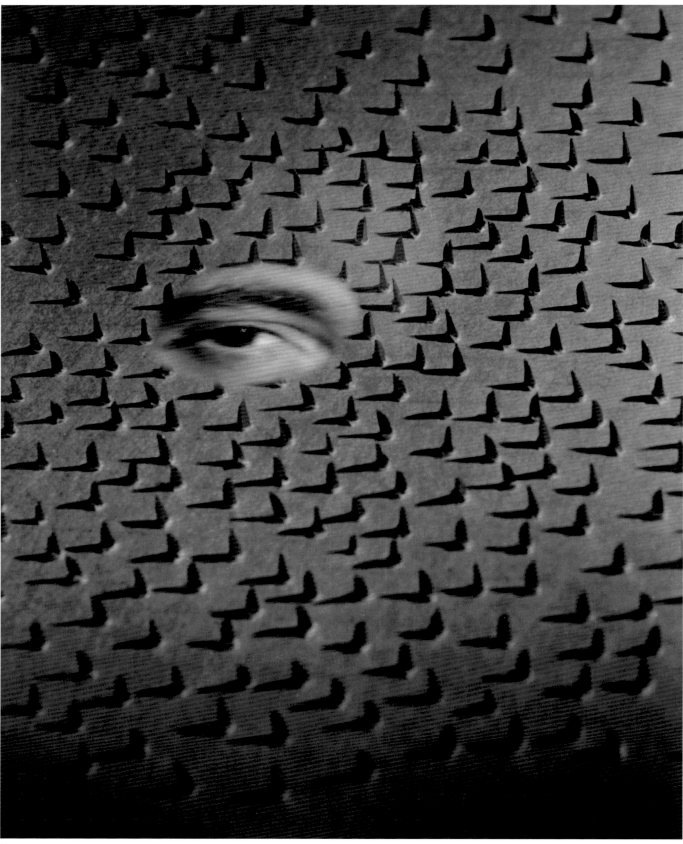

12

12 Nathan Lerner, *Eye and Nails (Montage without Scissors)*, 1940,
cat. 106 **13** James Hamilton Brown, *Untitled*, 1940s, cat. 15
14 Dina Woelffer, *ID Problem, Chicago*, 1946, cat. 207

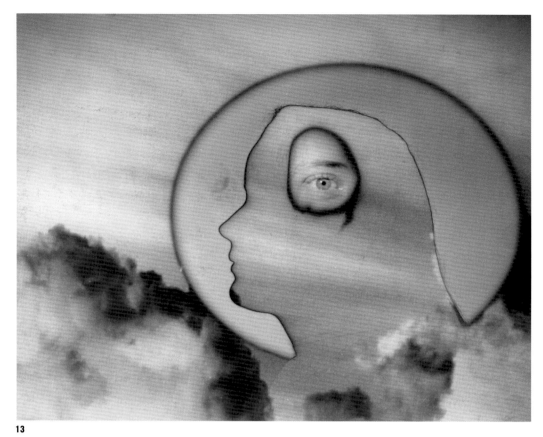

13

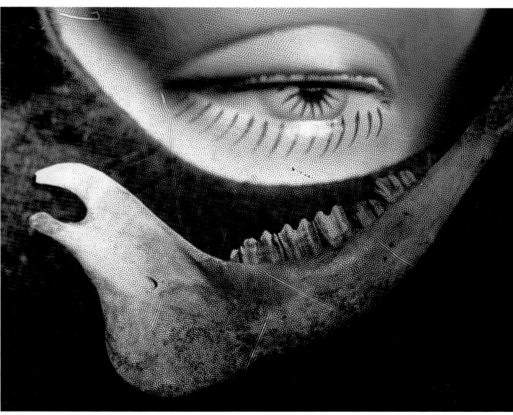

14

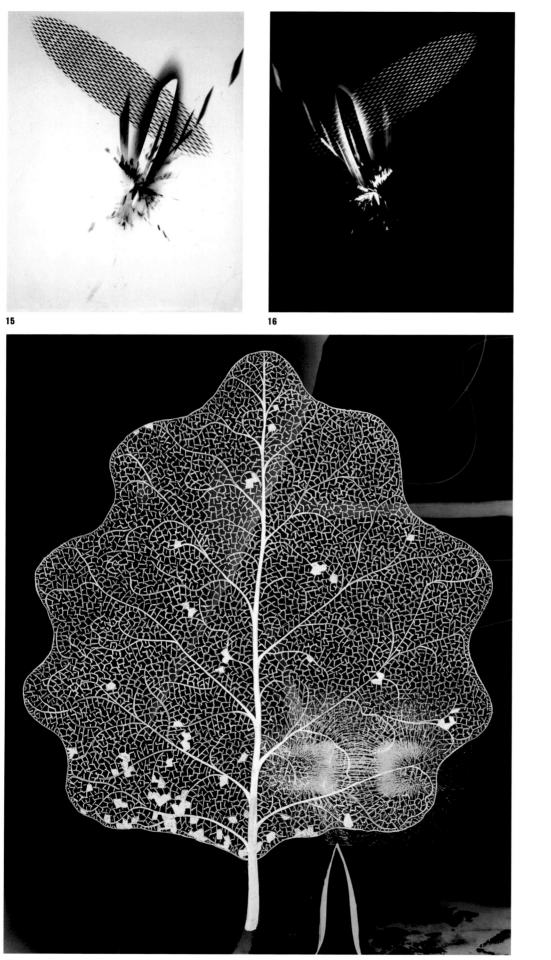

15

16

17

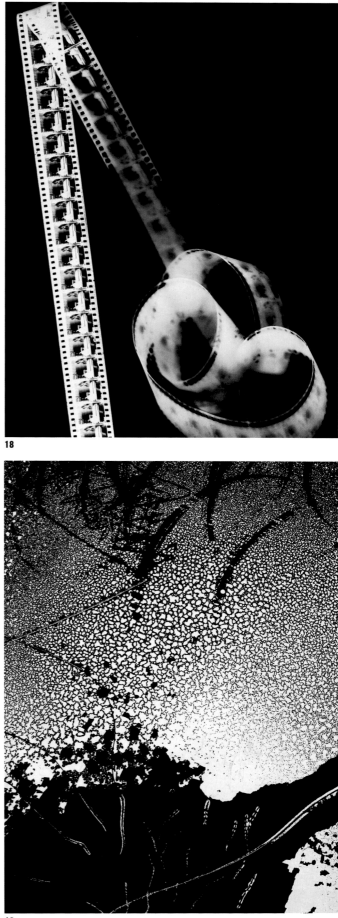

18

19

15, 16 Eugene Bielawski, *Grid and Crystals (Diptych)*, 1947, cat. 8, 9
17 György Kepes, *Untitled*, begun early 1930s with additions
1936/39, cat. 86 18 Hubert Leckie, *Untitled*, c. 1940, cat. 102
19 Max Pritikin, *Artificial Negative Greatly Enlarged*, 1946, cat. 147

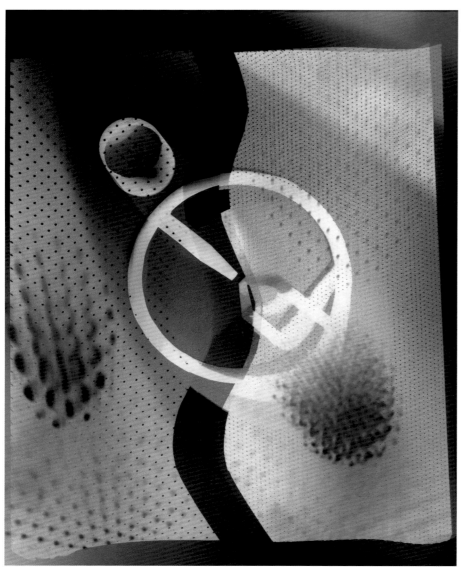

20

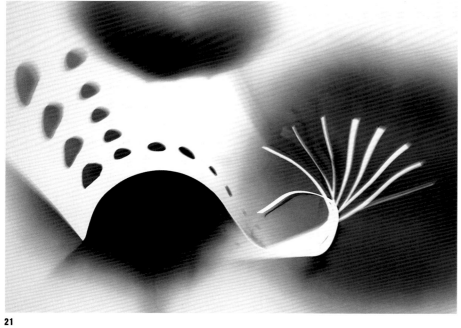

21

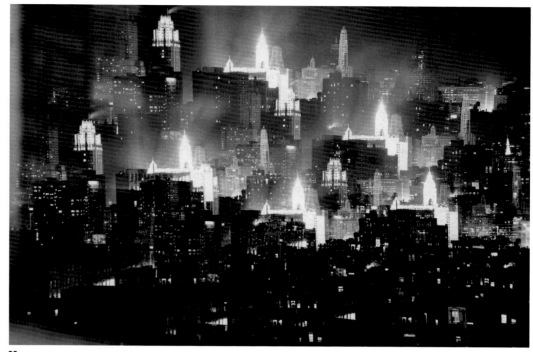

22

23

20 Arthur Siegel and László Moholy-Nagy, *Untitled*, 1946, cat. 164
21 George Barford and László Moholy-Nagy, *Untitled*, 1939, cat. 4
22 Frank Sokolik, *Untitled*, 1940s, cat. 192 23 William Keck,
Untitled, 1940s, cat. 84

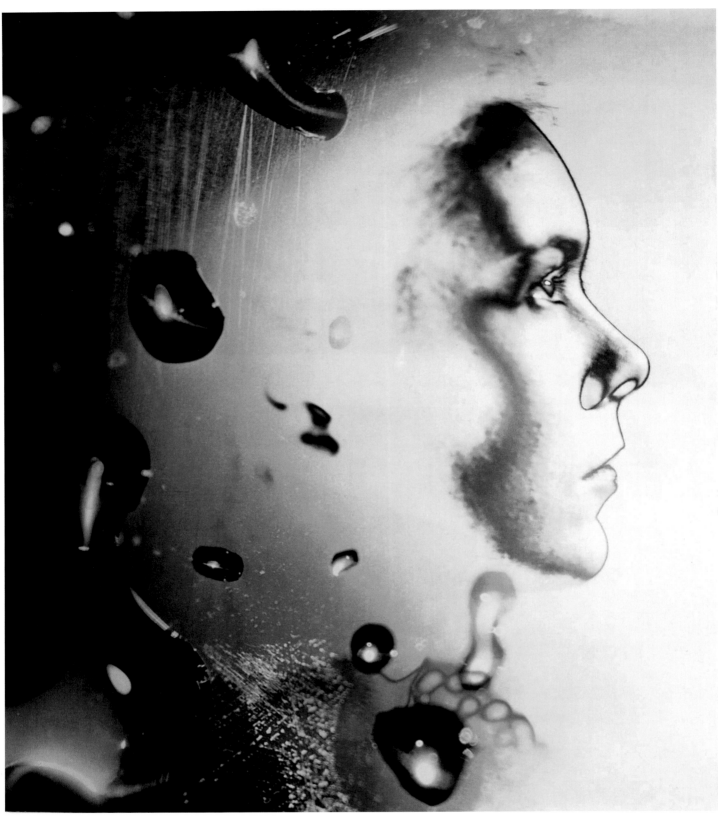

24

25

26

24 György Kepes, *Solarization*, c. 1938, cat. 90 **25** György Kepes, *Blue Woman with Vision*, 1939, cat. 91 **26** György Kepes, *Juliet's Shadow Caged*, 1939, cat. 92

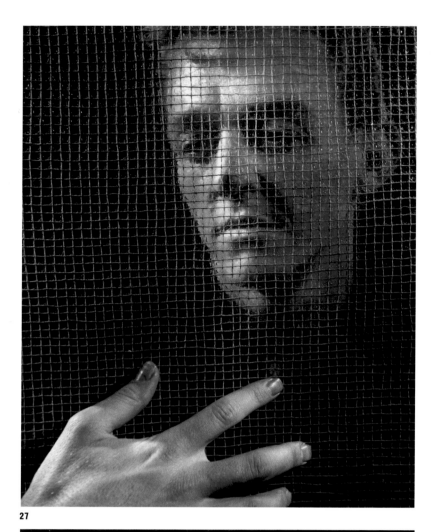

27

28

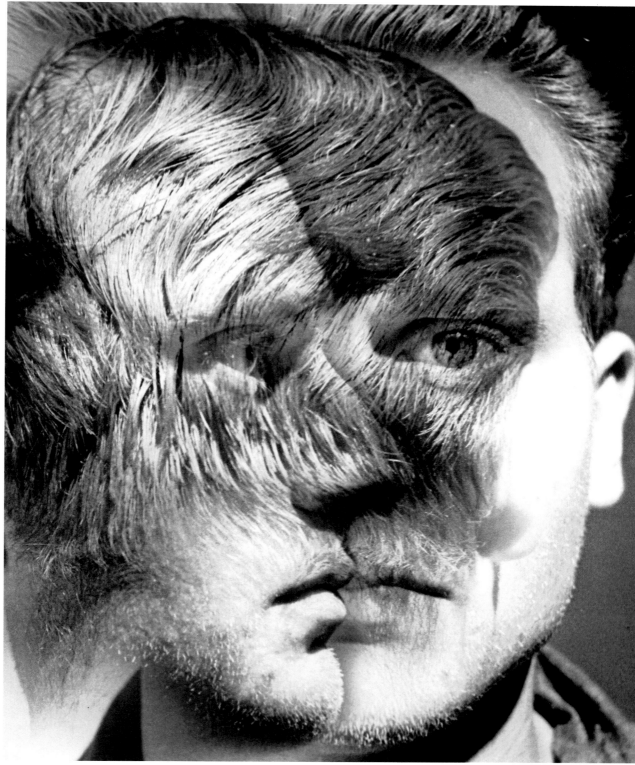

29

27 Milton Halberstadt, *Untitled (Homer Page)*, 1940/41, cat. 57
28 Nathan Lerner, *Montage without Scissors (Face and Sandpaper)*,
1940, cat. 107 **29** Milton Halberstadt, *Norm Martin*, 1940/41,
cat. 56

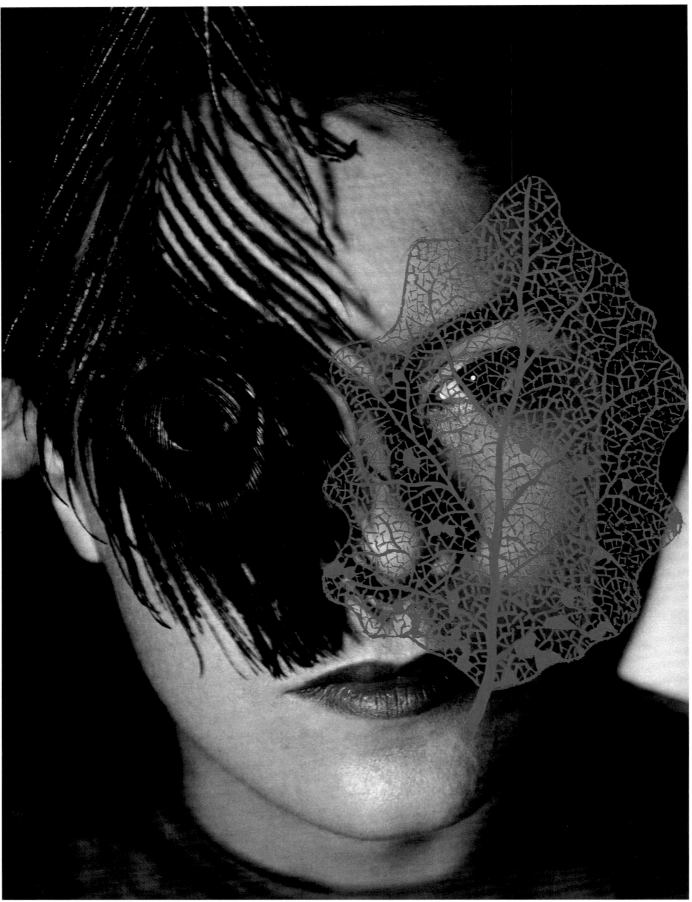

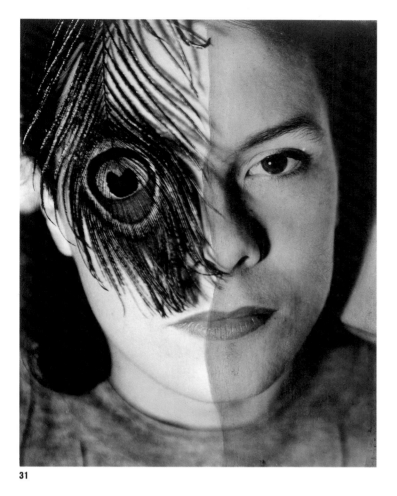

31

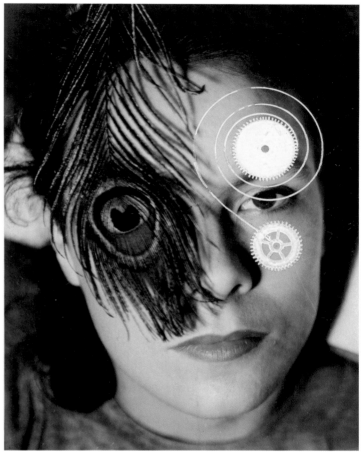

32

30 György Kepes, *Untitled (Juliet with Peacock Feather and Red Leaf)*, 1937/38, cat. 89 **31** György Kepes, *Juliet with Peacock Feather*, 1937/38, cat. 87 **32** György Kepes, *Juliet with Peacock Feather and Paint*, 1937/38, cat. 88

33

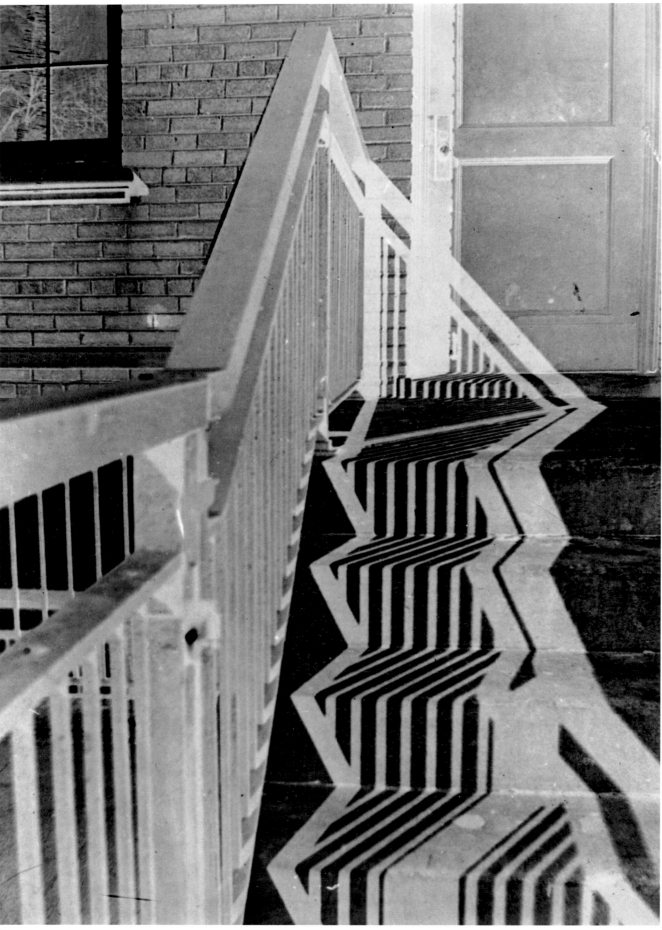

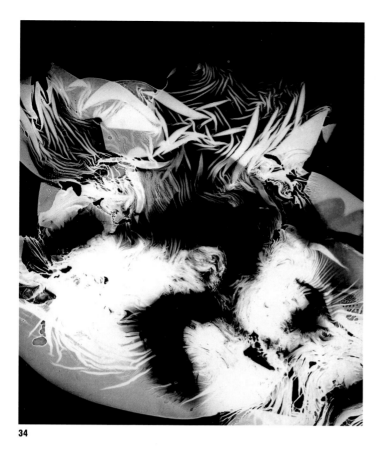

34

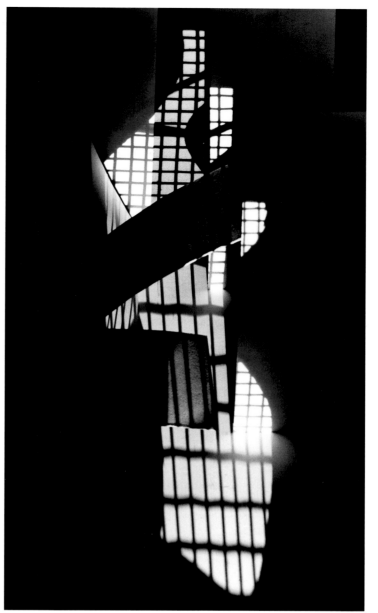

35

33 Gretchen Schoeninger, *Negative Exposure*, 1937, cat. 150
34 Elsa Kula and Davis Pratt, *Untitled*, c. 1943, cat. 99 **35** Henry
Holmes Smith, *Untitled (Light Study)*, 1946, cat. 186

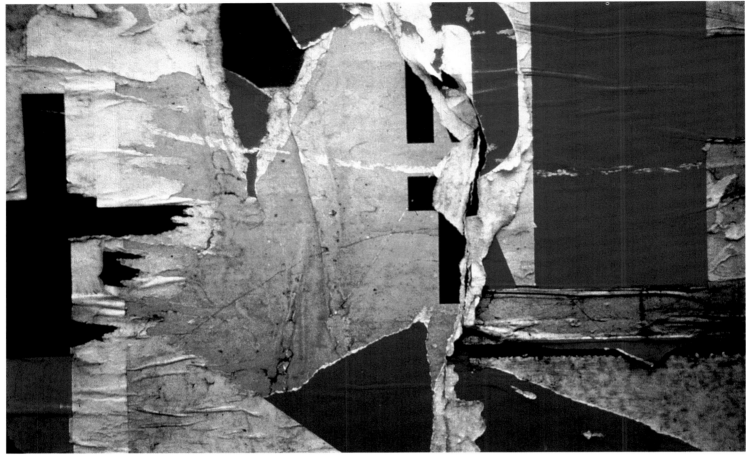

36

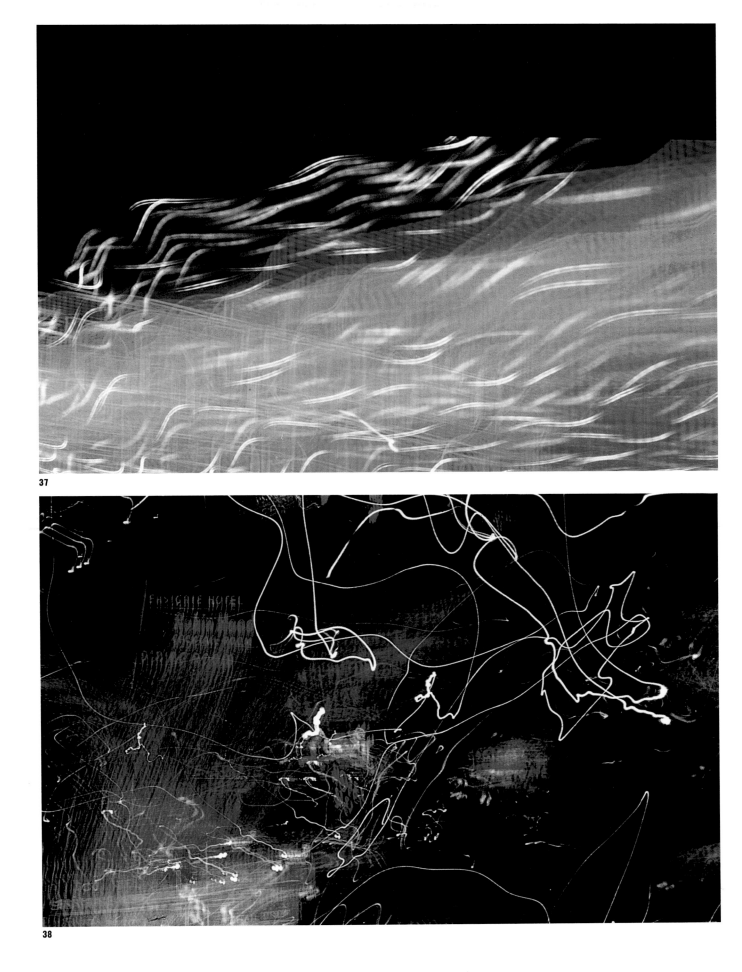

37

38

36 László Moholy-Nagy, *Billboard Detail, New York City*, 1940,
cat. 133 37 László Moholy-Nagy, *Traffic Lights*, early 1940s,
cat. 134 38 László Moholy-Nagy, *City Lights (Eastgate Hotel)*,
1939/46, cat. 132

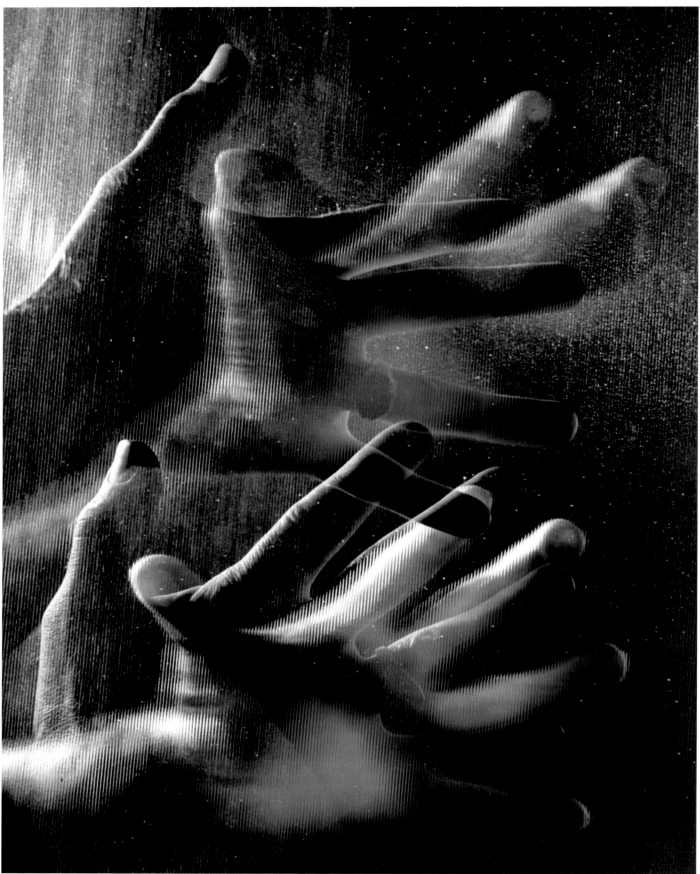

39

39 Arthur Siegel, *Untitled*, 1940s, cat. 154 **40** Arthur Siegel,
Nude (Hand Shadow over Breasts), 1940, cat. 153

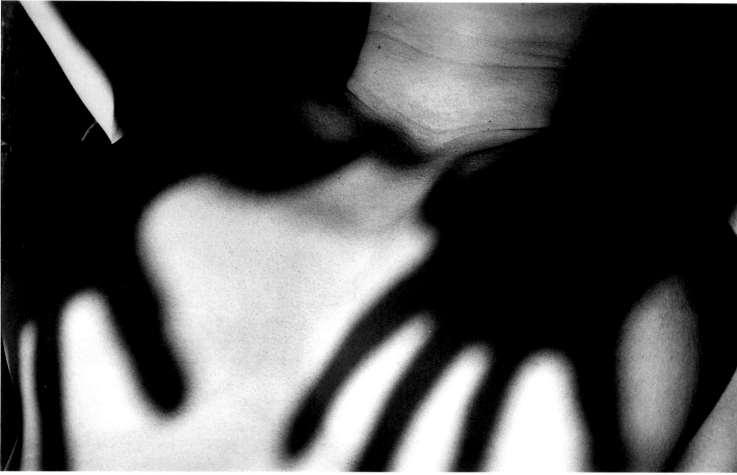

40

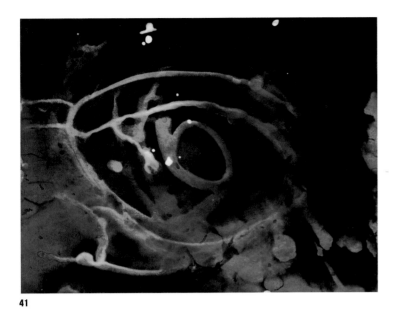

41

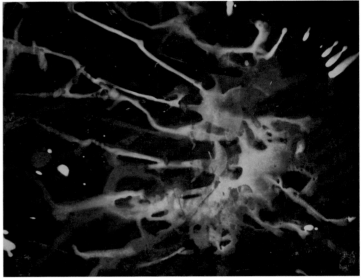

42

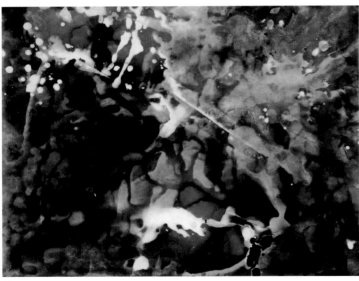

43

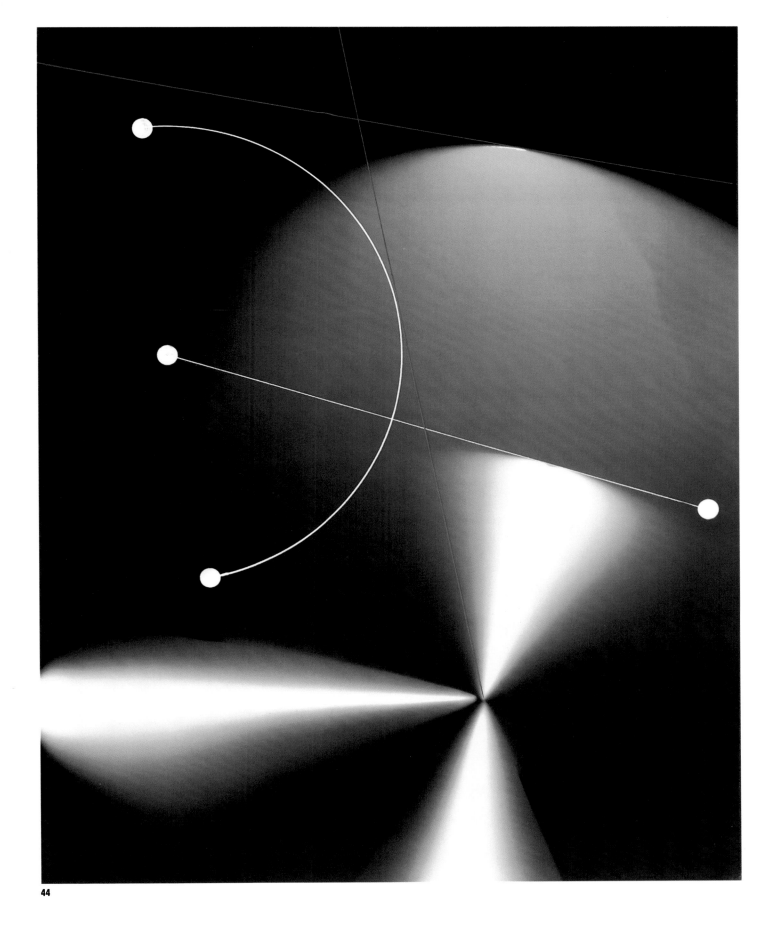

44

41 Myron Kozman, *Untitled*, 1938, cat. 96 **42** Myron Kozman, *Untitled*, 1938, cat. 97 **43** Myron Kozman, *Untitled*, 1938, cat. 98 **44** György Kepes, *Untitled (Photograph for* Direction Magazine*)*, 1939, cat. 93

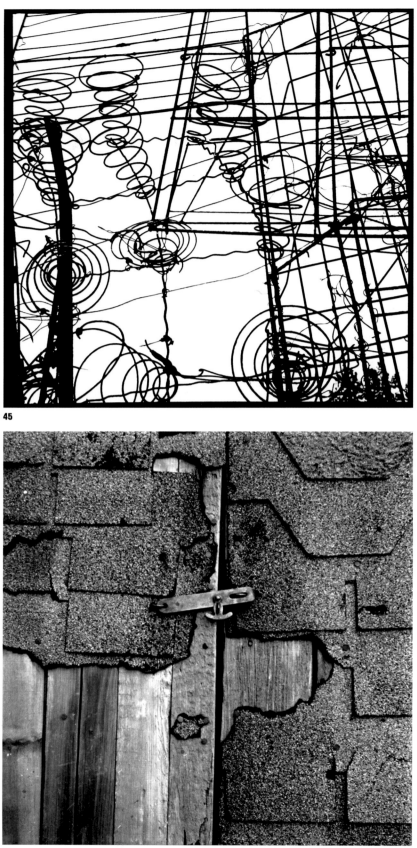

45

46

45 Frank Levstik, Jr., *Untitled (Bed Springs)*, 1945/46, cat. 109
46 Frank Levstik, Jr., *Utility Shack Door*, c. 1940, cat. 108
47 Robert Donald Erickson, *Self-Portrait*, 1946, cat. 50 48 Robert
Donald Erickson, *Chicago El Shadow Patterns*, 1946, cat. 51

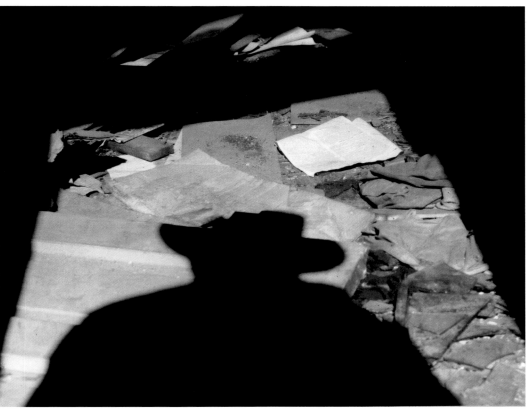

47

48

49

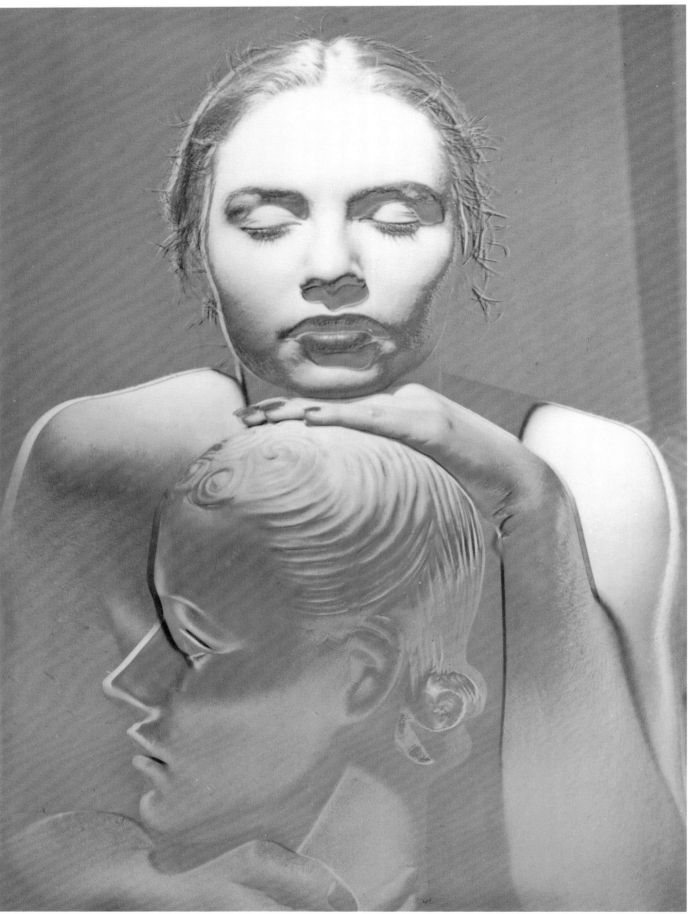

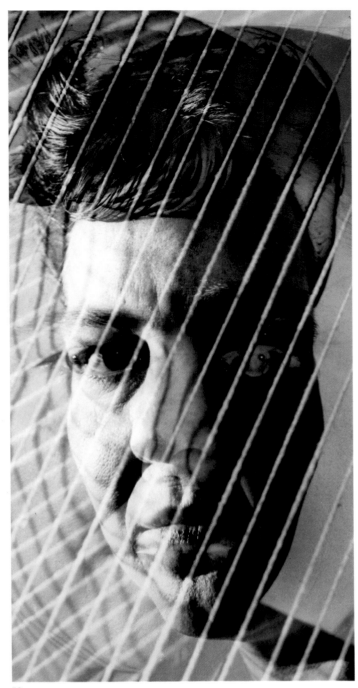

50

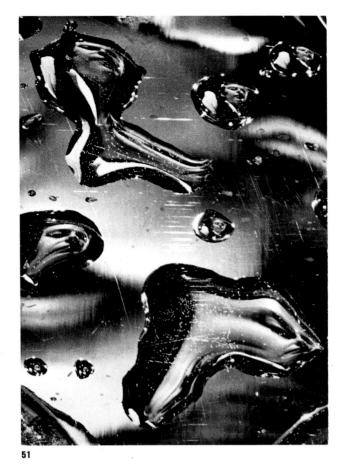

51

49 James Hamilton Brown, *Color Dream*, c. 1940, cat. 14
50 Milton Halberstadt, *Untitled (Margaret De Patta)*, 1940/41,
cat. 58 **51** Milton Halberstadt, *Olga, Chicago*, 1941, cat. 59

52

53

54

52 Arthur Siegel, *Right of Assembly*, 1939, cat. 152 53 Frank
Sokolik, *Untitled*, 1940s, cat. 191 54 Arthur Siegel, *Refugee*,
1945, cat. 155

"TO AN INDIVIDUAL W
PHOTOGRAP
AT THE INSTITUTE OF DESIGN, 1946-61

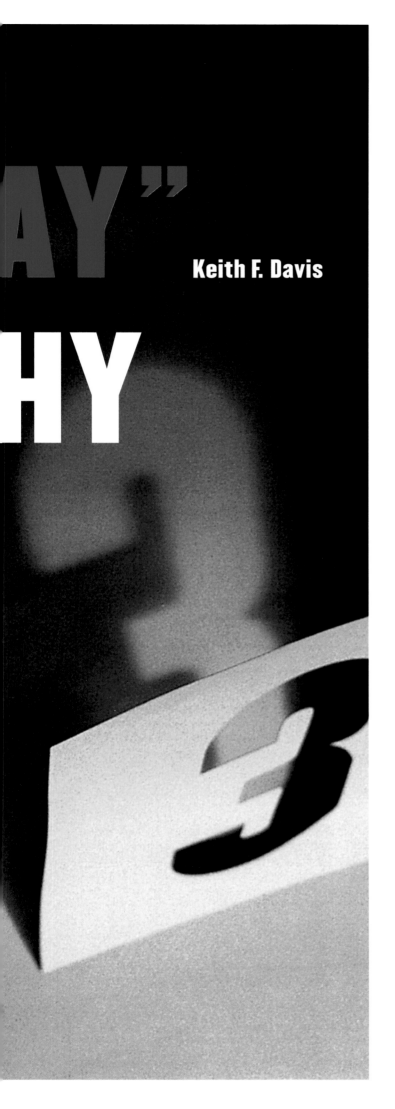

Keith F. Davis

Photography came of age – at the Institute of Design and in American education in general – in the years after World War II. The school's commitment to the medium, together with the talents of its faculty and students, ensured that the ID would be the leading program of its kind in the postwar era, and an inspiration and model for many others to follow. The central figure in the ID photography department between 1946 and 1961 was Harry Callahan. But Callahan was by no means alone, and the program in this period can only be understood as the result of a complex and continuous process of evolution. This complexity was a natural product of the forces at work, as the original ideas of László Moholy-Nagy were – in varying ways – honored, adapted, and ignored by a changing ensemble of personalities. All this, of course, took place within a shifting institutional framework with its own possibilities, requirements, and complications.

The key events in this period can be briefly chronicled. In early 1946 Moholy recruited Arthur Siegel to head the school's new photography program. Siegel, in turn, recommended the hiring of his friend Harry Callahan, who began in the fall semester. Following Moholy's death in November, his replacement, Serge Chermayeff, served as director from 1947 to 1951 followed by Crombie Taylor (1951–55) and Jay Doblin (1955–68). Conflicts between Siegel and Chermayeff led to Siegel's resignation in 1949 and Callahan's appointment as head of the photography program. That same year, the ID merged with the Illinois Institute of Technology, gaining a new sense of financial stability as well as additional layers of bureaucratic complexity. In 1951 Callahan hired Aaron Siskind. The two formed a superbly effective teaching team that would provide the creative nucleus of the school over the next ten years. A new graduate program in photography, initiated in 1950, awarded its first M.S. degrees in 1952. While graduate enrollment grew slowly in the 1950s, the advanced nature of this program shifted the overall emphasis of the photography department's instruction from the basics of the Foundation Course to the more highly individualized thesis projects. The public renown of the ID photography program increased markedly in this period, as Callahan, Siskind, and others were exhibited and published with increasing frequency. This era culminated in two important events in 1961: the publication of a special issue of *Aperture* – the premier "small" photographic journal of the era – devoted to the work of five ID graduate students, and Callahan's departure for the Rhode Island School of Design.

By the time of Callahan's resignation, everything had changed at the ID and in the world of photographic instruction at large. In both structure and curriculum, the school was far more academically orthodox than it had been in 1946. Moholy's original balance of idealism and pragmatism had shifted, probably inevitably, to a pronounced emphasis on the latter. At the same time, the growing academic interest in photography nationwide allowed young photographers to entertain seriously the idea of careers in teaching. Student enrollments, academic job postings, and a larger public and institutional attention to photography all grew together, culminating in the "photo-boom" of the late 1960s and 1970s. These forces continue to shape the ways we think about the medium.

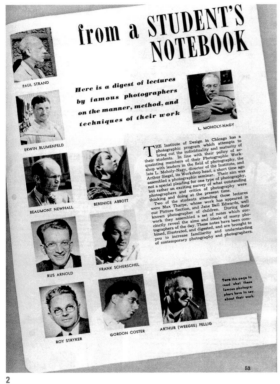

Fig. 1 Arthur Siegel teaching students at the Institute of Design, c. 1946.

Fig. 2 Feature story about "New Vision in Photography" seminar participants in *Popular Photography* 21:6 (December 1947).

Arthur Siegel shapes a program

The ID began its new photography program in early 1945 in a wholly pragmatic way, as a course of vocational study. On February 2, 1945, the school announced the establishment of a "Special Course in Photography" intended particularly for servicemen studying under the benefit of the recently announced G.I. Bill (officially, the Servicemen's Readjustment Act of 1944). This program was conceived as a two-year course of study leading to an academic certificate, but it could be condensed to a single year for those with reduced benefits. Its stated objective was entirely practical: to train young men and women for photographic careers in a variety of commercial and technical disciplines. From a business point of view, the establishment of this new program was both savvy and timely. Popular interest in the medium had never been higher; as stated in an internal school memo of February 6, 1945, discharged veterans were distinctly "photography-minded."[1] In addition, of course, the financial support provided by the G.I. Bill stimulated a vast increase in the number of students – by 1947, over one million – who chose to attend college. In the course of utterly reshaping the scope and nature of higher education in America, the G.I. Bill transformed the Institute of Design.

While the appeal of the new photography program was clear from the beginning, the major influx of students began with the demobilization after the end of the war. In the spring semester of 1945, enrollment remained relatively low, with forty day-students (twenty-eight full-time, twelve part-time), and about four times that number in the evening program.[2] This total included eight students (two full-time, six part-time) enrolled in the Special Photography course and another twenty in the evening photography classes. These modest numbers meant that the photography curriculum could be handled by the existing staff of James Hamilton Brown, Frank Levstik, Jr., and Frank Sokolik. The real surge of G.I. Bill students began in the fall of 1945, when enrollment leaped to a total of 461, with the majority of these students attending during the day.[3]

By the end of that semester, Moholy realized that the photography program required both additional staff and strong leadership. Knowing that what he needed was beyond the abilities of his existing faculty, Moholy asked Arthur Siegel to come to the school to establish a full-fledged photography department. Moholy's choice was eminently logical. Siegel had been a devoted student at the New Bauhaus years before and he believed deeply in Moholy's pedagogical principles. Siegel's interest in photography dated from his teenage years and he brought to the medium a uniquely varied expertise.[4] After studying sociology in college, Siegel taught in the art education department at Wayne State University, and made pictures in the modernist tradition of the era. He attended the New Bauhaus in the spring 1938 semester, and then returned home to Detroit, where he established a successful commercial and photojournalistic practice. In the early 1940s he freelanced for such national magazines as *Life*, *Fortune*, and *Colliers*, and did documentary work for the government's Farm Security Administration. He was also active in the

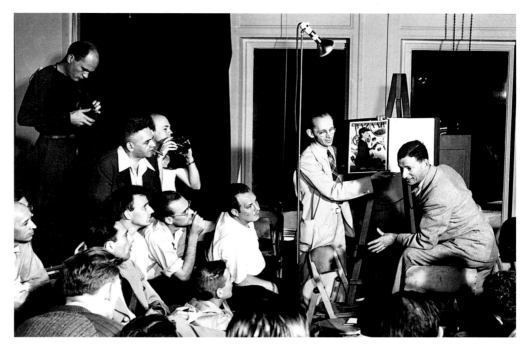

Fig. 3 Gordon Coster and Erwin Blumenfeld lecturing at the 1946 summer seminar. Shown at the far left, clockwise from top: Beaumont Newhall, Weegee (Arthur Fellig), and Harry Callahan.

Detroit Camera Club, working with – and encouraging – fellow club members such as Harry Callahan and Todd Webb. In the last two years of World War II, Siegel worked in technical photography and photoanalysis for the U.S. Air Corps, based at Camp Chanute, in Rantoul, Illinois. During a trip to Chicago at Christmas, 1945, Siegel visited Moholy at the school; he was offered a position and immediately accepted it. Siegel's discharge from the Air Corps came on a weekend in late February 1946; he began at the school on the following Monday.

Siegel would be an effective if often exasperating teacher (fig. 1). By all accounts he was a brilliant but difficult man. He was remarkably well read and verbally nimble, with a firm command of the history of the medium, and many impressive professional contacts. But with these strengths came less endearing qualities: deep insecurities, hypochondria, and an interpersonal style that could be bombastic and overbearing.[5] Undoubtedly, the rough edges of Siegel's personality led some students to discount the value of his insights and pronouncements. He was, nonetheless, a pivotal figure in the ID photography program, with a breadth of vision unmatched by any other staff member.

Siegel's mission to transform the school's two-year certificate course into a four-year degree-granting program required that he start nearly from scratch. When he arrived, the school owned only a handful of well-used cameras – including a cheap, 1920s-vintage 4-x-5-inch model that had belonged to Moholy – and two dilapidated Elwood enlargers.[6] The school's holding of books and teaching slides was similarly inadequate. Siegel began a protracted battle for additional supplies and equipment, made his own cameras available to students, and taught from his personal collection of slides and books. He also began important modifications in the course of instruction. Siegel recognized that incoming students were more impatient and demanding than

those of any previous generation. Most were veterans who had already given several years of their lives to military service. Older and more experienced than previous classes, they wanted to learn practical job skills as efficiently as possible in order to enter civilian careers. Siegel decided that too much time was being devoted to essentially academic exercises: the making of photograms, pinhole images, paper negatives, and abstract light studies. While accepting the basic validity of these activities, Siegel streamlined this part of the course and, drawing upon his own practical and documentary experience, required that students get out of the studio to photograph public events in the city.

At the same time, Siegel began planning an ambitious summer seminar titled "New Vision in Photography." This program – introduced at the close of the preceding essay by Lloyd Engelbrecht – aimed to accomplish two things: to provide a unique educational experience for students, and to promote the school and its new photography program nationwide. Despite an official enrollment of only eighteen (many more seem to have attended the lectures), "New Vision" was a success on both counts. The seminar took place over a period of six weeks – July 8 to August 16, 1946 – with one or two speakers visiting in a given week.[7] Moholy kicked the program off with five lectures on consecutive days summarizing his vision of photography. Other members of the staff, including Siegel and Levstik, also made presentations and oversaw the afternoon film program. In the following weeks, a stimulating variety of documentary and commercial photographers, picture editors, and a historian were brought in to speak for periods of up to five days each. The lineup included Berenice Abbott, Rus Arnold, Erwin Blumenfeld, Gordon Coster, Beaumont Newhall, Ed Rosskam, Frank Scherschel, Paul Strand, Roy Stryker, and Weegee (Arthur Fellig) (fig. 2). This group, with its emphasis on professional practice, documentary concerns, and photohistory,

clearly reflected Siegel's own interests and contacts in the field. The presentations were lively and engaging, and some of the photographers conducted workshops in their specialties (fig. 3). In addition to his two lectures, for example, Weegee took students outdoors to demonstrate his technique for photographing crime scenes, using a mannequin as a substitute for a corpse. (This session, notably enough, received national coverage in *Life* magazine.)[8] Others gave slide talks followed by extended question-and-answer sessions and free-ranging conversations over dinner. Abbott made six presentations in five days, covering topics as varied as "Print Criticism," "Portrait Lighting," and "Photography: Today and Tomorrow." Newhall gave five talks in as many days, beginning with a two-hour lecture titled "The Tradition: Photography in the Nineteenth Century."[9] Strand also gave talks on five consecutive days, on topics including "Function of the Artist and his Relation to Society," "Art as Heightened Reality," and "The Meaning of Craftsmanship."

The final and perhaps most important aspect of Siegel's plan for the new department was the expansion of its faculty. From the beginning, Siegel had had little respect for or rapport with either Levstik or Sokolik.[10] He viewed them as technically competent, but of limited imagination and talent. Recognizing that his own abilities lay primarily in historical and critical matters, Siegel decided that the best addition to the department would be a dedicated photographic artist who could teach – at least in part – by the example of his work and his sheer commitment to the medium. Siegel approached his friend Harry Callahan about the position (fig. 4). Then thirty-three years old, with little formal education, Callahan was anything but a "name" photographer; indeed, he was practically unknown on the national scene.[11] Nonetheless, Siegel recognized in Callahan's work a uniquely dedicated and inventive artistic voice. He was also pragmatic enough to know that he was unlikely to find many other candidates for the job, and that Callahan – then unemployed – would be willing to work for the $3,000 annual salary the school had to offer. Siegel's choice was an inspired one, with enormous historical consequences.

Harry Callahan at the ID

In 1946 Harry Callahan was happily married and passionate about photography, but otherwise at loose ends in his life. An unmotivated student, he had dropped out of college in 1936 to get married. For several years thereafter, he worked in a dull clerical job at Chrysler Motor Company, in his hometown of Detroit. He discovered photography in 1938, and it quickly became his primary, driving passion. At the Chrysler camera club, and other clubs in the city, he met a handful of similarly enthusiastic young photographers, including Siegel, who had recently returned from the New Bauhaus in Chicago. Callahan appreciated the directness of Siegel's photographs and the philosophy of the medium – drawn, in large measure, from Moholy's teaching – that Siegel so passionately espoused. Callahan became part of a small circle that met regularly to talk about photography and to take inspiration from Siegel's collection of books and journals. Callahan's real break-

through came in the late summer of 1941, when Ansel Adams presented a two-weekend workshop under the auspices of the Photographic Guild of Detroit. The precision of Adams's prints and his devotion to the simplest aspects of nature were revelations to Callahan. To the end of his life, he consistently stated that Adams's example "completely freed" him by making radiantly clear both the technical means and spiritual import of photography.[12]

The result was a genuinely astonishing burst of creative energy. Over the next few years, Callahan explored most of the themes and techniques that would characterize the next half-century of his career. His work was enormously varied, encompassing nature, the architecture and human activity of the city, and the intimate realm of the family. To this range of subjects, he applied an equally varied set of technical approaches. He used cameras of various sizes – from 35mm to 8-x-10-inch – and made extensive use of multiple exposures, high-contrast printing, and both black-and-white and color film. Callahan's quest was twofold: to discover the world around him and, at the same time, to conduct an exhaustive investigation of the basic syntax of photographic vision. From influences as disparate as Alfred Stieglitz's sublime purism (absorbed from Adams) and Moholy's relentless experimentation (promoted by Siegel), Callahan forged a wholly original artistic voice.

Despite the quality of his photographic work, Callahan's professional life had gone nowhere by early 1946. In 1944 he had moved from his clerical job to a position in the Chrysler darkroom, where he printed routine product and publicity images. By the fall of 1945, he worked up the courage to make a major change. In October he quit his job and moved with his wife, Eleanor, to New York City with the hope of establishing himself in the photography world. The experiment was a painful failure: Callahan felt utterly out of his element, made few significant pictures, and had no real job offers. After only six months in New York, he returned to Detroit, thoroughly depressed over his prospects. A short time later, toward the end of the spring 1946 semester, he was approached by Siegel to come to Chicago. Despite his need to earn a livelihood, Callahan at first resisted the idea. As a college dropout, without any obvious academic interest or ability, he felt distinctly unqualified to teach. Furthermore – a clear reflection of his own experience – he believed that creativity was a deeply personal matter that simply could not be taught. Siegel persisted, however, and persuaded Callahan to come and interview with Moholy. Nervous and prepared for immediate rejection, Callahan was amazed by Moholy's understanding. After looking through Callahan's portfolio, Moholy said quietly, "Only once in my life have I been moved like this." Callahan was immediately put at ease, but remained hopelessly tongue-tied. When Moholy asked him why he had made a particular picture, the young photographer could only stammer and shrug. Seeing his discomfort, Moholy gently responded, "Oh, I only asked – I don't think it matters if it's only for a wish." Callahan never forgot the generosity and insight of Moholy's comment. Years later, with great reverence, he recalled, "I think that was a terrific statement – there are wishes all the time when you're doing this."[13]

It is a telling measure of Moholy's insight that he gave Callahan the job, despite the obvious fact that the young photographer was inexperienced and inarticulate. What did Moholy see in him? Like Siegel, Moholy clearly felt that it was important to have on staff a photographer of real artistic merit who could instruct and inspire students, in part at least, by sheer example. In a more philosophical sense, however, Callahan was a living embodiment of some of Moholy's most fundamental values. Nathan Lerner has described Moholy's "innocence," his "open-minded, open-eyed curiosity."[14] Not surprisingly, Moholy recognized and valued these qualities in Callahan. For all his devotion to new materials, technical experimentation, and sweeping ideas of social change, Moholy's vision was founded on a deeply spiritual and optimistic notion of individual potential. Indeed, his entire educational program was based on the importance of personal growth and self-awareness, a *new* individuality that was an absolute prerequisite to any potentially more rational and egalitarian social order. Moholy's social utopianism never cohered into a clear political program; what remained most real was the power of art (or design) to transform, expand, and clarify individual awareness. The goal was one of integration and balance in order to achieve a new kind of psychic unity, a new wholeness of being.

This quest was, by necessity, a largely intuitive one in which knowledge was gained through constructive action as much as from abstract thought. In his last important address, Moholy observed: "When any human being works with his hands, whatever he does will be translated into the brain as knowledge. This knowledge, in turn, will react on his emotional self. That is how a higher level of personality is achieved."[15] Clearly, then, the most important kind of learning stemmed from the activities of *doing* and *making* – a dynamic engagement with one's tools and materials in order to enlarge our sense of both the world and the self. Further, from Moholy's pedagogical perspective, it was far more important to have an intuitive sensitivity and openness to ideas than to pretend or assume that all the answers were already known. As Moholy once said to Ferenc Berko, encouraging him to join the school's faculty, "The teacher who doesn't learn from his students would be a poor teacher."[16] Callahan's effectiveness as a teacher stemmed in large measure from the fact that he learned so much – and so eagerly – from the ID program. The perfect student became the perfect instructor.

For both Moholy and Callahan, life and art were fused in a feedback loop of cause and effect. Art held the power of changing one's life; it was, at the same time, an organic expression of life. This art/life dialectic held the potential of creating an enormous and genuinely transformative kind of spiritual energy. This passionate linkage of art and life is radiantly clear in both Callahan's photographs and his (infrequent) formal statements of purpose. In early 1946, while still in New York, Callahan applied for an artist's fellowship at the Museum of Modern Art with a statement that read in part:

In 1941 I was introduced to photography that had unlimited possibilities for me. I can honestly say that for the past five years I have devoted every spare moment to thinking about and doing

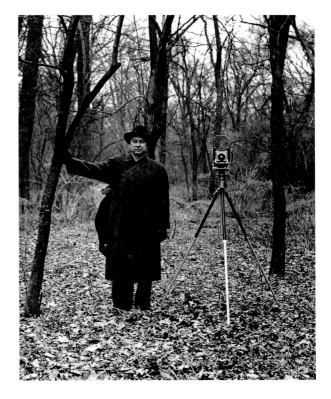

Fig. 4 Harry Callahan, 1950s.

photography as a means of expressing my feelings and visual relationships to life within me and about me....

My project could only be to photograph as I felt and desired; to regulate a pleasant form of living; to get up in the morning – free, to feel the trees, the grass, the water, sky or buildings, people – everything that affects us; and to photograph that which I saw and have always felt. This, I know, is not a definite project because life itself is not definite, but it could be the part of a lifetime project to help keep photography alive for me and with the hope that it would be alive for someone else.[17]

At the same time, Callahan published a personal credo in *Minicam* magazine.

Photography is an adventure just as life is an adventure. If man wishes to express himself photographically, he must understand, surely to some extent, his relationship to life. I am interested in relating the problems that affect me to some set of values that I am trying to discover and establish as being my life. I want to discover and establish them through photography.... I wish more people felt that photography was an adventure the same as life itself and felt that their individual feelings were worth expressing. To me, that makes photography more exciting.[18]

These themes of devotion, expression, and value have a profoundly spiritual resonance. Later in life, Callahan acknowledged that photography filled the void left by his turn as a young man from organized religion.[19] For him, photography was thus never merely a matter of art: it was a matter of self-understanding, communion, and transcendence.

Callahan moved to Chicago in the early summer of 1946 to prepare for his new career. Moholy did not have funds to pay him for the summer term, but he encouraged him to attend the "New Vision" seminar. Callahan, however, had little interest in listening to lectures. Instead, he put in long days assisting Levstik and Sokolik in the photography classrooms and lab. He loved the work and – somewhat to his surprise – found that he also loved the program. This was a discovery of recognition, a confirmation and clarification of what he already believed. Since at least 1941 Callahan had been working in basic sympathy with Bauhaus principles – a result, in roughly equal measure, of his astonishing, native intelligence and Siegel's informal "teaching." As he later recalled:

The program that the [school] had for the first year was everything I liked. The way they taught it was remarkable, so I just watched the teachers and did the same thing. I believed in the way the Bauhaus program was structured so much that I think my own teaching was okay.[20]

Callahan's teaching turned out to be considerably more than "okay," but it never came easily for him. It was, as he consistently pointed out later in life, both a "nourishing" and an "agonizing" experience. The job expanded him enormously: "Teaching taught me how little I knew and it forced me to think. I had to teach to get an education."[21] At the same time, he was perpetually insecure about what he had to offer students. His nervous anticipation over the next day's class caused him many sleepless nights. In the classroom, Callahan responded honestly to students and their

work without pretending to any final or universal answers. Believing firmly that language was inadequate to the task of fully describing pictures, Callahan communicated as much by gesture and expression as through words. He tended to look and listen carefully, pointing at pictures more than really discussing them, but the words he used were always carefully chosen.[22]

Callahan almost never showed his own pictures in the classroom. Students were aware of his work, of course, from his occasional shows in the city and from reproductions in magazines and catalogues. Everyone understood, however, that Callahan's reluctance to show his pictures stemmed from a fundamental pedagogical principle. As one of his finest students of this era, Yasuhiro Ishimoto, recently recalled:

In the four years I was at the school, I only saw three of Callahan's pictures. He never showed them to us. If he had shown them, students would have imitated them, and he didn't want that. We had to work for ourselves.[23]

On the other hand, Callahan regularly drew impetus for his photography from the problems he assigned in class, and he knew that his own process of exploration had deep relevance to his students. As a result, while he resisted showing finished prints in class, Callahan sometimes brought in recent contact sheets or shared working proof prints with them at informal gatherings at his apartment.[24] This made an immensely important point: however celebrated he may have been as an artist, Callahan was involved in the same quest – with the same uncertainties and excitement – as every one of his students.

Photography at the ID

The fall 1946 semester saw important changes at the Institute of Design. Growing enrollments prompted a move to new quarters, a distinguished 20,000-square-foot brownstone at 632 North Dearborn Street previously occupied by the Chicago Historical Society. Sadly, and most significantly, Moholy died of leukemia on November 24. During his yearlong illness, Moholy had become increasingly removed from the school's day-to-day operations. With his death, the ID entered a new era. Moholy's policies and ideals continued to be treated with reverence, even as they were steadily modified. Without his unifying authority, however, conflicts over staffing and administrative issues came increasingly to the fore. The first of these stemmed from the critically important decision to name his successor. Faculty members were nearly unanimous in lobbying for Walter Gropius, the founder of the original Bauhaus, who, they felt, could best carry on in the spirit of Moholy's vision. Instead, within three weeks, the board announced the selection of Serge Chermayeff, from the Department of Design at Brooklyn College. Although most of the faculty signed a letter to the board expressing no confidence in this choice, their protest was ignored and Chermayeff assumed his duties in February 1947.

The photography program came fully into its own in that tumultuous fall term. To meet the growing enrollment, the department was given the third floor of the North Dearborn Street building. The new darkroom was comfortably spacious and a former audi-

torium was converted into a studio. Two courses of study were now available: a four-year Bachelor of Science program and a two-year "Special Photography" certificate course. For the next three years Siegel headed the department with Callahan also teaching full time. Experienced staff members such as Brown, Levstik, and Sokolik continued teaching in the 1946–49 period in either the day or evening sessions, and other part-time or temporary instructors were brought in as needed. Gordon Coster, for example, a successful Chicago commercial and industrial photographer, taught in the fall of 1946 and again in 1950. In the spring of 1947, E. Atkinson taught color photography. Ferenc Berko, who had known Moholy in Europe in the 1930s, came to the school for the 1947–48 academic year. Berko taught photography classes every day as well as a film history class that met one night a week. In spring 1948 Hillar Maskar was hired as a lab technician, and taught part-time over the next four years. Victor Corrado and Wayne Miller joined the staff in the fall semester of 1948. Corrado taught part-time in the evening program, while Miller, a respected documentary photographer, was at the ID for the 1948–49 school year.

The course of study in these years continued the basic approach established by Moholy. The first year of the B.S. program was devoted to the Foundation Course curriculum. After completing this basic training, the student decided on one of four areas of emphasis: industrial design (prerequisite to architecture), advertising arts, textile design, and photography. For photography majors, the program for the next three years followed an established curriculum. The two-year Special Photography program, however, offered a condensed curriculum, with less emphasis on the Foundation Course and more on technical and business concerns (see fig. 5).

As an examination of these course listings reveals, the ID photography program was based on a fundamental duality: the achievement of professional-level expertise in a highly technical discipline, complemented by some semblance of a traditional liberal arts education. It was not enough to achieve specialized craft skills alone: students were expected to have at least a passing acquaintance with history, math, science, sociology, aesthetics, and business. As this pedagogical framework makes clear, the ID was not an "art school" in any traditional sense, though art was central to its mission. Following Moholy's precepts, the ID attempted to unify two great modern movements: one in fine art, the other in business. Understood in the broadest terms, business represented the possibilities and values of modern economic life, while art provided the means of both expressing and transforming life. Both art and business reflected basic human characteristics and motives: on one hand, the individual, spiritual, and intuitive; on the other, the collective, secular, and pragmatic. Together, they held the potential to create a powerful new synthesis of theory and practice, individual insight and social accord.

The result, however, was an often awkward overlap of visionary and vocational concerns. As Art Sinsabaugh, who entered the program in the summer of 1946, later observed:

Fig. 5 Courses in the ID's four-year Bachelor of Science program in photography and its two-year Special Photography program.

Four-year Bachelor of Science program in photography

First year
First semester

Drawing I	Algebra I
Color Composition I	Intellectual Integration
Sculpture I	Special Lectures
Basic Workshop I	

Second semester

Drawing II	Algebra II
Color Composition II	Photography
Sculpture II	Special Lectures
Basic Workshop II	

Second year
(3rd and 4th semesters)

Photography	Lettering
Mathematics	Mechanical Drawing
Physics	Special Lectures
Form & Civilization	

Third year
(5th and 6th semesters)

Photography	Form & Civilization
Advertising Arts	Architecture
Mathematics	Literature
Product Illustration	Special Lectures

Fourth year
(7th and 8th semesters)

Photography	Architecture
Advertising Arts	Special Lectures
Sociology	Elective

Two-year Special Photography program

First year
(1st and 2nd semesters)

Photography	History of Photography
Photo Chemistry	The Motion Picture
(1st semester only)	Drawing & Color Composition
Physics	Special Lectures
(2nd semester only)	

Second year
(1st and 2nd semesters)

Photography	Literature
The Motion Picture	Bookkeeping
Advertising Design	Special Lectures
Form & Civilization	

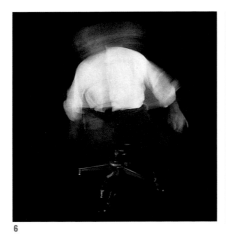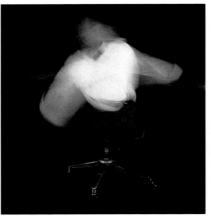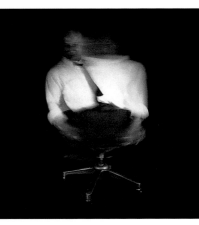

6

Fig. 6 Harry Callahan demonstrating virtual volume in a swivel chair, 1958. Photographs by Thomas Knudtson.

Many of us had high aspirations, not to make money but to be special in terms of ideas. Two-year students just back from the war wanted to learn commercial things. People like me must have driven them up the wall. This was an elitist school, a private, everybody-dedicated school – with a lot of commercial photographers. The influence of these people was changing the old qualities. Even Arthur Siegel had that kind of attitude: he represented himself as a working pro, legitimate both artistically and monetarily. He says he brought Callahan in because Callahan represented the other alternative, the photographer committed for purely creative reasons.[25]

In classic Hegelian fashion, the photography program attempted to create a new synthesis from the "thesis" of art and the "antithesis" of commerce. With photography, one could earn an honest living, create the most personal kind of art, or – ideally – do both.

The very breadth of this pedagogical ambition required that the medium be analyzed and taught from the ground up. The Foundation Course sought to do this through a systematic exploration of photography's basic technical characteristics and expressive possibilities. While inevitably adapted and modified, this approach remained central to the Institute's photography program at least through the early 1960s. The undergraduate curriculum included the following exercises, explored in a relatively unvarying sequence: pinhole camera, photograms, light modulators, virtual volume, lighting, negative techniques, refraction, reflection, viewpoint, microphotography, multiple exposure, form, related forms, and series (see figs. 6, 7).

Art Sinsabaugh's class notebooks provide a uniquely detailed summary of the curriculum in the late 1940s. Sinsabaugh began the four-year photography program in the summer of 1946, and took Photo I (taught by Frank Levstik, Jr.) in the fall semester. His notes for that class document the following exercises or "problems" (see fig. 7): pinhole cameras; photograms (using both contact and enlarging paper); the exploration of photographic volume and tone using cut-paper forms and a single light source; the control and use of contour lighting; and the evocation of texture. In his third semester, in the spring of 1947, Sinsabaugh's problems included photograms (this time using more complex forms and controlled or multiple exposures); cut-paper (with more intricate forms and two light sources); and texture and structure (recording subjects such as plant forms from close vantage points). This process of exploration continued in the fourth semester, with assigned problems in contour lighting; tone (the subtleties produced by two overlapping shadows); the angle shot (the use of very low- or high-angle vantage points); and reversal of perspective (creating unexpected relationships of size by framing and point of view).

Sinsabaugh's fifth-semester photography course, taught by Callahan, was devoted to a sky problem (making a clean, evenly processed negative in which at least 80% is sky); a series problem (close study of a single type or class of subject); negative technique (the systematic exploration of various exposure and development combinations); a gamma infinity problem ("pushing"

Fig. 7 Examples of students' photographic exercises, 1940s:
a photograms b light modulators c virtual volume d lighting e negative
techniques f refraction g reflection h viewpoint i multiple exposure j form
k portraits l documentary m children n people without people o texture

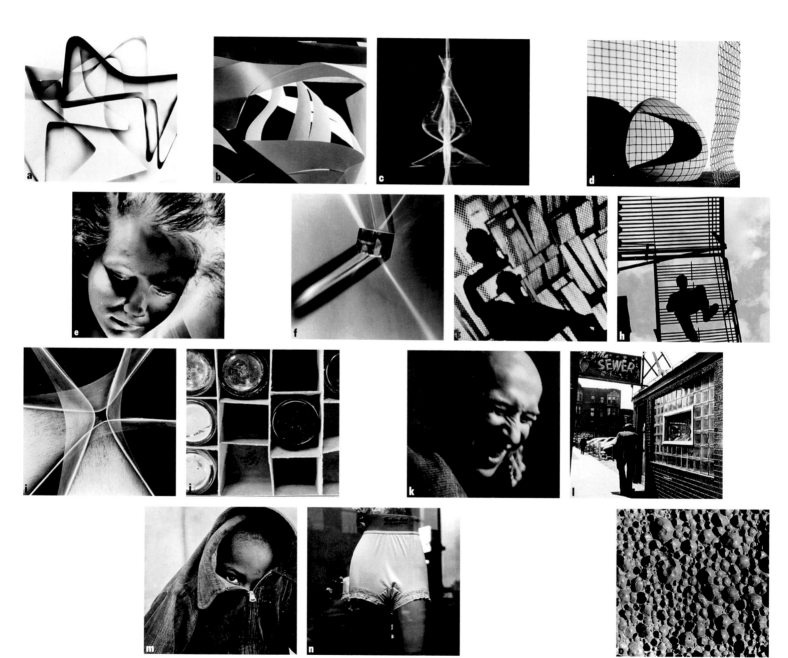

underexposed film by two-hour development without agitation); a water-bath problem (making printable negatives of extremely high-contrast subjects); a camera movement problem; near and far problem (the control of focus and depth of field with a view camera); a sculpture problem (recording a dimensional work with various types of light: diffuse, silhouette, point source, etc.); a portrait series (creating a graphic impression of a person through close study of details: ear, eye, mouth, etc.); and three double-exposure problems: "free" (any two subjects overlapped), "controlled" (two subjects combined in a systematic variety of ways), and "complicated" (second image placed within the silhouetted form of the first).

In the sixth semester, Callahan stressed fine print quality and required that students make only contact prints. The problems in this class included object analysis (exploration of some artifact or structure through a series of photographic details); the evidence of people (suggesting the human presence through telling scenes or artifacts); a telephoto problem (optical effect of viewing angle and distance); informal portraiture (engaging and photographing strangers on the street); self-documentation (recording one's intimate surroundings); and a nature problem (suggesting intangible aspects of nature such as the wind). In this term, Sinsabaugh also took Siegel's course in the history of photography.

In the first semester of his final year, Sinsabaugh took Wayne Miller's documentary course and "Experimental Photography," taught by Siegel. The former was highly structured and devoted exclusively to human subjects. The latter was an unstructured investigation of various process issues – Sinsabaugh, for example, made macro images of soap bubbles illuminated by flash and studied the visual effects of melting film emulsions. Sinsabaugh's eighth and final semester included a teacher-training component in which he assisted with the instruction of Callahan's classes. In addition, he took one more advanced photography workshop, a film history course, and satisfied the B.S. degree requirements in trigonometry and economics.

As this rather detailed summary suggests, the ID approach was at once technical and conceptual, specific and open-ended. Later critiques of the program of this period as simply "formalist" in nature are, themselves, too simple. In classic Bauhaus fashion, this curriculum began with a basic investigation of light and light-sensitive surfaces, from the making of photograms to the control and manipulation of lighting sources. In the next stage, the syntax of camera vision itself was explored: the nature of lenses, and the use of blur, controlled depth of field, and multiple exposures to shape reality. The purely technical problems of making a clean-sky negative, or understanding the relationship between exposure and development, ensured that students had a firm grasp of both the potentials and limitations of their tools. The medium's editorial and interpretive power was explored in assignments such as the portrait series, in which something of a person's being or character was to be conveyed in a sequence of intimate details. The most advanced assignments were remarkably subjective in nature. The subject of the "self-documentation" assignment, for example, was the student him- or herself, as revealed in the evi-

dence of their environment and possessions. The "informal portraiture" problem was particularly notable in this regard. Students were instructed to make portraits of strangers, but only after they had introduced themselves and engaged in conversation to learn something about their subjects. For the shy, insecure, or inarticulate – that is, for most students – this was an excruciating process. Callahan's devotion to this assignment stemmed from a clear sense of his own shyness and of the social handicap it represented. Significantly, then, this assignment was more about the values of human communication and self-understanding than any technical or artistic concerns. Finally, the "nature problem" – the assignment to evoke such intangible aspects of nature as the wind – can be understood in an entirely conceptual way. The wind can be sensed but not directly seen; we can only be aware of it through faculties other than sight (the pressure on our skin, for example) and through the visual evidence of its effects on other things (a tree's swaying branches). The result is a reminder – however subliminal or intuitive – that the world is in constant flux and that some of the most important aspects of life are not physical things, but *forces* and *processes*.

Engaging the real: the problems of self and society

At root, the ID photography curriculum was based on three fundamental notions: mastery of equipment and materials; self-understanding and self-expression; and an engagement with the objective world. While a number of writers on the ID have emphasized the importance of the first two of these notions, fewer have paid appropriate attention to the third. This engagement with reality was conceived broadly, as a matter of facts and ideas, present and past. Its importance in this period is clear, beginning with Callahan's simple but telling insistence that students interact with strangers on the street. Most obviously, an emphasis on empiricism and analysis lay at the heart of Siegel's teaching and shaped the way documentary and journalistic photography was taught in the overall curriculum.

Siegel's teaching was deeply informed by his restless curiosity and fundamentally analytical nature. "Everything affects everything else," he liked to say, and Siegel seems to have been interested in – and conversant with – just about everything.[26] For him, photography was only peripherally a technical matter. He advocated an informed, *critical* approach based on an understanding of the history of ideas and the challenge of "competing against all the other images that were ever made in the world." While the ambition was laudable, this was an almost impossible goal – and certainly one that Siegel himself never came close to achieving. The problem, of course, is that the project of seeking to absorb everything of intellectual value is an endless one – there are always more books to read – which can just as easily paralyze real creative effort as inspire it. As John Grimes has noted recently, Callahan and Siegel spent a great deal of time together, talking photography long into the night, in the years 1946–49. Characteristically, Callahan would be out on the street the next morning making pictures, while Siegel would stay at home to read. For Callahan, an idea was never fully real until it could be

expressed in pictorial form – or, perhaps more correctly, until it was found to be pictorially *useful*. For Siegel, ideas had an independent reality that transcended their application to picture making: the actual production of photographs was a distinctly secondary matter. As a result, as Grimes has observed, Siegel "talked more and did less than almost anyone in the field, but the talk was brilliant."[27]

Despite these problems of both message and messenger, Siegel's lectures were stimulating and wide-ranging performances. His multidisciplinary approach emphasized a fundamental reciprocity. Our perspectives on the world are shaped by biological and psychological factors, but these are not simply "givens"; from an understanding of science and culture, we gain the ability to shape, control, or amplify these basic traits. Society and self are thus intimately connected. In his course on the history of photography, for example, Siegel began with a review of the medium's technical and aesthetic characteristics.[28] He then discussed the problems of "organization" (a term he favored over the simpler concept of "composition") and meaning in broadly cultural ways, beginning with the sciences of biology, chemistry, and physics. He continued with an overview of the other disciplinary fields dealing with human knowledge: philosophy, semantics, psychology, economics, and sociology. In philosophy, for example, he discussed the basic traditions of epistemology, ethics, logic, and aesthetics. His treatment of psychology, a subject of particular interest, touched on a variety of sub-topics (normal, abnormal, educational, group, and child psychology) and approaches (the gestalt, behaviorist, and Freudian methods).

In addition to knowing oneself, Siegel emphasized the importance of knowing the world. Since all photographs have social implications, it was imperative that students research and study their subjects. Information came in many forms, all of which had potential value – from books, newspapers, archival records, and personal interviews, to the personal artistry of fiction, poetry, painting, and music. Focusing on the issue of the shaping and conveying of information, Siegel then analyzed the structure and objectives of the daily newspaper. He paid particular attention to the rich data contained in its advertising and classified sections. These, he pointed out, were clear indices of a city's economic health, demographic shifts, and labor and consumer trends, all of which had relevance to the making of photographs.

Siegel's pragmatism was evident in his blunt discussion of the difficulties of being a creative photographer in the real world. The school environment, he emphasized, was an artificial one; all but the independently wealthy would soon find it necessary to earn a living in the existing job market. This inevitability required that each student find answers to a few basic questions: How important is photography to me? What is the appropriate balance between practical, financial needs and an ideal state of creative freedom? Every choice – whether to work commercially, as a freelancer, a teacher, an independent artist, or simply as a hobbyist – involved compromises. The answers were not simple or generic; they could only be complex and personal. In the end, Siegel suggested, this quest for understanding and equilibrium resulted in a profound existential insight: "Freedom is the privilege of the mature artist."[29]

While limited in number, and distinctly uneven in quality, Siegel's personal photographs of this era are revealing. Beginning in 1946, he worked almost exclusively in color, a radically unorthodox choice at the time. In fact, Siegel was one of the most celebrated and influential noncommercial color photographers of the day.[30] His devotion to the medium came at significant cost, however. In the late 1940s there were only two real approaches to making color prints: commercial processes for the amateur market produced images that were cheap, unattractive, and impermanent; professional techniques were relatively stable but exceedingly difficult and expensive. In 1954, for a one-man exhibition at The Art Institute of Chicago, Siegel produced a small number of dye-transfer prints of some of his best color images. The expense was enormous: it took him years to pay off the debt and he never again used this process.[31] The only remaining option – which, by necessity, he also explored – was to "exhibit" color transparencies in the form of public slide presentations.

Siegel's images are diverse in subject matter. They range from various details of city life – the rhythms of pedestrian traffic, or a neon sign for a dry cleaners – to a series recording the images of color slides projected on his wife's nude body. Arguably, his most important and characteristic group of pictures was begun in 1951, after he suffered a mental breakdown and began Freudian analysis. Titled "In Search of Myself," this series focuses on anonymous shoppers on Chicago's State Street. The most compelling images utilize shop-window reflections to create a complex visual space in which lone faces or figures are immersed in a veritable kaleidoscope of commodities. This series is a perfect summation of Siegel's interests: it is at once about the forces of mass commercial culture and the mysteries of identity.

While Siegel's work reflects a highly personal form of "documentary" practice, a more traditional approach to social-documentary photography held an important place in the department's curriculum. In his classes, Siegel assigned projects of a standard photojournalistic nature: the recording of parades and other community activities, for example. In addition, accomplished documentary photographers were brought in as temporary faculty members. The most notable of these, Chicago native Wayne Miller, taught one day a week in the 1948–49 school year.[32] As it happened, Miller was just finishing a major documentary project – supported by two consecutive Guggenheim fellowships – on the theme "The Way of Life of the Northern Negro." Between 1946 and 1948, Miller worked in the black community of Chicago's South Side known as Bronzeville. His warm and humane images depicted the area's workers and residents, its street life and after-hours entertainment, its tenements, churches, and shops.[33]

Miller's class in documentary photography (as recorded in Art Sinsabaugh's notes) was structured as a series of problems. The first, on juvenile delinquency, was largely conceptual in nature. The class discussed the causes and effects of delinquency, and researched the organizations and individuals that could be sources of information on the issue. Finally, a strategy was devel-

oped on where and how photographs might be made. Following this largely theoretical discussion, four less ambitious assignments – on labor, children, Chicago culture, and the rich – were actually undertaken.[34] Miller consistently emphasized the importance of people – recognizably human situations, narratives, and emotions – as a kind of antidote to what he perceived to be the program's emphasis on abstract and experimental concerns.

Of course, many ID students did not need the spur of class assignments to engage and interpret the life around them. Two of the most outstanding students of this era, Marvin Newman and Yasuhiro Ishimoto, took the city and its people as their primary subjects.[35] In fact, to earn extra money, Newman worked on documentary assignments for two social welfare agencies, Hull House and the Lower North Side Settlement House.[36] This experience gave him an intimate familiarity with many of the city's working-class neighborhoods. Newman and Ishimoto often worked together, shooting either motion-picture film or still photographs. They photographed in the city's parks, recording old people lounging and children playing. In the downtown Loop, they recorded pedestrians and parades. In the neighborhoods, they recorded all kinds of details and activity, from the windows of storefront churches to the Halloween costumes of children. They worked at the beach in summer, and recorded the effects of new-fallen snow in the winter. All of this work is at once graphically bold and deeply humane, a rare and remarkable combination.

In truth, the human realities emphasized by teachers such as Miller were apparent – on some level – to everyone at the ID. Chicago was a tough and unsentimental place; evidence of the full spectrum of human achievement – success and failure, wealth and poverty – was everywhere visible. The ID building on North Dearborn Street was in an undistinguished, somewhat seedy part of town. As one student recalls, it was a working-class area that seemed "frozen in the 1890s," a neighborhood of flophouses and small shops with a notable syndicate presence. Occasionally, the police raided a nearby brothel on Clark Street. Most students lived a kind of bohemian existence in this area, sharing quarters in low-rent rooming houses.[37] While their education may have been elite in many respects, their daily lives were not. This gritty environment inevitably affected the outlook and social awareness of everyone at the school.

ID joins IIT

Significant changes in the photography program in 1949 included a major turnover in staff. By the summer of 1949, all of the experienced faculty members except Callahan were gone. Sokolik resigned at the end of the fall 1948 semester, followed by Siegel and Levstik at the close of the spring 1949 term. This was, in some measure, the result of a deliberate effort by Chermayeff – who has been described as "rather authoritarian, even dictatorial" in style – to get rid of much of the old guard.[38] Siegel's resignation came as the culmination of a series of personality conflicts and policy disputes with the director. Chermayeff immediately named Callahan the new head of the photography program.[39] Out of a sense of both respect and necessity, however, Callahan per-

suaded Siegel to continue at the school on a part-time basis. Over the next five years, he taught a night course in film history, while devoting increased attention to his personal work and freelance career.

One of the key policy matters that separated Siegel and Chermayeff was the question of affiliation. From the school's beginning, the ID's finances had been shaky and its academic structure unorthodox. For supporters such as Walter Paepcke, the school's independent status was an expensive luxury. As early as 1942, Paepcke explored possible affiliations with several local institutions, including Northwestern University, the University of Chicago, and the Illinois Institute of Technology. Henry Heald, the president of IIT, expressed the strongest interest, but he was leery of the cool relationship between Moholy-Nagy and Ludwig Mies van der Rohe, the last director of the original Bauhaus and current head of the IIT architecture program.[40] Talks were renewed in 1948, despite warnings by some of Moholy's former associates that those in Mies van der Rohe's camp would be less than sympathetic to the Institute's principles and objectives. Nonetheless, guided by Paepcke, Heald, and Chermayeff, the merger was approved by the IIT board and announced on November 30, 1949. In simplest terms, the ID became IIT's department of design. Six years would pass, however, before the school would leave its North Dearborn Street address for new quarters on the IIT campus.

As opponents of the merger had predicted, the very real benefits of financial and institutional stability came at a cost. The school decreased slightly in scope: while most of the courses were to be continued as before, it effectively surrendered its architecture program to IIT. There was also a palpable emotional effect on those devoted to the old ID. John Keener, a student at the time, has recalled "the sense of personal loss when IIT took over with its rules, regulations, and formality. ID students … resented the quashing of the spirit that the red tape implied."[41] Students and staff alike found themselves enmeshed in a large and impersonal bureaucratic system, with requirements that seemed unnecessarily intricate and arcane.

Even with the merger complete, bureaucratic turmoil and lingering antagonisms – personal and philosophical – made life difficult for just about everyone at the school.[42] When Chermayeff resigned in the spring of 1951, Crombie Taylor, from the Shelter Design department, became acting director. Over the next four years, some twenty-five candidates were considered and interviewed for the directorship. While many were men of considerable talent and renown, none could win a clear vote of confidence. Faculty and staff members bickered, shifting positions and alliances constantly, agreeing only to disagree. On his resignation in 1953, one member of the staff wrote an open letter, titled "Crisis in Leadership at the School of Design," in which he excoriated the "philosophy of contempt for students and faculty" demonstrated by the school's leadership.[43] This unhappy stalemate was brought to an abrupt conclusion in 1955, when IIT simply appointed a new director, product designer Jay Doblin, without bothering to consult the ID faculty. Their internal warfare tem-

Fig. 8 Art Sinsabaugh, July 1963.

porarily forgotten, the faculty united to protest this choice. The IIT hierarchy ignored the challenge and Doblin stayed, with tenure.[44]

Throughout this contentious period, Callahan moved to consolidate and strengthen the photography program. Sinsabaugh, who received his B.S. degree at the end of the spring 1949 semester, was his first full-time hire (fig. 8). Since entering the program three years earlier, Sinsabaugh had been Callahan's most enthusiastic student. As the teacher recalled many years later, Sinsabaugh "was a real joy – I'd give him assignments and he'd just dash out and do them."[45] In addition to having absorbed the ID aesthetic so fully, Sinsabaugh was a genuinely talented – if not, as yet, fully mature – photographer. He taught full-time until 1951, when falling enrollments in the day program forced his reassignment to the evening division. He continued in this capacity through most of the decade, before leaving to begin a photography program at the University of Illinois in Champaign.

Another important programmatic step – the establishment of a graduate program in photography – came about almost by accident in 1950. Callahan later recalled:

I had the first seniors in photography, and I was forced to figure out what to do with these students. I had them do a project just to keep them busy for the rest of the year. I was very conscious of two kinds of students: the kind who had to be told what to do, who needed a literal approach, and the others who were intuitive. I said to them, "Spend the first semester just photographing, trying to figure out who you are, and the second semester do a project based on that."

I'll never forget the day that class ended. I thought, "Thank God, this is over with, this is ended. How will I ever survive again?" And this guy comes up to me and says, "I want to take a master's degree." I didn't even know how to do an undergraduate! So I said

I don't know about one, but the student kept after me. So I went to Serge Chermayeff, who ... said "Have him make a statement of purpose, and we'll put it to the executive committee and decide whether he can do it." So the student did it, and they accepted it, and that's how the whole idea of the master's degree program started.[46]

The first M.S. degrees were awarded two years later, to Marvin Newman, Jordan Bernstein, and Floyd Dunphey.

The partnership of Callahan and Siskind

This expansion of the program only reinforced what Callahan already knew: another faculty member – a photographer of national stature with strengths different from his own – was desperately needed. Callahan wanted someone who could provide conceptual leadership, and who would be comfortable and articulate in the classroom, particularly with advanced students. He found all these qualities in New York photographer Aaron Siskind, whom Callahan had met in 1948 through their mutual friend, Todd Webb. Callahan first offered him a job in 1949, but Siskind was reluctant to leave New York, and two years passed before he finally accepted. The men understood, appreciated, and complemented each other in a remarkable way. Their teaching partnership – in Chicago from 1951 to 1961 and then in Providence, Rhode Island, from 1971 to 1976 – is justly legendary.

Aaron Siskind was nearly a decade older than Callahan, with considerably different life experiences (fig. 9).[47] After graduating from college in 1926 with a degree in English, Siskind taught this subject in the New York public schools for twenty-one years. His interest in photography, begun in 1930, was soon directed to the cause of civil rights and social reform. He was active in the Photo League, a group with distinctly leftist roots, through most of the

Fig. 9 Aaron Siskind photographing an Adler and Sullivan building on Chicago's South Side, c. 1953. Photograph by Richard Nickel.

1930s. Between 1936 and 1940, Siskind oversaw the activities of the League's Feature Group, which produced documentary photo-essays of progressive political interest. These included "Portrait of a Tenement" (1936), "Dead End: The Bowery" (1937), and "Harlem Document" (1937–40). By the early 1940s, however, Siskind's interests were clearly shifting from fact to metaphor, politics to poetry. His pictures became more personal, even psychological, as he moved his camera closer and closer to his subjects in search of a formal rather than narrative revolution.

Siskind's breakthrough, achieved in the summer of 1944, was eloquently described several months later in his essay "The Drama of Objects."

For the first time in my life subject matter, as such, had ceased to be of primary importance. Instead, I found myself involved in the relationships of these objects, so much so that these pictures turned out to be deeply moving and personal experiences....

For some reason or other there was in me the desire to see the world clean and fresh and alive, as primitive things are clean and fresh and alive. The so-called documentary picture left me wanting something....

[This] is an emotional experience. It is utterly personal: no one else can ever see quite what you have seen, and the picture that emerges is unique, never before made and never to be repeated. The picture – and this is fundamental – has the unity of an organism. Its elements were not put together, with whatever skill or taste or ingenuity. It came into being as an instant act of sight.

Pressed for the meaning of these pictures, I should answer, obliquely, that they are informed with animism – not so much that these inanimate objects resemble the creatures of the animal world (as indeed they often do), but rather that they suggest the energy we usually associate with them. Aesthetically, they pretend to the resolution of sometimes fierce, sometimes gentle, but always conflicting forces....

Essentially, then, these photographs are psychological in character.... The interior drama is the meaning of the exterior event. And each man is an essence and a symbol.[48]

In this remarkable statement, Siskind summarized the ideas that would come to define a much larger movement in creative photography over the next twenty years. He sought a purified way of seeing, unconstrained by habit or convention. From this perspective, the most trivial subjects had the potential to serve as symbols of the human condition. The stuff of his pictures was humble indeed: graffiti, torn posters, peeled paint, weathered facades. However, the tensions and ambiguities that Siskind discovered in this world of cast-off things suggested the uncertainty, longing, and dread that were part of every life. Siskind's pictures, which so often seem to teeter on the edge of obscurity and chaos, underscore the existentialist belief that life is uncertain, meaning conditional, and survival a function of individual will.

Just as importantly, Siskind's work pushed against the generally accepted boundaries of photographic practice. Indeed, despite his technical purism, Siskind's mature pictures were embraced most eagerly at first by the avant-garde painting community rather than by photographers. Siskind's ideas of psychology and symbolism were in full accord with those of the leading Abstract Expressionist painters. He enjoyed friendships with many of these artists, including Franz Kline, Barnett Newman, Adolph Gottlieb, and Mark Rothko. In addition, he showed regularly in New York at the Charles Egan Gallery, which specialized in the work of this group. Siskind's acceptance in the larger realm of avant-garde art gave him a stature nearly unique in mid-century American photography.

Callahan and Siskind were markedly different in personality and life experience. Callahan was shy and non-verbal, essentially apolitical, with a stable and uncomplicated home life. Siskind was gregarious and articulate, with a distinctly left-of-center political background, and an unsettled private life. Callahan found teaching agonizingly difficult; Siskind taught all his adult life and approached each day's classes with a relaxed professionalism.

These differences only magnified the basic beliefs – and passionate devotion to photography – that Callahan and Siskind shared. Both had taken up the camera for deeply personal reasons. For both men, photography provided a tool of self-expression and self-understanding, a means of uniting the truths of both objective and subjective experience. By the late 1940s, Callahan and Siskind had come to understand the medium in profoundly congruent ways. They respected the integrity of the process and the value of "pure" photographic technique (although they viewed this in slightly different ways). Photographs – as handcrafted, physical things – were real in and of themselves, and could be judged successful or unsuccessful *as* pictures, that is, in purely formal terms. Beyond this, both conceived of photography as a synthesis of realist and poetic concerns, of fact and intuition. The things of the objective world, Callahan and Siskind believed, carried the potential for at least two kinds of meaning: the deeply personal and the universal or archetypal. Successful pictures conveyed both levels of meaning, while suggesting a larger synthesis or unity. The goal was, at once, to view the world through the unique filter or screen of the self, while discovering reflections or symbols of the self everywhere *in* the world. This was, ultimately, a spiritual and epistemological quest of the highest importance: to understand the self in relation to one's community, one's era, and the existential human condition.

Given photography's central importance in their lives, it is not surprising that both Callahan and Siskind were highly productive in the 1950s. Callahan's work of this decade includes important groups of street pictures, images of his wife and daughter, and multiple exposures. In 1950 Callahan photographed in downtown Chicago, using a 135mm telephoto lens on a 35mm camera. He worked quickly and unobtrusively, recording at close range the faces of anonymous pedestrians.[49] He was fascinated by the idea of people "lost in thought" – of the tender, singular reality of one's inner life within the congested, public realm of the city. These images suggest that individual solitude is a basic aspect of the human condition – and thus, paradoxically, perhaps, a fundamental sign of human kinship. In the early 1950s Callahan also produced a large body of photographs of his wife, Eleanor, and, after


Fig. 10 Harry Callahan at his exhibition opening at The Art Institute of Chicago, 1951.


her birth in 1950, his daughter, Barbara. Callahan's "8 x 10 snapshots" pay homage to the simplicity of the common vernacular image while transcending the genre entirely. In these images, Eleanor is usually posed somewhat self-consciously, precisely centered in the frame in the mid-ground of the scene. The basic conventions of the home snapshot are observed, but the meticulous detail and tonal subtlety of the 8-x-10-inch contact print mark these as highly sophisticated productions. Callahan's pictures are both pointedly specific and broadly universal: in one man's family we find hints and echoes of our own. In this same period, Callahan explored the potentials of the multiple exposure, working with various camera formats and a variety of subjects. He was fascinated by the transformative power of the multiple image. The simple process of exposing two or more scenes on a single negative produces a multitude of unforeseen visual effects – a pictorial product that is both the sum of its parts and something radically new. The multiple exposure folds reality back on itself, replacing a straight photographic vision of solidity and permanence with one of transparency, instability, and weightlessness. From a philosophic and aesthetic point of view, this "abstraction" can be understood as a new kind of "realism" – the realism of simultaneous and interpenetrating forces, of the energy and impermanence of the modern city.

Siskind's work of this period focuses on four major subjects: urban facades, graffiti and detritus, the isolated human figure, and the stone walls of Martha's Vineyard, Massachusetts. Siskind was drawn to Chicago's older buildings, emphasizing formal relationships between structural and decorative details, the flatness of brick surfaces, and the real or implied openings of doorways and windows. In his urban wanderings Siskind often made tightly cropped images of weathered surfaces: peeling posters, chipped or spilled paint, and the anonymous marks of graffiti. These images explore the fertile territory between realism and abstraction, the banal and the sublime. Some are entirely nonobjective, using tone and texture to evoke an open-ended sense of mystery, movement, or melancholy. Others have a clearly anthropomorphic quality: chalk-drawn figures or simple skeins of paint suggest human figures that are at once generic and symbolic. Most commonly, these Rorschach-like figures are seen as isolated, fragmented, or distressed. Real human figures are central to Siskind's series "Pleasures and Terrors of Levitation," begun in 1953. Using a low viewing angle, he recorded the dark, solitary forms of teenage divers against the blank white field of the sky. These are profoundly existential images, depicting acts that are at once bold and absurd, exhilarating and terrifying. Siskind used a similar point of view when he began photographing the stone walls of Martha's Vineyard in the summer of 1954. These images – composed of blocky masses of black stone against the emptiness of the white sky – are about inertia, power, and the primeval. Significantly, however, even these images were understood to be imbued with a deeply human and emotional content. As Siskind stated: "I was concerned with the importance of how people feel in relation to each other, the nearness and the touch . . . about certain people I knew."[50]

Both Callahan and Siskind received widespread recognition in this period. Thanks to the support of Edward Steichen, curator of photography at the Museum of Modern Art in New York, Callahan's work was included in no fewer than ten exhibitions there between 1948 and 1962. In Chicago he enjoyed one-man shows at the 750 Studio gallery (1947) and The Art Institute of Chicago (1951). The latter exhibition, "Harry Callahan: Photographs by Series," was given the additional honor of inaugurating the museum's new photography gallery (fig. 10).[51] Other large one-person shows were held at the Kansas City Art Institute (1956) and the George Eastman House in Rochester (1958), and Callahan's pictures were seen in such notable group exhibitions as the 1956 Venice Biennale. In 1956 Callahan was awarded a prestigious Graham Foundation grant, with a stipend of $10,000. His first monograph, *The Multiple Image: Photographs by Harry Callahan*, appeared in 1961.

Siskind was equally visible in these years.[52] His work was seen in group shows at the Museum of Modern Art and elsewhere, and in solo exhibitions at such venues as the Portland (Oregon) Museum of Art (1952), Charles Egan Gallery, New York (1954), George Eastman House (1954), Denver Art Museum (1955), Santa Barbara Museum of Art (1955), and The Art Institute of Chicago (1955). His work was accorded serious attention in both specialized and popular photographic journals, from *Aperture* to *Modern Photography*, and even in such avant-garde literary publications as *Big Table*.[53] His first book, *Aaron Siskind: Photographs*, with an introduction by noted art critic Harold Rosenberg, was published in 1959 by Horizon Press.

Not surprisingly, Callahan and Siskind were often shown or featured together. With Siegel, they taught at Black Mountain College in North Carolina in the summer of 1951. In 1957 a two-person show, sponsored by the U.S. State Department, traveled to Paris, Algiers, and London. A four-artist exhibition, "Abstract Photography: Aaron Siskind, Harry Callahan, Arthur Siegel, Art Sinsabaugh," was circulated in the U.S. in 1957–58 under the auspices of the American Federation of Arts. Both Callahan and Siskind were included in the Museum of Modern Art's survey "The Sense of Abstraction in Contemporary Photography" (1960) and in the George Eastman House's new permanent installation, "The Art of Photography" (1961).

This compatibility was evident in all their activities at the school. Callahan and Siskind tended to associate with the same people and, unlike many ID faculty members, they got along well with both Taylor and Doblin. Other faculty friends included Hugo Weber, a brilliant, Swiss-born, abstract painter, and the celebrated architect Ludwig Mies van der Rohe. Siskind and Weber had many mutual friends in contemporary art circles, while Callahan and Mies were particularly close. In the classroom, Callahan and Siskind worked out a natural division of labor. While Siskind at first taught both Foundation Course and upper-level classes, he took on increasing responsibility for the more advanced students. Callahan, by contrast, taught most of the lower-level courses. They shared responsibility for graduate students, meeting with each of them – often together – on a regular

basis. Callahan was quiet and stolid in the classroom. Siskind was voluble and outgoing, radiating energy, always joking, challenging, prodding, and encouraging. Yet, as different as they were in style and approach, Callahan and Siskind worked together so seamlessly that to many students they seemed to be a single, all-encompassing presence. As Joseph Sterling has recalled, "We used to say 'HarryandAaron.' We didn't say 'Harry' or we didn't say 'Aaron,' we said 'HarryandAaron.' And that's because we were so influenced by both of them."[54] Similarly, Kenneth Josephson has said: "I now have difficulty separating Harry and Aaron in my experience as a graduate student – they were so intertwined."[55]

The undergraduate curriculum in the 1950s

The photography curriculum of this period was based clearly on the original ID model (fig. 11). Despite his own disinterest in photograms, for example, Callahan had all his beginning students make cameraless images according to Moholy's original pedagogical formula.[56] Siskind, in turn, respected the tradition and philosophy of the Foundation program despite the fact that it reflected a point of view somewhat different from his own. Naturally and inevitably, however, both men modified the existing curriculum. This was, in part, a matter of inventing new assignments. Callahan, for example, put increasing emphasis on the idea of working in series – the solution of a photographic problem through a logical, sustained process of inquiry. Siskind introduced the "copy problem," designed to emphasize basic technical skills at the Foundation level.[57] His "significant form" problem, assigned to more advanced classes, required that students photograph plant forms in Chicago's public greenhouses. In addition, Siskind introduced a junior-level course titled "The Basic Traditions," which examined the historical, technical, and conceptual concerns of photography's basic applications, including social documentary, journalism, portraiture, and commercial illustration.

Most important, perhaps, was Siskind's renewed emphasis on documentary practice. Given his experience in the Photo League, he naturally encouraged his students to record the social realities of present-day Chicago. One project was devoted to the problems of the elderly, and Siskind took students to City Hall to meet with representatives of the agencies designed to help this segment of the local population. In another project, undertaken in collaboration with the Chicago Housing Authority, Siskind's advanced class recorded both a new housing development and an adjacent slum. In the manner of a Feature Group project of the late 1930s, students discussed the overall problem at some length and came up with individual approaches. One student followed three typical youths through an afternoon of play that meandered through various neighborhoods. Another worked more symbolically, recording moody, shadowy figures in the slum area and brighter, more upbeat scenes of human interaction at the housing project.[58]

Siskind's most memorable documentary project was begun in the fall of 1952, when he sent advanced students to record one of the city's architectural landmarks, the Auditorium Building designed by Dankmar Adler and Louis Sullivan.[59] Their collective

11

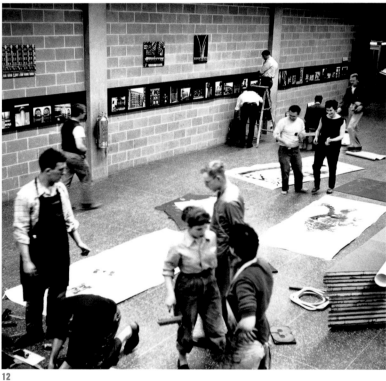

12

Fig. 11 Two-page spread
with a listing of photography
classes in the Institute of
Design's fall 1957 course
catalogue. See also pl. 126.

Fig. 12 Students installing a
second showing of the
Sullivan project photo-
graphs in Crown Hall, some-
time after 1955.

enthusiasm for the subject led Siskind to expand what had been a single assignment into a much broader project on Sullivan's architecture (see fig. 9). Initially, the students read books on Sullivan and compiled a list of his existing structures, but the project soon expanded beyond the domain of the photography department alone. Discussions on Sullivan's work were held with other ID faculty members – including Ray Pearson, from the Foundation Course program, and Konrad Wachsmann and Robert Tague, of the Shelter Design group. Small grants for equipment and materials were obtained from local architectural firms through the help of acting director Crombie Taylor.

The Sullivan project quickly took on a life of its own. A redesigned curriculum allowed the most interested upper-level students to work on the project over several semesters. Two of the most enthusiastic of these students, Len Gittleman and Richard Nickel, accompanied Siskind on two- or three-day trips to record Sullivan buildings throughout the Midwest. In 1954, a selection of this work was published in *Architectural Forum*, and an exhibition – documenting 75 of the 114 Sullivan buildings known to be still standing – was mounted by Nickel (fig. 12). To raise funds for the project, about six sets of a 100-print portfolio were made and sold (at $100 a set) to institutions such as Oberlin College and Yale University.[60] A book was seriously discussed, but never completed. Nonetheless, this project was of such importance to Nickel that he devoted the rest of his professional life to the cause of historic preservation and documentation.

In 1956 Callahan and Siskind described their undergraduate curriculum in "Learning Photography at the Institute of Design," an article cowritten for *Aperture*.[61] After a brief introduction outlining the basic areas of study at the ID, and the importance of a constructive interplay between them, the two described the objectives of the photography program clearly:

The general direction of the training is from the abstract, the impersonal, the exploratory to the personally expressive. And our aim can be stated: from within the framework of a broad professional education to open an individual way.

To this end, the four-year B.S. course was structured as follows:

1st Year: Foundation Course
2nd Year: Clarification of technique
3rd Year: Experiencing the photographic disciplines (traditions)
4th Year: Planned picture making: the feature, the project.

Callahan and Siskind described the Foundation Course as "largely traditional" in content. In addition to working in a wide range of two- and three-dimensional mediums, students studied photography half a day each week. The second year was devoted to a rigorous mastery of technique and a full exploration of the expressive potentials of photography's optical, mechanical, and chemical means. The third year was focused on Siskind's survey of the medium's basic traditions. As he explained:

Through a series of "problems" the student experiences the main streams, such as documentation, journalism, pictorialism, architecture, portraiture, illustrations, etc. Along with and parallel-

ing the actual work, an attempt is made to give the students perspective and enrich his understanding of what he is doing through historical study, examination and criticism of the "masters," and by picture analysis.

In the final year, students conceived and completed a project of their own.

These projects usually arise from an actual need and serve some social purpose. All the facets of the project – the interviewings and consultations and research, the outlining of a plan or acceptance of a script, the accommodation of "art" and objectivity to necessity and urgency – all these and many others may be, with proper guidance, a true testing ground of the young photographer's knowledge and spirit.[62]

This program obviously served a serious vocational role, training students for careers in a wide variety of disciplines, from photojournalism to commercial photography. It was just as clear, however, that the program was also about self-exploration: the process of coming to know – and to express – oneself *through* photography. It was understood that mastery of the medium was a necessary but not sufficient condition for success; it represented the beginning, not the end, of the problem of meaning. The goal, as Callahan and Siskind so concisely stated, was "to open an individual way": to encourage each student to recognize and develop what already lay within.

The graduate program in the 1950s

From a pedagogical point of view, this process of self-exploration came to its most precise focus at the graduate level. While the M.S. program served a critical educational function, however, it grew only gradually in size. In fact, through Callahan's departure in mid-1961, a total of only fourteen M.S. degrees in photography were awarded. These were given to Jordan Bernstein, Marvin Newman, and Floyd Dunphey (all 1952), Robert Fine (1954), Leon Lewandowski (1955), Joyce Lemensdorf and Richard Nickel (both 1957), Ray K. Metzker (1959), Kenneth Josephson (1960), and Vernon Cheek, Robert Hilvers, Joseph D. Jachna, George Nan, and Charles Swedlund (all 1961). Joseph Sterling received his M.S. a year later. The real boom in graduate education began in the late 1960s. While a total of seventeen advanced degrees in photography were granted by the ID between 1952 and 1965, eighty-nine more were awarded in the following ten years, 1966 to 1975.

Under Callahan and Siskind, the graduate curriculum was relatively simple. It required a basic understanding of the ID's teaching philosophy and the completion of a thesis project. Undergraduates who stayed on at the ID for the advanced degree generally began work on the thesis immediately. Students from other institutions were required first to take – or at least absorb the lessons of – the lower-level ID courses they were determined to be lacking. Ray Metzker, for example, received a B.A. in studio arts from Beloit College in 1953, before serving a stint in the army. His experience in photography was largely journalistic in nature. In his first year in the ID graduate program, 1956–57, Metzker aided Siskind with a small class of juniors and seniors. He also met with

Callahan, who guided him through the Foundation Course problems. With this behind him, Metzker turned his full attention to the thesis work in his second year.

Once engaged in their theses, students met with Callahan and Siskind on an informal basis every week or two. New pictures were presented, and criticism and encouragement were provided. By this stage, of course, each student was largely on his or her own. The subject or approach of the thesis had been determined; it was up to them to do the work. Joseph Jachna still recalls, with some emotion, the department's high expectations and the magnitude of his resulting effort. From thousands of original negatives he made 525 work prints. He carefully edited these to a final total of eighty, which were printed to the highest standard he could achieve and gathered in a handcrafted presentation box. As he gave this to Siskind for final approval, he remembers thinking, "I wasn't showing him a draft. It was either sink or swim. You're looking at eighty prints, a paper, in a box marked 'done.'"[63]

Inevitably, the thesis projects reflected both the educational principles of the ID and the individuality of each student. There is an undeniable "ID look" to much of this work. Many of the theses, in fact, were devoted to extended investigations of one or more of the basic problems assigned in the undergraduate curriculum. Each of these investigations, however, was given a distinctly individual inflection; no two bodies of work were the same. Marvin Newman's thesis, for example, submitted in February 1952, was titled "A Creative Analysis of the Series Form in Still Photography" (fig. 13). As outlined in his preface, Newman sought to "explore the variety of ways in which a group of photographs may be connected or related so as to constitute a series, and to formulate the principles that may apply to photographic series in general."[64] To this end, he presented twenty-two pictorial groups – generally of five or six pictures each – to illustrate variations on four basic syntactical principles: form, time, motion, and content. His approach was both varied and inventive. Time, for instance, was analyzed in five discrete groups of pictures: two under the subheading "sequential" ("1. MacArthur's Parade; 2. Three Years of Work [each picture represents six months of photographic development"]); and three under the sub-heading "specific" ("1. Eating, Lincoln Park; 2. Snowstorm, Near North Side; 3. Halloween, Settlement House"). His most abstract work – recording the shadows of pedestrians on Michigan Avenue – formed the final section of the thesis, in the category "Content: Idea."

While enormously sophisticated in visual terms, Newman's thesis bore little resemblance to what the IIT administration was used to seeing. While they understood theses in engineering, for example, photography was something entirely new. As a result, the school demanded a precise statement of purpose and methodology, for which Newman turned to Siskind for help. Despite this assistance, IIT continued quibbling over matters of format right up to a month before his scheduled graduation. As Newman has recalled:

The thing was finished, and everything they asked for, we had done. And yet, they started to say they wanted more of this and more of that. That's when the ID people really put their foot down, *and said that's enough. [IIT] just didn't want to give out the degree; it seems obvious. They were trying to hold on to whatever they thought were the boundaries of the Master of Science.*[65]

In the school's defense, the idea of a photographic thesis *was* a rather radical concept in 1952 – not only in Chicago, but in American higher education in general. The ID graduate program had no obvious precedent to follow; it was creating one.

In subsequent years, the thesis process became smoother – or at least more clearly codified – and much outstanding work was completed. In 1957 Richard Nickel received his M.S. with a 232-page thesis titled "A Photographic Documentation of the Architecture of Adler & Sullivan." This impressive achievement – intended as a model for a book he never lived to publish – contained detailed records of every Louis Sullivan structure, his own thoughts on the buildings, and notes accompanying his superb photographs.[66]

Ray Metzker submitted his thesis, "My Camera and I in the Loop," in 1959. On one level, this series of 119 prints had a very clear scope: Metzker limited himself to the area of downtown Chicago encircled by the tracks of the elevated railway. But Metzker brought to this modest geographical area an expansive expressive ambition.

In the winter/spring of 1957–58, I read Thomas Wolfe's Look Homeward Angel *and then* You Can't Go Home Again. *It was very potent for me. In "The Loop," I shared with Wolfe trying to describe … the multitude of events. He could see the drama everywhere, and that appealed to me. "The Loop" was a commitment to something large. I wanted something complex: night/day, people/building, traffic/silence. I wasn't interested in photographing my toes in forty different ways.*[67]

At the same time, however, Metzker's concerns were highly formal. He used the Loop as a way of exploring photography itself – the visual possibilities of blur, focus, vantage point, framing, and lighting that would provide the expressive vocabulary for the rest of his prolific and distinguished career.[68]

Kenneth Josephson's thesis, "An Exploration of the Multiple Image," was submitted in June 1960. In his introduction, Josephson stated:

Multiple images are common to all two-dimensional art media and related to them are the effects in music, where tones are blended (harmonic polyphony), and literature, in which thoughts and images are often combined (stream of consciousness). Thus music and literature were idea sources for this work as were the following: the photography of Harry Callahan; the history of photography; the works from all visual media; observations of the external world.[69]

Josephson's forty-nine images reflect the visual possibilities of four basic approaches: changes in camera position, focus, subject, and the combination of these three. While his project owed a considerable (and acknowledged) debt to Callahan, Josephson explored genuinely new territory. For example, his optical manipulations – using two exposures, in and out of focus, to record a single subject – created effects not explored by his mentor. Ultimately, this work taught Josephson how pictures may, in effect, be taken

apart and put together – a lesson that has informed all his subsequent work.

A similar project of deconstruction and reconstruction is evident in Charles Swedlund's 1961 thesis, "The Search for Form: Studies of the Human Figure." Working primarily in the studio, Swedlund fractured, multiplied, and abstracted the figure through a variety of techniques: multiple exposure, blur, manipulations of focus, and the use of high-contrast film. The resulting pictures provide a comprehensive inventory of the techniques of photographic seeing, while suggesting something more personal: a protean sense of energy and transformation.

Joseph Jachna's 1961 thesis, "Water," was the result of a deeply intuitive process of exploration. Jachna's meditative pictures of the surfaces of lakes and streams are at once technically "straight" and highly abstract. They are moody and dark, with the "objective" world reduced to shimmering, spectral reflections. The poetic impulse behind these pictures is suggested in a haiku that Jachna treasured at the time he was doing this work:

Clear colored stones
Are vibrating in the brook bed …
Or the water is.[70]

For Jachna, water was at once the simplest of things and the most mysterious: "Water – In nature it is the link between the real and the unreal. It's a tease. It holds secrets." As Moholy would have appreciated, Jachna found water to be the ultimate light modulator, creating effects that could be almost invisibly ephemeral or "like fire." Ultimately, in the mercurial ebb and flow of liquid surfaces, Jachna found a compelling metaphor for the transient nature of existence itself.[71]

Finally, the subjectivity of Joseph Sterling's 1962 thesis, "The Age of Adolescence," is filtered through a more traditional social-documentary approach. Fascinated by the complex problems of coming-of-age, Sterling photographed teenagers outside school, at the beach, in the park, and hanging around on front stoops. He focused on the rituals of fashion and the dynamics of the group. At its heart, this work is fundamentally psychological. Sterling explored the characteristic teenage tension between bravado and insecurity, the awkward, dynamic process of forming a sense of self.

The end of an era

The ID continued to change, of course, during the time these and so many other talented students were in residence (fig. 14). With the freedom provided by his Graham Foundation grant, Callahan went to France for the 1957–58 academic year. As a temporary replacement, Siskind hired the brilliant and enigmatic artist Frederick Sommer. Both a meticulous photographic craftsman and a kind of philosophical mystic, Sommer brought an entirely new voice to the ID photography program. He taught both studio photography and a design course. One of his assignments in the latter was to "design the perfect insect."[72] In his photography classes, Sommer taught fine technique and – something harder to describe – a more sophisticated sense of pictorial coherence and balance. Joseph Jachna recently described the quality of Sommer's instruction:

For me, music was the metaphor … getting [the tones of the print] at just the right pitch, like music that sounds just right. And that's where Fred Sommer contributed a lot, because he talked that way. We had some difficulty understanding him, but ultimately he was trying to get to something that we really all wanted to get to, and did in our own way. One thing he did more than Harry or Aaron was to talk about the frame very specifically, where that frameline was and how everything [within the image related to] the edge of the frame…. That's [an important] concept in itself, to think that one part affects the other.[73]

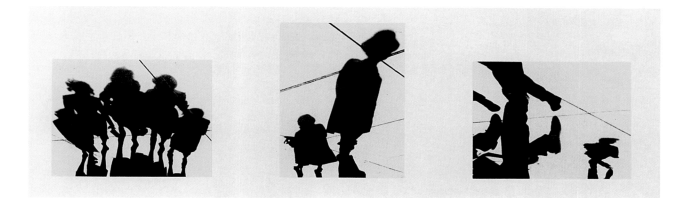

Fig. 13 Page from Marvin Newman's master's thesis, "A Creative Analysis of the Series Form in Still Photography," 1952. See also pls. 102, 103.

During his time in Chicago, Sommer made relatively few photographs; instead, he spent his free time reading and cooking.

Several important publications that appeared between 1957 and 1961 showed what the school was capable of producing. The first of these, *Student Independent 2*, was designed and produced by ID students with the support and supervision of Siskind. This second issue, devoted to photography, was laboriously printed by a student group led by Ray Metzker. Despite working on a primitive proofing press, with stock discarded from local paper houses, their result was so impressive that it led to the official founding of the Press of the Institute of Design, codirected by Siskind and Gordon Martin, an independent printer and full-time faculty member.[74] Siskind himself spent much of 1959 engaged in the editing and production of his Horizon Press monograph. Aided by Art Sinsabaugh, then employed in the printing industry, Siskind was on press for two weeks during the early summer. In his absence, graduate student Kenneth Josephson handled Siskind's classes. In 1961 Callahan's first monograph, *The Multiple Image*, was issued under the imprint of the new ID press.

In that same year, *Aperture* published an issue titled "Five Photography Students from the Institute of Design, Illinois Institute of Technology" (fig. 15). This issue of the journal was an all-ID production: designed by Edward Bedno, of the design faculty, it included an introduction by Arthur Siegel, and portfolios of work (all drawn from their thesis projects) by Josephson, Sterling, Swedlund, Metzker, and Jachna. Each portfolio included a statement of purpose and five to eight pages of high-quality reproductions. The result was remarkably elegant and cohesive – a major tribute to both the photographers included and to the ID program as a whole.

The experimental vitality of the photographs was underscored by Siegel's breathless introduction, written in the Beat style of Jack Kerouac. His essay began with a free-form poem:

Photography Is
science
system
process
technique
tool
documentation
pages from life
creative treatment of actuality
archives of memory
mirrors of memory
extension of the eye
enlargement of vision
hobby
business
profession
means of expression
way of life
poor man's Rorschach
language
art
etc
etc
etc[75]

The manic heterogeneity of this inventory was a reflection of Siegel himself, as well as his way of paying tribute to Moholy's original, utopian vision. It was also, one suspects, an ironic commentary on the school's relatively orthodox status – stable, accredited, and bureaucratic – a decade and a half after its founder's death.

It was also in 1961 that Harry Callahan resigned to take a position at the Rhode Island School of Design. Recruited by his friend

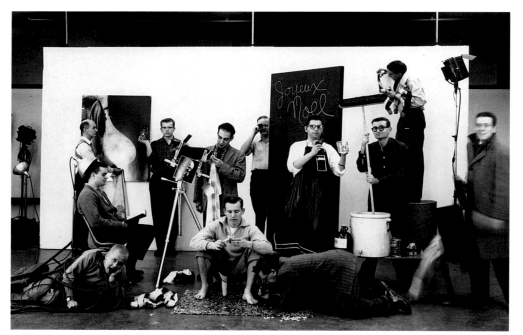

Fig. 14 Christmas card for Harry Callahan, from ID photography department teachers and students, inside Crown Hall at IIT, 1957. From left to right, first row: Ray Metzker, Joseph Jachna, Aaron Siskind; second row: Howard Levant, Paul Zakoian, Bob Tanner, Carl Flarsheim, Art Sinsabaugh; third row: Glen Allen, Don Stascall, Frederick Sommer, and Joseph Sterling, with a photograph of Harry Callahan on the tripod.

David Strout, then a dean at RISD, Callahan did not agonize over the decision. RISD offered him a considerably higher salary than he was receiving at the ID, as well as the autonomy to set up a program from scratch. While he certainly saw virtues in the ID program in 1961, Callahan was tired of the squabbling and the politics. His departure brought a pivotal period in the school's history to a close.

Conclusion

Memory is by nature selective. It is tempting – and entirely human – for the remembered past to assume a distinctly rose-tinted hue. Memory filters, shapes, and simplifies the past – creating something altogether new, an amalgam of fact and wish. In seeking to describe a program that has already taken on the aura of legend, we run the risk of confirming myths rather than dispelling them. Certainly, the period in question had its share of unhappiness and failure, and of simple, dull mediocrity. Every period does. Moreover, there cannot be a single, definitive history of this program: everyone associated with it has his or her own story to tell. Myths and interpretive perspectives aside, however, it seems clear that the fifteen years between 1946 and 1961 were something special at the ID. More noteworthy photographers came out of this program than from any comparable institution. The influence of these graduates on subsequent generations of photographers has been profound. Decades later, a remarkable percentage of the photography field still carries some ID blood in its veins.

The ID was both a magnet and an accelerator. It attracted many of "the best and the brightest" at a critical time in the growth of the field, and it motivated students to high levels of achievement. The ID provided an environment in which photography was *valued* in a deep and abiding way. This was not simply a matter of making art or of earning a living. It was, in the final analysis, a matter *of* living – of finding one's own kind of meaning, or at least struggling to do so, through photography. For students such as Joseph Jachna, the lessons learned at the ID were all-encompassing: "I was learning photography as art, but I was also learning how to be a person in the world: a man, a husband, a father, a teacher, all this stuff together."[76] "All this stuff together" mattered enormously, and photography stood at the heart of this process as both catalyst and compass.

Long after leaving the place, Harry Callahan said: "I think that going to the Institute of Design in Chicago saved my life."[77] He was not alone.

Fig. 15 *Aperture* 9:2 (1961) devoted a separate issue to five students at the Institute of Design, with a cover photograph by Joseph Sterling (see pl. 143).

55

55 Harry Callahan, *Untitled (Lakefront Fence)*, c. 1947, cat. 20
56 Harry Callahan, *Church Window*, 1940s, cat. 18
57 Harry Callahan, *Light Abstraction*, 1946, cat. 19

56

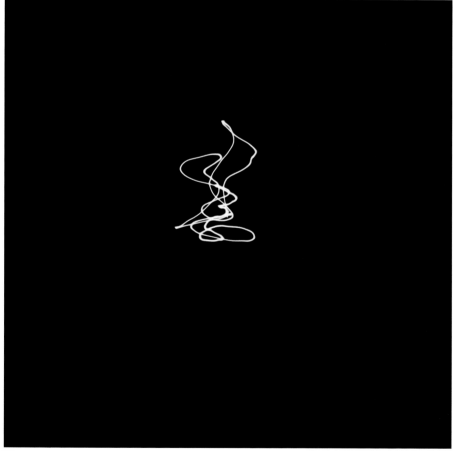

57

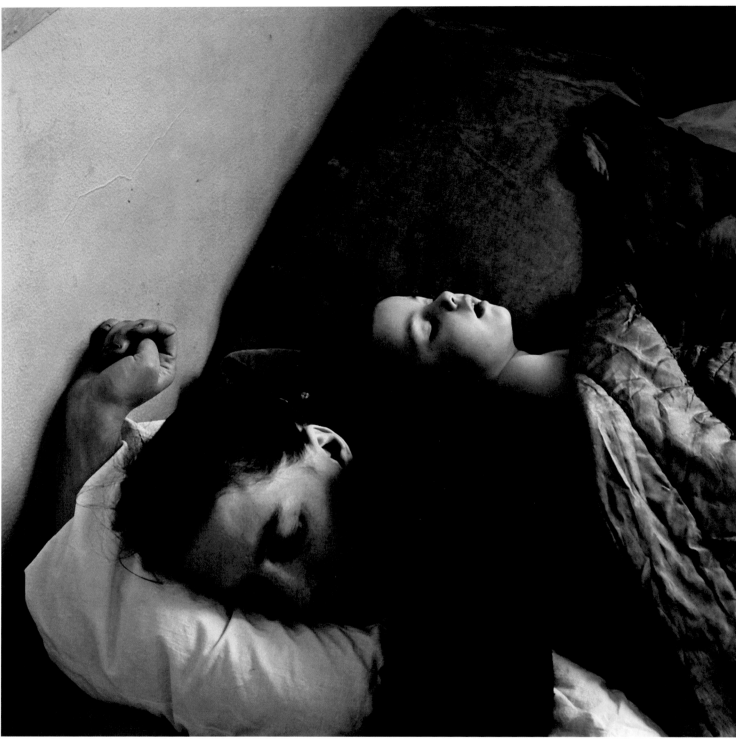

58 Harry Callahan, *Eleanor and Barbara, Chicago*, c. 1955, cat. 33
59 Harry Callahan, *Eleanor*, 1948, cat. 26 60 Harry Callahan, *Untitled*,
1953, cat. 32

59

60

61

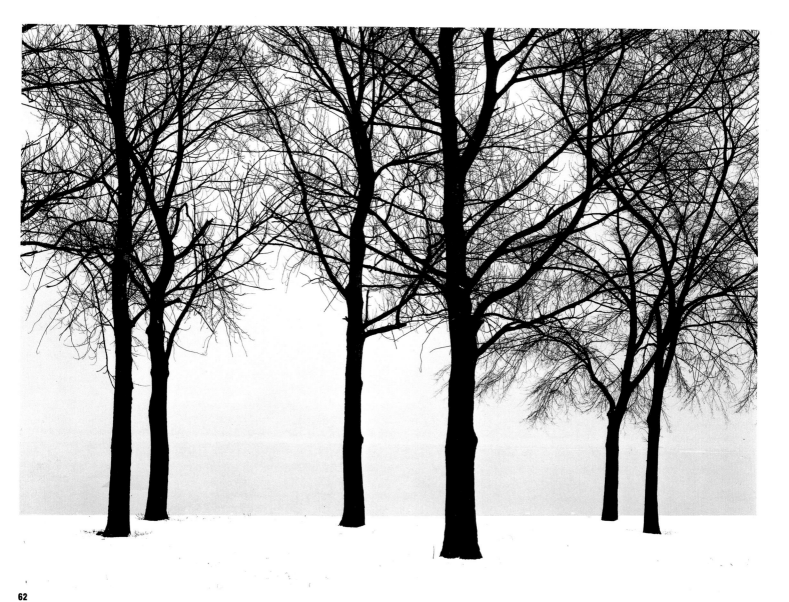

62

61 Harry Callahan, *Weeds against Sky*, c. 1948, cat. 24
62 Harry Callahan, *Chicago*, 1950, cat. 27

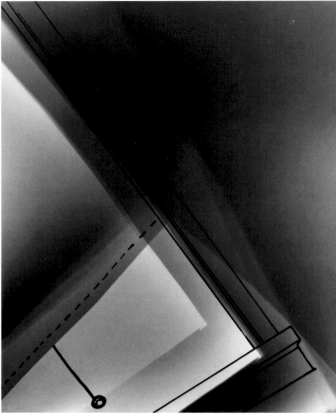

63

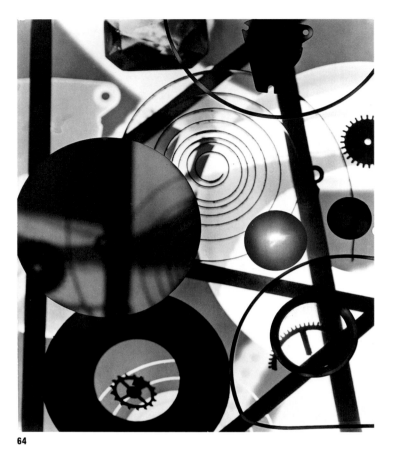

64

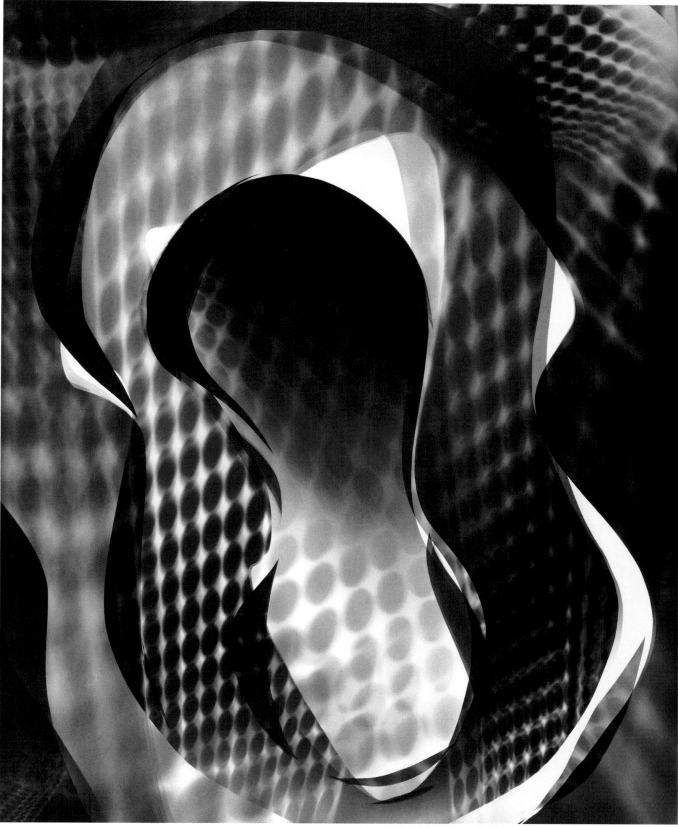

65

63 Lois Field, *Untitled*, c. 1948, cat. 54 **64** Bernard Siegel, *Solargram 10*, 1949/50, cat. 165 **65** Arthur Siegel, *Photogram*, 1948, cat. 157

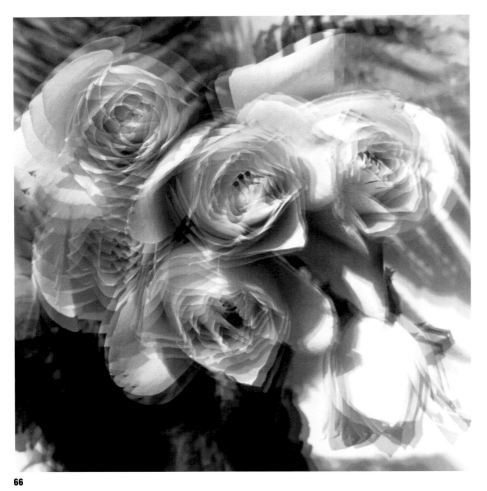

66

67

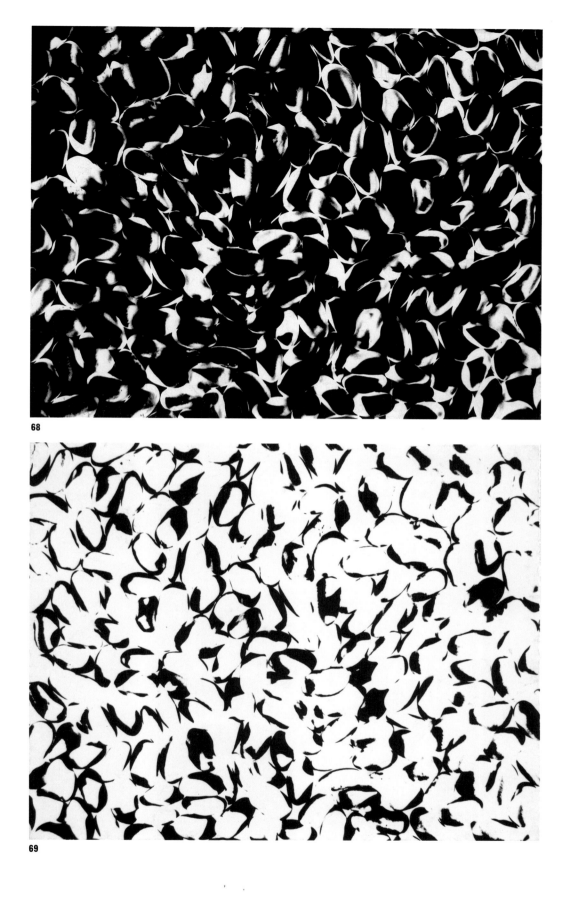

68

69

66, 67 Arthur Siegel, *Untitled*, 1955, cat. 162, 163
68, 69 Lyle Mayer, *Untitled*, 1950s, cat. 115, 116

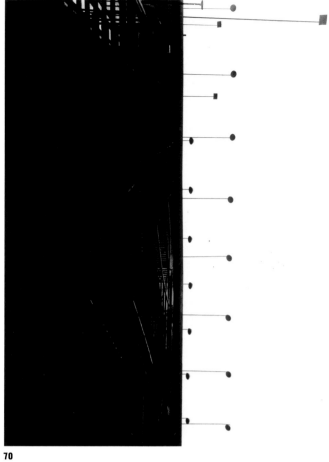

70

71

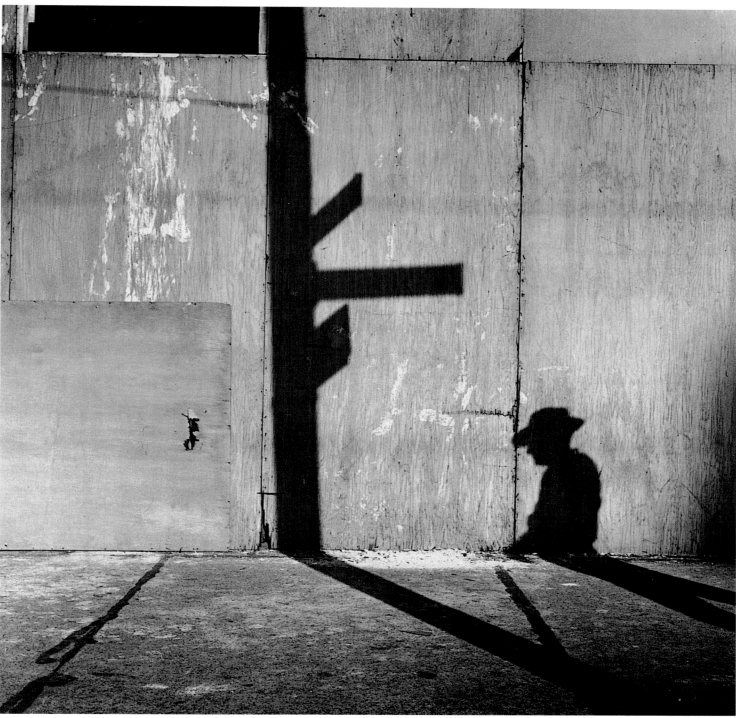

72

70 Ferenc Berko, *Billboard Lights, New York, USA*, 1950, cat. 7
71 Paul Hassel, *Chicago*, 1950, cat. 61 **72** Yasuhiro Ishimoto, *#4, Chicago*, 1950, cat. 69

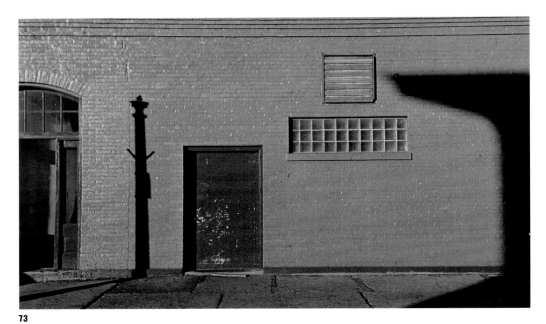

73

74

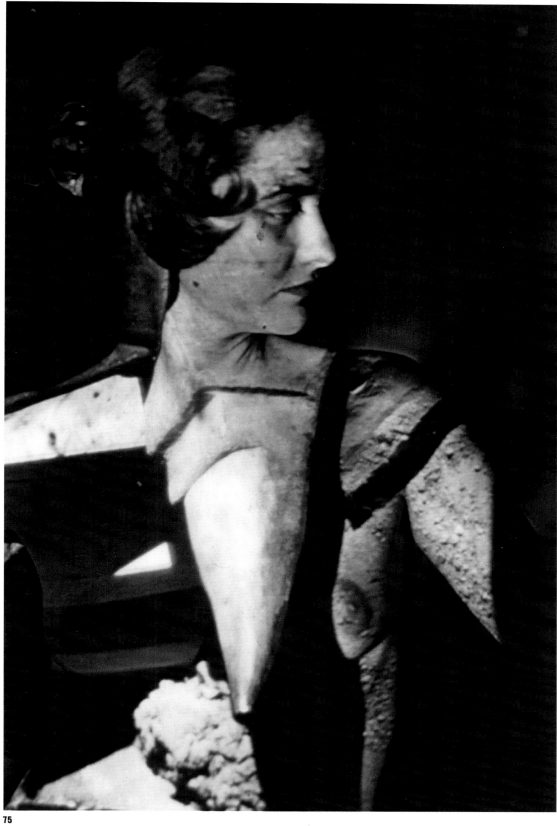

75

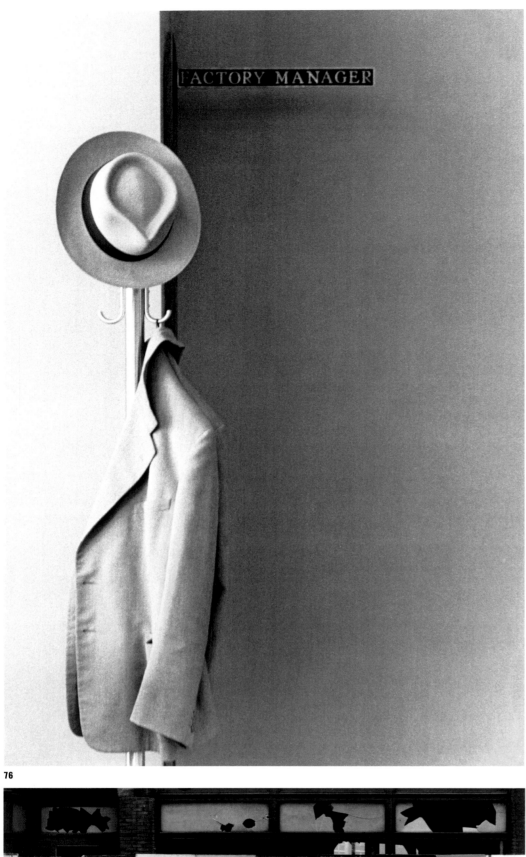

76

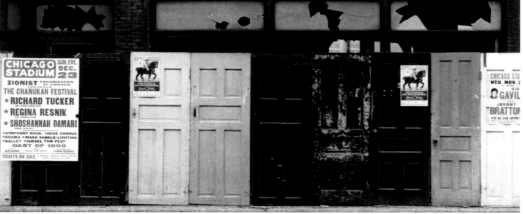

77

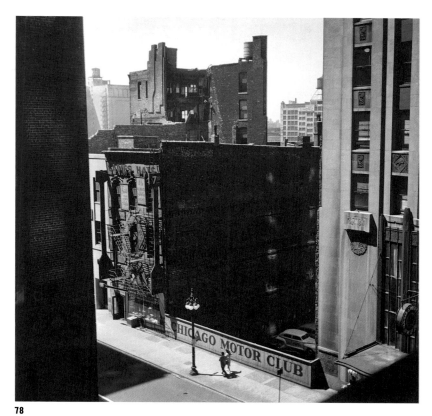

78

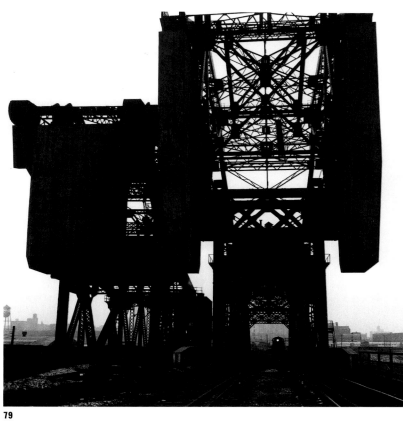

79

76 James P. Blair, *Columbus, Ohio*, 1956, cat. 10 **77** Lyle Mayer, *Untitled*, 1951, cat. 117 **78** Gordon Coster, *Chicago Motor Club*, c. 1950, cat. 39 **79** Robert Stiegler, *Bridge*, 1959, cat. 197

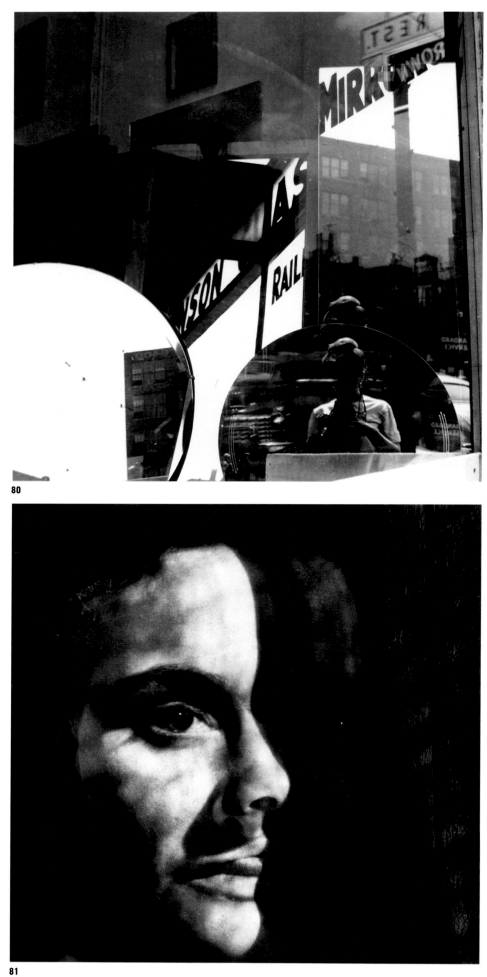

80

81

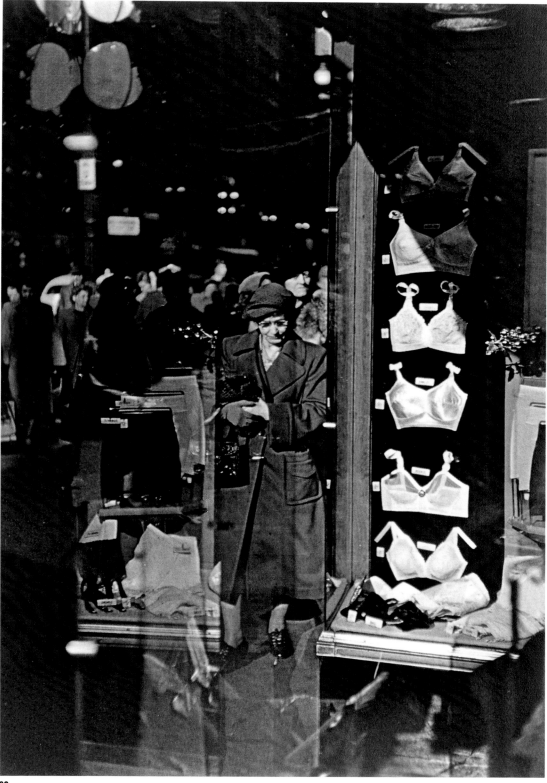

82

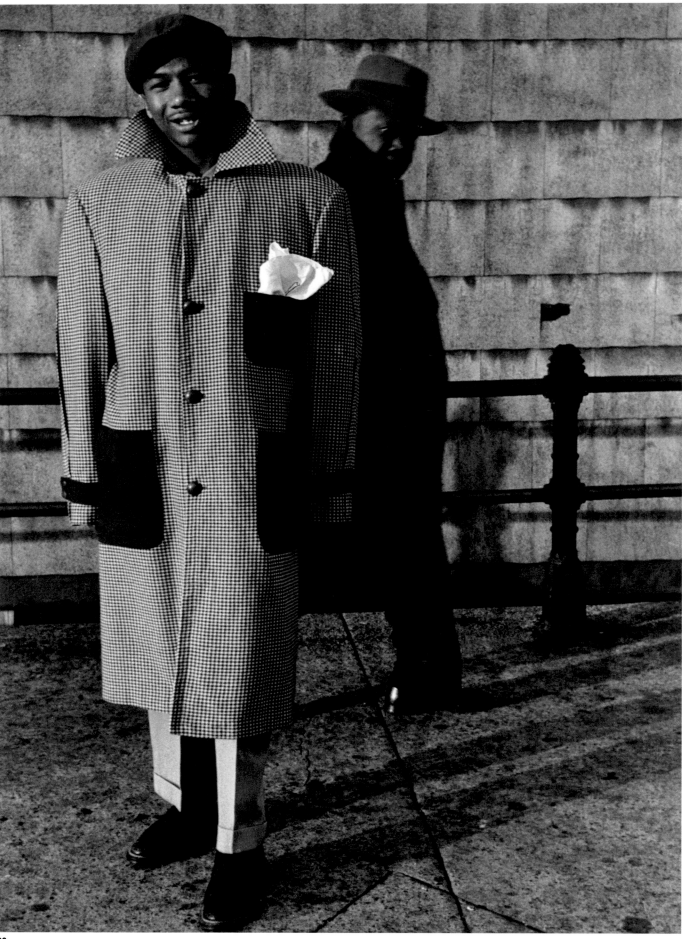

83

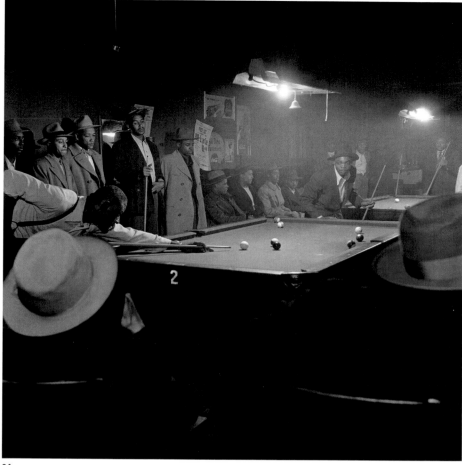

84

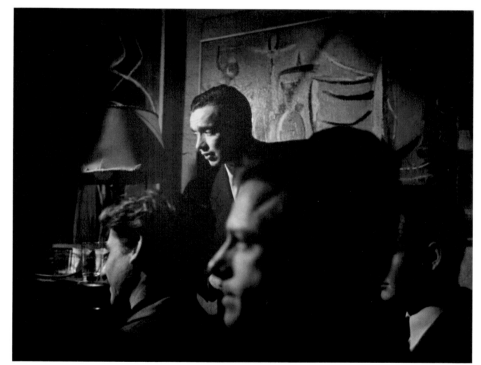

85

83 Marvin E. Newman, *Untitled, Chicago*, 1950, cat. 138
84 Wayne Miller, *Afternoon Game at Table 2*, 1946/48, cat. 126
85 Wayne Miller, *Untitled*, 1949, cat. 128

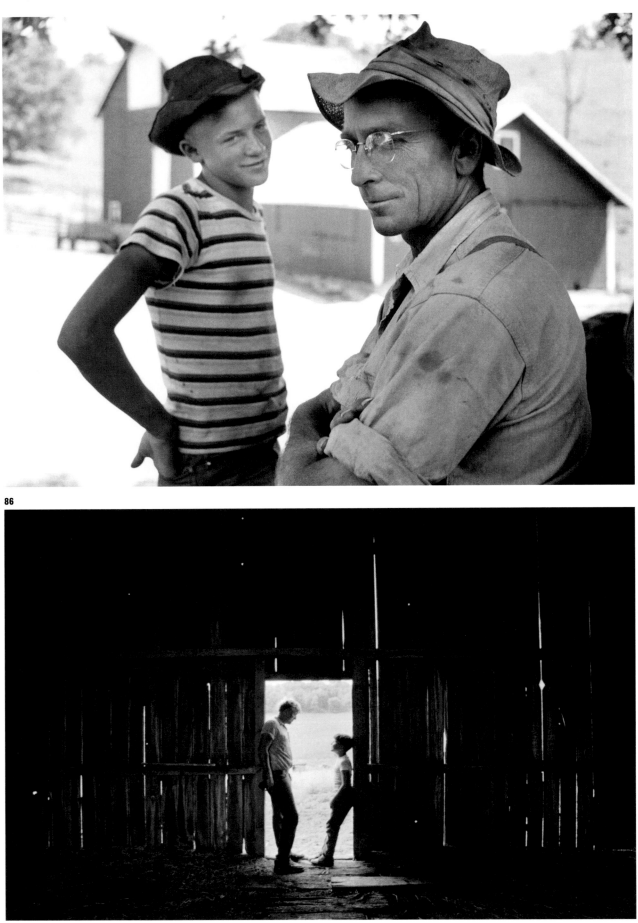

86

87

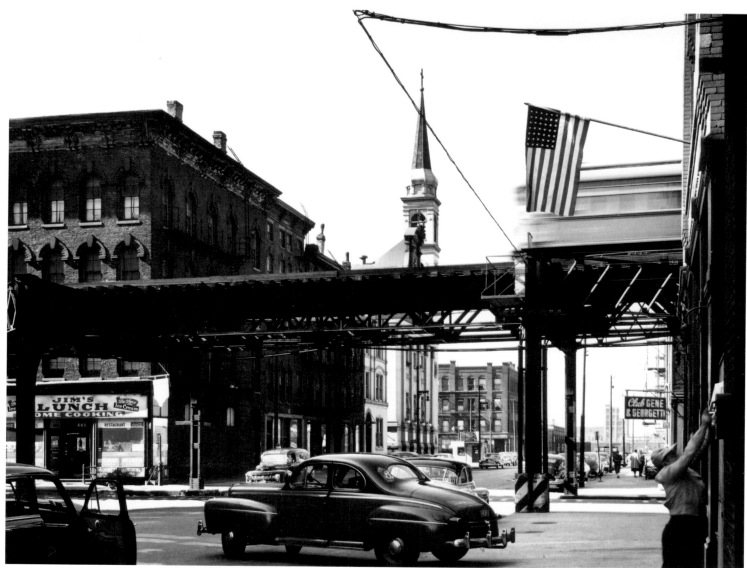

88

86 Archie Lieberman, *Bill Hammer Jr. and Bill Hammer Sr., Jo Daviess County, Illinois*, 1955, cat. 111 87 Archie Lieberman, *Bill Hammer Jr. and his son Jim, Jo Daviess County, Illinois*, 1971, cat. 112 88 Harold Allen, *Illinois and Franklin Streets, Chicago*, 1950, cat. 1

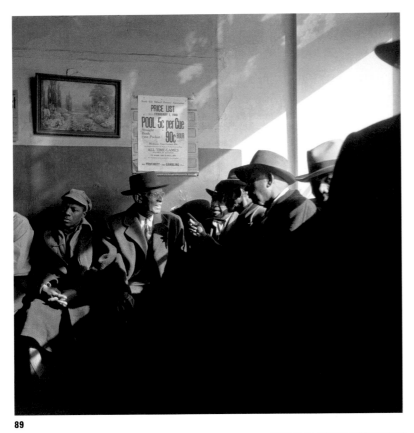

89

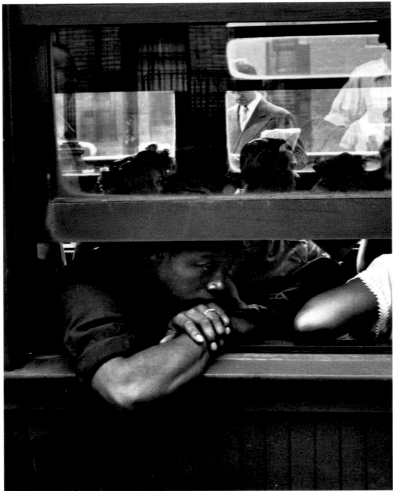

90

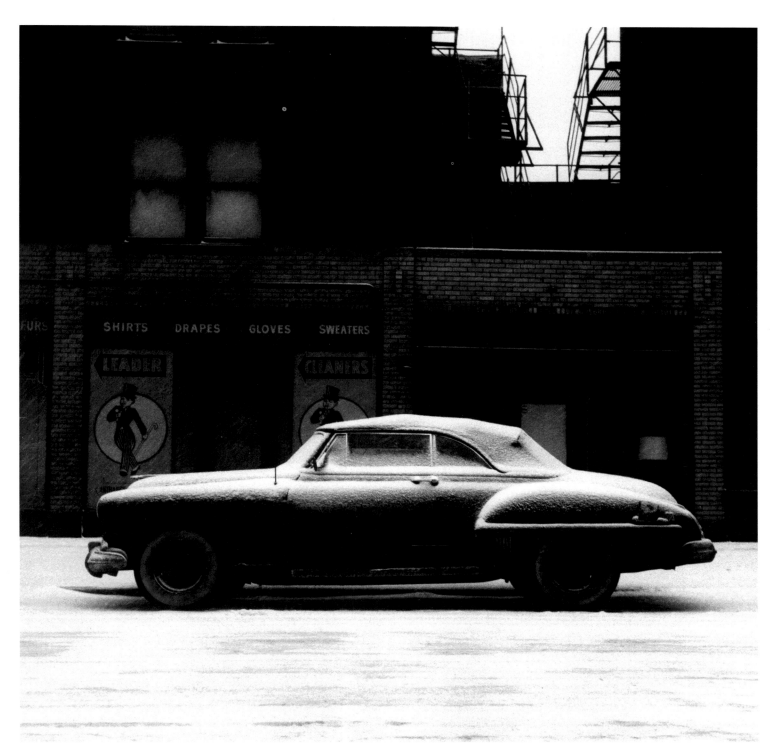

91

89 Wayne Miller, *Keeping Warm, Pool Hall*, 1946/48, cat. 127
90 Marvin E. Newman, *Third Avenue El*, 1949, cat. 137
91 Yasuhiro Ishimoto, *Untitled*, 1949/50, cat. 66

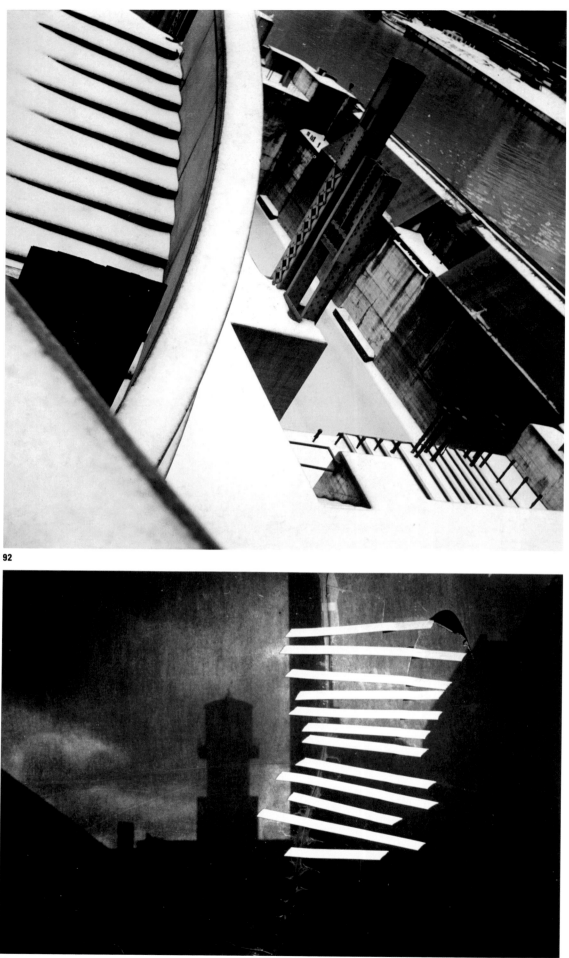

92

93

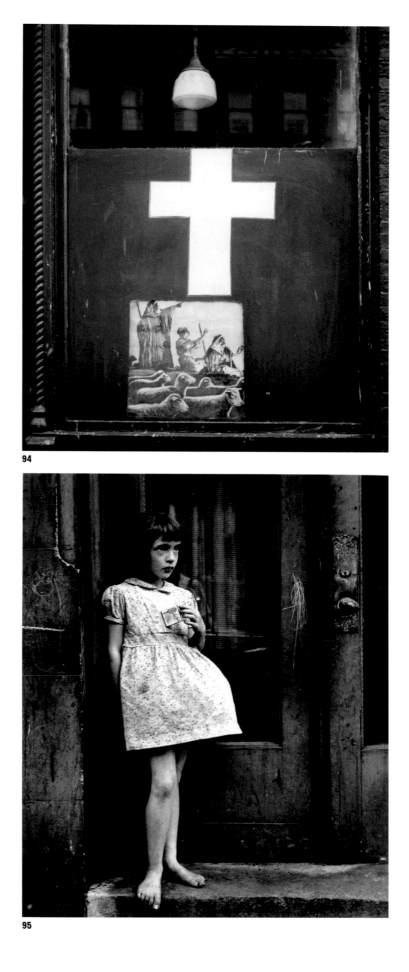

94

95

92 Charles Lichtenstein, *Untitled*, c. 1947, cat. 110 **93** Yasuhiro Ishimoto, *#75, Chicago*, 1959/61, cat. 70 **94** Ray Martin, *Untitled*, 1950s, cat. 114 **95** Yasuhiro Ishimoto, *Untitled*, 1948/52, cat. 65

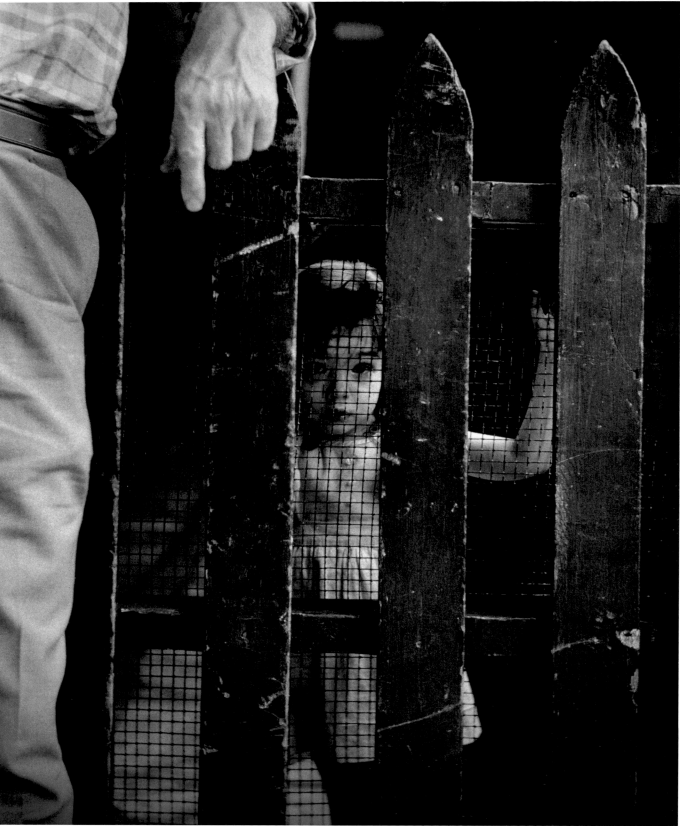

96

96 Yasuhiro Ishimoto, *Untitled*, 1948/52, cat. 64 **97** Homer
Page, *Untitled*, c. 1947, cat. 144 **98** Homer Page, *Untitled*, c. 1947,
cat. 145

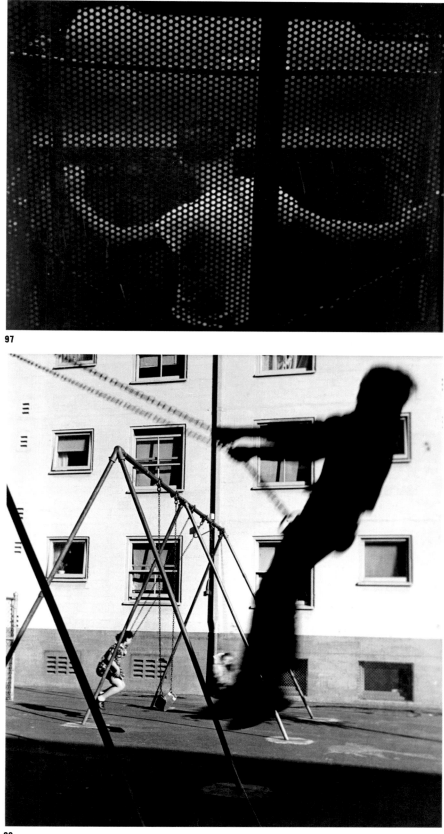

97

98

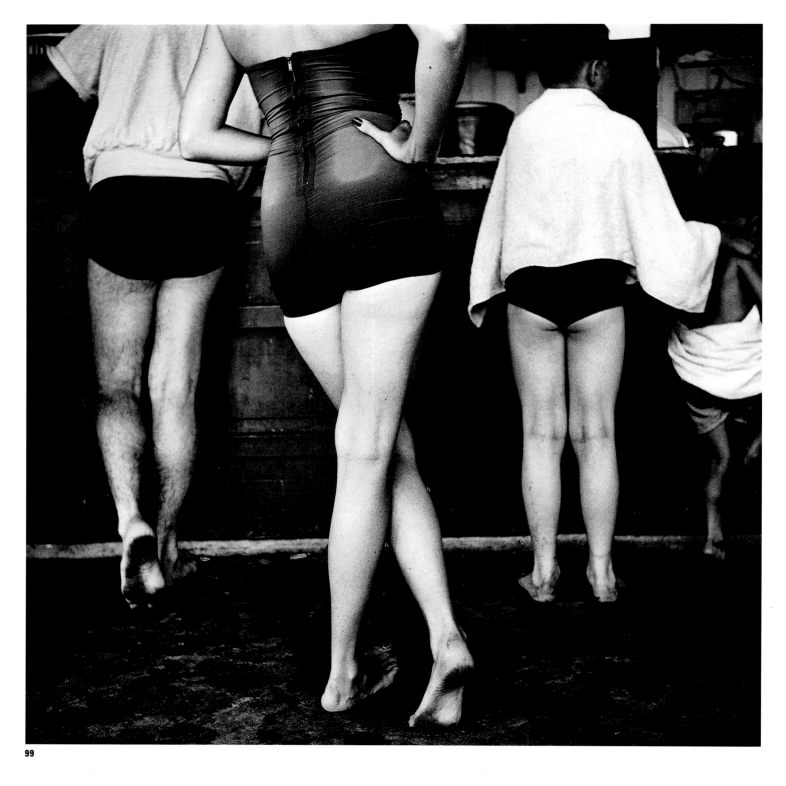

99

99 Yasuhiro Ishimoto, *Untitled*, 1949/50, cat. 68 **100** Yasuhiro
Ishimoto, *Untitled*, 1949/50, cat. 67 **101** Dina Woelffer, *Chicago*,
1947, cat. 208

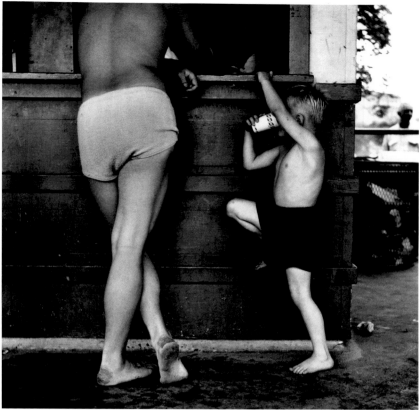

100

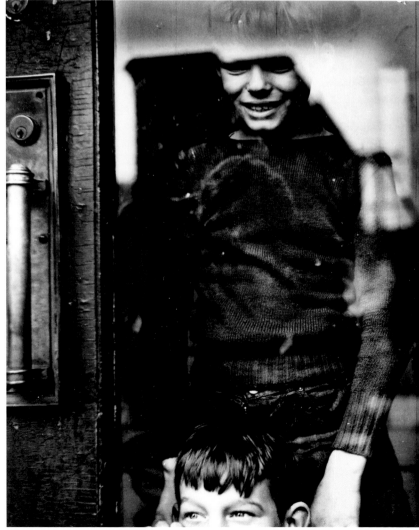

101

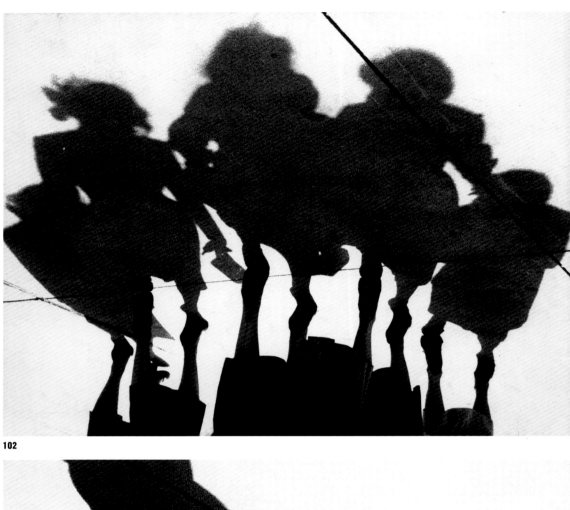

102

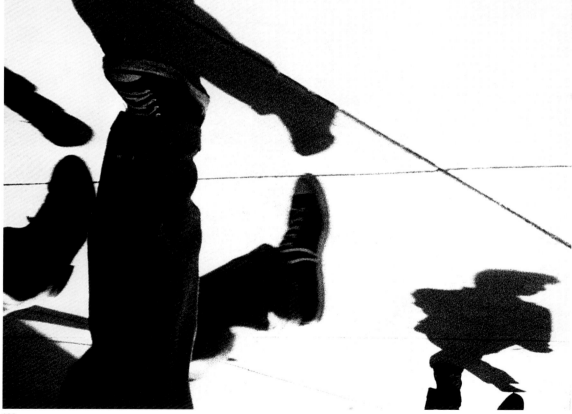

103

102 Marvin E. Newman, *Chicago*, 1951, cat. 139 **103** Marvin E. Newman, *Untitled*, 1951, cat. 140 **104** Harry Callahan, *Portrait of Aaron Siskind*, 1951, cat. 31

104

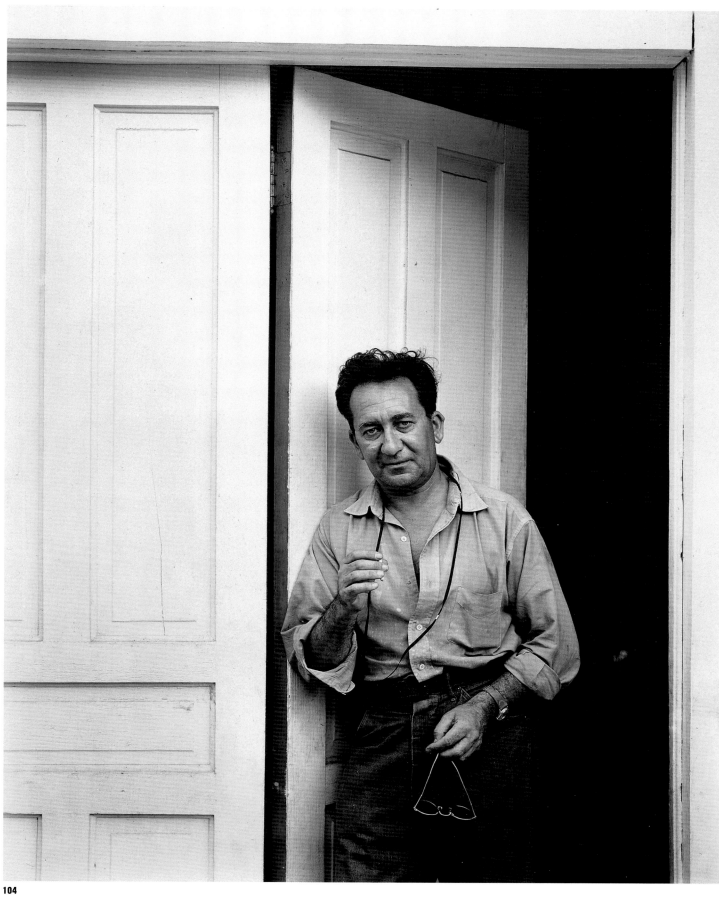

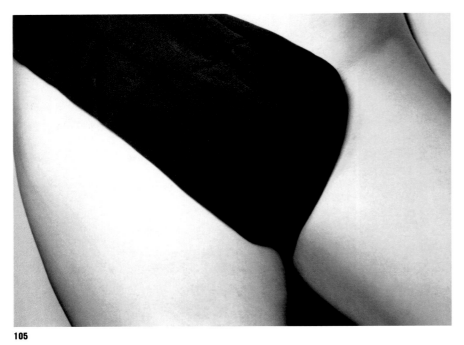

105

106

107

108

105 Harry Callahan, *Untitled (Eleanor)*, c. 1947, cat. 21 **106**
Harry Callahan, *Untitled (Eleanor)*, c. 1947, cat. 22 **107** Harry
Callahan, *Untitled (Eleanor)*, c. 1947, cat. 23 **108** Paul Hassel,
Harry Callahan, c. 1950, cat. 60

109

109 Harry Callahan, *Chicago*, 1950, cat. 29 **110** Harry Callahan, *Chicago*, 1950, cat. 30 **111** Harry Callahan, *Chicago*, 1950, cat. 28

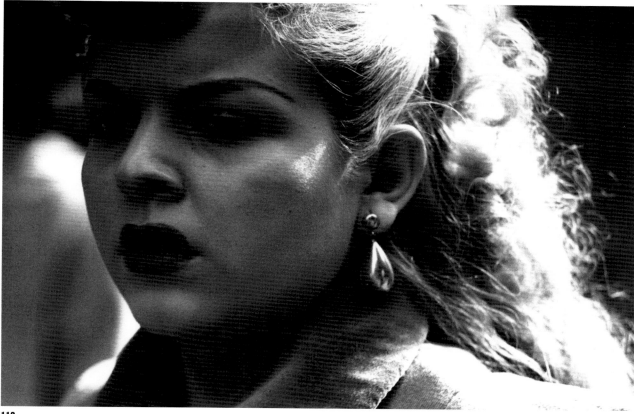

110

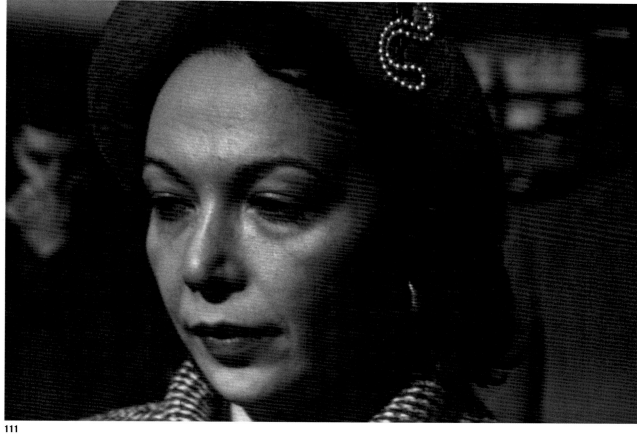

111

112 Aaron Siskind, *Chicago 224*, 1953, cat. 176 **113** Aaron
Siskind, *Chicago 30*, 1953, cat. 175 **114** Aaron Siskind,
Kentucky K7, 1951, cat. 173 **115** Aaron Siskind, *Tenayuca
(T-2'55/M4)*, 1955, cat. 183

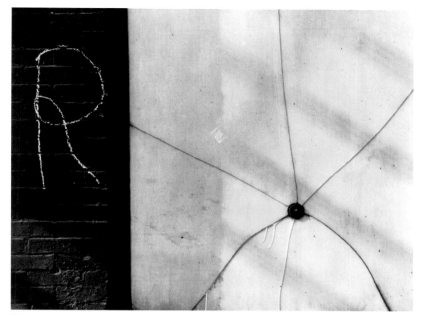

113

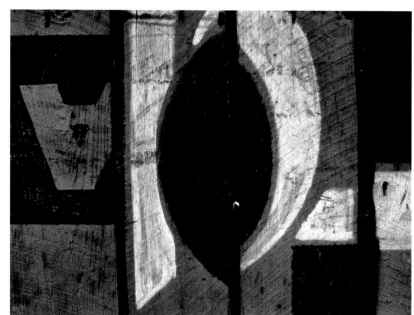

114

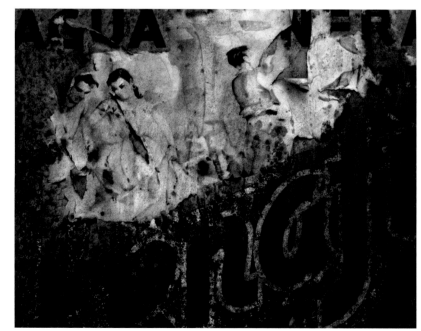

115

116

117

118

119

120

120 Aaron Siskind, *Martha's Vineyard (UR 127B)*, 1954, cat. 182
121 Aaron Siskind, *Pleasures and Terrors of Levitation 491*, 1954,
cat. 181 **122** Aaron Siskind, *Pleasures and Terrors of Levitation*
474, 1954, cat. 180

121

122

123 Richard Nickel, *Untitled (Demolition of Proscenium Arch,
Garrick Theater)*, 1961, cat. 143 **124** Richard Nickel, *Untitled
(Carson Pirie Scott and Co. Store, detail of ornament on lower
stories)*, c. 1950, cat. 141 **125** Richard Nickel, *Untitled (Carson
Pirie Scott and Co. Store)*, c. 1955, cat. 142

124

125

126

127

128

126 Aaron Siskind, *Walker Warehouse*, 1953, cat. 178 **127**
Aaron Siskind, *Chicago*, 1953/54, cat. 179 **128** Len Gittleman,
Untitled (Carson's Facade), c. 1953, cat. 55 **129** Aaron Siskind,
Walker Warehouse, 1953, cat. 177

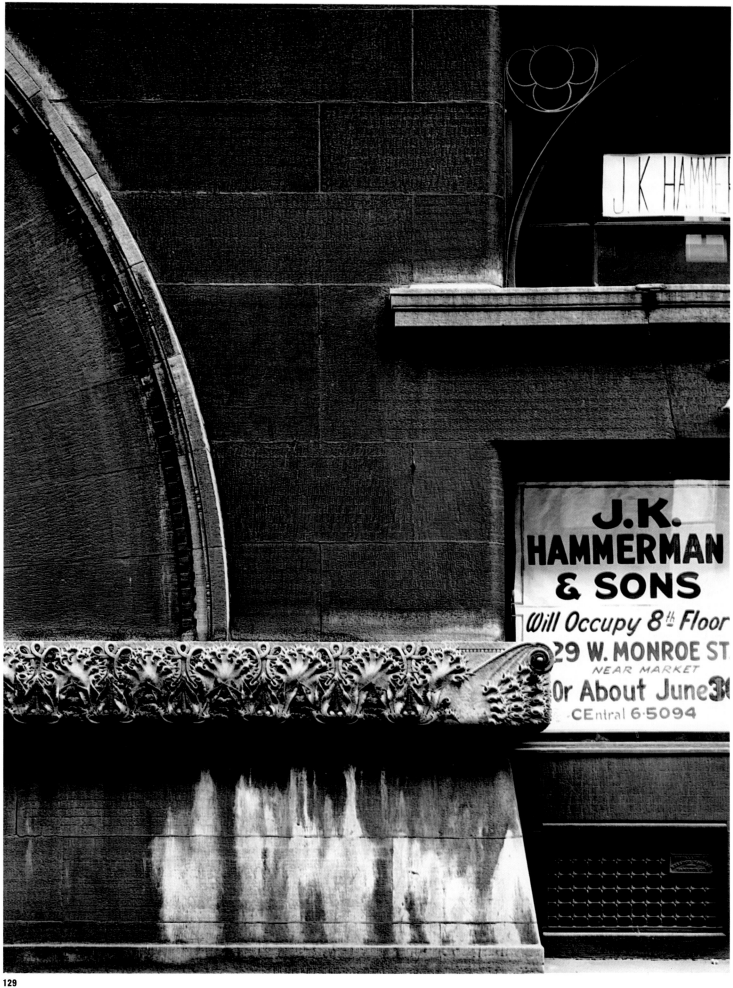

129

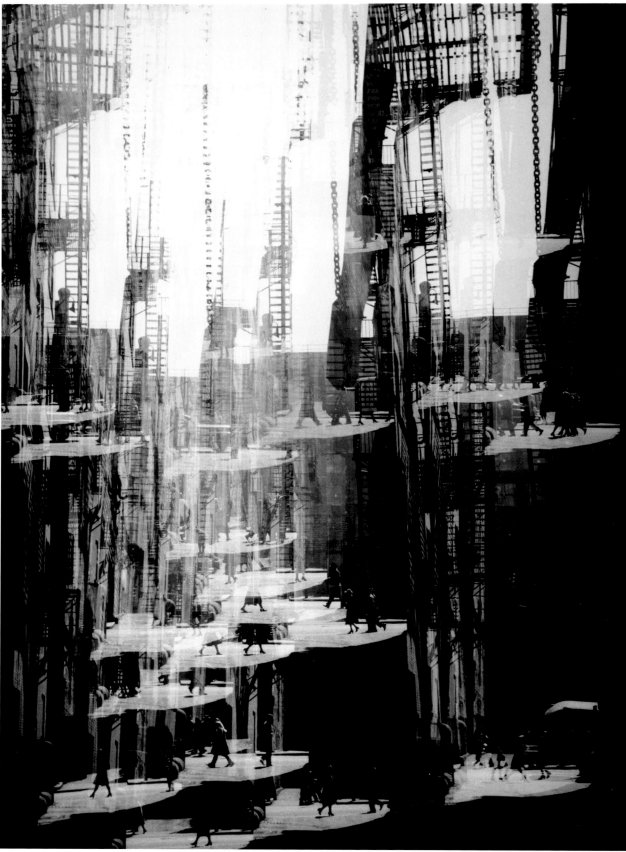

130

130 Harry Callahan, *Untitled*, 1948, cat. 25 **131** Ray K. Metzker, *Chicago*, 1957, cat. 118 **132** Kenneth Josephson, *Trees, Chicago*, 1959, cat. 76

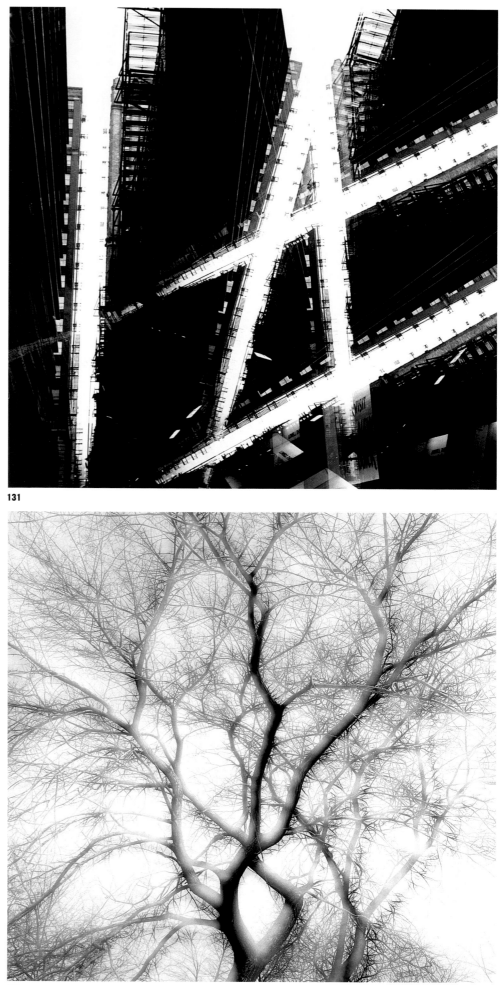

131

132

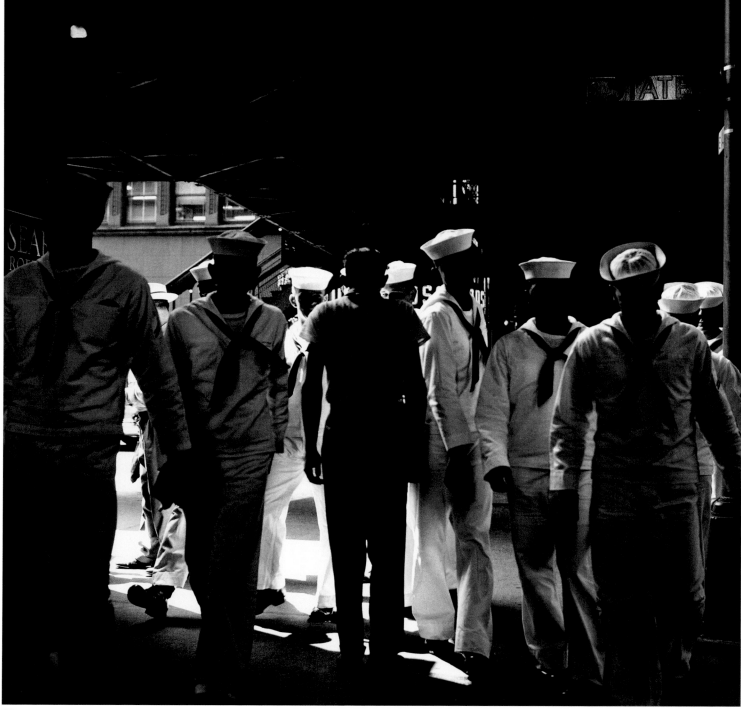

133

133 Ray K. Metzker, *The Loop: Chicago*, 1958, cat. 119
134 Ray K. Metzker, *Chicago*, 1958, cat. 120

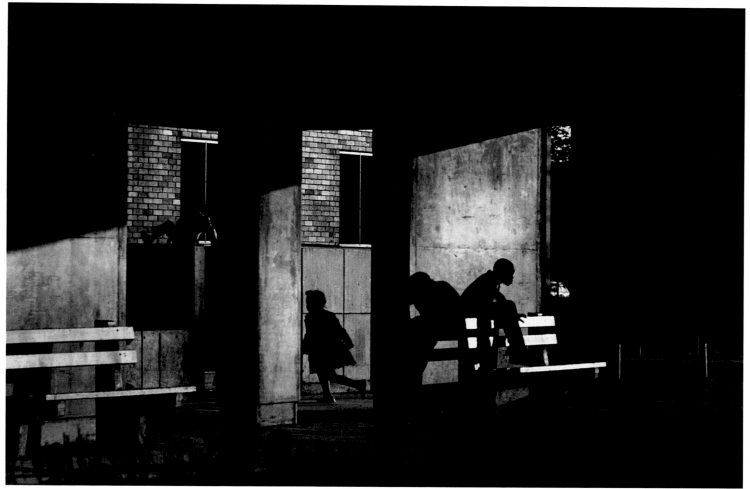

134

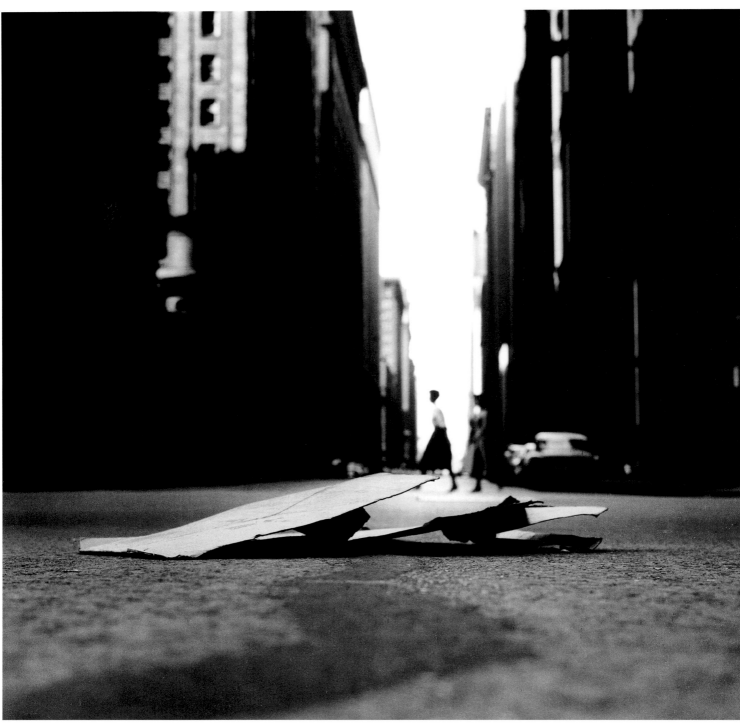

135 Ray K. Metzker, *Untitled*, c. 1959, cat. 121 **136** Kenneth
Josephson, *Chicago,* 1961, cat. 77 **137** Ray K. Metzker, *Untitled*,
c. 1959, cat. 122

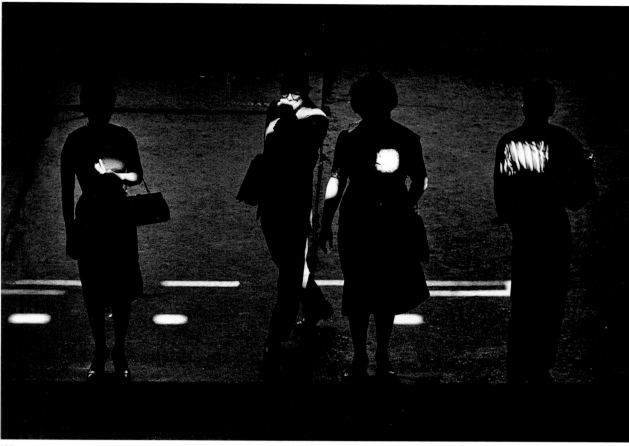

136

137

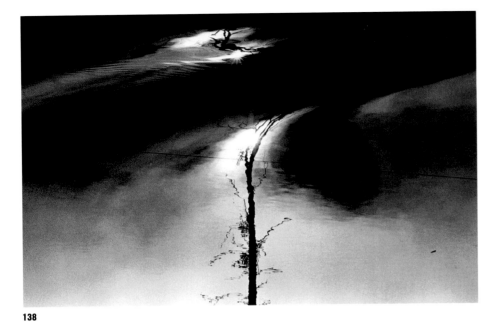

138

139

138 Joseph D. Jachna, *Untitled*, 1958/61, cat. 72 **139** Joseph
D. Jachna, *Untitled*, 1959, cat. 73 **140** Joseph D. Jachna,
Untitled, 1958, cat. 71

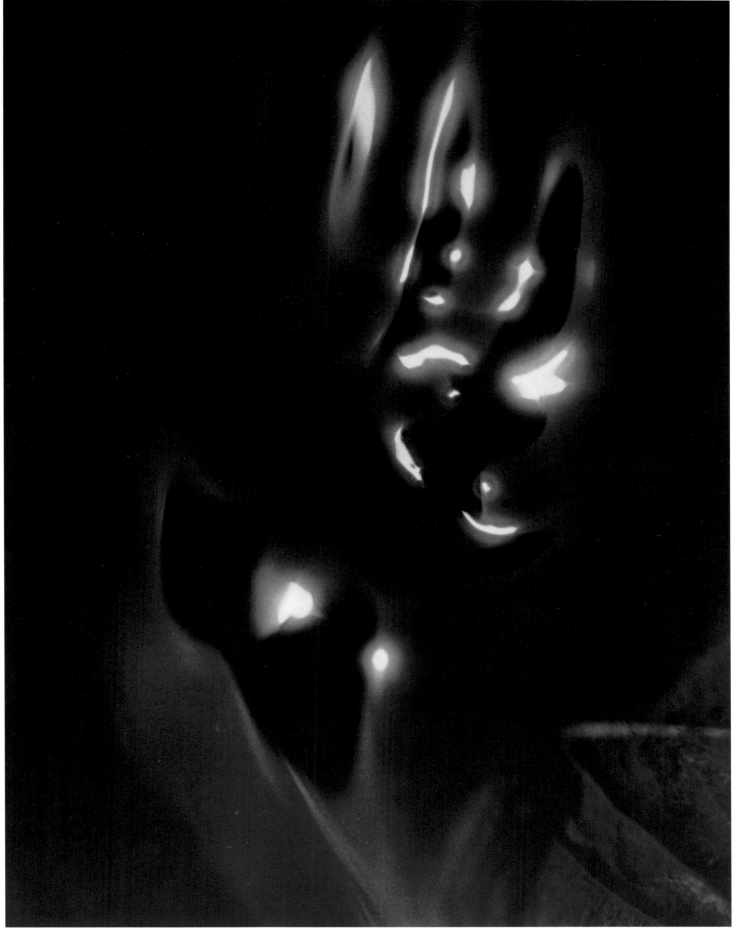

140

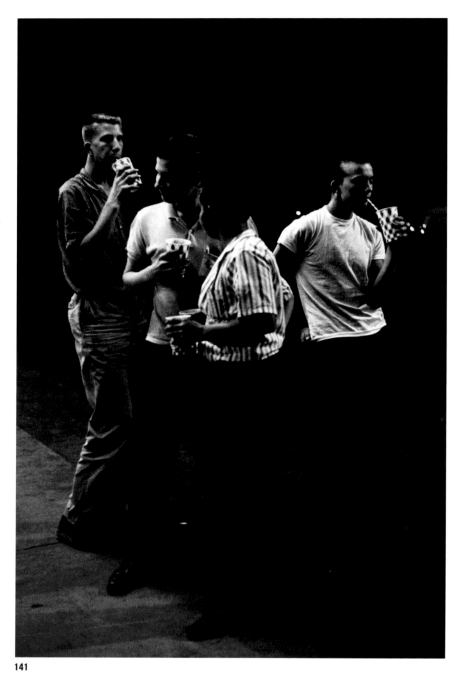

141

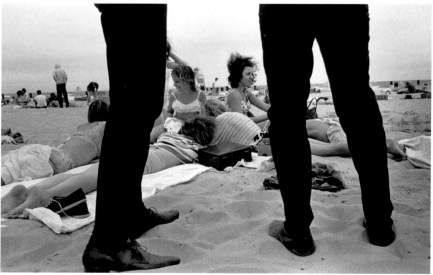

142

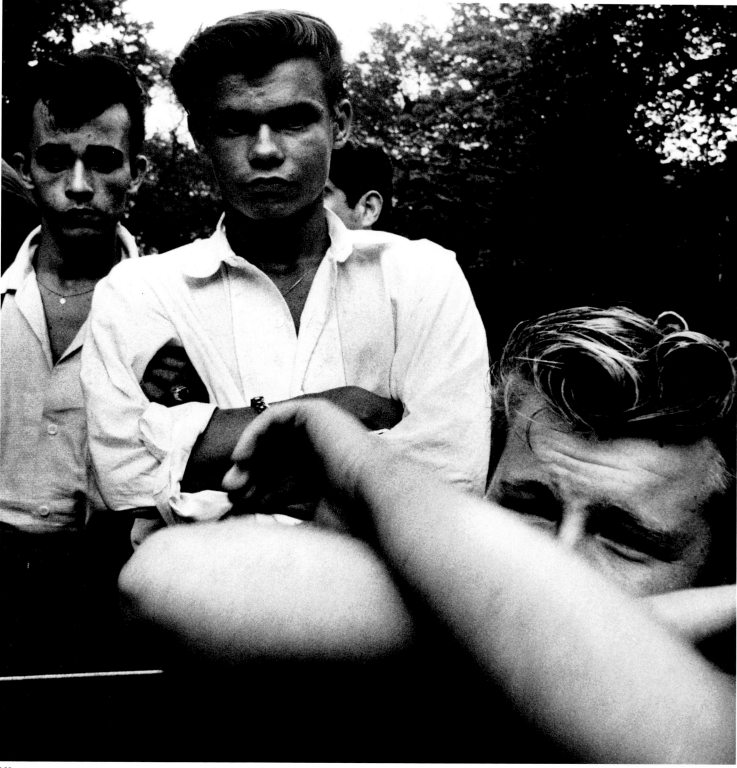

143

141 Joseph Sterling, *Chicago*, 1959, cat. 195 142 Joseph
Sterling, *Untitled*, 1964, cat. 196 143 Joseph Sterling, *Untitled*,
c. 1959, cat. 194

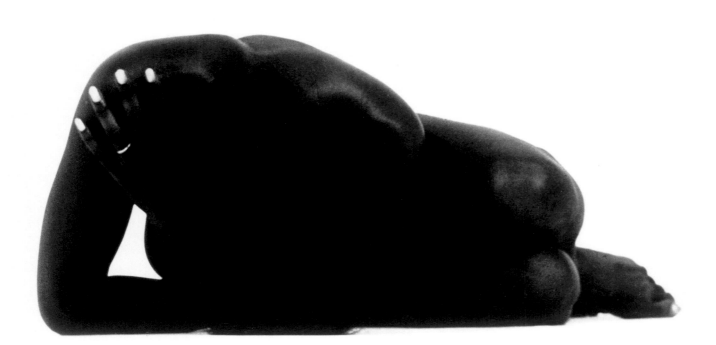

144

144 Charles Swedlund, *Untitled*, c. 1961, cat. 200 **145** Charles
Swedlund, *Untitled*, c. 1968, cat. 201 **146** Charles Swedlund,
Multiple Exposure, c. 1957, cat. 199

145

146

147

148

149

147 Art Sinsabaugh, *Midwest Landscape #34*, 1961, cat. 168
148 Art Sinsabaugh, *Midwest Landscape #15*, 1961, cat. 167
149 Art Sinsabaugh, *Midwest Landscape #4*, 1961, cat. 166

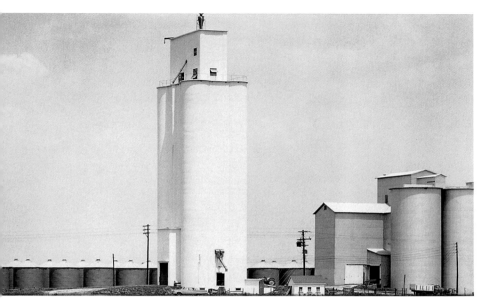

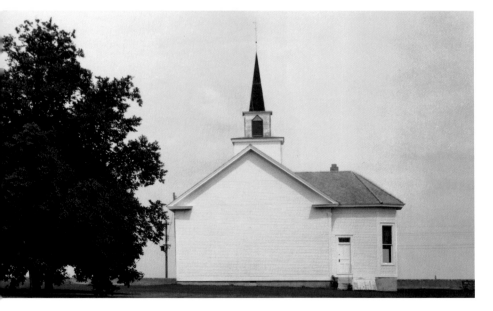

PHOTOGRAPHY ON ITS OWN

THE ID IN THE 1960S

HY

John Grimes

A school of photography within a school of design

As the history of photography is absorbed into the history of art, it is possible to think of the Institute of Design as an influential art school, but the ID was never an art school. It was a school of design offering an education useful to artists that was partially taught by artists, and it had a small program devoted to exploring photography with an intensity matched by no other. That program became one of the primary sources of photographic culture as it evolved from the late 1950s to the 1970s, not only because of its outstanding teachers and students but also because of the school's peculiar, conflicted, intellectual character, its isolation, and its internal dynamic. The features that made it strong during that period were, from the present perspective, weaknesses. The most conspicuous of these was its isolation within a school of design, which was itself a neglected and misunderstood part of a school of engineering.

László Moholy-Nagy, the first director of the ID, loved photography, but subsequent directors of the school could not find much use for it. At the beginning photography fit the model of a New Bauhaus because it was a technological means of image making that reached its audience through the printing press – a democratic art form for the age of mass-production. The course of study that Moholy developed in his tiny, independent school as it evolved from the 1937 New Bauhaus to the 1944 Institute of Design integrated photography fully, but after his death in 1946 the photography program, because of its insistence on the primacy of personal expression, developed as a specialty sharing little with the overall philosophy of design.[1] By 1951 Art Sinsabaugh could justly complain in a note to Harry Callahan, "We both know photography is the bastard child of this school."[2] Serge Chermayeff, then director, didn't have anything against the medium, but his priority, educational and therefore financial, was the Shelter Design (i.e., architecture) program. Chermayeff's departure for Harvard in 1951 started a divisive, four-year interregnum that only ended in 1955 when the IIT board, frustrated by the faculty's inability to agree on a new director, stepped in and appointed Jay Doblin over their unanimous objection (fig. 1). While Aaron Siskind, who taught from 1951 to 1971, made the photography program what it was in the 1960s, Jay Doblin determined the limits within which photography could function. The story of the sixties really starts with his appointment, because the changes Doblin made inadvertently created the conditions under which Siskind could develop a model of photographic education, carried to the rest of the world by his students, that was distinct from existing models of education in painting and sculpture as well as photography. The director of the Institute of Design in 1955 possessed powers as complete as any that could be found in academia, having absolute control over admissions, faculty, budgets, and the nature and mission of the school. Once appointed, Doblin was free, barring total revolt by his own faculty appointments, to remake the school in service of his concept of design. He stayed for thirteen years, remaining director of the school through 1968, taking every opportunity that presented itself to further his agenda.

Fig. 1 Jay Doblin in a studio at Crown Hall, c. 1960. Photograph by Charles Swedlund.

Fig. 2 Collage by Elsa Kula, in John Chancellor, "The Rocky Road from the Bauhaus," *Chicago Magazine* (July 1955). In this collage, director Jay Doblin walks a tightrope between the ID's former Dearborn Street building and its new home in IIT's Crown Hall. Those who have already tumbled off include former directors Serge Chermayeff and Crombie Taylor. Moholy looks down from above.

Doblin came to the ID from the design office of Raymond Loewy in New York. Loewy was also a part of the migration of European modernism to this country, but a very different part than the one Moholy represented. Although Moholy did commercial work, he was primarily an artist and manifesto maker whose position at the Bauhaus gave him license to sloganeer and the freedom to do so without having to sell his ideas in the commercial marketplace. Loewy was a commercial designer who saw design as a business practice; he was not an artist and certainly not an art theorist. After eleven years in Loewy's office, Doblin had learned about the workings of product design in a high-stakes business climate. He believed that design was a professional field completely separate from art, and that design education was actually harmed by its association with art in schools. In 1974, at an ID reunion, he remarked that when he first came to the school he regarded Moholy and the rest of the Bauhaus types as "*beaux-arts* dilettantes" playing at design. In 1979 Doblin described to me his first day at the school during the late summer of 1955. Arriving unannounced, he had found the halls of the Fine Arts building empty, but was led by a crashing sound to the print shop where he found a group of students and faculty gathered around a proofing press watching one of their number (Richard Koppe, he later learned) beating a locked chase of type with a set of tire chains and periodically rolling prints of the damaged type. He said, "I thought I had been made director of an asylum."

His account is interesting because he knew exactly what these people were doing. No outsider to academic design, having taught at the Pratt Institute in New York, Doblin saw the clear evidence of experimentalism. He knew full well that they were playing with the relationship between legibility, letterform, and texture to see what visual discoveries such a test might yield, but he thought the whole issue was trivial and the experiment useless. Joseph Sterling has recounted that years after both had left the ID, Doblin told him that he would have preferred to get rid of Callahan and Siskind, along with printmaking teacher Misch Kohn and all other art-oriented faculty, but at the time did not think he could get away with it.[3]

Doblin wanted to build a professional school, but the remnants of Moholy's "experiment in totality" could not be extinguished. The entrenched curriculum had developed during the period from 1946 to 1949 when the enrollment had expanded tenfold with the influx of returning soldiers from World War II and the course was expanded from two to four years. After Moholy died in 1946, the task of building a complete four-year school fell to his protégés and the former students he had hired to teach the coming flood of enrollees. The school built by his followers was a four-year extension of the Foundation Course, and the graduate program, started in 1950, was a two-year continuation of the same. In 1955, when Doblin took the first steps to professionalize the school and put an end to its Moholy fixation, the old faculty resisted (fig. 2). Never a believer in tenure, even for himself, he let it be known that his idea of academic freedom was the freedom to leave. Some left, and others, like Arthur Siegel, who had returned after Chermayeff's departure, found their contracts had not been renewed. Those who stayed either accommodated themselves to the new program or became marginalized malcontents telling stories of the old days at parties and in the privacy of their classrooms.

Konrad Wachsmann, never a favorite of Chermayeff's, left in 1955, sensing that Doblin would be no better and that his own particular interest, the Shelter program, would no longer be a priority. Koppe, Callahan, and Eugene Dana left in 1961. Subsequently, Koppe and Dana joined other ID refugees and alumni at the University of Illinois at Navy Pier (now named the University of Illinois at Chicago), where they built a design program based on Moholy's principles. Callahan, who had a complete aversion to all things academic, and especially the kind of ideological warfare that has killed so many schools, had stayed out of the fight. But as the changes Doblin made took hold and he saw friends on the faculty depart or get fired, his interest in moving to a position nearer New York, and with a larger salary, increased. The offer in 1961 to teach at the Rhode Island School of Design came at a very good time.

The separation of the school from the cultural life of Chicago started at the same time as Doblin's appointment. The union of the Institute of Design with the Illinois Institute of Technology made perfect sense in 1949 since IIT's president, Henry Heald, was a leader in the Unity of Art and Science movement and a believer in Moholy's New Vision. For its part, the ID was in need of the long-term stability, funding, and accreditation that a university could supply. Also, such a partnership, some imagined, would recreate the Bauhaus, because Ludwig Mies van der Rohe, the last director of the Bauhaus, was already the head of the architecture program at IIT. With the addition of Moholy's school, IIT would house the clear heir to the famous parent.

During the fall semester of 1955, the ID moved from downtown Chicago to the IIT campus on the South Side. The school occupied the basement of Crown Hall, Mies's pavilion and masterwork. Quickly, the ID became less a Chicago institution and more a department of IIT. Charles Swedlund had just finished his first year when the move came:

Faculty rebelled against the commercialism of Doblin, and the South Side made a big difference. Faculty left. Being in the basement was a metaphor. During the move it was chaos. They were divesting the library because there wouldn't be a separate ID library on campus. Siskind came up to me and handed me two books. He said, "Here, take these. I don't want them to get lost." Towards the end it was like the evacuation of Saigon. They were dumping cabinets full of stuff. I took some of the contents home, including some photos by Sinsabaugh. They were throwing them out. It was kind of a panic.[4]

Between the time the ID became part of IIT and the actual move south, Heald had left to head the Ford Foundation, and the new president, John Rettaliata, unlike Heald, had little interest in art or science and no interest at all in the combination of the two. The university's then ultra-modern campus had been planned by Mies and many of the buildings were designed by him, but it was located adjacent to Bronzeville, a formerly prosperous African-American neighborhood once famous for jazz clubs and nightlife. During the 1950s and 1960s this part of Chicago became the center of the city's efforts at urban renewal. Huge tracts of land were cleared, destroying what had been a poor but functioning community to make way for the now infamous housing projects, the Robert Taylor Homes and Stateway Gardens. The political coalition that built the projects had mixed motives. Whether the politicians were attempting to improve the lives of the economically disadvantaged or, as some now argue, to isolate and pacify a growing, predominantly black underclass did not affect the outcome. Invisible walls grew up around the IIT campus separating rich from poor, white from black. The change was gradual, but during the sixties, IIT, and consequently the ID, became an island in an increasingly hostile environment. No longer physically a part of the Chicago scene, and situated in a part of town that Chicagoans were starting to avoid, it was soon out of mind, becoming a Chicago secret known only to a select few.

Any combination of Mies's architecture school and Moholy's design institute, however, proved impossible. Walter Gropius of Harvard University had warned Chermayeff that there would be animosity on the part of Mies's school toward the ID.[5] During the late 1950s Callahan and Mies could be seen hitting the bars together, and Siskind did some photographic work with Mies and other architecture faculty, but overall there was more friction than collegiality. The IIT architects disliked the ID Shelter program, which was substantially cut back and redirected to avoid overlap with any part of architecture. Some architecture faculty disliked the experimental spirit of the ID. The Bauhaus program over which Mies had presided in Berlin was a very different one from the earlier program in Weimar in which Moholy had taught. The ID constantly violated one of Mies's most quoted dicta: "You can't invent a new architecture every Monday morning." The ID wanted to reinvent the world twice a week. Others on the architecture faculty reviled design as "decoration" or "advertising." ID designers, but not the photographers, insisted that IIT's architecture department

was "stuck," unable to move beyond the successful formula of its leader.

Then there was the problem of money. Although joining IIT had provided financial stability for the ID, the level of funding was based on classroom teaching – thirty students, a teacher, and a chalkboard – and was insufficient to support studio education or extensive laboratories. Consequently, faculty salaries were brutally low, and there was no money for equipment or operations. The university justified low pay by arguing that faculty members were professionals who maintained independent practices off campus, but while this was mostly true in architecture, it was only partially so in the ID and it certainly wasn't true for Siskind. According to Nathan Lyons, who came to the school to teach in 1963, Callahan's salary during his first year at RISD was $13,000, not exceptional for a senior faculty member in studio arts; at the time, however, Siskind – equally famous – earned less than $8,000.[6] One could question whether the ID was ever financially healthy. Moholy had supported his independent school with the sale of his paintings, commissions, and grants. Doblin balanced the budget by seeking out projects corporations would sponsor, projects that would generate publicity and hence sponsorship, and by holding the ID Auction, in which artists, designers, and collectors each year were solicited for contributions of artwork to be auctioned off for the benefit of the program. Siskind's connection to the Abstract Expressionists in New York brought works by Franz Kline and others that were sold at this event to help cover operating costs. When these sources were not enough, Doblin simply wrote personal checks, using his external design income to balance the budget.

Once he had decided that he couldn't eliminate photography, Doblin supported it when it was easy to do so, and otherwise left it alone to pursue its own path. In 1960, when he wanted to start an ID press to publish school projects, he asked the faculty what was available that could be published immediately. When Siskind, with whom he'd always maintained a cordial relationship, suggested Callahan's photographs, Doblin wrote a personal check on the spot for $4,000 to fund *The Multiple Image: Photographs by Harry Callahan* as the first ID publication. Occasionally there would be money left over from a sponsored project in product design, and Doblin would give what was left to Siskind to improve the facility. Naturally, it was never enough, resulting in darkrooms that were cobbled together by students and faculty and outfitted with what used and donated equipment Siskind was able to obtain.

Photography students came to campus only for classes, but everything those classes referred to happened elsewhere. This lack of community was no problem for the graduate students, adults living off campus who traveled to school by car or train. School was where one used the darkroom and met with Siskind (fig. 3), and Siskind was the program, not the ID and certainly not IIT. The administration of IIT during this period saw its mission as training engineers for midwestern corporations. The liberal arts, social sciences, and even mathematics were

relegated to the role of service departments teaching the courses necessary for academic accreditation, so the ID didn't have many likeminded allies or any natural constituency within the university. The undergraduate photography program was eliminated (for reasons discussed later), even as its enrollment peaked around 1967, but Siskind's interests had shifted to the graduate program as early as 1961 because it had no curriculum, no accountability to the overall design program, and was entirely under his control.

The times

During the period from 1960 to 1980 fine art photography found its economic niche, but in an unexpected place, academia. Along with real estate, with which it is intimately connected, education was among the big growth industries of the sixties. A booming economy coupled with an unprecedented surge of college-age students provided the fuel. Across the country state university systems expanded with multiple campuses, and if states didn't move fast enough, counties and cities jumped in with their own four-year colleges. When there was no room left for full university programs, junior colleges and urban mission schools sprouted to keep the money flowing. The Soviet launch of the satellite Sputnik in 1957 had spurred the government to support science and engineering education, freeing funds that colleges and universities used to start programs they could not otherwise have afforded. Lyndon Johnson's Great Society opened the floodgates: every American was to have a college degree and the government was paying. Photography was a special beneficiary of national goals in education because it was new, and in an environment of limitless growth, every one of these new state schools could afford new programs and faculty. The onslaught of new students, baby boomers riding in on a tide of affluence and a sense of personal entitlement, demanded photography, film, and animation. Photography, more than any other medium except film, which deserves separate discussion, provided a vehicle for the aspirations and complaints of the time. Catchphrases of the era are instructive:

"The whole world is watching." The photographic documentation of the civil rights movement and later the 1968 Democratic Party convention in Chicago demonstrated the aggressive nature of seeing. With its special claims to veracity, the camera was the ideal witness. The committed and the morally outraged, the disaffected and the wholly alienated, all found in photography a means of exposing both the gross and subtle cruelties of society. The outsider with his camera traveled silently through the land of iniquity, a secret agent of justice. Later, in a book, a magazine, or an art gallery, the sneering villainy of the oppressors could be seen by all, and the wounds of the victims, in photographic verisimilitude, would cry out for recompense and retribution (see fig. 4).

"Turn on, tune in, drop out." Altered perception as the source of artistic expression was another hot idea of the period. The Beats had thoroughly incorporated drug use into their methods, just as William S. Burroughs maintained that his work depended

were represented only by the occasional reefer at parties in the latter part of the decade, and the music was more likely to be classical than hard rock.

At first there was only one class, the seminar. The graduate photography program was almost monastic, a sub-cult of a forgotten order. The movements and passions of the big world penetrated only dimly to the tiny office in the corner of the basement of Crown Hall where Siskind (fig. 5), a chain-smoking gnome guru, would meet weekly with his few disciples. Students of the graduate program were unlikely leaders in the establishment of photography as the hottest area of the fine arts, but they had a monomaniacal commitment to the medium, the proper training, and just the right credentials to capitalize on the growth of photographic education, which would have occurred, although in a very different form, even if the ID had never existed.

In 1962 the photography program was a tutorial with Siskind. Once a week the students would meet in the photography studio to go over their work. Although Siskind suggested to some that they work with Misch Kohn in printmaking, students didn't take other classes or get involved with the school as a whole. Instead, they worked very hard every day making pictures. Siskind was grateful that there was a place that would let him teach photography and pay him, however little, to do it, and the ID was his platform. At 59, he was not interested in moving on. He was proud of the graduate program that he, for the most part, had built, and now that the rest of the school had gone its own way, he could pursue his work and his program. He was also proud of his students, who became as much a part of his family as his wife and stepdaughter. He promoted their interests as much as his own and invited them into his life as assistants, comrades, and potential colleagues. Over the decade various students – Reginald Heron in 1960, Charles Traub and Doug Baz in 1970 – were companions and drivers on his photographic excursions, Siskind being a notoriously bad driver himself. In between, other students filled the position. Students would spot his prints, organize and ship materials for shows, and sometimes go with him to a gallery where he was showing work or be present when Siskind was interviewed by journalists so that they could see what it was like to be a serious photographer in the world.

Siskind's method of teaching was to reveal to students just what they needed to know when they needed to know it. On first meeting him students were often disarmed by this tiny, thick, New York street character, slightly disheveled with sparkling eyes. Wearing a wrinkled jacket made shabby by numerous scorch marks and holes from the falling ash of the cigarette perpetually on his lower lip, Siskind's first comment was usually a wisecrack. He would ask to look at a new student's work, though this examination took only as much as a minute, never more, after which he was likely to say, "You don't know much about photography. We'll have to change that." Thereafter the student enrolled for a certain number of credits as a directed study. No matter what they did at the

Fig. 5 Aaron Siskind, late 1950s.

school, students were accountable only to Siskind. In the relative silence of Crown Hall there was one clear voice and one point of view.

In the class – there was only the one – Siskind might point out technical deficiencies, but he would never suggest how a student might go about correcting them. At other times he would start to talk about literature, painting, leftist politics of the 1930s, or photography. Eventually, the discussion would come back to the pictures the students had brought in, every one of which Siskind would recall in detail. He might suggest an assignment or other photographs for a student to look at. He might select several of a student's best pictures and encourage that individual to do more with the ideas they contained. The difference between this critique and any other was that the student could sense that there was more that Siskind had left unsaid. More would follow when the student was ready to hear it.

If the students needed them, there were assignments. The photography assignments from the Foundation Course were originally based on "the eight varieties of abstract photographic vision" as enumerated by Moholy in 1936.[7] By 1946 these had evolved into a list of assignments that were supposed to lead any student from complete visual ignorance to skillful form-making in the course of two years. The Foundation Course was a system based on the concept that performing a series of experiments, which revealed the unique properties of the photographic medium, could transform the experimenter (fig. 6). Moholy had argued that these experiments taught one basic lesson: "In photography we must learn to seek not the 'picture,' not the aesthetic of tradition, but the ideal instrument of expression, the self-sufficient vehicle for education."[8]

The Foundation experience was a mystical voyage of discovery and self-transcendence carried out by formal means, and its avatar was Harry Callahan. In 1982, when I asked him what he considered to be the best way to teach photography, Callahan replied instantly: "In 1946, when I came to the school they handed me a piece of paper with a list of ten assignments to give the students. I thought it was the best way to teach photography then, and I think it's the best way to teach photography now."[9] Callahan not only taught the Foundation, he *did* the Foundation, and, arguably, during the period he taught in Chicago, he made one of the great bodies of pure and elegant work in photography. Callahan was gone by 1961, but throughout the 1960s he remained essential to the ID. Charles Swedlund calls him "the textbook of ID photography."[10]

Understanding the Foundation Course assignments and their evolution through time is essential to understanding what made photographic education at the ID different and what gave the work its distinctive look. No student was ever assigned to make art even though doing so was the unstated goal. Instead they were asked to consider the properties and processes of photography and photographing like tone, or chance, or transformation, to see what images might result from considering these elements in isolation. While Siskind was the mentor to all the students and the force behind the development of the ID's singular

approach to the medium, he still had to have Callahan, or some equivalent stimulus, to make his own innovations work. In the absence of the person, the system was the next best thing. In her first teaching job after finishing at the ID in 1966, Barbara Crane taught the ID Foundation to teenagers at New Trier, a North Shore high school, and she showed the results at the next conference of the Society for Photographic Education. Crane remembers that Walter Rosenblum, a board member of SPE, was outraged by her presentation and that he kept hissing that she was demonstrating "a system" and that creativity could not be systematized. He wanted to call a board meeting to condemn this aberrant form of education, but Siskind calmed him down.[11] From its conception the Foundation Course was indeed a system, and Moholy and his followers were clear that their intention was to create designers, not artists. If one of the nineteenth-century concepts carried into the modern period was that art is the product of "genius," the key to the pedagogy of the Bauhaus was the recognition that genius could not be taught, only process and elemental composition. The photography foundation was a means of teaching specifically photographic form and fostering creativity. That some of the students would be artists could be hoped but not guaranteed. On top of this structure Siskind built his program.

The set of assignments listed below encompasses the ten from 1946 as developed by various teachers and carried out in advanced as well as basic classes over the next thirty years, until they were no longer given because the practice of photography had changed.

Light
The photogram
The light modulator
Close-up – texture
Studio lighting
 Light box
 Shadow contour lighting

Multiples
Transparency
Reflection
Distortion
Multiple exposure

Motion
Stopped motion
Virtual volume
Camera motion

Contrast
Shallow focus
Deep focus
Near and far (large and small)
Organic vs. geometric
Tone
 Only black and white
 90% white
 90% black

Groups/sequences
House numbers
Alphabet

Solarization/reticulation

Sky

Copy Stand

Transformation

Social Landscape
The next 36 people
 walking down the street
The streetscape
Environmental portrait
Outdoor portrait
Studio portrait

Fig. 6 Cover of Joseph D. Jachna and Bluhma Lew's *Photography Foundation Course*, a hand-made book with gelatin silver prints, early 1960s.

Students in photography at the Institute of Design before 1965 would have done most or all of these assignments. Later, there were exceptions made for students like Keith Smith, who was already a working artist, but even those who were not put through the process were familiar with it and used elements of the Foundation Course in their work. Before she came to the ID, Barbara Crane had been introduced to Moholy's *Vision in Motion* in a photography class in California. When Siskind didn't assign her to take the Foundation, she did it on her own as part of her thesis. Each assignment had multiple purposes. The photogram, for example, was a good way to teach students about making continuous tone images and developing prints, without having to teach them how to use a camera or expose film properly. It was also Moholy's bridge between painting and photography, although a beginning student need not know that. The close-up taught focusing, reproduction ratios, and proper compensation for bellows extension, and strategies of abstraction could be introduced through a discussion of the results. The Foundation was emphatically a formalist approach in which, as Moholy argued, the "unique characteristics of the medium of expression" were discovered. The experiments yielded "the objective factors that determine the effectiveness of an optical work of art."[12] Examining the results also allowed instructors to show organizational strategies for images such as juxtaposing positive and negative (as, for example, in the work of David Avison, Barbara Blondeau, and Ray Metzker); transparency of plane in which one used doorways, reflections, collaged elements, and multiple exposures as embedded planes within the image that one both looked at and through, just like the image plane of the print itself, often producing mysterious spatial ambiguities (e.g., Andrew Eskind and Linda Connor); repetition with variation and chance (e.g., Barbara Crane's neon series); and always the dominance of light over volume in the image, the world as light modulator.

The list above could also be used as an index to Callahan's work during the time he taught in Chicago, if one leaves out those that call for darkroom manipulation. If Callahan ever made a photogram or a solarized negative, for example, it is a well-kept secret. He resisted any image-making process involving the darkroom. Pictures had to be made in the camera; the darkroom was used solely to make prints of those pictures. He made multiple exposures, for example, in the camera, but never in the enlarger. In addition, Callahan rarely added assignments to the list. He taught them, and he did them, even ones from the Foundation Course assignments that weren't in the photography class. In the three-dimensional program, for instance, paper folding was the equivalent of the photogram, and a transition from two to three dimensions. Students would take drawings, collages, or photographs, fold them into three-dimensional reliefs, and then use these objects as light modulators in the photo studio. Callahan used this technique as well as others from the two-dimensional design classes.

In his own work, Siskind had no use for any of these exercises. If Callahan skipped one or two, Siskind only did one or two, and then for reasons unconnected to the ID. But the assignments were nevertheless the basis of his teaching from the beginning. He taught Foundation photography in 1951, continued to do so on and off until Joseph Jachna was hired in 1961, and thereafter taught Foundation occasionally in the summer for extra money; he also included some of the assignments in his advanced classes. Siskind was proud of his additions, one of which, the copy problem, was technical. He delighted in making

students reproduce all of the tonal range in a photograph when rephotographing it on a copy stand because it taught them what they needed to know about exposure and development without recourse to the dreary tests of the zone system. He substituted this problem for Callahan's sky assignment (photograph a clear blue sky and make a print with no streaks, dust, or scratches) because he didn't feel right giving the students an assignment he couldn't do himself. Most of the graduates of the 1960s complain bitterly that no one at the ID ever taught them anything about photographic technique, but, as a group, they are excellent technicians.

Siskind's conceptual contribution was the transformation, or "significant form," assignment, and it was his own constant assignment as well. He championed the idea that a photograph was a "new object in being" and not just a representation of the world. In *Aaron Siskind: Photographs* (1959), he speaks of the "immanence of nature," the process in which the external world causes mental events.[13] This process was central to his own picture making and he emphasized it to his students. He would send them to the Lincoln Park Conservatory to point their cameras at the exotic plants there, but then instruct them to look very carefully at the images their cameras presented and to find in the interplay between the formal characteristics of the image and their own imaginations something that was more than a plant. This addition to the list is the only assignment not based on a formal or technical characteristic of the image.

It must be noted that while Siskind incorporated the elements of the school's visual training regimen into the graduate program, he had no great admiration for Moholy and no special enthusiasm for design. He believed that he and Callahan had created a new and better way of teaching photography that surpassed the old Bauhaus ways. They took what they could use and discarded the rest, especially Moholy's naïve belief that the artist could save the world through engagement in mass-production and communication.

Until 1967 these assignments were carried out using large-format view cameras. Since Siskind himself used a 4-x-5-inch view camera, it seemed natural to him that his students should too. These heavy and cumbersome cameras were part of the process and the look. In the mid-1960s students used roll-film cameras as well, usually the inexpensive Yashica D, but 35mm photography was still regarded as an advanced technique. Students were discouraged from buying a 35mm camera as a "first" camera. "More photographers have been hurt by a Leica than helped by it," Siskind told his student William Larson.[14]

No assignments in color are on the list, even though color was part of Moholy's imperative for the new vision, which he argued proceeded from chiaroscuro to color, from pigment to light, and from light to light in motion. Siskind did not make color pictures and what pictures Callahan had made in color only appeared after 1976 when John Szarkowski at the Museum of Modern Art signaled that color was museum-approved with the exhibition and publication of *William Eggleston's Guide*. In the mid-1960s Siskind took his students to a lecture at the Art Institute by Arthur Siegel, who showed his 35mm color work on State Street made with a Leica. The combination of small format and color was too much for Siskind. He called out, "Did you give them a number?" referring to the practice of low-grade street portraitists who photographed passersby and handed each a card on which to order prints.

Siskind simply had no interest in color photography. Most other "creative photographers" (the code of the time for those aspiring to the status of artists) who made their livings through commercial work agreed. Some, like his friend Max Yavno, divided their black-and-white and their color work by client. Color was commercial; black-and-white was personal. When Siegel had been head of photography from 1946 to 1949, color was part of the core program, but only as color slides. Making prints was expensive, time consuming, and the result faded quickly. Without an advocate on the faculty, color fell into disuse. In 1961 George Nan, a graduate student who had learned color at the Rochester Institute of Technology, taught the other students color printing, but when he left, color disappeared again.[15] In 1967 William Larson and a few others made color prints "almost in spite of the place."[16] Swedlund revived color when he taught at the ID, but he felt "a definite antagonism. Color was discouraged."[17]

Another conspicuous feature of the ID in those years was the absence of history. Art history was represented in the school by a single introductory survey taken only by undergraduates, and the history of photography was not a part of the ID program at all until Siegel rejoined the faculty on a full-time basis in 1967. Certainly it came up in Siskind's classes, but history, theory, and criticism, now a significant part of art school training (for better or worse), were lacking entirely.

All the Foundation assignments save Siskind's "transformation" were formal, but this formalism is deceptive. The given parameters were formal and hence all results were similar in one respect, but no ID assignment had as its goal simply doing the assignment. The goal was to find ways of addressing issues that went beyond a recitation of the vocabulary of photographic effects. By doing the assignments students made many kinds of images, not just the photographs they would have chosen to make on their own. Through this process, of course, they developed an understanding of choices in their own work, and an appreciation of and ability to talk about ways of working that were not their own. This helped them later as teachers. The problems they took for themselves and the experiments they made were part of the process of finding what Siskind called one's "image" or "subject." Linda Connor's thesis, for example, uses the copystand problem as a part of the technique, along with collage, fractured perspective, and a variety of ID formal strategies, but the subject is memory, represented as a landscape, in which old photographs are pieces of time combined into an ambiguous, but psychologically complete, whole. Once the subject is identified, the origin of the earlier images is not only unimportant but unnecessary, and in some of the images it is unclear whether there is any element of authorial arrange-

ment. The images from her graduate portfolio have been extensively published and collected, but the thesis, for her as for the rest of the ID photographers, was just one of many related but distinct bodies of work, which in her case includes large-format landscapes that also address memory, but in the markings of the land and rocks by past inhabitants. These are just as mysterious as her collages in spite of (or because of) all the clarity that an 8-x-10-inch negative brings to them. When Charles Traub first started on a body of work concerning the birth of his son, Aaron, Siegel objected, finding the work too personal and potentially sentimental. Unfazed, Traub instead produced a thesis exploring texture in landscape, which contains both positive and negative prints, but finished the body of work on his son as well. In fact, most ID students were working on several ideas at one time. The course of study gave them many options and a powerful methodology for exploring the medium.

For Siskind significant form was the basis of good work and using formal strategies could make students into picture makers, but form was insufficient in itself. His teaching concentrated on helping students find their "subject." Using the ID method also helped Siskind avoid teaching by example, especially the example of his own work. Students did not copy Siskind. In the very few cases when a student attempted it, he dismissed the work immediately: "Why are you making my pictures? Make your own pictures." In fact, Siskind's work does not bear repetition, and he knew it; followers would only dilute the concept. Photography really is different from painting. Siskind actually diminished his own reputation over the years by not keeping his images rare after the fashion of his friend Frederick Sommer.

The ID graduate thesis

The thesis, or body of work, that each student produced as part of the graduate program was Siskind's most important contribution to the ID and to photographic education in general. A typical graduate program in the fine arts at the time (and even now) maintained standards of quality through admissions. The student's culminating project or show was often a record of the work done while in residence. In photography there weren't undergraduate schools with programs in which students could establish track records as photographers. Accepting only proven successes was also contrary to an idea handed down from Moholy's days, which asserted that creativity is a universal human trait that can be brought out in everyone. Also, it was mostly the case that individuals devoted to photography had little or no experience with the fine arts. Siskind had to accept students on a hunch, teach them photography, and then show each how to live and work as a "serious person" pursuing a vision. The thesis was the means to this last goal.

The Feature Group essay that Siskind had helped to define at the Photo League in New York was one source of the thesis. The ID method of experimentation and extensive analysis was another. He had extended the Feature Group experience in the Sullivan project that students and faculty worked on in the

1950s. There were also sponsored projects done for the city department of planning and the Chicago school system, but the thesis was not group work. A group of students undertook the Sullivan *project*, whereas Richard Nickel produced a *thesis* on the architecture of Louis Sullivan. The photographs by Jachna, Metzker, Swedlund, Sterling, and Kenneth Josephson, published in the 1961 *Aperture* issue, were from their graduate projects. These represented Siskind's idea of what a thesis should be: an original body of work executed over an extended period with extreme intensity and care revealing significant form and addressing a subject. The thesis was a basis for a life's work, during which one might produce many such bodies of work or extend and elaborate just a few. Tom Porett, for example, was known as a radical experimentalist while a student and thereafter; nonetheless, he was capable of a range of styles and is represented in this volume by a documentary image. Barbara Crane's spare "human form" images, derived from an attempt to explore pure line after the fashion of printmakers, are in contrast to later bodies of work that rely on the ultimate in full detail and full tone. Tom Barrow displayed a straight, albeit very form-conscious approach in his pictures of automobiles in the Loop, but also pursued multiple imagery. For Siskind individual images could be visually arresting or instructive, but only bodies of work demonstrated photography at its highest level. To achieve that level, he insisted on continuous work, but he did not expect – or lead students to expect – continuous success. One learned rapidly that success was infrequent and came only through effort. His strongest criticism, silence, fell on students who failed to produce. Roslyn Banish recently recalled, "If somebody didn't bring stuff in, you could see it. Aaron wouldn't look at him. He wrote him off. He was not a serious person."[18]

The photography world at the ID

The small group of students sitting in the photo lab office each week in 1961 had all been through the Foundation assignments in one form or another. Jachna, Swedlund, and Heron had been undergraduate students. As soon as Jachna graduated, he was hired to teach the basic courses that he had himself completed. Though never precisely catalogued, the Foundation Course maintained continuity through a sequence of teachers who had been through it themselves. When Jachna's contract was not renewed in 1969 because of an alleged "tenure quota" – mythical or actual – Swedlund was hired to teach the foundation. The graduate group was constantly changing through the departure of some and the arrival of others. Length of time in the program was variable, from as few as two years to as many as eight. One simply stayed until the thesis was complete. Many students took full-time jobs after they finished their class work and thereafter met with Siskind at his apartment. The only time all currently active students might see each other was at parties.

Siskind was unquestionably the local contact in the small community of those devoted to serious photography, and parties at Siskind's were part of a student's introduction to the world. When Minor White, Clarence John Laughlin, Frederick

Sommer, David Heath, or Robert Frank came to Chicago, there was a gathering at Siskind's for the guest, the graduate students, and the local photography community. After the education conference that Nathan Lyons organized in 1962 and the founding of the Society for Photographic Education the following year, there was a more formal and accessible national network, but art photography operated on a first-name basis well into the 1970s. In the interest of community and the promotion of the medium, all flavors of photography were welcomed, at least on a social level.

Siskind's increasing fame and connections brought a larger group of students to the ID who sought out the program because they admired his work or because they were sent by others who admired it. The crush of students started in 1965; from a changing cast of four or five, the program grew to fifteen and then more. For all its fame and extensive influence, the ID graduate program had always been small. From 1952 to 1964 there were only fifteen master's degrees awarded in photography, fewer than two a year. In 1970, however, twenty-three students graduated. As enrollment grew, the weekly discussion of so many students' work became difficult. Siskind once told Jachna that before the seminar he would be physically sick, worrying that he would have nothing to say.[19] Naturally, that never happened.

The growth of the school demanded greater resources and more structure. Additional faculty were hired to distribute the burden, and Siskind became more willing to let students follow other advisors. While Siskind was in Rome in the fall of 1967, Wynn Bullock replaced him, exposing students to a different point of view and giving them a new sense of freedom. When there had been a single voice, it was the voice of unassailable truth, but now there were multiple truths. In the same year, Arthur Siegel, who had taught at the school on and off in the evening program since he had left the school in a fight with Chermayeff in 1949, was hired to teach full time (fig. 7). Siskind wanted Siegel to work with students in the area of documentary, but Siegel also brought back the advanced experimental problems, which he organized into a course that all photographers after 1967 experienced, and he created a formal history course. Siegel was not really an historian, but he may have been one of the best critics of photography so far. He subjected the body of serious photography known in publication to intense scrutiny, and he based his insights on the internal evidence of the work, applying his knowledge of sociology, gestalt psychology, and Freudian analysis. The Freudian interpretation of art has massive, insurmountable difficulties, and has now been wholly, or at least partially, discredited. But Freud, like voodoo, works on those who believe, and many photographers of the last century believed either explicitly or implicitly since the truth of Freud was a popular assumption from the 1920s into the 1970s. Using Freud on Man Ray or Edward Weston works in the same way as using Plato and Aristotle on the painters of the Italian Renaissance. In a way that art historians are seldom able to do, Siegel excelled in uniting a strong formal analysis with an empathetic reading of the work that grew out of his own experience as a photographer facing the same issues and choices. Siegel was also a little neurotic, so Freud works on him too. He desired recognition for his images and his ideas but feared failure. This internal conflict manifested itself as self-congratulatory verbal bluster coupled with an unwillingness, even an inability, to produce and promote his own work. He stalled on invitations to show or publish his work until the opportunity passed, and he tape-recorded his lectures and even his private meetings with students in hopes that he could eventually write it all down, but he never got around to it.[20] Unfortunately, the tapes do not adequately represent his contribution since he didn't really give for-

Fig. 7 Arthur Siegel teaching, 1970s.

mal lectures. The existing tapes mix extensive digressions on everyday matters with sometimes outrageous conjectures about photography that cannot be understood outside of the context of previous classes and the thousands of slides that had already been seen, but his former students all testify that his history of photography class was the high point of each week. William Larson, for example, has remarked, "Aaron taught us how to be photographers, but Arthur taught us what photography was."[21] The mature form of the graduate program had three parts: classes in the first year or year and a half covering documentary photography, experimental photography, and the history of photography (plus Foundation and printmaking for selected students); a paper on the history of photography to be completed before graduation; and the thesis, which was guided by Siskind as before, but now with the help of Jachna and Siegel.

In the spring of 1966, after years of unsuccessfully applying, Siskind received a Guggenheim Fellowship to support the work in Rome that he had been pursuing for some years. He and his wife, Carolyn, were already planning to spend the summer there. The award provided a great deal of satisfaction, and the funds made him financially independent from teaching during the period it covered. Over the summer Doblin took the next step in remaking the school by overhauling the curriculum. Siskind had always been very good at organization and administration. A teacher of English before coming to the ID, he was conscientious about attending meetings and observing bureaucratic protocols, and he had left a complete schedule of his travel plans and addresses where materials could be sent. Nonetheless, in his absence and without soliciting his opinion, the rest of the faculty eliminated all undergraduate majors. The undergraduate program would henceforth produce "comprehensive designers" rather than specialists.

It was a move away from training students in visual form-making and physical craft, a process that Doblin saw as producing "exotic menials" (Richard Latham's term), who could not function within the emerging corporate context. While there would still be undergraduate courses in photography, all students would receive a degree in design. In 1966 there were probably twelve to fifteen active graduate students, but there were three times as many undergraduates. Thereafter, undergraduate enrollment in photography courses declined. From that moment until he left the ID, Siskind spent all his time on the graduate program, which, though increasing in size, was now as isolated from the rest of the Institute of Design as the Institute of Design was from IIT and the rest of the world. To make matters worse, fewer students would mean fewer faculty and a limit to the potential growth of the graduate program. In the same year, without consulting Siskind, Doblin hired a local professional to teach color photography to the undergraduates since Siskind wouldn't teach it and the visual designers wanted color printing capabilities for their students.

Although the ID was on the evolving map of photographic inquiry, photography was still on a separate map from art. The ID was not an art environment and thus had no painting or sculp-

ture program. The only teachers besides Siskind who worked consciously as artists were Misch Kohn, a printmaker, and Cosmo Campoli, a sculptor. Printmaking was permissible at the ID because, like photography, it produced a multiple original and was a necessary tool for designers. Otherwise it would have been expunged from the school. Sometimes the two forms, photography and printmaking, dovetailed. For example, as a way to promote photography at the ID the students issued portfolios, known as the *Student Independent* series, which published original prints, not reproductions. These portfolios were collected by institutions because each contained original signed prints by the faculty as well as the students. In the mid-1960s students working with Kohn and Siskind issued a *Student Independent* of photographically based printmaking processes. Although this portfolio was not as widely collected as the purely photographic portfolios, it was the one effort to explore printing technology as an adjunct to pure photography.

For the most part the pictures that ID photographers produced were made for the wall. In a school founded on the media of mass-production and communication, the photographers devoted themselves to making precious objects. A photograph at the ID was a luminous black-and-white print on glossy paper (dried matte) usually no larger than 11 by 14 inches and dry-mounted on white board. Such items were not expensive to make, but their making required extraordinary care and attention. Photography was stripped down to its modernist essence: pure image. From Siskind's point of view at that time, it would have been desirable for every photograph to be more or less the same size, on the same paper, mounted on identical white board. By limiting each work to a uniform physical presence, the image could be considered for itself alone. As a rule the ideal image at the ID, the photographic image, was to be dematerialized, transparent, scaleless, and perfect. It was precious, but in a very peculiar fashion. The new object in being was the image, not the print.

Breaking out of this mold happened occasionally, as was the case with Keith Smith, but more often later in the decade and as exceptions: for example, Barbara Blondeau's long film strips from 1967, David Avison's ultra-wide landscapes from the 1970s, or Dale Quarterman's three-dimensional photo-sculptures in 1971. As the decade progressed, Siskind, and especially Siegel, stressed that graduate work should expand the boundaries of the medium. The strip photographs of Blondeau and the slit-scan images of William Larson are cases where the power of the images overwhelms the technique, and there is no sense of gimmickry, but this is not the case with all the experimental work. Geoff Winningham, though dedicated to black-and-white documentary photography, did his graduate project in color using a Widelux, 35mm panorama camera to photograph passersby on downtown streets. The rotation of the lens during hand-held exposures created a variety of motion effects, with some subjects appearing clearly and others swept into virtual volumes. Immediately after graduation he was photographing professional wrestlers with a Leica to much more memorable

effect. Winningham now says that the ID actually hardened his view that the best photography is straight, unmanipulated camera vision, even though he remembers Larson as a "genius, who made these amazing pictures."[22] Jonas Dovydenas dropped out of the program to pursue a more straightforward approach to the medium. That images might be sequenced and combined with text to create a different sort of work was discussed but not often tried. Even Roslyn Banish's side-by-side frames from 1968 are meant to be viewed as a single image. Only after she left the ID and was teaching in England did it occur to her that a book – rather than a print for the wall – might be the work itself.[23]

The program was based on camera vision, and investigations undertaken were specific to photography. The "system" was a way of learning what the medium had to teach. ID photography, sometimes called the Chicago School of photography, has been widely criticized for pursuing an agenda not consistent with contemporaneous art practice. Such a judgment presumes that ID photographers were supposed to be engaged in an art practice, though, from one point of view, they weren't. Photography had little recognition or respect in the art world. From its inception, artists have used photography as a tool, but outside of the tradition that the ID represents they have not used it for itself. Interested exclusively in camera vision, photographers at the ID did not pursue traditional art media except through photography. Most graduates called themselves photographers, not artists; a few even held to the old idea that photography was superior to art. Only later, after photography had gained general acceptance in the art community, were they able to call themselves artists without a mental stutter, and it was also later, as teachers in fine arts contexts, that some extended their ways of working to address art issues rather than purely photographic ones. The images by Ken Josephson in the 1970s are an amazing combination of exquisite formalism, print quality, ID multiple imagery, and high concept. Too beautiful to qualify as purely conceptual work and too smart to dismiss as clever optical effect, they define their own ground.

It was certainly possible to make money in commercial photography and to do so using the ID methods, but most ID photographers wished for the opportunity to pursue their own agendas rather than those of paying clients. Self-directed photography was not a way of making money then or even now. The appearance of so many new programs and teaching positions allowed ID graduates to pursue the work to which they had committed themselves as students. Moreover, ID students could teach all types of photography in a variety of situations.

Although most former students insist that they were never taught anything about the technical side of photography, it turned out that they knew or had learned on their own much more than they thought. Since the ID was nominally a professional school, all the graduates were expected to have professional competence. They could use view cameras as well as roll-film cameras, and they had experience in studio lighting, assignment documentary, architecture, and all the rest of the

modes of photography practiced around the world. They could work with designers and art directors. In short, they knew more about photography than just how to make their own pictures, and they knew a way to teach photography that would work regardless of context. Most importantly, they were intensely dedicated to the medium. The opportunities to teach at the college level were in different departments and at a variety of levels. The program they had been through made ID graduates qualified for all of them.

From 1955 to 1985 most of the photographers who came out of the graduate program became teachers of photography, and many started their own graduate programs. By 1971 dozens of schools were turning out students with a Master of Fine Arts degree in photography. Viewed cynically, it was a pyramid scheme in which teachers taught teachers to teach teachers, a strategy that could not succeed indefinitely. But the ID also created photography as a field of inquiry that made the camera more than a technological tool, and developed an aesthetic that could stand on its own without special pleading in the presence of the traditional modalities of art.

The isolation of the Institute of Design from art by circumstance and from commerce by daily choice in its presence created the unique circumstances that allowed the ID aesthetic to flourish under the guidance of strong teachers, especially Siskind. But by the end of Siskind's time at the ID, the world had changed. The ID was no longer unique; it was one of a growing number of places where photography was valued and studied. In essence, the ID had created much of its own competition, and most of these newer programs and institutions of photography were better informed about the field, better staffed, and better funded. When photography was the outsider, the Institute of Design provided a home; thereafter it was just another place to visit.

As the decade of the 1960s progressed, the countercultural spirit of the times did slowly make itself felt at ID. The undergraduate students became less accepting of a professional education with the new crops of design entrants tending to see design as a personally liberating and potentially subversive activity, a way to drop out of corporate capitalism rather than a way to join it. In the face of this change in attitude and knowing that his own product-planning consultancy was committed to a number of large-scale projects, Jay Doblin resigned in 1968. After his departure the administration of the school was turned over to James Montague as acting director. Montague shared most of Doblin's ideas and attitudes, but held them with a greater fierceness and a disdain for compromise.

There is a long list of embittered former faculty members of the Institute of Design, to which Aaron Siskind added his name in 1970. He thought he had everything worked out with Doblin so that the mandatory retirement age of sixty-five would not be a problem for him. Even if he had to "retire," Siskind understood that he could continue as professor emeritus indefinitely. Instead, in the spring of 1970, without warning, he received an invitation to an IIT retirement dinner to be held in his honor. He

felt betrayed. Whatever arrangements he may have had with Doblin were not binding on the new administration, and Montague had no interest in keeping Siskind on the faculty, having often expressed the opinion that photography was uncooperative with the rest of the school and that change was needed. In the interest of the many students who had come to school to study with Siskind, he was reappointed for the following term, but he was not to be the program head, just another teacher. Misch Kohn and Charles Swedlund chose this time to leave, principally because they did not like the way the school was treating Siskind.

Postscript

In the early summer of 1971 I went to see Aaron to talk about futures, his and mine. Unable to accept admission to the ID because of the Vietnam War, I had been meeting with him off and on since 1968 as a sort of private student. We sat that day on moving boxes in his otherwise vacant apartment on Wellington Street. He said then that he would never again set foot in Crown Hall, and, as far as I know, he never did, but he sent me, and others after me, to Crown Hall to study with Arthur Siegel. He said that he didn't know what he would find in his new position at RISD (where he joined Callahan that fall) or even how long he would stay in Providence. Despite his personal feelings about the school, he made it clear to me that he still believed that the ID was the best place to learn photography.

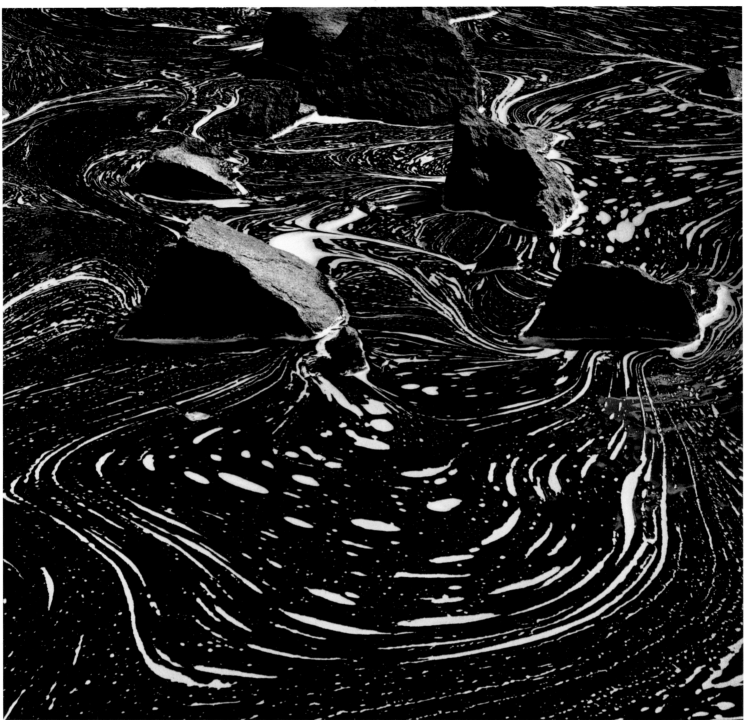

150

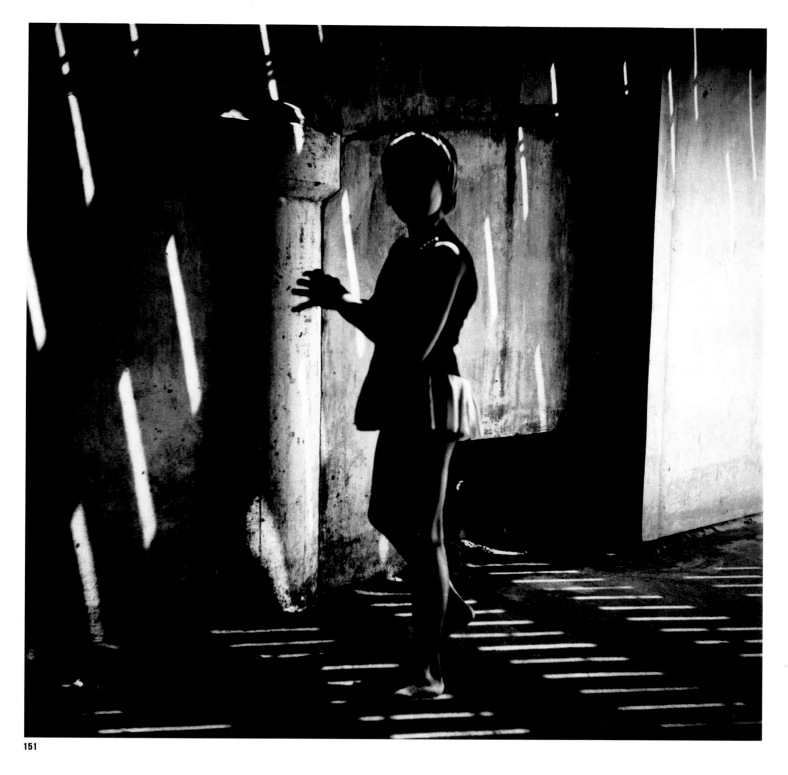

151

150 Joseph D. Jachna, *Foam and Rocks, Slough Gundy, Wisconsin,*
1967, cat. 74 **151** Ray K. Metzker, *Atlantic City,* 1966, cat. 124

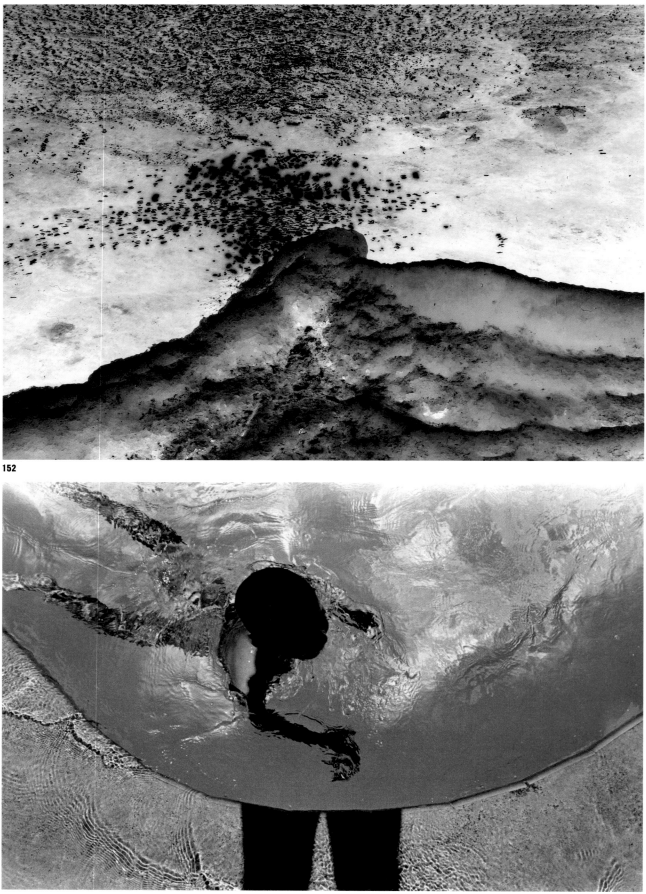

152

153

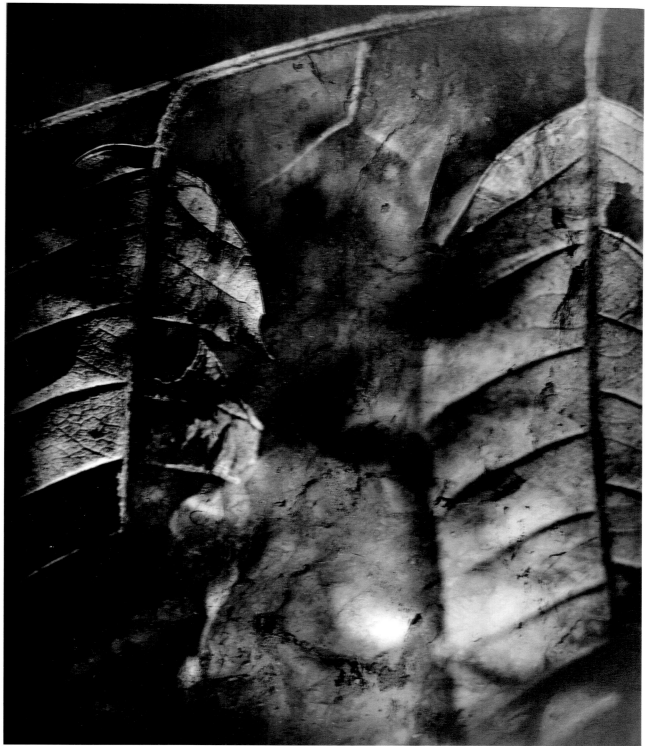

154

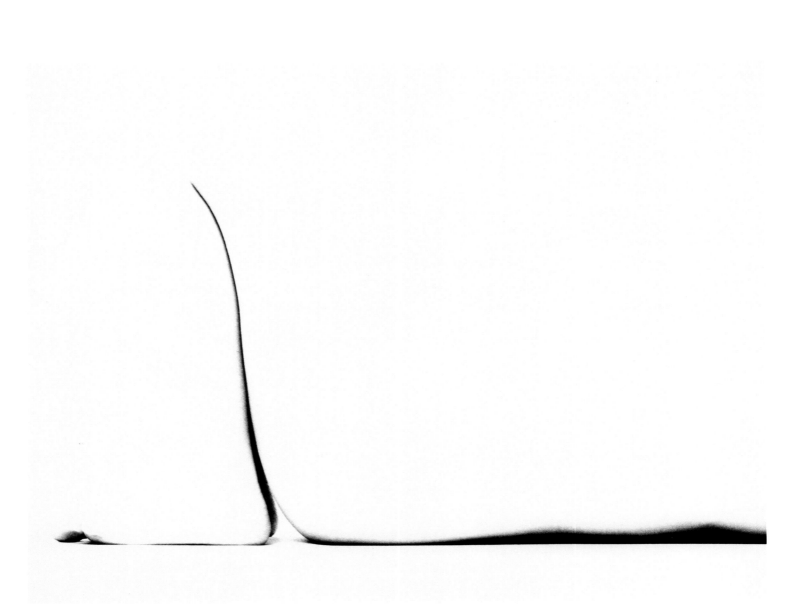

155

155 Barbara Crane, *Human Form,* 1965/66, cat. 42 **156** Barbara Crane, *Human Form*, 1965/66, cat. 43 **157** Lynn Sloan, *Untitled (G15/10)*, 1970, cat. 185

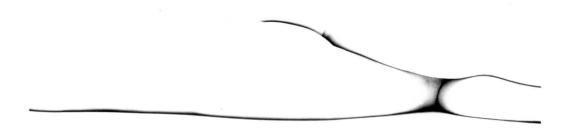

156

157

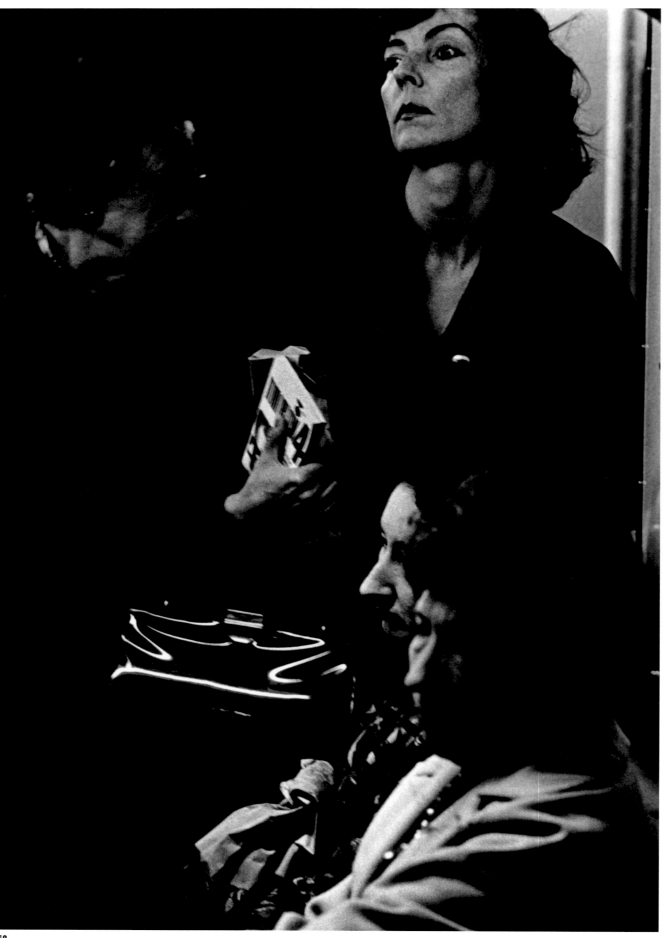

158

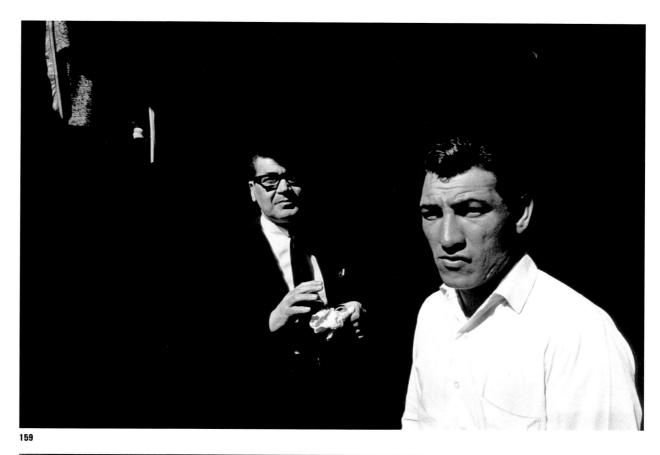

159

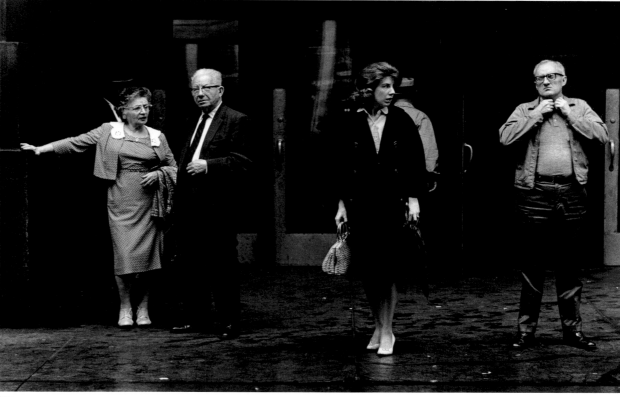

160

158 Reginald Heron, *Untitled*, 1964, cat. 62 **159** Thomas Porett, *Untitled*, 1966, cat. 146 **160** Reginald Heron, *Untitled*, 1965, cat. 63

161

162

161 Andrew Eskind, *Untitled*, 1971, cat. 52 **162** François
Deschamps, *Wisconsin*, 1971, cat. 48 **163** Art Sinsabaugh,
Chicago Landscape #205, 1965, cat. 171

163

164

165

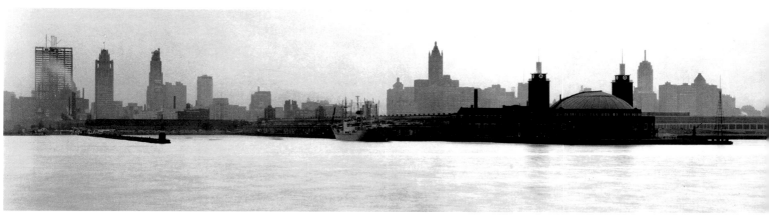

166

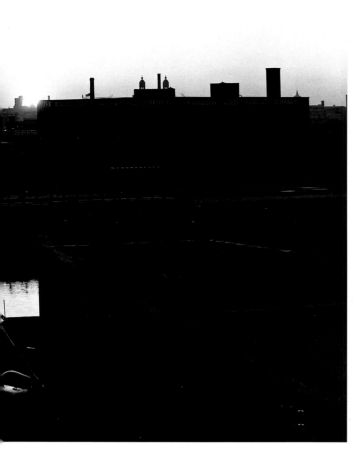

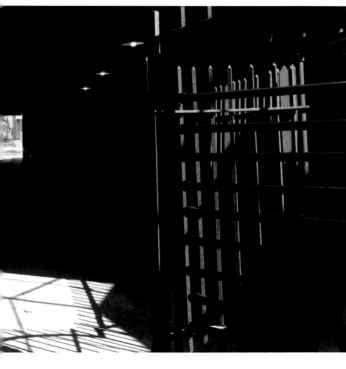

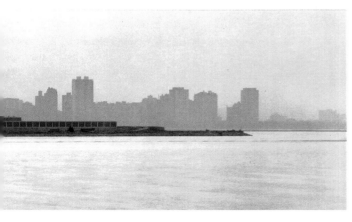

164 Art Sinsabaugh, *Chicago Landscape #13*, 1964, cat. 169
165 David Avison, *Under the Illinois Central 2, Hyde Park*, 1970,
cat. 2 **166** Art Sinsabaugh, *Chicago Landscape #122*, 1964,
cat. 170

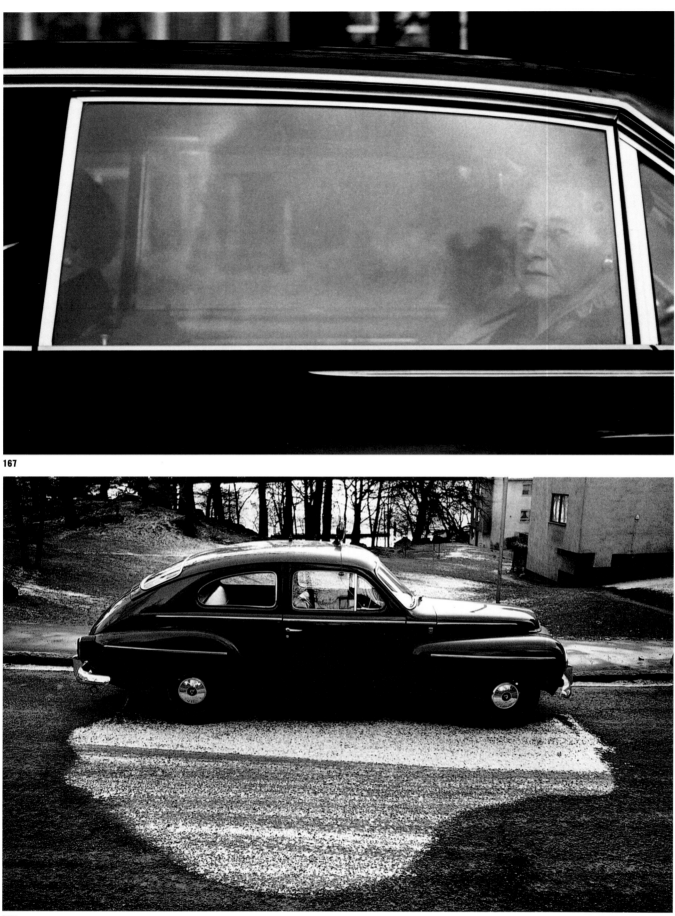

167

168

169

170 Nathan Lyons, *Untitled (Minneapolis)*, 1965, cat. 113
171 Kenneth Josephson, *Chicago, 1963 #63-2-8*, 1963, cat. 79
172 Thomas Knudtson, *Barn Wall, Victor, NY*, 1959, cat. 94

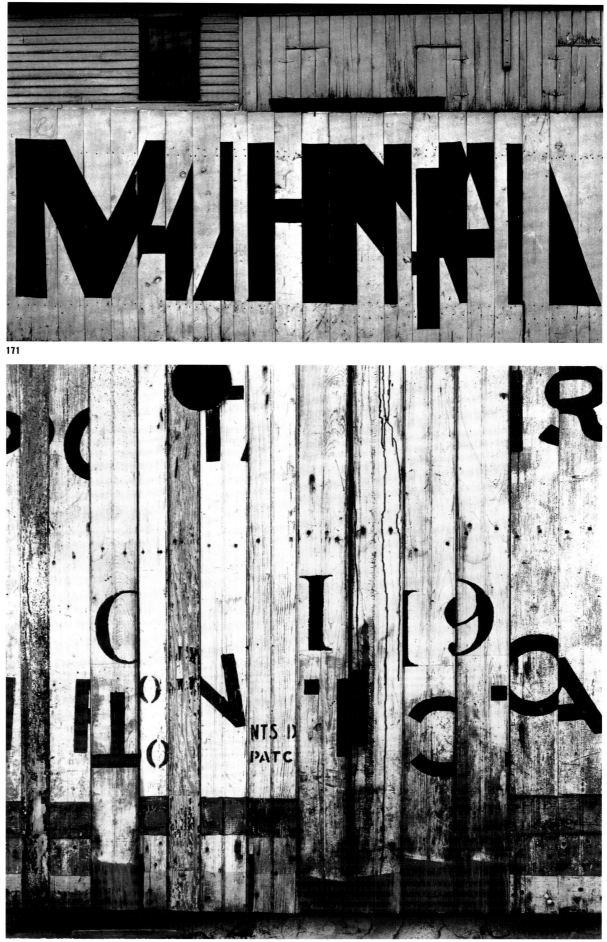

171

172

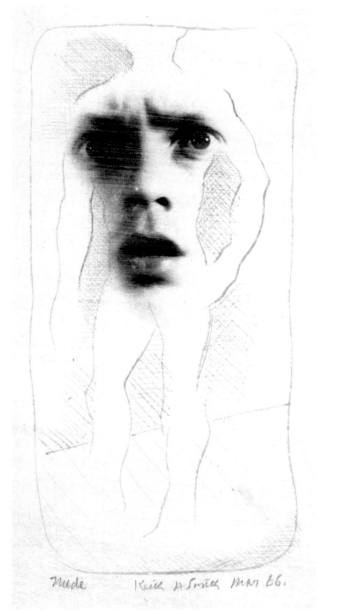

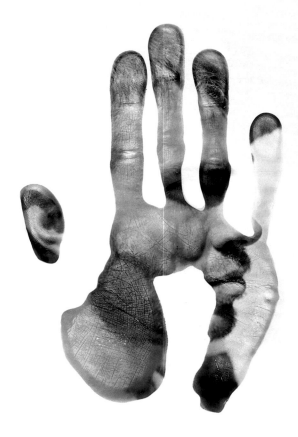

174

173

173 Keith A. Smith, *Nude*, 1966, cat. 188 **174** Keith A. Smith, *Untitled*, 1965, cat. 187 **175** Keith A. Smith, *Book 2*, 1969, cat. 189 **176** Keith A. Smith, *Book 11*, 1969, cat. 190

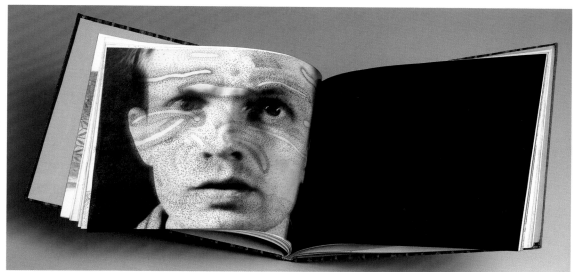

175

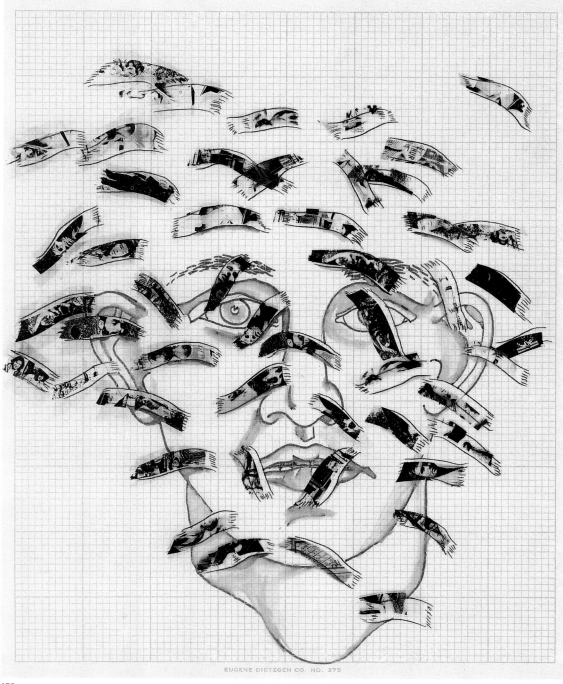

176

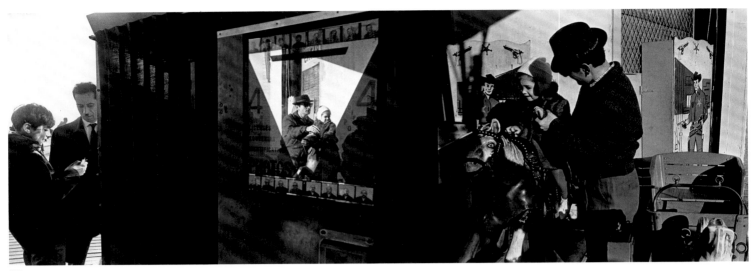

177

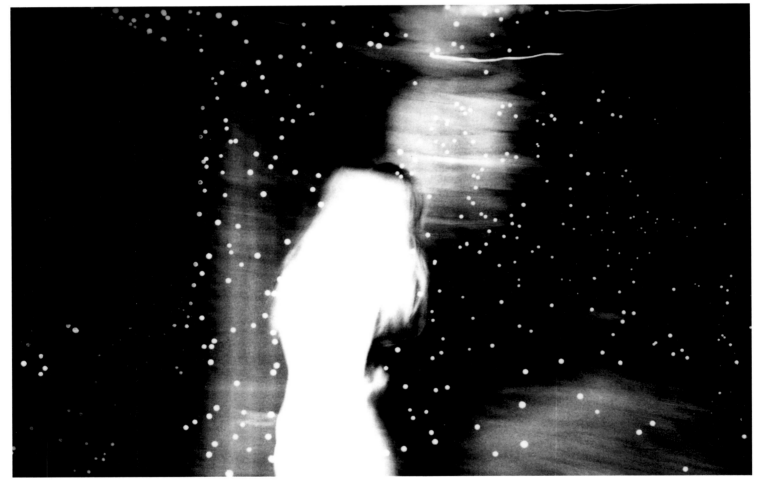

178

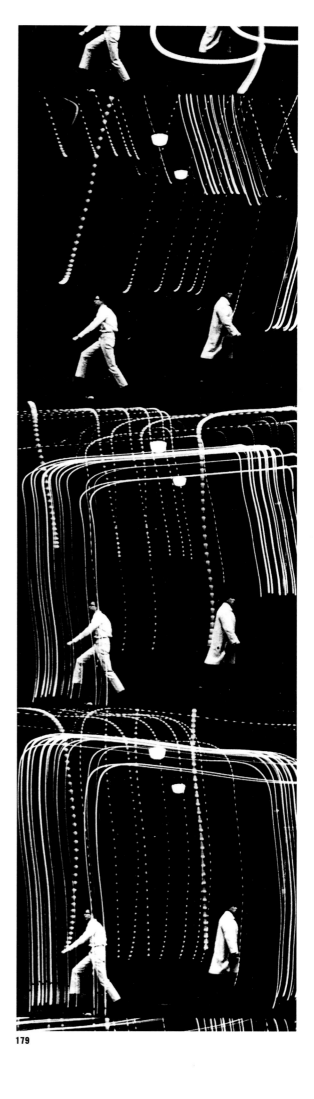

179

180

181

182

183

180 Barbara Blondeau, *Untitled*, 1968, cat. 12 **181** Barbara
Blondeau, *Untitled*, 1968, cat. 13 **182** William Larson, *Figure in
Motion*, c. 1968, cat. 101 **183** William Larson, *Still Films*,
1967/70, cat. 100

184

184 Ray K. Metzker, *Composites: Philadelphia*, 1966, cat. 123
185 Barbara Blondeau, *Untitled*, 1966/67, cat. 11 **186** Ray K.
Metzker, *Tall Grove of Nudes*, 1966, cat. 125

187

188

189

187 Eileen Cowin, *Untitled (Waiting for Your Call)*, 1971, cat. 41
188 Eileen Cowin, *Untitled (Desk)*, 1970, cat. 40 189 John Wood, *Birds and Bomber*, 1965/68, cat. 209

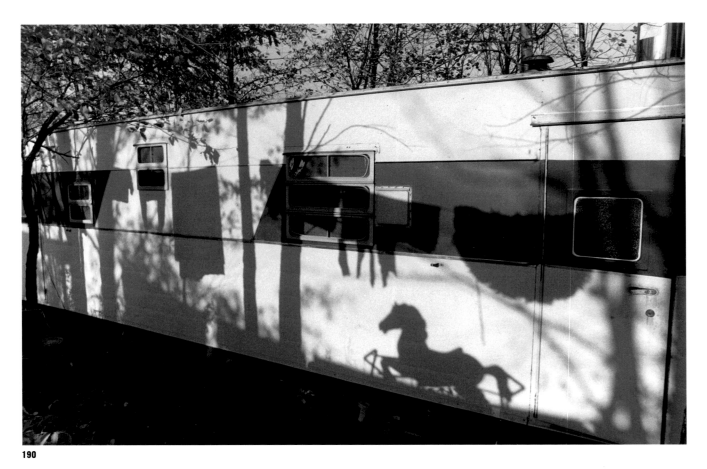

190

191

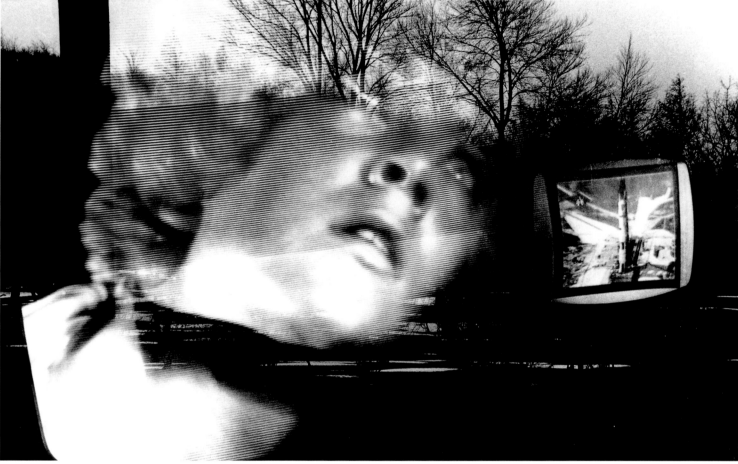

192

193

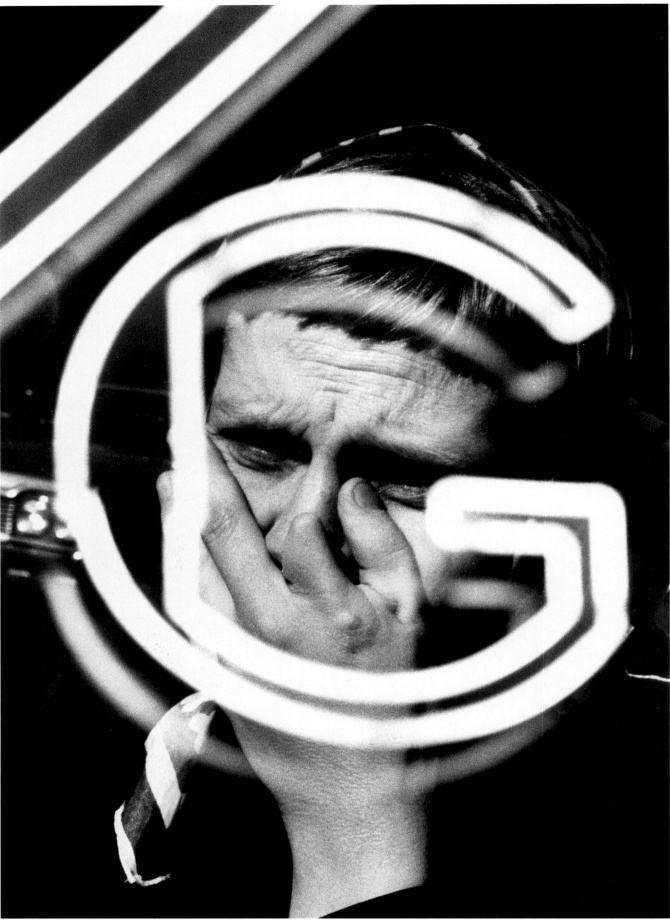

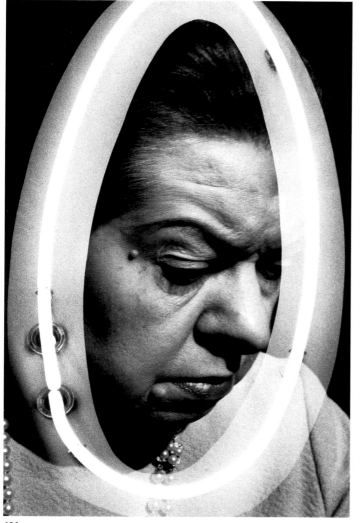

194

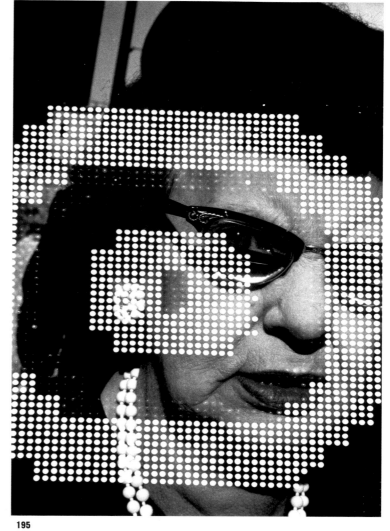

195

193 Barbara Crane, *Untitled*, 1969, cat. 44 **194** Barbara Crane,
Untitled, 1969, cat. 45 **195** Barbara Crane, *Untitled*, 1969, cat. 46

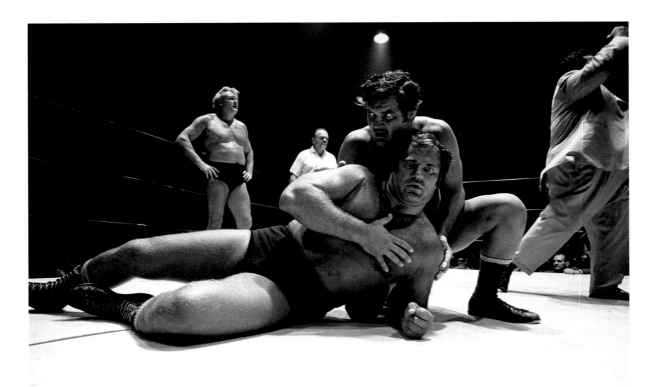

196

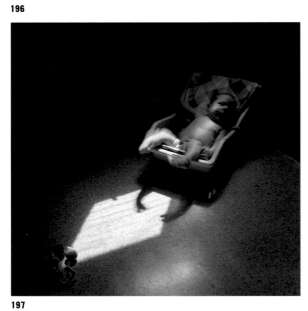

197

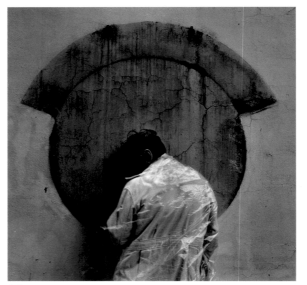

198

196 Geoff Winningham, *Tag Team Action*, 1971, cat. 206
197 Charles Traub, *Aaron, Chicago*, 1971, cat. 203
198 Charles Traub, *Meatyard, Kentucky*, 1969, cat. 202
199 Jonas Dovydenas, *Ironworker, Chicago*, 1969, cat. 49

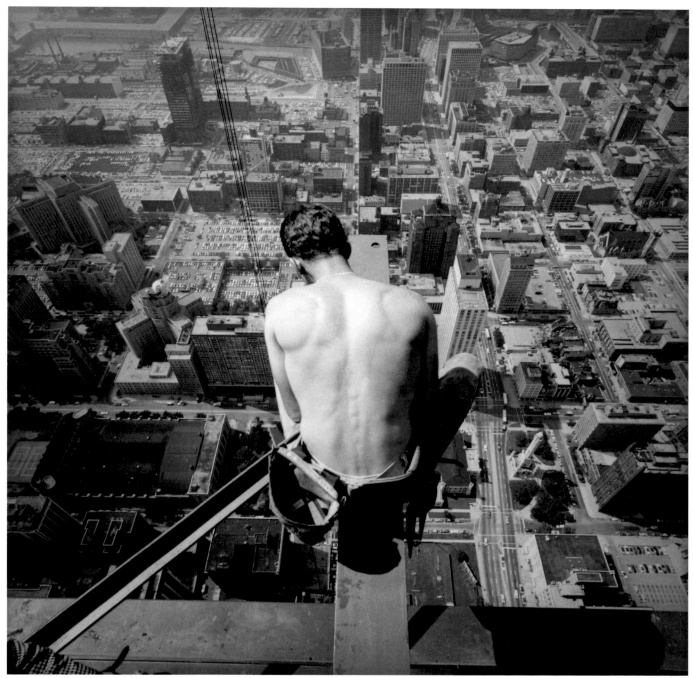

199

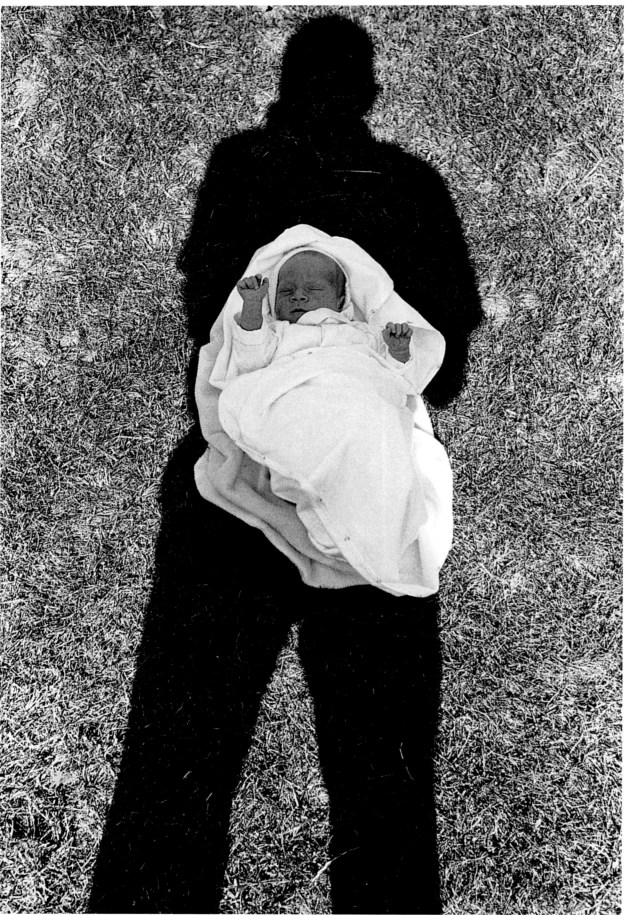

200 Plates, 1961–71

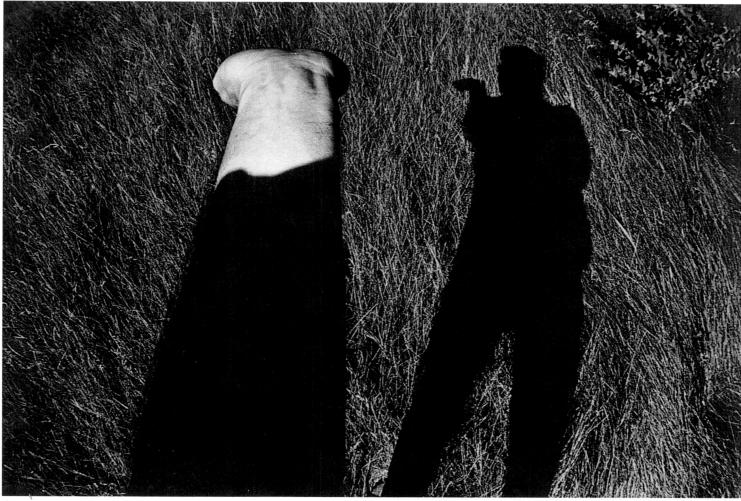

201

200 Kenneth Josephson, *Matthew*, 1963, cat. 78 **201** Joseph D. Jachna, *Door County, Wisconsin*, 1969, cat. 75

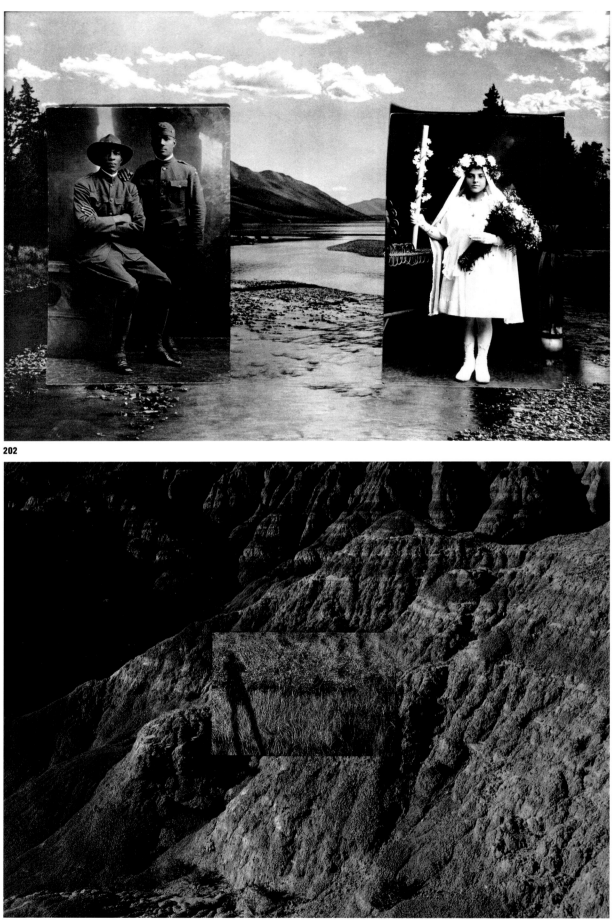

202

203

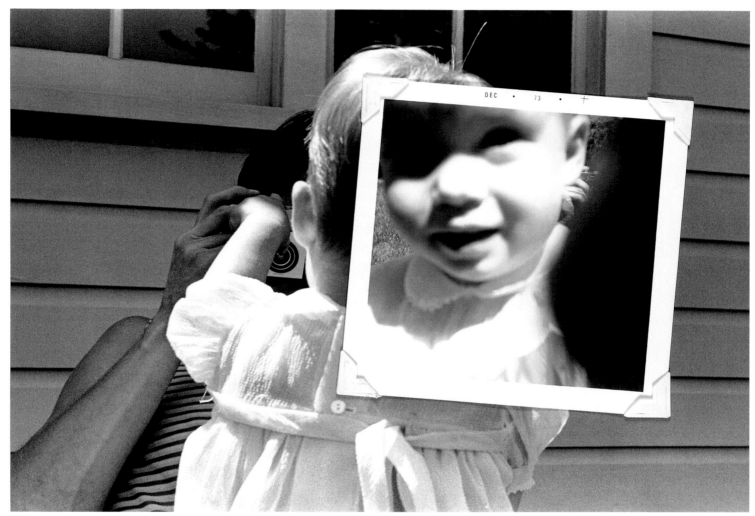

204

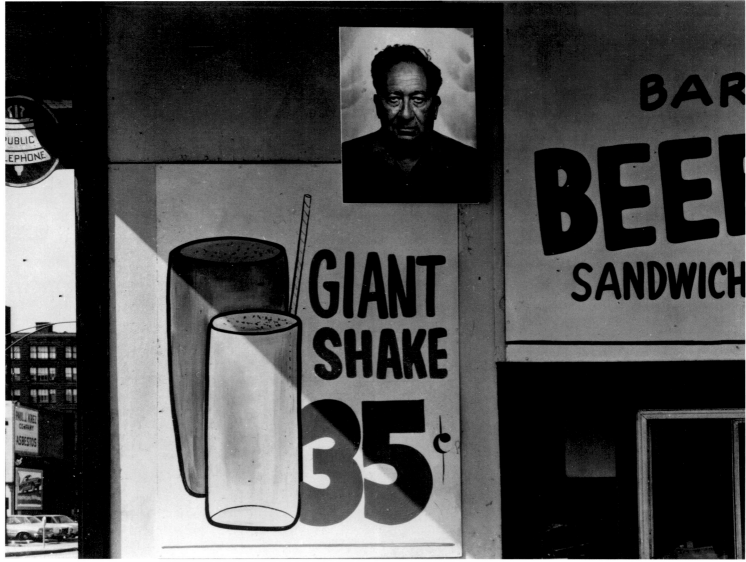

205

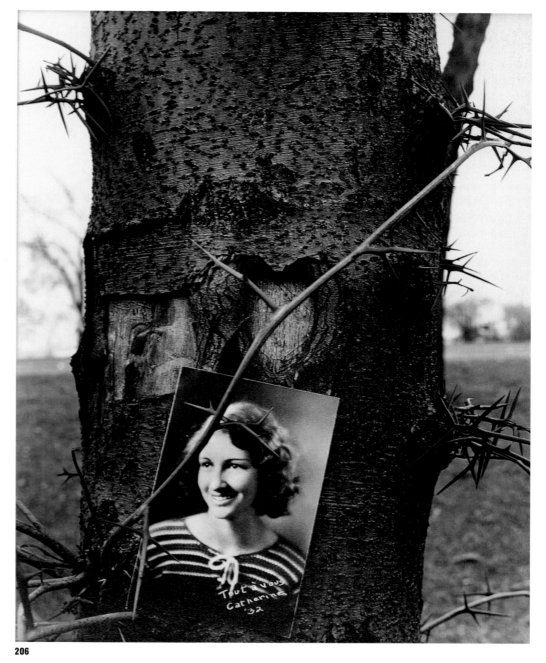

206

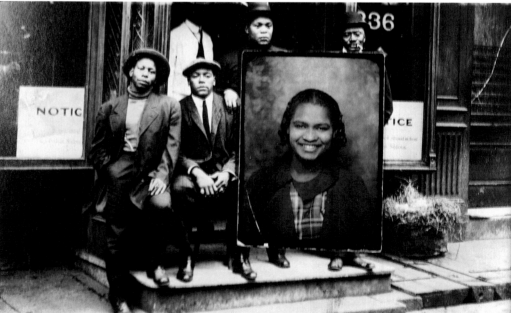

207

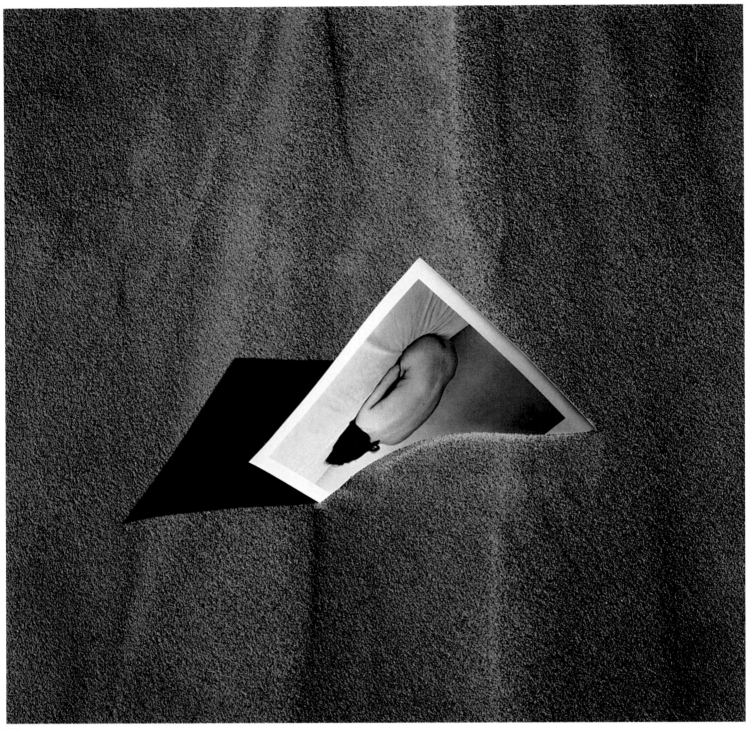

208

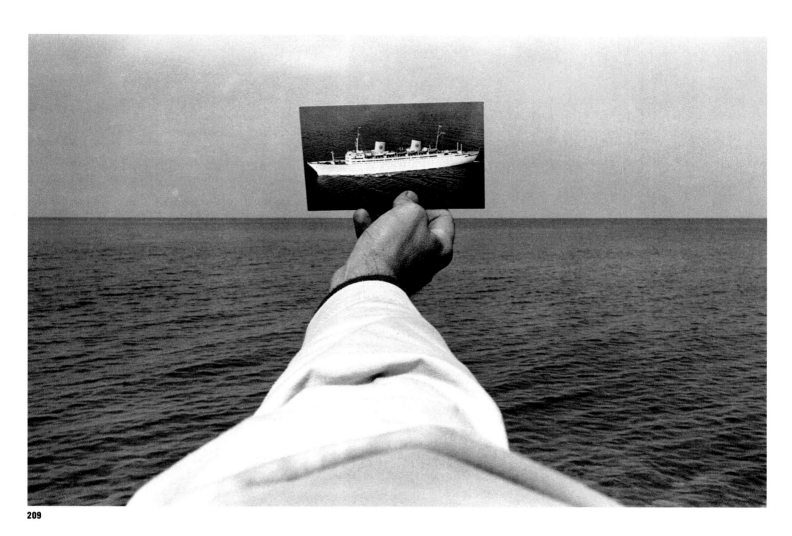

209

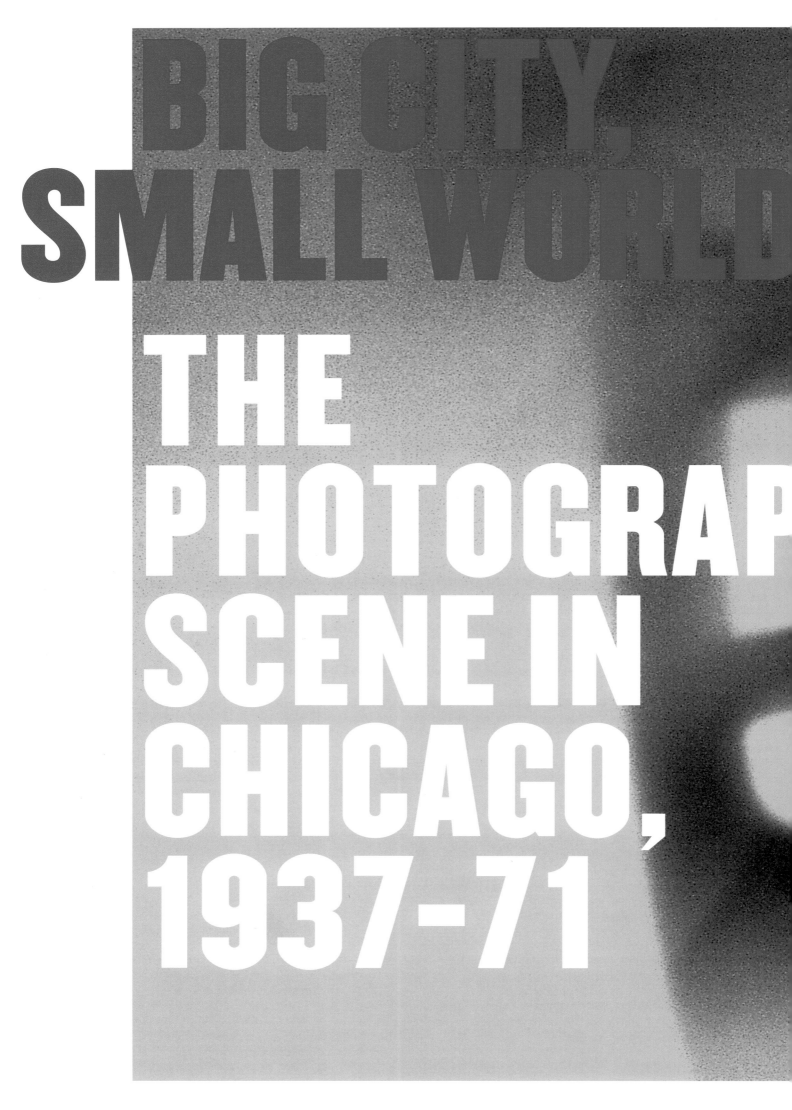

BIG CITY, SMALL WORLD

THE PHOTOGRAP[H]

SCENE IN

CHICAGO,

1937–71

Larry Viskochil

HY

When the New Bauhaus opened its doors in 1937, its students and teachers were not the only photographers in town. Chicago had for a century served as a center of photographic art and commerce, and it possessed an active photographic community. Hundreds of local firms specialized in portrait, architectural, and advertising photography, as well as in manufacturing and selling photographic equipment. Students at the New Bauhaus and later the Institute of Design would enjoy many opportunities to see the work of and associate with the city's commercial photographers, the members of its camera clubs and professional organizations, and numerous visiting photographers. Nevertheless, the ID constituted a separate world of experimental design, and its students and faculty did not actively participate in the everyday life of the photographic community. From its very beginning the New Bauhaus was, according to Arthur Siegel, made up of a "small group of maybe thirty people who just stuck around the school, talked, interacted. It was like an island in the city of Chicago."[1]

To heighten an awareness of the outside worlds of photography and inspire the student body, the ID invited artists and writers passing through Chicago to lecture, run workshops, and collaborate with its faculty. At the same time, both students and faculty gradually broke from the insularity of the school to participate in various photographic organizations such as camera clubs, which were enjoying a golden age in the 1940s and 1950s (fig. 1). For example, three principal ID faculty – Harry Callahan, Arthur Siegel, and Aaron Siskind – all had camera club roots before coming to Chicago. In addition, the Fort Dearborn Camera Club on Michigan Avenue was particularly well known to ID faculty and students like Yasuhiro Ishimoto, Marvin Newman, and many others who used its extensive darkroom facilities when their own lab space or that of the school was limited.

Institute of Design faculty and representatives of the commercial photography world also regularly spoke at local camera clubs. While some ID teachers decried the pictorialism and salon aesthetics that were still in vogue at many of the clubs in the 1940s and 1950s, camera clubs provided the only real photography community until the advent of professional associations for photographers, educational organizations for photography teachers, and art organizations that would include photographers. Professional groups like the Chicago Photographic Guild, the Council of Photographic and Art Studios, the Architectural Photographers of America, the Chicago chapters of the Professional Photographers of America and the American Society of Magazine Photographers, and other organizations would, over time, provide alternatives to the camera club scene.

Besides offering lectures, darkroom facilities, juried competitions, technical advice, and comradeship, the clubs and associations also offered a public face for members' work. Photography in Chicago had for decades been exhibited in "salons," juried public exhibitions whose goal was to legitimize photography as an art form and bring it to popular audiences. The Art Institute hosted such salons from 1900 until 1938 and

1

2

Fig. 1 A meeting of the Fort
Dearborn Camera Club,
1957.

Fig. 2 Two examples of the
Chicago photography
scene: advertisements for
Central Camera Co. and the
Institute of Design in *1948
Chicago International
Exhibition of Photography*.

the Chicago Historical Society filled this role from 1942 through
1947. Gradually, the Chicago Area Camera Clubs Association
(CACCA) took over this function. The annual catalogs that doc-
umented each salon list familiar names in the local and national
universe of art photography – Ansel Adams, Arnold Genthe,
Fritz Henle, Yousuf Karsh, Fred Korth, Mildred Mead, H. S.
Shigeta, Max Thorek, and more. Even young, future ID students
like Yasuhiro Ishimoto were regular entrants. Hoping to attract
such students, the ID placed a display ad in the 1948 catalog
promoting a curriculum offering "Photography as a creative
medium" (fig. 2).

There were limited opportunities to see photographs in a
museum setting. The Art Institute of Chicago held photography
exhibits in the 1940s in the Prints and Drawings Department,
but it was not until 1951, the year in which it opened a separate
gallery for photography, that it exhibited photography on a regu-
lar basis. Over the next two decades the opportunity to see pho-
tography there gradually increased, as the Art Institute staged
almost 130 exhibitions including one-person shows for such ID
faculty and students as Callahan, Siegel, Siskind, Ishimoto, Ray
Metzker, Joseph Jachna, and Art Sinsabaugh, as well as group
shows with many others associated with the ID. The Chicago
Historical Society also continuously exhibited photographs from
its massive collections of historical images and, in partnership
with CACCA, began a program in 1948 to systematically pro-
duce, publish, and show photographs of urban life and architec-
ture, helping create an atmosphere that was seldom found in
other cities of continuous urban photodocumentation. The
Museum of Science and Industry, the Field Museum of Natural
History, the Chicago Academy of Science, the Newberry
Library, and smaller ethnic and specialty museums also exhib-
ited photographs now and then from their collections relating
to their own missions.[2]

If museums were slow to exhibit photographs, there were
numerous other venues where one could see or display work.
Art galleries, like the Albert Roullier Gallery, also exhibited pho-
tographs in the thirties, and Katherine Kuh, the former Art
Institute curator of twentieth-century paintings, showed Ansel
Adams, Edward Weston, László Moholy-Nagy, György Kepes,
and others in her commercial gallery between 1935 and 1941.
After World War II a few more galleries sprang up, most notably
the 750 Studio, which two ID students, Merry Renk and Mary
Jo Slick, opened with a partner in 1947. They staged fifteen
exhibitions, including the work of several ID students and fac-
ulty, and gave Harry Callahan his first one-person show (fig. 3).
Student work was also exhibited by the Momentum Group in the
late forties and fifties as a reaction to being excluded from the
Art Institute's annual "Chicago and Vicinity" shows. In the fifties
and sixties, other commercial galleries across the city began
to exhibit photographs sporadically, including the Avant Arts
Gallery, Benedict Galleries, Bordelin Gallery, Baldwin Kingery
Gallery, ETC Gallery, Gallery 500D, Holland-Goldowsky Gallery,
Superior Street Gallery, the Seven Stairs Gallery in Stuart
Brent's bookstore, Werner's Book Shop, and Kroch's and

Brentano's Wabash Avenue bookstore (whose art department also served as a sort of unofficial library for ID students).

There were other places for ID students and faculty to see photographs as well. Hedrich-Blessing Architectural Photographers staged exhibits in their headquarters as early as 1935. Almer Coe Optical Company and, later, other photographic equipment firms and camera stores like Standard Photo and Altmans also occasionally displayed photographs. Other businesses – gift shops, design and furniture stores, hotels, movie theaters, and restaurants and taverns, such as Ricardo's Restaurant – allowed photographers to mount small exhibitions on their walls. The Old Town Art Fair and the 57th Street Art Fair showed photographs at their annual street exhibitions. The Cliff Dwellers and other private clubs; social service organizations like Hull House; the Old Town Triangle Gallery and other art centers; the McKerr Observatory and Gallery on top of the Board of Trade Building; and various other non-commercial locations also displayed photographs from time to time.[3] And, of course, the best photographic coverage of the events of the day could be seen in *Life, Look,* and other similar publications in what was becoming the great age of photojournalism.

Yet, having opportunities, limited as they were, to view photography in galleries and museums did not mean that ID students took advantage of them in any consistent way. More print viewing undoubtedly took place around kitchen tables in student apartments, at school parties, and at nearby bars than in any commercial gallery or institutional setting. Teachers frequently had parties in their apartments (to which students were invited) for photographers visiting the school or passing through Chicago. The ID photography community was, after all, a small one with only about fifty people heavily involved in it at any one time. Most of the faculty purposely did not show their work to students in the classroom for fear of blind imitation; their pictures, however, could be seen at school events like scholarship auctions or in the intimacy of their own homes.

Seeing photographs *in* Chicago often meant seeing images *of* Chicago. While documenting the city, or even specifically promoting social documentary photography, was not an established goal of the ID photography program, over the history of the school Chicago benefited as much from the ID's documentary work as the ID benefited from the city and from local photographic projects. Chicago's central location, its position as a hub for transportation, commerce, and industry, its varied population mix, and its architecture made it one of America's most studied cities, a metropolis that journalists and academics in many disciplines could use as a prototype.

A model for some of the documentary work that the ID produced in both early and later years was the ambitious record compiled by the photographers who worked for the Farm Security Administration (FSA) and its successor, the Office of War Information (OWI), during the late 1930s and early 1940s. The FSA/OWI sent several of its staff, especially Jack Delano, Russell Lee, and John Vachon, to photograph the Chicago area during the years when the ID was establishing itself and deciding its mission. The images they produced to examine Depression conditions and to promote the war effort were reprinted in academic studies of the city and in the popular press. The great picture magazines and the developing specialty periodicals devoted to photography as an art and craft were also widely available to the ID faculty and even to its poorest students. These publications also sent their photographic staffs to cover Chicago or hired local photographers, like Arthur Siegel, to do it for them. The photographs of well-known local photojournalists such as Mickey Pallas, Archie Lieberman, Art Shay, Wallace Kirkland, and Tony Rhoden were seen by large audiences throughout Chicago and on the national stage. Chicago-area newspapers and news services employed hun-

Fig. 3 Invitation to Harry Callahan's first one-person show, held at 750 Studio, Chicago, 1947.

Exhibition of photographs

harry callahan
10 november thru 29 november 1947

SEVEN FIFTY STUDIO

750 north dearborn street superior 3622
mary jo slick merry renk olive oliver
noon to 8 p.m. monday thru friday

dreds of others from the photo community as well. Because of their public forum, press photographers were the most visible to and most emulated by students of photography. The influence of the fine art photographer – not very prominent even today – was in its beginning stages during these years of the forties, fifties, and even the sixties. The "stars" of photography, other than Moholy, Callahan, Siskind, and a few others like them nationally, were the media-connected recorders and concerned interpreters of the American and world scene who could tell important social stories of interest to a broad audience.

Moholy had encouraged documentary work as well as "art photographs" from the beginning. His faculty saw no contradiction in doing both because of Moholy's stress of the Bauhaus principle of social reform through good design. At least two members of the faculty, Gordon Coster and Wayne Miller, were hired especially for their documentary backgrounds, and others, like Nathan Lerner and Arthur Siegel, had practiced social documentary photography extensively as part of their own work. Harry Callahan was so impressed with the teaching of Miller and Coster that he chose Aaron Siskind, an experienced social documentarian from New York, to come to the ID to teach. Siskind forcefully urged students to take advantage of the city's many likely subjects for documentation and interpretation such as Maxwell Street, Chicago's famous flea market and immigrant port of entry.

Photographing around Maxwell Street was a long tradition among photographers associated with the ID. Nathan Lerner recorded its inhabitants and decaying storefronts from about 1935 to 1940, although his images were not widely seen until years later. Ishimoto and Newman also covered the market and its active outdoor music and religious scene with both still and motion-picture cameras in the late 1940s and early 1950s. James Newberry undertook an extensive documentary of the market that became his 1973 master's thesis.

In their graduate thesis projects, many students chose to emphasize social commentary over formalism. Some would argue, as Ray Metzker did with his 1959 thesis "My Camera and I in the Loop," that his photographs of people and structures in downtown Chicago evolved into a personal statement rather than a document. Nevertheless, his images provide a unique record of a specific time and place and help document the character of the city. Other master's degree theses from the 1960s explored Chicago railroads, teenagers, underprivileged children, parks, skyscrapers, and neighborhoods.[4] Everyday class assignments also used the documentary approach as one vehicle for developing photographic skills and formal vision. Siegel's lecture courses even gave detailed instructions on how to research a documentary project: from reading newspapers to conducting interviews to sheer observation.[5] Photographic projects were sometimes initiated by the community rather than by the school and its faculty. When the Chicago Housing Authority, for example, suggested that documenting its housing projects and the surrounding slum areas might make a good class assignment, the school readily agreed. Faculty used their influence to gain access for students into buildings, meetings, political conventions, and other public and private spaces and events.

Photographing architecture was a natural consequence of the school's close involvement with architectural design. With its Bauhaus origins, much of the ID curriculum was devoted to the discipline. It was a happy accident, then, that the school was located in a city of such architectural importance: the photographic documents created over the years constitute a truly astounding legacy. Siskind, for example, began assigning a class problem to photograph buildings designed by architect Louis Sullivan shortly after he had arrived at the ID in 1951.[6] He soon converted the assignment to a standing production unit of students who hoped to provide a useful product in the spirit of the ID's mission. Some students, particularly Richard Nickel, who made Sullivan the subject of his thesis, continued to photograph architecture in Chicago and across the country for years. Siegel also contributed greatly to the documentation of Chicago architecture when he joined his students in an assignment to produce Chicago's Famous Buildings (1965). The book began as a list of Chicago's landmarks that Siegel assigned as a shooting script. Over the years ID graduates and teachers would use their skills to document the city in other ways. Art Sinsabaugh's Chicago Landscape document of the "prairie city" had the support of city agencies, and later government programs, such as the Historic American Buildings Survey, would employ ID-trained photographers as well as others from the commercial community.[7]

The city has also been blessed with important commercial architectural photography firms throughout its history. Among them were the Chicago Architectural Photographing Company, the Fuermann Brothers, and Kaufmann and Fabry, the official photographers of the 1933 Century of Progress Exposition. The best-known internationally is the firm of Hedrich-Blessing, which, founded in 1929 as a family business, originally made a name for itself when it was commissioned by Chicago architects to record their work at the Exposition. Ken Hedrich's innovative images of Holabird and Root's Chrysler Building and George Fred Keck's House of Tomorrow brought the firm work from the great architects of the day, including Frank Lloyd Wright and Mies van der Rohe.[8] The faculty and students at the ID and the city's commercial architects and photographers could not help but notice each other's involvement with the growing "Chicago School" of architecture.

The ID, from the beginning, had not opposed commercial photography. Indeed, Moholy and other faculty promoted the differences between the pure aestheticism of art schools and the ID's more practical purposes. Moholy did commercial work himself, as did Callahan and Siskind. Siegel made most of his living from commercial assignments, and most other photography teachers at ID worked in the business at least part-time. Some students at the ID had professional experience before they came to the school for more education. Others, like many of the GI Bill recipients after the war, were clear in their desire for quick training for a professional photographic career. They all

competed within – and benefited from – a lively and long-standing commercial photography environment in the city.

The largest employers of commercial photographers were the studios that catered to the needs of Chicago's retail stores and mail-order catalog giants like Sears Roebuck, Montgomery Ward, Aldens, and Spiegel. Kranzten Studios, for example, had over a hundred employees in the catalog heyday. Kaufmann & Fabry, another large commercial studio, started out as an outdoor architectural photography firm but gradually moved to interior work such as banquet and convention photography and advertising photography. Other active firms, like the Moffett Studio, specialized in portrait or wedding photography and employed large staffs, and Root Photographers was the biggest school yearbook photographer in the Midwest with almost fifty photographers. Many other commercial photographers worked alone or had small studios with few employees or apprentices. Stephen Deutch, who occasionally spoke at ID, "did everything – except food or buildings" out of his studio on Wacker Drive where he worked for forty-three years. Another occasional speaker at ID was Rus Arnold, who wrote for *Camera 35* and other photographic publications and maintained a large and varied commercial practice in Chicago's Hyde Park neighborhood. Fred Korth specialized in industrial photography and images of Chicago; in 1949 he published *The Chicago Book*, a pictorial study that gained considerable local and national attention.

With all the work being done by the catalog-house photographers and in small studios for the large department stores and other apparel outlets, fashion photography became a substantial business for many photographers in postwar Chicago. Even Arthur Siegel gained considerable commercial income from his fashion work, and some later ID students, like Kenneth Josephson, dabbled with the idea of being fashion photographers. Victor Skrebneski, who briefly studied photography at the ID in the late 1940s, is clearly the most prominent of those who followed this path. Skrebneski opened his studio in 1952, and his images soon helped define a Chicago fashion photography style. Stan Malinowski, another ID student, opened his studio in 1963 and also specialized in fashion. Like Skrebneski, Malinowski saw his work widely published in both fashion and general magazine advertisements. Other studios specializing in advertising and illustration, annual reports, copy work, portraiture, and other services added to the city's vibrant photography scene. Students from the ID looked to these concerns for inspiration, employment, and further professional education.

Many of these commercial studios provided informal apprenticeship programs to train photographers in their specialties. Hedrich-Blessing apprentices, for example, would eventually populate leading architectural photography firms across the country in much the same way that students from the ID would initiate photography teaching programs everywhere. Beyond the School of the Art Institute, other photography schools rivaled the ID. Most were more trade schools than art or design colleges, but they were viable alternatives. The Ray-Vogue School (formerly the New York School of Photography) offered regular instruction for those interested in fashion, product, or other commercial work. Later, the Winona School of Photography, backed by many of the commercial firms in the area, would provide training classes and seminars for several commercial photography disciplines.

The Chicago photographic community was also served by a wide assortment of photographic equipment retailers, manufacturers, and photofinishers. L. F. Deardorff and Sons, a manufacturer of large-format cameras, stayed in Chicago because all the big catalog houses used their cameras to photograph products. Callahan used to have Meryl Deardorff himself come to his classes to demonstrate view cameras, and Sinsabaugh had Deardorff build a 12-x-20-inch camera for him when he needed a special instrument to interpret the "prairie city." Photographic supply stores like Central Camera, Standard Photo, and Altman's served as unofficial meeting places for ID students and the rest of the photographic community. These stores also did photofinishing for students without easy access to school labs or home darkrooms. The first custom black-and-white lab in Chicago, Astra Photo Service, did not open until 1955. In 1959 photojournalist Mickey Pallas opened Gamma Photo Labs for magazine photographers and freelance professionals. Labs like these employed ID students and also served as a place of communal interaction, even providing exhibition space, for photographers across the city.

Graduates from the ID seeking to enter Chicago's photographic community had many options beyond the fine art of their teachers. While many elected to become teachers themselves, many others chose photographic careers in journalism, architecture, preservation, social reform, advertising and illustration, and other commercial fields. Yet, even though the opportunities were large, the photographic community itself was relatively small. Those trained at the ID often received as much of an education in the life of the city and its commercial and artistic practices as they did in the philosophy and methodology of the institution in which they studied. The business climate favored photographic visions of the world that were marketable rather than avant-garde, preferred personal approaches lacking self-conscious artfulness, and picked practical solutions rather than personal conceptions and self-revelations. One result is a documentary tradition that has produced an extensive picture of a city that is both useful and expressive. As the business leaders who brought the school to the city and promoted its growth had hoped, the ID, the city's commerce and industry, and the people of Chicago benefited mutually from each other's presence. The Institute of Design could not have chosen a better place to develop and share its unique vision.

VISION IN MOTION

FILM AND PHOTOGRAP AT THE INSTITUTE DESIGN

Elizabeth Siegel

The sound film is one of the most important inventions of our time. It will enlarge not merely the visual and acoustic capacities of mankind, but also his consciousness.[1]

László Moholy-Nagy, 1932

I think every still photographer now and then thinks they ought to do movies, and I wanted to try it.[2]

Harry Callahan, 1977

Around 1948 or 1949, Harry Callahan, like many still photographers, thought he ought to do movies and indeed decided to try it. He got hold of a movie camera and made two short films, *Motions* and *People Walking on State Street*.[3] These silent, black-and-white films seem like his familiar photographs magically sprung to life, as women saunter along Chicago's State Street, light flickers upon water, and a flashlight traces lines in a dark room. As investigations of movement and form, these films make sense not as part of any tradition of narrative cinema, but rather as logical departures from still photography; they rightly belong to the domain of fine art rather than theater.

There is something about the medium of film that has made many still photographers long to trade in their Graflex for a Bolex, to expand their learned skills of formal composition by encompassing the variables of time and motion. Yet film and photography have maintained separate histories, and the theoretical and practical intersections of the two have fallen into a kind of historiographical gap.[4] The connections between them are murky at best: is film simply photography in motion, or is it something more – something to do with time, subjectivity, editing, or narrative? Do photography and film share certain formal and ontological characteristics, or do they operate in two entirely different systems? Is there a natural, fluid transition from still to moving pictures, or is it much more complicated than it first appears? The many photographers who have also made films – in addition to Harry Callahan, László Moholy-Nagy, and others from the Institute of Design, one could also name Brassaï, Anton Bruehl, Robert Frank, Helen Levitt, Danny Lyon, Gordon Parks, Man Ray, Paul Strand, and Charles Sheeler, to pick only some notable examples – attest to the fact that the strict separation of the two media occurs only in the realm of criticism and reception, not in artistic practice. Jan-Christopher Horak, in the first comprehensive study of the links between still photography and cinema, has shown that photographers who made films were critical to the development of avant-garde cinema, and that they gave that medium a very specific kind of subjectivity in keeping with the individual vision of a photographer.[5] Particularly in the realm of abstract film, where narrative is secondary to form, photographers have contributed greatly to an expansion of film's expressive possibilities.

Callahan, then, was not the only still photographer to venture into film; he was not even the only one at the Institute of Design. Instead, he was building upon a tradition of film exploration that had been practiced at the school since its earliest years with Moholy. Yet the cinematic production of the ID is strikingly absent from histories of avant-garde or experimental film,

although it provides a missing link of sorts between the European avant-garde and experimental American filmmaking. The standard account of avant-garde cinema locates its origins in the 1920s and 1930s in France, Germany, and the Soviet Union, with particular emphasis on abstraction and surrealism. According to this narrative, when European artists immigrated to the United States around World War II, experimental film followed; Maya Deren's 1943 *Meshes of the Afternoon* is commonly regarded to be its first American flowering.[6] There are several likely factors that contributed to the historical omission of the ID's cinematic work: first, Moholy himself moved outside of film circles; second, the films produced by ID faculty and students were not screened for mass audiences, but were rather more insular and personal endeavors; and third, Chicago was not the mecca for film production and reception that New York or even San Francisco was. Still, Moholy's connection to European avant-garde cinema and his subsequent influence on film production at the school – as well as the wealth of films made under the school's auspices after his death – suggest that this absence from the standard histories needs to be corrected.

A close examination of some of the films produced at the Institute of Design will help fill in these critical gaps between the European and American cinematic avant-garde and will elucidate the relationships among photography, film, and the artists who choose to pursue both. From the school's beginnings with Moholy and his concept of "vision in motion," through the years of individual, subjective vision under Callahan, and well into the 1960s that brought forth a return to experimentation, film at the ID was taught and practiced in tandem with photography. Perhaps because of this, ID films share certain themes and formal properties; non-narrative, often abstract and experimental, they are concerned with the possibilities and limitations of film itself. Film was dependent on, and affected by, photographic practices at the school, and in turn, photography also became more cinematic. This intimate and reciprocal relationship generated an extraordinary group of films that are only now beginning to get the attention they deserve.

By the time Moholy arrived in Chicago in 1937 to head the New Bauhaus, he had already been experimenting with and writing about film for over a decade.[7] Long before he actually produced a film, Moholy had written several screenplays, dreaming of how he might put his vision into motion. His graphic sketches for *Dynamic of the Metropolis* (1921–22), *Once a Chicken, Always a Chicken* (1925–30), and *Lightplay Black White Gray* (1930) – of which only a portion of the last was executed on film – reveal an overriding concern with symbolic content, camera angle, and rhythmic sequencing over any movement into three-dimensional space.[8] The first motion picture he finally produced in 1929 was an impressionistic study of the old port of Marseilles, France.[9] Moholy's next film better approached his stated cinematic goals: the abstract *Lightplay Black White Gray* tracked his specially designed Light-Space Modulator in motion, as light reflections danced upon its shimmery and perforated

surfaces. A series of more documentary and amateur movies followed, including films on the Architecture Congress in Athens and the London Zoo, as well as home movies of his two daughters. Moholy would eventually go on to produce at least ten films, in addition to directing group projects and documenting student activities at the School of Design.

But it was in his writing on film, more than in creating films themselves, that Moholy would leave his mark. Film would become for him the purest expression of "vision in motion," the title of his posthumously published book, in which he summed up his philosophical and pedagogical aims. Moholy defined this central concept as "simultaneous grasp" and "seeing while moving," which were the appropriate modes for comprehending modernity; it was a concept that encompassed both artistic practice and vision proper.[10] Moholy was frustrated by mainstream cinematic practice, however, which he felt was dominated by antiquated conceptions derived from painting. To combat what he perceived as a dependence on pigment over light and a reliance on still photography, he suggested mobile spatial projection, achieved through such means as convex or concave screens, a succession of transparent screens, or the simultaneous projection of several films. Film was to be the ultimate visual statement for the modern age, a medium that possessed revolutionary potential to "enlarge not merely the visual and acoustic capacities of mankind, but also his consciousness."[11]

For Moholy, film was the logical culmination of a series of moves away from easel painting toward the harnessing of light itself as a pictorial medium. He went so far as to assert, in 1932, that Kazimir Malevich's Suprematist painting *White Square* (1918) symbolized nothing so much as the film screen, the perfect backdrop upon which to project light in motion.[12] Cinema, as he presented it, emerged from a tradition of fine art rather than one of theater or literature, and abstract film was the proper expression of its possibilities. "Painting, photography, film and television are parts of one single problem although their techniques may be entirely different," Moholy explained. "They belong to the same realm; that is, to visual expression, where cross-fertilizations are possible."[13] Not an end in itself, photography was a critical step in this evolution toward vision in motion, its light sensitivity part of the key to film.[14] Indeed, there existed strictly photographic strategies for achieving this integrated or simultaneous vision, such as multiple-exposure, which revealed time across a single picture plane; but when photography was made to *move*, the possibilities for modern expression were limitless.

Moholy brought his fascination with and theories of film with him to the New Bauhaus in 1937. The fledgling school optimistically listed film as part of the teachings of its Light Workshop, although no motion pictures seem to have actually been produced that first year. This was doubtless a function of time and of equipment: the first year, all students went through the Foundation Course workshops, intending to specialize in the later semesters, and the course catalogue seems overly hope-

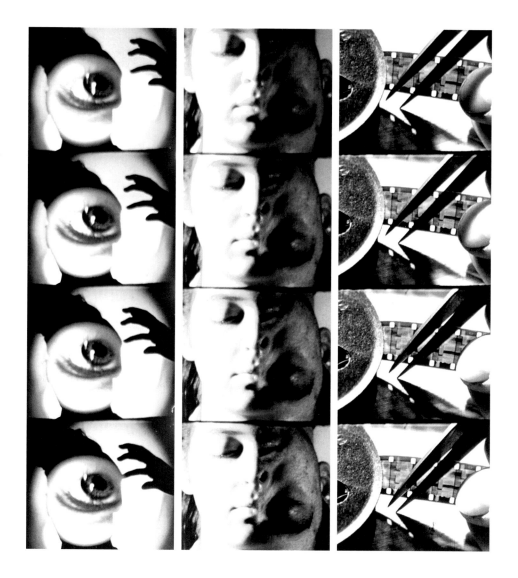

Fig. 1 Frames from *Do Not Disturb* by László Moholy-Nagy and students from the Institute of Design, 1945.

ful in terms of what students might accomplish, especially with meager resources and a hurried starting schedule. Brochures for the reorganized School of Design also suggest that work in film would follow experimentation with still photography – a pedagogical structure fully in accord with Moholy's belief that film emerges from photography – and one flyer offered an evening course specifically geared toward film, "Experiments in the Motion Picture." But it was not until 1942, when the school received a grant from the Rockefeller Foundation for photographic and motion-picture equipment, that film production became a reality. At the first graduation ceremonies, in June of that year, Moholy inaugurated his new moving-picture program with three rolls of 16mm color-film footage celebrating the work of the students; this film would eventually be released in 1944 as *Design Workshops*, motion-picture publicity for the school.[15] Other documentary projects followed – mostly in color, a technology that thrilled him – including films on year-end exhibitions and students working in the photography room. Moholy explained in the 1942–43 course catalogue that the

Rockefeller grant would help "the School to continue the avant-garde work which has been so essential in making the film a prominent part in our search for contemporary expression."[16] Film would henceforth occupy an important position in the school's pedagogy, and the program left no doubt about the avant-garde territory it would inhabit.

In 1945 Moholy directed the motion-picture class at the school in the production of an eighteen-minute 16mm color film called *Do Not Disturb* (fig. 1). In a cooperative endeavor typical of the early years of the Institute of Design, the students were the actors, writers, cinematographers, editors, and crew.[17] The film followed a basic story line of two young women and two young men in love, but revealed underlying tensions made apparent through dream sequences and repeating symbols. Abstract and experimental, the short film emphasized emotion over traditional narrative, with jealousy a recurring theme. The students, under Moholy's direction, approached the project with the same kind of openness one would find in the Foundation Course, delighting in the possibilities of the Parallex camera.

They loosely followed the shooting script, taking advantage of both intuition and available materials. As Richard Filipowski, a student in the motion-picture class, later recalled, the shooting had a spontaneous flavor: "We thought it was a good day to shoot outdoors, so we'd wander around and do that. Or we dreamed up a scene where I would jump through a flaming cut-out, and we did that…. So we made it up as we proceeded. We'd shoot, and then we'd review what we had, and we'd store it away, and then the final project was putting all these snippets together."[18] In his capacity as director of the project, Moholy would review the day's splicing and urge Filipowski, who served as the provisional editor, to remove a frame here or there to tighten a sequence.

The result is a classic example of ID experimentation, and typifies the look of cinema in the school's early years. *Do Not Disturb* employed such techniques as multiple exposure, reverse motion, handheld camera, selective depth of field, split screen, prism lenses, extreme close-up, rapid motion, and distortion and tricks with mirrors. In this respect, the film paralleled the photography being taught and practiced at the school at the same time, corresponding in spirit to Moholy's "eight varieties of photographic vision."[19] It was also a perfect teaching project, since it allowed students to discover and extend film's inherent properties and possibilities and then put their technical skills to the service of a finished piece. The repeating symbols montaged throughout the film to relate characters and express emotion – roses, doors opening and closing, fire, photographs of women in magazines, boiling liquid – allowed the students to circumvent traditional narrative in favor of an abstract surrealism that approached that of the European avant-garde.

Do Not Disturb is also a film that is well aware of its photographic origins. Besides explicitly referencing photography – showing students in the photography studio, with close-ups on a light meter, a camera with its aperture opening, lights, and seamless backdrop paper – the students actually recreate one of Moholy's famous photomontages, *Jealousy* (figs. 2, 3). This 1927 image depicts repeating silhouette portraits of Moholy and a crouching sharpshooter aiming through him at a woman passing by; its symbolic resonance sets the tone for the film. In the film, as Filipowski walks through a hole in the seamless paper that echoes the silhouette of Moholy's photomontage, a camera snaps, and we then see the students gluing cut-out figures, including the portrait of Moholy, to a piece of paper to reconstruct *Jealousy*. Later, they stare at it pinned to the wall, casting their own shadows on the picture's silhouettes. In revealing film's debt to photography, however, the filmmakers also highlight a crucial difference: photomontage operates in the realm of synchronicity, where everything happens at once across the picture plane, whereas film possesses temporal linearity, unfolding in frames across time. Both can be said to represent Moholy's concept of "vision in motion." In the end, however, cinema appears to win out: the final seconds show a reel of film; a pair of scissors snips an editing cut, and the screen goes black.

Films such as this were made in a relative cinematic vacuum, for Chicago did not have the filmmakers and viewership of cities like New York or San Francisco, which had thriving cinema communities. During the early years of the school, students and teachers who produced films did so more within the context of the Foundation Course than of avant-garde cinema.[20] Although students recall Moholy screening *Lightplay Black White Gray*, it was not until he hired Arthur Siegel to start up a specialized photography program that films were regularly shown at the school. The 1946 "New Vision in Photography" summer seminar kicked off this new program, and along with photographs, the brochure declared, "Motion pictures will be shown and discussed with the aim of achieving a perspective for their future development."[21] Siegel assembled a screening schedule of some fifty films from Europe and America, including the latest documentary and experimental pictures. He began with Moholy's films (including *Do Not Disturb*), and proceeded with some of what are now considered classics of the medium: *Un Chien Andalou, The Cabinet of Dr. Caligari, Meshes of the Afternoon, Potemkin, Ballet Mécanique,* and more; these would become models for the practice and potential of avant-garde cinema.[22] After the 1946 seminar (and Moholy's death later that year), Siegel remained to teach the history of photography and film, often screening and commenting on film series. His commitment to the medium was something of an anomaly in 1940s Chicago. "You have to put this in context," he later recalled. "Nobody was interested in motion pictures except nuts."[23]

At the same time that the school offered film analysis, it also began to focus more on teaching film production, variously employing Robert Longini, Robert Edmunds, Jiri Kolaja, Ferenc Berko, and former student Filipowski to teach "The Art of the Motion Picture" as part of the Photography and Film Workshop. As in the photography courses of this period, film classes were structured around problems and technique, beginning with basic use of the camera and experiments with slow and fast motion, superimposition, positive and negative images, color, and sound. Students were then to work in a film production unit, learning scripts and editing, and collaborating with other workshops and community groups on experimental, documentary, educational, scientific, and industrial films. In a departure from the Moholy era, in which experimentation was often its own end, the coursework culminated in a finished product, with an emphasis on personal direction and expressive form.[24] Photography and film were still seen to be on a pedagogical continuum, however, and thoughtful teachers of both, like Berko, tried to unite them in the classroom. In a memo to Arthur Siegel, he suggested making experimental shorts with the students that would draw upon their exercises in photography with the goal of a "closer interrelationship between films and photographic problems."[25]

Some of the films produced in the late 1940s and early 1950s forged exactly that connection. Harry Callahan's *Motions,* for example, seems explicitly photographic, perhaps because it so closely echoes his own photographs and his try-

anything approach to formalism (fig. 4). In this nine-minute, black-and-white silent film, many of the signature techniques he employed in photography are present: in-camera multiple exposure, high-contrast abstraction, an investigation and elevation of the ordinary around him. To these still experiments, he added kinetic ones. As he later recalled, "I photographed movement, and I think I had everything in it except the kitchen sink. I tried slow motion, fast motion, holding the camera upside-down – everything I could think of."[26] It was as if all his pent-up energy of wanting to make his images move were finally released, and the effect is mesmerizing even today. The motion occurs mostly in the subject matter: pedestrians striding down the street, cars zooming down Lake Shore Drive, cracked ice floes softly butting and parting. In a remarkable sequence, the movement battles against itself in double exposure, as the cars head in one direction and water patterns pass by in the other. Callahan filmed much of this from the single-point perspective of a still photographer, with occasional sweeping pans following a car or a person, and some experimental jerking of the camera, but little movement into space. In the editing, however, he found a kind of musical rhythm, a back and forth that adds another level of motion to the whole. Perhaps the most kinetic shot is also his most personal: a mobile self-portrait of Callahan filming from a moving car, his shadow merging with the street's textures in a moment of self-referentiality rarely seen in his still photographs (fig. 5). Like photography at the school, film was becoming an individual endeavor, one with opportunities for an outwardly directed, yet highly personal, vision.

Two of Callahan's students, Yasuhiro Ishimoto and Marvin Newman, also produced a film closely related to their photographic investigations.[27] *The Church on Maxwell Street,* a black-and-white sound film the two made in 1951, documents the spectacle of an outdoor revival meeting at Chicago's famed immigrant flea market, an area both men had extensively recorded with still cameras (and a general favorite among ID students interested in documentary photography) (fig. 6). The film was a joint effort: Newman had learned the rudiments of film in a class at the school, but Ishimoto, who had a lucrative side job and thus was one of the only students at the school ever to have any money, owned the camera, a 16mm wind-up Bolex.[28] Both worked the film camera, and, as Newman later recollected, they made a lot of mistakes, including shooting the film at silent speed, and the sound at sound speed. Unable to match the sound with the images, they returned to Maxwell Street and recorded sound inside the church, eventually overlaying the prayer songs with the footage. The disjunction between film and sound is not immediately apparent, however, because the music acts as background to the close-ups of hands clapping, mouths moving, and feet tapping. As in Callahan's *Motions,* the energy of the film is found more in the kinetic subject-matter than in its treatment, with the two students employing a few rapid pans but otherwise a fairly stationary camera. It is in the editing that they depart most from the limitations of the single, still photograph, as when they cut back and forth between a boy convulsively and ecstatically dancing and a man on crutches being urged to attempt to walk again.

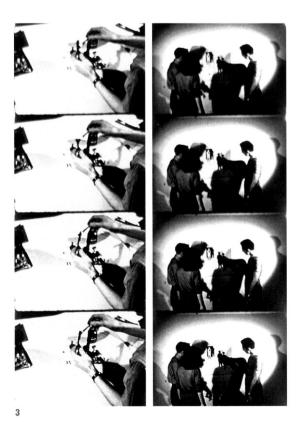

Fig. 2 László Moholy-Nagy, *Jealousy,* 1927, collage with photographic/photomechanical and drawn elements, George Eastman House, Rochester, New York.

Fig. 3 Frames from *Do Not Disturb* by László Moholy-Nagy and students from the Institute of Design, 1945.

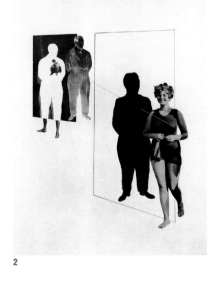

2

3

Not surprisingly, the hallmarks of these films made by photographers are often single-point perspective, careful composition, and, in particular, creative editing. Sequencing photographs was standard practice at the Institute of Design, and perhaps the school's most lasting contribution to photographic pedagogy was the "body of work" – the thesis. In fact, Newman was one of the first students to receive a master's degree in photography, and his thesis, "A Creative Analysis of the Series Form in Still Photography" (see fig. 13 in the essay by Keith Davis), spread a single photographic idea over numerous frames in a near-cinematic structure. Callahan himself worked in series, several at a time, and noted this connection: "The series gave rise to the thesis, which was really an enlarged series. I have always felt that all of my work was the series."[29] In the context of a group of images collected or sequenced together in a specific way, any single photograph was not so much the decisive moment as it was a succession of moments.[30] The linkages between pictures – or between film sequences – provide order, create rhythm, and sometimes imply narrative. Thus, just as these films are rather photographic, photographic practice at the ID had a particularly cinematic component.[31]

In contrast to the films of the 1950s, ID film production in the 1960s took place in an increasingly self-conscious environment. One significant change was the prominence the school now accorded to cinema; for the first time (beginning in 1967), students were allowed to submit a master's thesis in cinematography – a film, in other words – for their photography degree.[32] Another was the context of film reception in Chicago, as groups like the Center Cinema Co-op, the Magick Lantern Society (later, the Film Center at The School of the Art Institute of Chicago), and the Filmgroup at N.A.M.E. Gallery (later, Chicago Filmmakers) sprang up to screen and nurture contemporary experimental films.[33] Still, a strong relationship remained between cinematic and photographic practice at the school. As former student Brian Katz put it, "There didn't seem to be a difference at the time. It was just another kind of photography. You thought about it a little differently."[34] The film *Alphabet*, a student project directed by Arthur Siegel, was an extension of the popular ID photographic assignment to discover and document the alphabet out in the world. With clips of neon lights, animations, and other letters, the film is an elegant treatment of shapes and form in a found environment. Robert Stiegler's *Lichtspiel Nur 1* (1962) strung together frames of stills (basically, photographs) of blurred light in a manner reminiscent of Moholy's or Callahan's color images, questioning the nature of motion depicted in still photography and film. And Larry Janiak, who joined the faculty in 1968 to teach film and animation, made films inspired by the school's first photographic images,

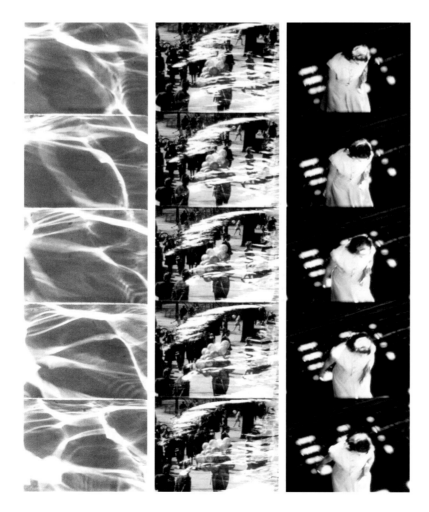

Fig. 4 Frames from *Motions* by Harry Callahan, 1948/49.

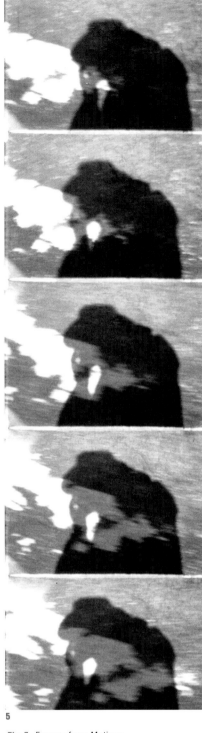

Fig. 5 Frames from *Motions* by Harry Callahan, 1948/49.

Fig. 6 Frames from *The Church on Maxwell Street* by Marvin Newman and Yasuhiro Ishimoto, 1951.

Fig. 7 Frames from *Silent Sound* by Kenneth Josephson, 1964.

the photogram – he made films without a camera. In his 1970 piece *DL #2 (Disintegration Line #2)*, he applied photochemicals directly to the film to create mesmerizing, entirely abstract spots and patterns, returning full circle to Moholy's goals of painting with light and color.

Two films by Kenneth Josephson illustrate cinema's intimate connection with, and then departure from, a photographic way of seeing. His first film, *33rd and LaSalle* (1960–62), documents the demolition of an old building at that intersection, focusing on still pictures hotographs within the building and film posters on its exterior – amid the wrecking ball's destruction. With meticulous framing through windows and walls, Josephson presaged his own later "Images within Images" photographic series, which themselves have a cinematic component.[35] In his second film, *Silent Sound* (1964; fig. 7), he treated the entire film-going experience as part of the production process, and the film became a performance that must be enacted through time, with perhaps unwitt' ng participation. Explicitly about film, *Silent Sound* (so called because the projec-

tor's whirring supplies the soundtrack) follows the course of a 16mm film being screened until it breaks, and the projectionist has to rethread it in front of a waiting audience. The film collapses the depicted and actual events, which both occur simultaneously; with time progression a crucial component, it is tied more to performance art than it is to photography.

After 1971, cinema at the ID became separate from still photography, completing the process of specialization that was begun when the photography program split off from design in 1946. From this time on, film and animation gained in significance as an art form on campuses throughout the country, and would later be joined by video, whose influence continues today.[36] At the Institute of Design, the history of film before 1971 is the history of films made by photographers; this was not necessarily the case elsewhere, nor would it be later. The films produced under the school's auspices reflect this: highly formal to the point of abstraction, more concerned with vision than narration, and with a predilection for still montage over a kinetic camera, ID films, for the most part, are photographs made to move.

Filmography

The following is a partial record of films completed at the Institute of Design prior to 1971; it does not include films made before or after a photographer's tenure at the school (for example, the early films of László Moholy-Nagy are not included). Every attempt has been made to list all the participants and their films, although it should be recognized that a list such as this is only a beginning; it is my hope that this will spur future research. Some of the films listed below no longer exist or cannot be located. Where possible, I have provided the location. Many of these films can be found in the Elmer Ray Pearson Collection at the Chicago Historical Society (CHS); others are in the Arthur Siegel Collection, Ryerson and Burnham Libraries, The Art Institute of Chicago (AIC); the remaining films, some of which I have not personally been able to view, are largely in the private collections of the filmmakers (PC). Where I have been unable to locate a film, I have marked it with an asterisk (*).

Jerry Aronson, *TM*, 1968, AIC; *Plastic Fantastic Lover*, 1968, PC

Harry Callahan, *Motions*, 1948/49, CHS; *People Walking on State Street*, 1948/49*

Wayne Boyer, *TV Ears*, 1967; *Drop City*, 1968; *Portrait*, 1968; *Stone Reflection*, 1970, all PC

Eugene Dana, *Boxing Tonight*, n.d., CHS

Mary Ann Dorr, educational film on Maxwell Street, 1955, PC

Robert Frerck, *Nebula*, 1968; *Nebula 2*, n.d., both AIC

Len Gittleman, *A Motor Control Drawing*, c. 1953 (assisted by Leon Lewandowski), CHS

Len Gittleman, Michael Train, and John Wood, *The Press*, c. 1953, CHS

Kurt Heyl, *Roslyn*, 1965; *Country*, 1965; *American Alternative*, 1966; *My Neighborhood*, 1967, all PC

Yasuhiro Ishimoto and Marvin Newman, *The Church on Maxwell Street*, 1951, PC

Larry Janiak, *Allegro*, 1960; *DL #1 (Disintegration Line #1)*, 1960; *Adams Film*, 1963; *Glasshouse*, 1964; *Life & Film*, 1965; *DL #2 (Disintegration Line #2)*, 1970; *Homage #5*, 1970, all PC

Kenneth Josephson, *33rd and LaSalle*, 1960–62; *Silent Sound*, 1964, both PC

Brian Katz and Thomas Knudtson, *Perils of the Lavatory*, 1964/68, PC

Myron Kozman, *Man Needs Food*, 1940s*

Nathan Lerner, *Light Machine*, 1941 (with Moholy-Nagy), PC

Charles Lyman, *Liela*, 1966; *The New Moon*, 1970, both PC

Mel Menkin and Eudice Feder, *The Vertical Yawn*, c. 1940, PC

Gerald Moeller, *Aureola*, 1970; *River Legend*, 1971, both PC

László Moholy-Nagy, *Children's Workshop*, 1940, CHS; *Interview with Students and Display of Student Work*, 1942, CHS; *Work of Camouflague* [sic] *Class*, 1942, CHS; *Student Exhibition 1944 #1*, 1944, CHS; *Student Exhibition 1944 #2*, 1944, CHS; *Design Workshops*, 1942– 1944, CHS; *Students Working in Photo Room*, c. 1945, CHS. See also Nathan Lerner and Group Projects

Ron Nameth, *Aaron Siskind*, 1967, Center for Creative Photography, Tucson. See also Group Projects

Marvin Newman, *Morning Becomes*, 1951, PC. See also Yasuhiro Ishimoto

Thomas Porett, *Water*, 1966, Institute of Design

Hans Schaal, *Virginia*, c. 1967; *1968*, 1969, both PC

Arthur Siegel, *Filmic Dance #1*, n.d.; *Filmic Dance #2*, n.d.; *Cameras Internal*, n.d., all AIC. See also Group Projects

Art Sinsabaugh, *Aaron Siskind Photographs*, 1966*

Robert Stiegler, *Traffic*, 1958, PC; *Lichtspiel Nur 1*, 1966, AIC; *Full Circle*, 1968, PC; *Capitulation*, 1965, PC

Ron Taylor, *The Boy*, 1967; *Matte*, 1967; *Stage Life*, 1967; *Moth*, 1967, all PC

Michael Train, see Len Gittleman

Hugo Weber, *Vision in Flux*, 1950s, PC; *Progress Documentation of a Large Painting*, n.d., PC

L. S. Wonder, *The Lecture*, 1966, CHS

John Wood, see Len Gittleman

Group Projects from the Institute of Design

Do Not Disturb, 1945, organized by László Moholy-Nagy with motion-picture class students Richard Filipowski, Robert Graham, Stanley Kazdailis, Patricia Parker, Joanne Reed, Nick Savage, Walter Schwartz, and Beatrice Takeuchi, CHS

Hearts and Arrows, 1950, directed by Richard Filipowski, with Jordan Bernstein, James Blower, Elmer Foote, John Kleinkopf, Virginia Lockrow, and Robert Sterelczyk, CHS

Chicago Morning, 1952, produced and edited by Boris Yakovleff, narrated by Studs Terkel, filmed on the morning of April 16, 1952, by eleven Institute of Design students, CHS

Designer and Industrial Society, 1951, Keld Helmer-Petersen, cinematographer, CHS

Alphabet, 1964, project of the Institute of Design cinema group under the direction of Arthur Siegel, filmed and edited by Ronald Nameth, with Doug Boucher, Beverly Capps, Peter Gold, Kurt Heyl, Janet Petry, and Jim Sween [sic], AIC

EPILOGUE
AFTER 1971

John Grimes

Not much changed at the Institute of Design after 1971, but in part through the influence of its graduates, photography had become more widely accepted as a serious artistic practice, and photographic education had grown exponentially. Apprenticeship was giving way to the study of an established tradition and a variety of known practices. In short, photography was becoming a mature field rather than an oddity. After Aaron Siskind's departure from the ID in 1971, Arthur Siegel took over the leadership of the photography program, continuing in that role until 1978. Whereas Siskind was unassuming and approachable, Siegel was feisty and, until one got to know him better, protective of his time. You got Siskind in manageable doses, just what you needed to know at that moment. You got Siegel all at once in a torrent of fact and opinion, although he relaxed into his role as time went on. Students of the time remember Siegel's Laws. Among these were "Everything is connected," "Never force a camera or a woman," and "Make fifty of one thing and you'll be in the Museum of Modern Art."

In keeping with the pattern of the school from the beginning, Siegel hired ID graduates to teach – Alan Cohen in 1972 to explore the methods of scientific photography, and me in 1975 to teach the foundation and documentary classes. When color photography came into its own in the mid-1970s, Siegel, who had worked principally in color since the introduction of Kodachrome in 1938, also hired David Rathbun, formerly Eliot Porter's printer, to teach the dye-transfer process. Siegel's surviving prints were all made by this method, and he wanted the school to use the most permanent process available. He later brought back former graduate student Patty Carroll to teach color photography using the improving, but still fugitive, Kodak and Ilford materials.

The students who attended the ID after 1971 didn't come because they were familiar with the work of Arthur Siegel, but they didn't know the work of Aaron Siskind either. Nor was the tradition of the New Bauhaus (ancient history by then) an attraction. Few students, many of whom came at the recommendation of former ID students or faculty, were aware of the school's legacy until after they arrived.

The graduates continued to succeed as photographers, showing and publishing their work, and taking university teaching positions in continuance of the ID tradition of spreading the message. Many of the ID photographers in the early 1970s had started with Siskind but acknowledge Siegel as equally important in shaping their development as image makers and their understanding of the medium. Siegel expanded and elaborated his history of photography and his experimental course. His ability to understand and to verbalize the possibilities and problems inherent in any group of pictures presented to him was astounding. The graduate seminars, which now met periodically in the evening, were both exhausting and invigorating, with students and faculty participating in a rigorous analysis of potential thesis work spurred on by Siegel's penetrating questions and unexpected insights.

Fig. 1 Friends and former students salute Aaron Siskind on the occasion of his seventy-fifth birthday, 1978. From left to right, first row: Heidi Jachna, Virginia Jachna, Jody Todd Jachna, Tim Jachna, John Dylong, Anita Douthat, Gary van Dis, Arthur Wise, Larry Janiak, Ed Bedno, Mary Ann Dorr Lea, Lynn Martin Windsor, Patty Carroll, Alan Cohen, Jed Fielding, Elizabeth McGowan, Kenneth Josephson, Esther Parada, Jane Wenger, Robert Stiegler, Mati Maldre, Danae Voutiritsas, Margaret Sabella, Tom Knudtson. Second row: Joseph Jachna, George Strimbu, Eleanor Strimbu, Heather Swedlund, Liz Swedlund, Alison Swedlund, Charles Swedlund, Arthur Bell, Lewis Kostiner, Joan Redmond, Lynn Sloan-Theodore, Katharine Lee Keefe, Albert H. Newman, Julie Siegel, Irene Siegel, Barbara Karant, Diana Olson, Ruth Aizuss Migdal, June Finfer, Nick Kolias, Nicky Kolias, Barbara Crane, Paul Zakoian, Jay Boersma, Dave Dapogny. Third row: Luther Smith, Susan Friedman, Mark Krastof, John Church, Anne Rorimer, John Vinci, Arnold Gilbert, Robert Fine, Jeffrey Gilbert, Muriel K. Newman, Brian Katz, Art Sinsabaugh, Laura Volkerding, Stef Leinwohl, Sharon Stauffer, Steve Hale, Harry Bouras, Arlene Bouras, Roland Ginzel, Shirley Sterling, Joseph Sterling. *Photograph by David Avison.*

Siegel invited a series of visiting faculty to fill out the program, which by now had actual required courses and published procedures. Garry Winogrand was the first of a succession of photographers who filled in for a year or less at a time. Winogrand came from a very different tradition of photography, one based on magazine publication and centered in New York. He shared the ID conceit that photography was scaleless but little else. He refused to make large prints "because they would be something else, not photography," and he insisted on straight photography, having no patience with multiples, light modulators, or any picture based on the list of ID assignments. Leicas started to show up in every student's hands, and street photography as social commentary became the dominant mode of working.[1] Although he only stayed one year, his influence persisted, passing from student to student. Later visiting artists included Les Krims, Geoff Winningham, Ed Ranney, and Arthur LaZar. Each brought new ways of approaching the medium, increasing the breadth of the program beyond the unapologetic formalism of the Foundation, and incorporating other traditions.

In 1960 the ID was one of only a handful of schools that offered a graduate course, but by 1978 there were programs everywhere, many of them staffed by recent ID graduates (see fig. 1). Locally, there were programs at The School of The Art Institute of Chicago (led by Kenneth Josephson, Frank Barsotti, and Barbara Crane), the University of Illinois at Chicago Circle (Joseph Jachna, Esther Parada, and Hans Schaal), and a huge undergraduate and eventually a graduate program at Columbia College (Jim Harrison, Charles Traub, Lynn Sloan, Barry Burlison, Alan Cohen, Charles Reynolds, Brian Katz, and a host of other ID graduates). Moreover, in contrast to the ID, each of these schools had galleries, lecture series, more faculty, and a desirable downtown location. The focus of photography in Chicago was shifting. On the national scale, both Callahan and Siskind now taught at the Rhode Island School of Design. Ray Metzker taught at the Philadelphia College of Art. William

Larson ran the program at Tyler School of Art, and Art Sinsabaugh at the University of Illinois at Urbana-Champaign. Geoff Winningham taught at Rice University, Linda Connor at the San Francisco Art Institute, Cal Kowal at the University of Cincinnati, Charles Swedlund at Southern Illinois University, Reginald Heron at Indiana University, and Thomas Barrow at the University of New Mexico. Other graduates were teaching at Alfred University, Florida International University, Bard College, the State University of New York, Montana State, a host of community colleges, and a few high schools. An exhaustive list would read like a directory of photography with ID graduates as program heads or leading teachers in many of the better art and photography programs across the country. While the field of photographic education expanded everywhere else, the ID program remained small and isolated, its growth limited by its context.

Through the 1970s photography was the next big thing, but at the same time photography was gaining legitimacy as an art form, many artists were rejecting modernism, the basis for photography as a thing in itself. Yet, as ID graduates became part of the larger art world – showing in galleries, teaching in art schools, and entering the art discourse carried on in galleries, publications, and conferences – they became part of a field where the ID way, sometimes called the "Chicago School," was just one of many. In the wider world of the fine arts many artists using photography in their work regarded the camera as another instrument, like a welding torch or a pencil, chosen as needed in service of an idea but uninteresting in itself. Further,

many artists were rejecting craft, beauty, and formal invention – hallmarks of ID photography. Photographs as used in conceptual, environmental, and performance works demonstrated an aggressive dislike for the image qualities valued at the ID. In this new and more robust educational environment, a program in a design school based on camera vision seemed to many to be incomplete and outside the mainstream.

After Jay Doblin's departure in 1968, the school fell into another protracted period of political infighting during which a sequence of ten acting or fully appointed directors came and went. The students got drawn into the conflict, causing enrollment to fall, which in turn brought on a financial crisis.[2] The IIT administration attempted to get the program back on track by convincing Doblin to return in 1977, but he left again after six months, asserting that fixing the problems of the school would take more time than he had to give. Unpredictable as always, he recommended that I be made acting director of the ID and allowed the opportunity to rebuild the program. It took three years of planning, negotiation, and compromise under constant threat of discontinuance for the faculty to agree on a basis for rebuilding.

Because of personal illness, Arthur Siegel missed the upheaval surrounding Doblin's return, and died in February of 1978. For the ID his death marked the end of an era. He had been a student in the New Bauhaus in 1937, a faculty member on and off since 1946, and was the last link to the school's beginnings. Siegel brought Callahan, Callahan brought Siskind, and Siskind brought back Siegel. What these three created

within Moholy's and then Doblin's school was a sheltered but intense environment where individuals with a singular interest in the medium of photography could explore and extend what that medium could be if approached as an independent mode of inquiry related but not subsidiary to other forms of image making.

The graduate photography program at ID continued for another twenty-three years after Arthur Siegel's death. Callahan, Siskind, and Siegel were part of the first generation of photographic educators. The second generation, many of whom they trained, had a broader knowledge of the medium, its history, and its context, but although that sophistication made the programs they built less eccentric, it also made them less distinct from one another. The ID remained unique by pursuing its long-standing mission of exploring and humanizing technology, even though the progress of that continuing experiment eventually diminished the importance of photography within the school. Part of the rebuilding in 1978 involved the exploration of new technologies, especially computing, first as a design tool and then as a medium in its own right. It seemed clear even then that the experimental mode in imaging had been or soon would be taken over by video and computer imaging and that straight documentary, as the most neglected part of photography within the fine arts, would be an area in which the school could excel. Documentary and computer imaging became the two possible areas of specialization for photography students after 1985. David Plowden was brought in to expand the documentary area. Patty Carroll took over in documentary after Plowden left to spend more time on his ambitious publishing agenda, and Jay Wolke succeeded Carroll in 1992 when she left to live in England for a time. I led the other initiative, moving the experimental branch of the ID's tradition into digital imaging, interactive media, and imaging software development. Although underfunded and unnoticed (often people were surprised to learn that the ID still existed), the graduate photography program continued successfully through the 1990s, producing one or two graduates a year, but in 1998, after another restructuring eliminated the entire undergraduate program, the ID could afford only one position devoted to photography. The last purely photographic graduate projects were completed in May 2001. The current graduate design program, like Moholy's original New Bauhaus, is directed toward humanizing new technology using methods from cognitive science, the social sciences, and business. Photography is a valued part of user research, and integral to imaging and the development of interactive informational environments, but it is no longer studied in isolation from its communication context.

All graduates of the ID know when the school ceased to be relevant or important in the world. For each the date was either the year he or she left or the year that his or her mentor left. The history of the school reads like the libretto for a bad opera or a comedy routine. The school was thought to have died in 1938 when the New Bauhaus was closed, and it died again with Moholy in 1946. It expired in 1949 when Serge Chermayeff

came and in 1953 when the Shelter program was weakened. It was killed by Jay Doblin's arrival in 1955 and by Harry Callahan's departure in 1961. It was definitely over when Doblin left in 1968, and then when Siskind was forced out in 1971. Arthur Siegel's death was the very end of the line in 1978, the new programs of the 1980s destroyed it for certain, and it breathed its last with the last of the undegraduates in 1998. Despite these multiple deaths, however, the ID continues to live, even thrive.

Today the Institute of Design is one of the largest graduate design programs in the world with over one hundred full-time students. The current director is Patrick Whitney, who in 1997 engineered the school's move back downtown to 350 North LaSalle Street, a few blocks from the building where the ID was located from 1946 to 1955 (now a nightclub). It is still part of Illinois Institute of Technology, which now recognizes the ID as one of its strongest programs. As of fall 2001 photography became part of visual communications.

The Institute of Design has gone through many transformations during its existence partly because its faculty keeps trying to work out the logic of design in relation to the needs and challenges of the times, and partly because whenever inertia and calcification starts to set in some internal eruption or external force compels it to move on. Photography has come full circle. It was part of Moholy's design synthesis based on mass media. It defined a course of its own as a fine art movement in the middle of the last century, enabled by the artist's access to a vast audience through photomechanical reproduction, and it is now part of a new design synthesis for a digital, post-mass age.

NOTES

Moholy-Nagy

I wish to thank Diane Kirkpatrick, Lloyd C. Engelbrecht, Robert V. Sharp, and, especially, Elizabeth Siegel, for their helpful critiques of earlier versions of this article.

1 This institution was known by three names when it was under Moholy-Nagy's direction. It was founded as the New Bauhaus by the Association of Arts and Industries in 1937. This school was closed in 1938. Early in 1939 Moholy founded his own school, the School of Design in Chicago, which was reorganized and renamed the Institute of Design in 1944. All of these entities are referred to here as "the school."

2 I regret that space constraints made it necessary to present these recollections paraphrased and unattributed. They are included, nevertheless, because they are such important appreciations of Moholy-Nagy.

Engelbrecht

I gratefully acknowledge generous support from the College of Design, Architecture, Art, and Planning of the University of Cincinnati.

1 See the course catalogue for the 1937–38 year, *The New Bauhaus: American School of Design* (Chicago: Association of Arts and Industries, 1937), 4. The curriculum diagram was borrowed from one used at the German Bauhaus that did not include photography at all.

2 László Moholy-Nagy to Walter Gropius, December 16, 1935, Bauhaus-Archiv, Berlin. Portions of the letter, in English translation, appeared in Andreas Haus, *Moholy-Nagy: Photographs and Photograms* (New York: Pantheon Books, 1980), 51. These two photographs (present location unknown) were portraits of his friend Carl Koch.

3 László Moholy-Nagy, "Light: A Medium of Plastic Expression," *Broom: An International Magazine of the Arts* 4:4 (March 1923), 283–84.

4 László Moholy-Nagy, "Photography in the Study of Design," *The American Annual of Photography, Volume Fifty-nine, 1945* (Boston: American Photographic Publishing Co., 1944), 162.

5 See the 1939–40 course catalogue, *School of Design*, inside front cover. The source was given as Herbert Bayer, Walter Gropius, and Ise Gropius, eds., *Bauhaus 1919–1928* (New York: The Museum of Modern Art, 1938), but Barr's statement was printed only on the dust jacket, as recounted by him in a letter, Alfred Barr to Jane Fiske McCullough, September 22, 1966, reel 1207, frame 1198, Archives of American Art, Washington, D.C.

6 See *School of Design* (note 5), 1.

7 Such courses were later begun at the Bauhaus by Walter Peterhans, who himself came to Chicago in 1938 to join Ludwig Mies van der Rohe at I.I.T., where Peterhans taught, not photography, but the Foundation Course. See Katherine C. Ware, "Photography at the Bauhaus," in Jeannine Fiedler and Peter Feierabend, eds., *Bauhaus* (Cologne: Könemann, 2000), 506–29.

8 László Moholy-Nagy, *Painting, Photography, Film*, trans. by Janet Seligman (Cambridge, Mass.: MIT Press, 1967).

9 László Moholy-Nagy, *The New Vision: From Material to Architecture* (New York: Brewer, Warren & Putnam, [1932]); this was a translation of Moholy's *Von Material zu Architektur*, Bauhausbücher 14 (Munich: Albert Langen Verlag, 1929).

10 Gustav Stotz, ed., *Internationale Ausstellung des deutschen Werkbunds Film und Foto, Stuttgart, 1929* (Stuttgart: Das deutsche Werkbund, 1929; reprint: New York: Arno Press, 1979); also reprinted in the same year by the Deutsche Verlags-Anstalt, Stuttgart, utilizing a more complete copy of the original catalogue. The Stuttgart reprint also includes additional material not part of the other reprint.

11 Ute Eskildsen and Jan-Christopher Horak, eds., *Film und Foto der zwanziger Jahre* (Stuttgart: Verlag Gerd Hatje, 1979), 171, 192, 194, and 201.

12 Selections from the "German International Traveling Photography Exhibition" were seen in Tokyo and Osaka in 1931. See Akiko Okatsuka, "Consciousness and Expression of the Modern," in *The Founding and Development of Modern Photography in Japan (Nihon kindai shashin no seiritsu to tenkai)* (Tokyo: Tokyo Metropolitan Museum of Photography, 1995), 22.

13 Stotz (note 10) (New York and Stuttgart: 1979), 51–53; Eskildsen and Horak (note 11), 77–79.

14 Beaumont Newhall, "Photo Eye of the 1920s: The Deutsche Werkbund Exhibition of 1929," *New Mexico Studies in the Fine Arts* 2 (1977), 7, 12; Eskildsen and Horak (note 11), 73–75; Stotz (note 10) (New York and Stuttgart, 1979), 50. Eleanor M. Hight, *Picturing Modernism: Moholy-Nagy and Photography in Weimar Germany* (Cambridge, Mass.: MIT Press, 1995), 205.

15 Moholy-Nagy (note 8), 48–49.

16 László Moholy-Nagy, *60 Fotos*, ed. by Franz Roh (Berlin: Klinkhardt & Biermann, 1930).

17 Lloyd C. Engelbrecht, "The Association of Arts and Industries: Background and Origins of the Bauhaus Movement in Chicago" (Ph.D. diss., University of Chicago, 1973), 43–59 and 86–97; idem, "László Moholy-Nagy in Chicago," in Terry Suhre, ed., *Moholy-Nagy: A New Vision for Chicago* (Springfield: University of Illinois Press and Illinois State Museum, 1990), 24–25; Charlotte Moser, "'In the Highest Efficiency': Art Training at the School of the Art Institute of Chicago," in Sue Ann Prince, ed., *The Old Guard and the Avant-Garde: Modernism in Chicago, 1910–1940* (Chicago: University of Chicago Press, 1990), 204–08.

18 Walter Gropius to Norma K. Stahle, May 18, 1937, Bauhaus-Archiv, Berlin; reproduced in Peter Hahn and Lloyd C. Engelbrecht, eds., *50 Jahre New Bauhaus; Bauhausnachfolge in Chicago* (Berlin: Argon Verlag, 1987), 12.

19 The telegrams, now lost, are quoted in László Moholy-Nagy to Walter Gropius, May 28, 1937, photocopy in the Bauhaus-Archiv, Berlin. A somewhat different account of the exchange between Stahle and Moholy, including quotations from some documents that can not now be located, appears in Sibyl Moholy-Nagy, *Moholy-Nagy: Experiment in Totality,* 2nd ed. (Cambridge, Mass.: MIT Press, 1969), 139–40.

20 Walter Gropius to László Moholy-Nagy, June 10, 1937, Bauhaus-Archiv, Berlin.

21 *Chicago Daily News*, August 23, 1937, 7; *Chicago Tribune*, August 22, 1937, pt. 1, p. 19.

22 "Marshall Field Gives Family Residence to Industrial Art School," *Chicago Tribune*, January 5, 1936, pt. 5, p. 10. Field himself was otherwise not active with the Association of Arts and Industries.

23 Henry Holmes Smith, interviewed by Lloyd C. Engelbrecht, Peoria, Illinois, November 1972, and Bloomington, Indiana, December 1972.

24 Nathan Lerner, interviewed by Charles Traub, Sept. 1977, Center for Creative Photography, University of Arizona, Tucson; CCP Audio Tape Collection, box 3.

25 Henry Holmes Smith, "Into Light: The New Bauhaus and Nathan Lerner," a 1973 essay based on a lecture by Smith, published in *Henry Holmes Smith, Collected Writings 1935–1985* (Tucson: Center for Creative Photography, University of Arizona, 1986), 107–08.

26 See "Printing-Out Paper (P.O.P.)," in Jerry Mason et al., eds., *International Center of Photography Encyclopedia of Photography* (New York: Crown Publishers, 1984), 411.

27 Engelbrecht, "Association of Arts and Industries" (note 17), 282 and figs. 109 and 110; Hahn and Engelbrecht (note 18), fig. 11 on p. 241; "Exhibition, Work from the Preliminary Course, 1937–1938, The New Bauhaus, American School of Design," mimeographed pamphlet describing an exhibition at the New Bauhaus that opened July 5, 1938; a photocopy is in the Special Collections Department, University Library, University of Illinois at Chicago (hereafter UIC Library).

28 László Moholy-Nagy, *The New Vision: Fundamentals of Design, Painting, Sculpture, Architecture*, rev. and enlarged ed. (New York: W.W. Norton, 1938), fig. 138.

29 "Exhibition" (note 27).

30 György Kepes, interviewed by Robert Brown, March 7 and August 30, 1972, and January 11, 1973, 15, typescript in the Archives of American Art, Washington, D.C.

31 Smith (note 25), 107. See also László Moholy-Nagy, *Vision in Motion* (Chicago: Paul Theobald, 1947), 65–66.

32 László Moholy-Nagy, "Make a Light Modulator," *Modern Photography* 2:7 (March 1940), 38–42.

33 Moholy-Nagy (note 31), 198. The two photographs illustrated, made by Henry Holmes Smith, are erroneously labeled "J. J. Smith."

34 Nathan Lerner, "Memories of Moholy-Nagy and the New Bauhaus," in Adam J. Boxer, ed., *The New Bauhaus, School of Design in Chicago: Photographs, 1937–1944* (New York: Banning and Associates, 1993), 14.

35 Kepes (note 30).

36 This statement was part of a mimeographed compendium in which all of the faculty described their courses; a photocopy is in the UIC Library. Smith's copy of the relevant pages, now in the Center for Creative Photography at the University of Arizona, is stamped with the date of April 1, 1938.

37 Lerner (note 24).

38 Lerner quoted in Moholy-Nagy (note 31), 200.

39 Illustrated in Astrid Böger and Roger Manley, eds., *Modernist Eye: The Art and Design of Nathan Lerner* (Raleigh: Gallery of Art and Design, North Carolina State University, 2000), 7.

40 Lerner quoted in Moholy-Nagy (note 31), 198–200.

41 Moholy-Nagy (note 31), 200.

42 See "Light Study," in Smith (note 25).

43 György Kepes and Nathan Lerner, "Light, Creative Use of," in Dagobert D. Runes and Harry G. Schrickel, eds., *Encyclopedia of the Arts* (New York: Philosophical Library, 1946), 558–62. The article was evidently written about 1942.

44 Arthur Siegel, interviewed by James McQuaid and Elaine King, October 29–November 6, 1977, Chicago, part of the George Eastman House Oral History Project. A copy of the transcript is in the Ryerson and Burnham Libraries, The Art Institute of Chicago.

45 Henry Holmes Smith, "My Year with Moholy-Nagy: A Brief Memoir," October 26, 1976, 8, typescript in the Center for Creative Photography, University of Arizona.

46 Arthur Siegel, "Photography Is," *Aperture* 9:2 (1961), 48.

47 Smith (note 45), 6.

48 Richard Koppe, "The New Bauhaus, Chicago," in Eckhard Neumann, ed., *Bauhaus and Bauhaus People* (New York: Van Nostrand Reinhold, 1970), 237.

49 Kepes (note 30), 14.

50 Siegel (note 44).

51 Henry Holmes Smith, interviewed by Charles Traub, April 13, 1979, Center for Creative Photography, University of Arizona, Tucson; CCP Audio Tape Collection, box 3.

52 *Chicago Daily News*, November 27, 1937, 24 and December 4, 1937, 11.

53 Beaumont Newhall, *Focus: Memoirs of a Life in Photography* (Boston: Bulfinch Press, 1993), 47, 49.

54 "Photography by the New Bauhaus School," *Townsfolk: Society, Sports, Travel and the Fine Arts* 20:5 (June 1938), 18; see also the Museum of Modern Art Archives, Department of Circulating Exhibitions, C/E 11.1 42(3);

and *Photography, 1839–1937*, intro. by Beaumont Newhall (New York: The Museum of Modern Art, 1937).

55 Engelbrecht, "The Association" (note 17), 301–06, and "Moholy-Nagy in Chicago" (note 17), 39–41; and Kepes (note 30), 14–19.

56 *Maholy-Nagy* [sic] *(plaintiff) vs. Association of Arts and Industries (defendant)*, file no. 38c14366, docket #92, fee book 394/539, p. 588, register 129, Judge Harry M. Fisher, Circuit Court of Cook County.

57 Clarence J. Bulliet, "Around the Galleries: Of Bauhaus and the New Mousetrap," *Chicago Daily News*, July 9, 1938, 13; "The Bauhaus Touch," *Art Digest*, August 1, 1938, 27; B. Holme, "Chicago," *The London Studio* 16:92 (1938), 268–69.

58 *Time*, July 11, 1938, 21.

59 See Bayer et al. (note 5), 216.

60 Moholy-Nagy (note 28), figs. 11–15, 16a, 16b, 43–50, 77, 78, 105a, 105b, 138, 163, 164, 178, and 179.

61 Sibyl Moholy-Nagy to Ise and Walter Gropius, December 24, 1938, Bauhaus-Archiv, Berlin.

62 Barford's statement was made in 1997 at an Institute of Design reunion in Chicago. The 1939 students are listed by name on a sheet in the Robert J. Wolff files, Archives of American Art.

63 László Moholy-Nagy to Walter Paepcke, January 25, 1939, Paepcke Papers, Department of Special Collections, Regenstein Library, University of Chicago.

64 László Moholy-Nagy to Elizabeth Paepcke, April 11, 1939, Paepcke Papers (note 63).

65 The property is described in a document for a four-year renewal of the lease (for the nominal sum of $1.00 per year) dated February 23, 1945, signed by Elizabeth and Walter Paepcke, and signed and dated March 8, 1945, by Moholy; this document is in the Hattula Moholy-Nagy papers, Ann Arbor, Michigan.

66 Sibyl Moholy-Nagy to Walter and Ise Gropius, January 11, 1939, Bauhaus-Archiv, Berlin.

67 The students are listed on a sheet in the Wolff files (note 62).

68 Harold Allen, interviewed by David Travis, Elizabeth Siegel, and others, August 12, 1998; tape and transcript in the Photography Department, The Art Institute of Chicago.

69 Nathan Lerner, "James Hamilton Brown" [1993], in Boxer (note 34), 48.

70 "School of Design Awards," *Magazine of Art* 33:10 (October 1940), 592.

71 See Moholy-Nagy (note 31), 116–17. Milton Halberstadt, telephone interview with Elizabeth Siegel, May 4, 1999; tape and transcript in the Photography Department, The Art Institute of Chicago.

72 On Halberstadt, see Susan Ehrens, "Susan Ehrens Looks at the Life and Work of Halberstadt," *Black & White Magazine* 2:6 (February 2000), 58–64.

73 László Moholy-Nagy, "The Bauhaus Education" and "The New Vision," *Proceedings of the Pacific Arts Association Fourteenth Annual Convention, San Francisco, California, April 1–4, 1939* (Stanford: Stanford University Press, 1939), 66 and 80, respectively.

74 "Mills College, California, June 1940, Schedule for Art Courses in the Summer Session," Wolff files (note 62). A copy of the summer session catalogue is in the UIC Library.

75 "Fair Features New Exhibits, Clipper Sailing, Pageant of Photography, Paris Pre-War Pictures Among New Island Attractions," *San Francisco Examiner*, July 10, 1940, 12; see also Golden Gate International Exposition, San Francisco, *A Pageant of Photography*, intro. by Ansel Adams (San Francisco: Crocker-Union, 1940), which included an essay by Moholy and a reproduction of one of his photograms.

76 "Three Day Art Meeting Opens Here Today," *San Francisco Examiner*, July 11, 1940, 16; "Art Federation Meet Opens Here Today," *San Francisco Chronicle*, July 11, 1940, 11; see also Jane Watson, "Federation's First Far-Western Convention," *Magazine of Art* 33:7 (July 1940), 429–31. "Amateur Photographers Will Hold Camera Conclave Here on July 25," *Oakland Tribune*, June 30, 1940.

77 See László Moholy-Nagy, "Making Photographs without a Camera," *Popular Photography* 5:6 (December 1939), 30–31 and 167–69, and idem (note 32).

78 See, for example, László Moholy-Nagy, *The New Vision and Abstract of an Artist*, 4th rev. ed. (New York: George Wittenborn, 1947), 17.

79 Museum of Modern Art Archives, Department of Circulation Exhibitions, C/E 11.1 65(1).

80 László Moholy-Nagy to Robert J. Wolff, June 7, 1942, microfilm in the Wolff files (note 62). The names of the graduates were confirmed during a telephone interview between Lloyd C.

Engelbrecht and Myron A. Kozman, December 30, 1996.

81 Illustrated in Hahn and Engelbrecht (note 18), 200, fig. 12.7.

82 György Kepes, *Language of Vision* (Chicago: Paul Theobald, 1944).

83 Sibyl Moholy-Nagy (note 19), 220, 221.

84 For the most complete account of the summer seminar in a well-researched recent article, see Mark B. Pohlad, "A Photographic Summit in the Windy City: The Institute of Design's 1946 'New Vision in Photography' Seminar," *History of Photography* 24:2 (summer 2000), 148–54.

85 Arthur Siegel, "Photography Summer Seminar Program," mimeographed, Arthur Siegel Collection, box 17, folder 5, Ryerson and Burnham Libraries, The Art Institute of Chicago.

86 "Institute of Design Offers Summer Seminar," *Popular Photography* 19:1 (July 1946), 162.

87 Siegel (note 44).

88 John Grimes, "Arthur Siegel: A Short Critical Biography," *Exposure* 17:2 (summer 1979), 27.

89 László Moholy-Nagy to Beaumont Newhall, August 29, 1946; photocopies of this letter are in the files of the Department of Photography, The Art Institute of Chicago, and the Bauhaus-Archiv, Berlin.

90 Siegel (note 44).

91 Max Thorpe and Jane Bell Edwards, "From a Student's Notebook," *Popular Photography* 21:6 (December 1947), 174.

92 Sibyl Moholy-Nagy (note 19), 245.

93 Walter Gropius to Lucia Moholy, December 12, 1946, Bauhaus-Archiv, Berlin.

Davis

1 New Bauhaus/Institute of Design Collection, Special Collections Department, University Library, University of Illinois at Chicago, box 1, folder 13.

2 School memo of March 3, 1945. As recorded in school documents, enrollment numbers fluctuated somewhat from week to week.

3 Stephen Daiter, *Light and Vision: Photography at the School of Design in Chicago, 1937–1952* (Chicago: Stephen Daiter Photography, 1994), 61.

4 For basic biographical data on Siegel, see John Grimes, "Arthur Siegel: A Short

Critical Biography," *Exposure* 17:2 (summer 1979), 22–34; and Larry A. Viskochil, "Arthur Siegel: A Life in Photography, 1913–1978," *Chicago History* 10:2 (summer 1981), 66–73.

5 As John Grimes has written, "Already in 1937 Siegel was that combination of intellectual brilliance, tactless candor, insecurity, and hypochondria that brought him, in the latter part of his life, the title of The Son of a Bitch of Photography"; Grimes (note 4), 22. Similarly, John Alderson has noted that Siegel "was tough, irascible, strong-willed . . . [and] at times bombastic and opinionated"; see "Arthur Siegel: 1913–78," *Exposure* 16:1 (spring 1978), 3.

6 Arthur Siegel, interviewed by Mary Harris, Chicago, November 4, 1971, 18. Transcript in the Arthur Siegel Collection, Ryerson and Burnham Libraries, The Art Institute of Chicago.

7 A detailed prospectus for this seminar is in the Siegel Collection (note 6). This prospectus was clearly drawn up before the event, however, as it does not mention Blumenfeld, Rosskam, or the specific topics of Stryker's presentations. For a brief contemporary summary of the program, see Max Thorpe and Jane Bell Edwards, "From A Student's Notebook," *Popular Photography* 21:6 (December 1947), 53–56, 174, 176. For a fine recent discussion, see Mark B. Pohlad, "A Photographic Summit in the Windy City: The Institute of Design's 1946 'New Vision in Photography' Seminar," *History of Photography* 24:2 (summer 2000), 148–54.

8 "Speaking of Pictures . . . Weegee Shows How to Photograph a Corpse," *Life* 21 (August 12, 1946), 8–9.

9 Beaumont Newhall, *Focus: Memoirs of a Life in Photography* (Boston: Bulfinch Press, 1993), 170.

10 In later interviews, Siegel characterized Levstik as "an ordinary commercial photographer" and "a little scatter-brained [although] full of good will and commitment and so on." He viewed Sokolik as "a chemist" who was "a little difficult to deal with," "a very sour kind of guy." See Siegel (note 6) as well as Arthur Siegel, interviewed by James McQuaid and Elaine King, October 29–November 6, 1977, Chicago, part of the George Eastman House Oral History Project. A copy of the transcript is in the Ryerson and Burnham Libraries, The Art Institute of Chicago.

11 Significantly, however, Callahan's first – and perhaps most definitive – published statement of purpose had recently appeared; see "An Adventure in Photography," *Minicam Photography* 9:6 (Feb. 1946), 28–29.

12 See "Harry Callahan: A Life in Photography," interview with Callahan conducted by Harold Jones and Terrence Pitts of the Center for Creative Photography, University of Arizona, Tuscon, February 1977; in Keith F. Davis, *Harry Callahan Photographs: An Exhibition from the Hallmark Photographic Collection* (Kansas City: Hallmark Cards, 1981), 51.

13 Callahan in Davis (note 12), 55–56; Callahan also related this story in numerous later interviews.

14 From a talk given May 11, 1974, at an ID reunion; see the Nathan Lerner Papers, Chicago Historical Society.

15 Sibyl Moholy-Nagy, *Moholy-Nagy: Experiment in Totality*, 2nd ed. (Cambridge, Mass.: MIT Press, 1969), 243.

16 Ferenc Berko, telephone interview by Elizabeth Siegel, April 7, 1999; tape and transcript in the Department of Photography, The Art Institute of Chicago.

17 Letter of January 30, 1946; cited in John Szarkowski, *Callahan* (New York: Museum of Modern Art and Millerton, N.Y.: Aperture, 1976).

18 Callahan (note 11), 28–29.

19 See, for example, Keith F. Davis, "The Rhythms of the City," in *Harry Callahan: New Color, Photographs 1978–1987* (Kansas City: Hallmark Cards, 1988), particularly p. 9.

20 Callahan in Davis (note 12), 56.

21 Ibid.

22 Art Sinsabaugh's class notes include the following: "QUOTE – Callahan, in talking of the fallacy of composition, said, 'Composition has validity after you feel something.'" Sinsabaugh class notebooks, Sinsabaugh Archives, Indiana University Art Museum, Bloomington.

23 Alan Artner, "Coming 'Home': Ishimoto returns to his favorite city for retrospective," *Chicago Tribune* (June 6, 1999), sec. 7, pp. 10–11.

24 Reminiscence of James P. Blair, in Louise Shaw, Virginia Beahan, and John McWilliams, eds., *Harry Callahan and His Students: A Study in Influence* (Atlanta: Georgia State University Art Gallery, 1983), n.pag.

25 Quoted in Charles Traub, "Photographic Education Comes of Age," in Charles Traub and John Grimes, *The New Vision: Forty Years of Photography at the Institute of Design* (Millerton, N.Y.: Aperture, 1982), 39.

26 Alderson (note 5), 6.

27 Laura N. Stoland, "Interview with John Grimes on the Institute of Design and Photography in Chicago," May 24, 1994, transcript, Museum of Contemporary Art, Chicago, Oral History, 12.

28 The following is drawn from a detailed typescript, made by one of his students, of the topics covered in Siegel's spring 1949 course in the history of photography; Siegel Collection (note 6), folder 17.7.

29 Ibid.

30 See, for example, "Modern Art by a Photographer," *Life* (November 20, 1950), 78–84; and Siegel's three-part series "Creative Color Photography," *Modern Photography* 16:1–3 (January–March 1952). For overviews of this general subject, see such volumes as Manfred Heiting, ed., *50 Years: Modern Color Photography, 1936–1986* (Cologne: Messe- und Ausstellungs, 1986).

31 John Grimes, *Arthur Siegel: Retrospective* (Chicago: Edwynn Houk Gallery, 1982), n.pag.

32 Miller recalled in a recent interview that he became involved at the school through the invitation of Callahan and Chermayeff. He did not have much contact with Siegel and even less with the other staff members. Miller left Chicago in 1949. Wayne Miller, conversation with Elizabeth Siegel and David Travis, October 11, 2000; notes in the Department of Photography, The Art Institute of Chicago.

33 See Wayne F. Miller, *Chicago's South Side 1946–1948* (Berkeley: University of California Press, 2000).

34 Sinsabaugh was not in sympathy with this approach. As he wrote in his class notebook: "The whole slant this semester was on people – a heretofore neglected part of my photography since I have started to 'grow up.' I did not like Wayne's particular slant or approach to the problems though – He gave the mood and you, the student, had to look for it. The only means of finding it was to use recognizable symbols. In other words, I feel, you were looking for outward things." Sinsabaugh ID Notebook no. 2, Sinsabaugh Archives (note 22).

35 Ishimoto entered the ID in 1948 and received his B.S. in 1952; Newman entered in 1949 and received his M.S. in 1952.

36 Marvin Newman, telephone interview by Elizabeth Siegel, April 6, 1999; tape and transcript in the Department of Photography, The Art Institute of Chicago.

37 David Windsor, telephone interview by Elizabeth Siegel, March 30, 1999; tape and transcript in the Department of Photography, The Art Institute of Chicago.

38 Peter Selz, "Modernism Comes to Chicago: The Institute of Design," in Lynne Warren, ed., *Art in Chicago, 1945–1995* (Chicago: Museum of Contemporary Art and New York: Thames and Hudson, 1996), 46. In later interviews, Siegel was even more blunt and critical of Chermayeff's personality.

39 This is my understanding of this important episode. In truth, the exact sequence of and causal relationship between Siegel's resignation and Callahan's promotion remains a bit unclear.

40 Victor Margolin, *The Struggle for Utopia: Rodchenko, Lissitzky, Moholy-Nagy, 1917–1946* (Chicago: University of Chicago Press, 1997), 242. Interestingly, it is recorded that, in declining to consider a merger, the chancellor of the University of Chicago stated that "art had no room in a university." Selz (note 38), 48.

41 Recollections of John P. Keener, March 12, 1999; Department of Photography, The Art Institute of Chicago.

42 Siskind, for example, was amazed at the tension, mutual distrust, and political maneuvering he found among the ID faculty when he arrived. He recalled an episode in which a rumor arose of an apparent conspiracy by the German-speaking faculty (Wachsmann and Weber) to take over the school. Siskind tried to disprove the rumor by showing it to be baseless and ended up persona non grata to the "other" side. Aaron Siskind, interviewed by Charles Traub, November 29, 1977; tape at the Center for Creative Photography, University of Arizona; transcribed by Elizabeth Siegel, September 1999, Department of Photography, The Art Institute of Chicago.

43 Selz (note 38), 48.

44 Ibid.

45 Callahan in Davis (note 12), 56.

46 Shaw et al. (note 24), n.pag.

47 The definitive source of information on Siskind's life and work is Carl Chiarenza, *Aaron Siskind: Pleasures and Terrors* (Boston: New York Graphic Society, 1982).

48 Aaron Siskind, "The Drama of Objects," *Minicam Photography* 8 (June 1945), 20–23, 93–94; also reprinted in Chiarenza (note 47), and (in slightly abbreviated form) in Nathan Lyons, ed., *Photographers on Photography: A Critical Anthology* (Englewood Cliffs,

N.J.: Prentice-Hall, 1966), 96–98. See also Siskind's 1950 "Credo," reprinted in Deborah Martin Kao and Charles A. Meyer, *Aaron Siskind: Toward a Personal Vision, 1935–1955* (Chestnut Hill, Mass.: Boston College Museum of Art, 1994), 57.

49 To a fascinating degree, Callahan's work of this period can be understood in light of the specific assignments he gave to his students. This work combines aspects of at least two matters discussed in class: the recording of people on the street and the "pushing" of film speed. Seeking a tenfold increase in film speed, Callahan developed these rolls of 35mm film to gamma infinity – in some cases, for hours at a time. Callahan in Davis (note 12), 54.

50 Cited in Chiarenza (note 47), 101.

51 It also received a full-page review in *Newsweek* (May 7, 1951), 48.

52 As Carl Chiarenza has observed, Siskind's work received almost unprecedented public attention beginning in 1946. Between 1946 and 1951, he was given twelve one-person exhibitions, a total that few if any other fine art photographers of the era could match. Chiarenza (note 47), 91.

53 The importance of Siskind's work is indicated by its centrality to the problem in the 1950s of interpreting artistic photographs. See, for example, "The Experience of Photographs," *Aperture* 5:3 (1957), 112–30, in which five of Siskind's images were subjected to poetic analysis. *Big Table* 3 (1959) includes a portfolio of five images (including cover) from Siskind's "Pleasures and Terrors of Levitation."

54 Joseph Sterling, interviewed by Richard Sessions, Gallery 312, Chicago, April 13, 1995.

55 Shaw et al. (note 24), n.pag.

56 This is reported in S. P. Karr, "The Third Eye," *Art Photography* 4 (September 1952), 34, which provides an interesting vignette on the photography department's program and personalities as of 1952.

57 In this problem, students were required to photograph some two-dimensional image (another photograph, for example), and to make a print that matched the original as closely as possible. This tested all manner of technical skills: lighting, camera alignment, negative exposure and development, and fine (or at least "accurate") printmaking.

58 Karr (note 56), 33–34.

59 The following summary is based largely on Chiarenza (note 47), 97. According

to Richard Cahan's biography of Richard Nickel, Siskind's initial assignment to photograph the Auditorium Building came in the fall of 1951, and the Sullivan project was well underway by the spring 1952 semester. Richard Cahan, *They All Fall Down: Richard Nickel's Struggle to Save America's Architecture* (Washington, D.C.: Preservation Press, 1994), 52.

60 Chiarenza (note 47), 97.

61 Aaron Siskind and Harry Callahan, "Learning Photography at the Institute of Design," *Aperture* 4:4 (1956), 147–49. This issue contains other articles on photographic education by William Rohrbach, of the University of California-Santa Barbara, and Minor White, the journal's editor and photography instructor at Rochester Institute of Technology.

62 Ibid.

63 Joseph Jachna, interviewed by Elizabeth Siegel, July 21, 1999; tape and transcript in the Department of Photography, The Art Institute of Chicago.

64 Marvin Elliott Newman, "A Creative Analysis of the Series Form in Still Photography" (M.S. thesis, Illinois Institute of Technology, 1952), iv.

65 Marvin Newman, telephone interview by Elizabeth Siegel, April 6, 1999; tape and transcript in the Department of Photography, The Art Institute of Chicago.

66 Cahan (note 59), 240.

67 Anne Wilkes Tucker, *Unknown Territory: Photographs by Ray K. Metzker* (Houston: Museum of Fine Arts Houston and Millerton, N.Y.: Aperture, 1984), 121.

68 Ibid., 7.

69 Cited in Sylvia Wolf, *Kenneth Josephson: A Retrospective* (Chicago: The Art Institute of Chicago, 1999), 22.

70 *Aperture* 9:2 (1961), n.pag.

71 Ibid.

72 John Weiss, ed., *Venus, Jupiter & Mars: The Photographs of Frederick Sommer* (Wilmington: Delaware Art Museum, 1980), 62.

73 Jachna (note 63).

74 Chiarenza (note 47), 144.

75 The comic, opinionated, stream-of-consciousness essay that follows provides considerable insight into Siegel's rhetorical style and character.

76 Jachna (note 63).

77 Barbaralee Diamonstein, *Visions and Images: American Photographers*

on *Photography* (New York: Rizzoli, 1981), 19.

Grimes

The content of this essay is based on my personal experiences as a student, teacher, and administrator at the Institute of Design from 1968 to the present; my conversations during that time with Harry Callahan, Aaron Siskind, Art Sinsabaugh, Arthur Siegel, Jay Doblin, and other faculty members; and interviews with former students and teachers conducted over the past year, 2000–2001. Tapes of these interviews can be found in the study collection of the Department of Photography, The Art Institute of Chicago. Assistance was also provided by many individuals not directly quoted, who helped me understand the spirit of the time, especially Alan Cohen, Patty Carroll, Reginald Heron, and Irene Siegel.

1 In recent years the phrases "personal expression" and "self-expression," which are found in descriptions of the ID photogaphy program through the 1970s, have taken on negative connotations because they seem to indicate self-indulgence and disconnection from the issues of the ongoing discourse in favor of some kind of self-actualization. In fact, these phrases were used to distinguish work in which the photographer is the author of the ideas contained therein from "editorial illustration," in which the photographer gives form to messages provided by a client such as is the case in most commercial photography.

2 Handwritten note from Art Sinsabaugh to Harry Callahan, December 13, 1950, Sinsabaugh Archives, Indiana University Art Museum, Bloomington.

3 Joseph Sterling, interviewed by author, February 2001.

4 Charles Swedlund, interviewed by author, August 16, 2000.

5 Peter Selz, "Modernism Comes to Chicago: The Institute of Design," in Lynne Warren, ed., *Art in Chicago, 1945–1995* (Chicago: Museum of Contemporary Art and New York: Thames and Hudson, 1996), 48.

6 Nathan Lyons, interviewed by author, January 26, 2000.

7 László Moholy-Nagy, "From Pigment to Light," in Nathan Lyons, ed., *Photographers on Photography: A Critical Anthology* (Englewood Cliffs, N.J.: Prentice-Hall, 1966), 80. Originally published in *Telehor* 1: 2 (1936), 32–36.

8 Ibid., 78.

9 Talk by Harry Callahan to ID graduate students at the Gilbert Gallery, Chicago, March 1982.

10 Swedlund (note 4).

11 Barbara Crane, interviewed by author, August 2000.

12 Moholy-Nagy (note 7), 74.

13 *Aaron Siskind: Photographs* (New York: Horizon Press, 1959).

14 William Larson, interviewed by author, January 21, 2000.

15 George Nan did his thesis in color. The prints, now forty years old, are so badly faded that no sense of the original images can be gotten from viewing them.

16 Larson (note 14).

17 Charles Swedlund, interviewed by author, January 2000.

18 Roslyn Banish, interviewed by author, January 29, 2000.

19 Joseph Jachna, interviewed by author, September 2000.

20 These tapes are in the Arthur Siegel Collection, Ryerson and Burnham Libraries, The Art Institute of Chicago.

21 Larson (note 14).

22 Geoff Winningham, interviewed by author, 2000.

23 Banish (note 18).

Viskochil

1 Arthur Siegel, interviewed by James McQuaid and Elaine King, October 29–November 6, 1977, Chicago, part of the George Eastman House Oral History Project.

2 The Museum of Science and Industry had acquired a collection of photographs from the salons, camera clubs, and collectors in the 1930s with the intention of building a permanent exhibition on scientific (including fine art) photography, but it never came about. Some of the collection, recently rediscovered at the museum, was exhibited in 1960 when Max Thorek, the principal donor, died.

3 In 1968 eleven exhibits jointly called "Response" opened in mostly Near North art galleries to protest Mayor Daley's handling of the demonstrations that took place outside the Democratic Party convention. Photography was well represented. Up to this time fine art galleries had resisted showing photographs to their clientele, but in the 1970s galleries began to appear that were devoted solely to photographs. The first, the Limited Image on Oak Street, was only open for 1971–72. The Exposure Gallery on North Clark Street was operated out of the home of a former editor/photographer. The Chicago Gallery of Photography, more of a co-op than a gallery since no photographs were for sale, sold admissions to see exhibitions at its West Irving Park location. Other galleries promoting photography continued to pop up briefly, but they were rare, especially if devoted solely to photography.

4 Similar social documentary projects resulted in thesis topics in the 1970s and 1980s that covered South Side blues clubs, architecture, graffiti, Maxwell Street, theater interiors, and various city and suburban neighborhoods and communities.

5 Arthur Siegel Collection, Ryerson and Burnham Libraries, The Art Institute of Chicago, folder 17.7. Student notes from Arthur Siegel's 1949 course on the history of photography, possibly belonging to Bob Mayer.

6 Ray Pearson, in the ID Architecture Department, had talked to Siskind about documenting the destruction of Sullivan's Walker Warehouse and soon was giving slide lectures to photography classes.

7 Both Harold Allen and Barbara Crane worked on this important project.

8 *Oral History of William C. Hedrich,* interviewed by Betty J. Blum; compiled under the auspices of the Chicago Architects Oral History Project, the Ernest R. Graham Study Center for Architectural Drawings, Department of Architecture, The Art Institute of Chicago, and the Prints and Photographs Department, the Chicago Historical Society (Chicago: The Art Institute of Chicago, 1994). When Bill Hedrich returned from World War II, he went to the ID to brush up his photography. His brother Ken told him not to study photography there because "we want you just as you were. Don't touch it." He was glad he studied with the sculptor Alexander Archipenko instead, because the photography teachers "were more into a specialized type of ethereal thing that was far out, like photograms and printing through leaves and doing things like that."

Siegel

I wish to thank Wayne Boyer, Richard Filipowski, Tom Gunning, Larry Janiak, Hattula Moholy-Nagy, Marvin Newman, and the staff of the Chicago Historical Society for their help with this essay.

1 László Moholy-Nagy, "Problems of the Modern Film," in Richard Kostelanetz, ed., *Moholy-Nagy* (New York: Praeger

Publishers, 1970), 135. This essay was written in 1928–30 and originally published in *Cahiers d'Arts* 7:6–7 (1932).

2 "Harry Callahan: A Life in Photography," interview with Callahan conducted by Harold Jones and Terence Pitts of the Center for Creative Photography, University of Arizona, Tucson, February 1977; in Keith F. Davis, *Harry Callahan Photographs: An Exhibition from the Hallmark Photographic Collection* (Kansas City: Hallmark Cards, 1981), 58.

3 *Motions*, like many of the films discussed in this essay, can be viewed at the Chicago Historical Society, where it is part of Ray Pearson's Institute of Design Collection, G1991.205. For specifics on films and locations, see the filmography at the end of this essay.

4 Interestingly enough, this was not always the case, and the example of the road not taken is particularly instructive. In the first version of his landmark *History of Photography*, Beaumont Newhall included film. Originally called *Photography, 1839–1937*, this 1937 catalogue for the Museum of Modern Art's exhibition of the same name bears the marks of one of Newhall's advisors, Moholy. Subsequent revisions, in which film dropped out almost entirely, show the influence of another advisor, Alfred Stieglitz; for more on MoMA and photography, see Christopher Phillips, "The Judgment Seat of Photography," *October* 22 (1982), 27–63.

5 See Jan-Christopher Horak, *Making Images Move: Photographers and Avant-Garde Cinema* (Washington and London: Smithsonian Institution Press, 1997). Horak points to this historiographical and critical omission, attempts to link the two media through several case studies (including a chapter on Moholy), and provides a thorough list of films made by photographers.

6 See, for example, The American Federation of Arts, *A History of the American Avant-Garde Cinema* (New York: The American Federation of Arts, 1976); P. Adams Sitney, *Visionary Film: The American Avant-Garde 1943–1978* (New York: Oxford University Press, 1979); and Scott MacDonald, *Avant-Garde Film: Motion Studies* (Cambridge and New York: Cambridge University Press, 1993). More recently, film historians have demonstrated the stirrings of an American avant-garde cinema prior to 1945, finding links between European and American practices; see Jan-Christopher Horak, ed., *Lovers of Cinema: The First American Film Avant-Garde, 1919–1945* (Madison: University of Wisconsin Press, 1995).

7 For more on the films of Moholy-Nagy, see Horak (note 5); Barbara Rose, "Kinetic Solutions to Pictorial Problems: The Films of Man Ray and Moholy-Nagy," *Artforum* 10:1 (September 1971), 68–73; Eleanor Hight, *Moholy-Nagy: Photography and Film in Weimar Germany* (Wellesley, Mass.: Wellesley College Art Museum, 1985); and various writings on film by Moholy in Kostelanetz (note 1).

8 See film sketches for all three in Kostelanetz (note 1). Rose (note 7) notes that in Moholy's outline of *Dynamics of a Metropolis*, the diagrammed directions "can be projected on a two-dimensional plane; none describes a complex movement into space, or any sequence of shots of continuous movement. The opening sequence of a crane is described as follows: 'shot from below, diagonally, from above.' In other words, from the different viewpoints from which a Cubist painter might depict an object which he is analyzing" (72).

9 There is some disagreement about the dates of Moholy's earliest films; the dates I refer to here are from the filmography by Derek Owen, "László Moholy-Nagy," *Film Dope* 44 (March 1990), 18–20, and confirmed with Moholy's daughter, Hattula Moholy-Nagy.

10 Moholy-Nagy, *Vision in Motion* (Chicago: Paul Theobald, 1947), 12.

11 Moholy-Nagy (note 1).

12 "The development of the suprematist Malevitch may serve as an example. His last picture: a white square on a square white canvas is clearly symbolic of the film screen, symbolic of the transition from painting in terms of pigment to painting in terms of light. *The white surface can serve as a reflector for the direct projection of light, and what is more, of light in motion.*" Moholy-Nagy (note 1), 132 (italics in original).

13 Moholy-Nagy (note 10), 272.

14 Moholy's position on film changed slightly over the years. Initially, he believed film to be a combination of light and motion, but by the time he wrote *Vision in Motion*, he argued that motion alone was the real key: "While in photography not the camera but the light sensitive emulsion is the key to genuine work, in the motion pictures not the emulsion, but the possibility to produce motion is the key to film production." Moholy-Nagy (note 10), 278.

15 Moholy wrote to Robert Jay Wolff on June 7, 1942, about the school's graduation ceremonies: "Then we showed 3 rolls of color movie on the school. . . . I announced at this occasion the newest grant ($7500) which we received from the Rockefeller Foundation to develop our motion picture dept." "Letter to Robert Jay Wolff," in Kostelanetz (note 1), 178.

16 "Evening Classes, Chicago Institute of Design [*sic*] (1942–1943)," in Kostelanetz (note 1) 180.

17 The students were Richard Filipowski, Robert Graham, Stanley Kazdailis, Patricia Parker, Joanne Reed, Nick Savage, Walter Schwartz, and Beatrice Takeuchi; the screenplay, from which the film strays somewhat, was published in Moholy-Nagy (note 10), 290–91.

18 Richard Filipowski, telephone interview with author, March 17, 1999.

19 Moholy-Nagy (note 10), 207–08.

20 These include *The Vertical Yawn* (c. 1940), a film of drawbridges opening above the Chicago River by Mel Menkin and Eudice Feder; *Man Needs Food* (c. 1946), a film by Myron Kozman and others, which included painting directly on the film; and even later endeavors such as *Hearts and Arrows* (1950), a symbol-laden love story by ID students under Richard Filipowski.

21 "New Vision in Photography" brochure, July 8–August 16, 1946.

22 A complete list can be found in the Arthur Siegel Collection, Ryerson and Burnham Libraries, The Art Institute of Chicago.

23 Arthur Siegel, interviewed by Mary Harris, November 4, 1971, Black Mountain Spool 61, p. 22. Transcript in the Siegel Collection (note 22).

24 See syllabi in the Siegel Collection (note 22), and published course catalogues in the Special Collections Department, University Library, University of Illinois at Chicago.

25 Ferenc Berko, "Suggestions for the summer term, 1948," memo in the Siegel Collection (note 22).

26 Callahan (note 2), 58.

27 In 1951, Newman also made a three-and-a-half-minute film about Chicago waking up called *Morning Becomes*, in which he experimented with a variety of editing techniques. Other notable films from this period include a group student project, *Chicago Morning*, filmed on the morning of April 16, 1952, by eleven Institute of Design students; and *The Press*, a black-and-white film to music by students Len Gittleman, Michael Train, and John Wood, c. 1953.

28 Information on the film's production is from Marvin Newman, telephone interview with author, April 6, 1999.

29 Callahan quoted in Charles Traub, "Photographic Education Comes of Age," in Charles Traub and John Grimes, *The New Vision: Forty Years of Photography at the Institute of Design* (Millerton, N.Y.: Aperture, 1982), 45.

30 "The decisive moment" is a term popularized by Henri Cartier-Bresson; see *The Decisive Moment: Photography by Henri Cartier-Bresson* (New York: Simon and Schuster, 1952).

31 Colin Westerbeck has argued that Ishimoto's photographs have a distinctly cinematic quality, especially in their use of sequencing and multiple-exposure to get beyond the single masterpiece. "Vision in Motion: How Yasuhiro Ishimoto Made Movies Using a Still Camera," lecture at The Art Institute of Chicago, July 20, 1999.

32 See the list of cinematography theses in Traub and Grimes (note 29); these students include Jerry Aronson, Wayne Boyer, Robert Frerck, Kurt Heyl, Nicolas Kolias, Roger Lundy, Gerald Moeller, Ronald Nameth, Ronald Rabin, and Hans Schaal.

33 For the experimental film context in Chicago, especially from the 1960s on, consult Bill Stamets, "Experimental Film in Chicago," in Lynne Warren, ed., *Art in Chicago, 1945–1995* (Chicago: Museum of Contemporary Art and New York: Thames and Hudson, 1996), 109–12.

34 Brian Katz, interview with author and David Travis, The Art Institute of Chicago, August 3, 1999.

35 See Andy Grundberg's discussion of the image within the image as a tracking shot in "Kenneth Josephson: The Photograph and the Möbius Strip," in Sylvia Wolf, *Kenneth Josephson: A Retrospective* (Chicago: The Art Institute of Chicago, 1999), 9–40.

36 On video in Chicago, see Kate Horsfield, "Towards a History of Chicago Video," in Warren (note 33), 124–28.

Grimes, Epilogue

1 Winogrand used a Leica M2 with a custom, rapid rewind crank made by Marty Forcher's Cameras International in New York, a screw mount Canon 25mm lens specially adapted for the Leica, and a Minolta supplemental, wide-angle viewfinder.

2 The reduction of the national commitment to college education under Richard Nixon also contributed to budget reductions.

BIOGRAPHIES

Compiled by Lisa Meyerowitz and Elizabeth Siegel.

Harold Allen

American, 1912–1998. Born in Portland, Oregon, Harold Allen was raised in Idaho and Wyoming before moving to Chicago in 1937. He began photography at an early age, and majored in industrial design at The School of the Art Institute of Chicago. He took an evening course in photography at the School of Design with György Kepes in 1940. Allen was drafted into the U.S. Army in 1942 and sent to study photographic technique at the *Life* Magazine Photo School for the Armed Forces in New York. In 1948 he returned to Chicago to join the faculty at the School of the Art Institute, teaching part-time from 1948 to 1960 and full-time from 1966 to 1977. Allen also studied architectural history at the University of Chicago (1948–54) and is well known for his architectural photography. He retired in 1977 and was featured in a retrospective exhibition at the Art Institute in 1984. LM

David Avison

American, b. 1937. Born in Harrisonburg, Virginia, David Avison grew up in suburban Washington, D.C., and then North Hollywood, California. He first experimented with photography at age eight using a 127 Donald Duck camera. He studied physics at the Massachusetts Institute of Technology, and earned a Ph.D. in theoretical physics at Brown University in 1966. In 1969 Avison moved to Chicago to attend the ID, and received a master's degree in 1974, working with Arthur Siegel on wide-view photographs. Throughout his career, Avison has pursued panorama photography to escape traditional notions of the medium. He taught at Columbia College, Chicago, from 1969 to 1986 and received a National Endowment for the Arts Fellowship in 1977, the same year as his solo exhibition at the Art Institute. He currently lives and works in Boston. LM

Roslyn Banish

American, b. 1942. Roslyn Banish was born in Chicago, and attended college at the University of Michigan. She entered the ID in 1964 and earned a master's degree in 1968. Her thesis under Aaron Siskind, "Contiguous Frames," which presented two frames side by side that were intended to be seen as a single image, countered the ID's emphasis on "pure" photography. She has continued to explore narrative forms as a freelance photographer, especially in the form of documentary books. Her current work, such as *Focus on Living: HIV/AIDS in America* (forthcoming 2002), takes narrative a step further by combining photography with text. She has exhibited her work in England and the United States and lives in San Francisco. LM

George Barford

American, 1913–1998. Born in Marion, Ohio, George Barford received a bachelor's degree in education from the Milwaukee State Teachers College in 1935, and a master's degree in fine arts and fine arts education from Teachers College, Columbia University, in 1938, with further study at Ohio State University and the University of Illinois. He taught the Basic Workshop and photography at the School of Design in 1939; during this time he also collaborated with László Moholy-Nagy on a series of photograms. He held several other teaching appointments, including another year at the ID (1946–47), before joining the faculty of the Illinois State Normal University, where he taught crafts, three-dimensional design, and contemporary art and architecture from 1947 until his retirement in 1980. Barford exhibited paintings, prints, sculpture, ceramics, and jewelry widely in the Midwest, and produced twelve color films on art, design, and architecture. He wrote extensively in educational journals, and published *Understanding Modern Architecture* in 1986. ES

Thomas Barrow

American, b. 1938. Born in Kansas City, Missouri, Thomas Barrow studied graphic design at the Kansas City Art Institute, earning a B.F.A. in 1963. He studied filmmaking with Jack Ellis at Northwestern University in 1964, and photography with Aaron Siskind at the ID from 1965 to 1967. He completed a Master of Science degree in photography in 1967 with a thesis titled "The Automobile." Often produced in large series, his work explores the nature of photography itself as reflective medium. Barrow worked as an independent photographer in New York, 1967–73, and thereafter in New Mexico, where he continues to teach at the University of New Mexico. Barrow has exhibited his work in solo and group exhibitions throughout the United States, Great Britain, and Canada; he has also worked as a museum curator and as an editor. He was awarded National Endowment for the Arts fellowships in 1973 and 1978. LM

Ferenc Berko

American, b. Hungary, 1916–2000. Filmmaker and photographer Ferenc Berko was born in Hungary, but at age five moved to Germany, where he later met several Bauhaus artists and designers including László Moholy-Nagy, Walter Gropius, and György Kepes. He took his first photographs at age ten, and was largely self-taught.

Berko went to London in 1932 to escape Nazism, and he worked as a freelance documentary photographer and cinematographer in London, Paris, and Bombay. Invited by Moholy to become an instructor at the ID, he taught there only one year, 1947–48, after Moholy's death. While at the ID, he experimented principally with color photography. Berko moved to Aspen in 1952, when industrialist and philanthropist Walter Paepcke invited him to photograph conferences and festivals for Container Corporation of America. He worked as a freelance photographer and exhibited his photographs regularly until his death in March 2000. LM

Eugene Bielawski

American, b. 1911. A Chicago native, Eugene Bielawski studied at Northern Illinois University and Northwestern University, receiving a bachelor's degree in education. From 1939 to 1944, he assisted in the Basic Workshop at the School of Design, and after György Kepes's departure, began teaching photography as well. In 1945 he moved to California, and taught a summer course based on Bauhaus methods at the California School of Arts and Craft in Oakland; the following school year, he served as director of the art department at the California Labor School in San Francisco. From 1947 to 1964 Bielawski edited the magazine *Design Contemporary*, and worked with his wife (and former School of Design student) Margaret De Patta on her jewelry business. Since 1964 he has focused on making sculpture and jewelry, interior design, and lecturing at art schools and design conferences. He lives in Richmond, California. ES

James Pease Blair

American, b. 1931. Born in Philadelphia, James Blair attended the ID from 1950 to 1954. He earned a bachelor's degree in photography and worked with Aaron Siskind documenting Louis Sullivan buildings and undertaking a study of a black family in South Chicago. Blair became a photojournalist, and during service in the Navy photographed North Vietnamese refugees. After several years working in television and film, Blair joined the staff of National Geographic in 1962, continuing to document people's lives in South Africa, Greece, Eastern Europe, India, and the United States. He has received numerous awards for his work, which focuses on environmental issues, science, and social change. He lives in Washington, D.C. LM

Barbara Blondeau

American, 1938–1974. Barbara Blondeau was born in Detroit, and came to Chicago to study at The School of the Art Institute of Chicago, where she received her B.F.A. in painting in 1961. From 1963 to 1966, she attended the Institute of Design, studying photography under Aaron Siskind and

Joseph Jachna and experimenting with a variety of photographic techniques and formats. She earned her M.S. in 1968 with a thesis of long strip pictures, made by winding a roll of film past an open shutter and printing the entire roll as a single frame; this work produced some of her signature images. Blondeau continued to photograph and exhibit while teaching photography at several institutions – St. Mary's College, Notre Dame, Indiana; Moore College of Art, Philadelphia; and the Philadelphia College of Art – before her untimely death from cancer in 1974. ES

James Hamilton Brown

American, active in Chicago 1940s–1950s. A native of Chicago, James Hamilton Brown studied at The School of the Art Institute of Chicago and worked in various photographic studios before serving in the Army in World War I. Upon his return, he practiced photography first as an amateur, and then as a full-time professional photographer with the Whitaker-Christenson Studios. He was hired by Moholy-Nagy to teach evening classes at the School of Design, from 1940 through 1946, alongside György Kepes, Frank Levstik, and Frank Sokolik. The school seems to have had an immediate effect on Brown, who began creating his own visual world through such photographic techniques as solarization, montage, reflection, and refraction. He later continued these innovations into the 1950s, with a commercial practice he called "Filmgraphics," which employed unusual special effects for advertising purposes. ES

Wynn Bullock

American, 1902–1975. Born in Chicago, Wynn Bullock grew up in Los Angeles, where he studied photography with Edward Kaminski at the Art Center School, 1938–40. He served in the U.S. Army from 1942 to 1944, and later operated the portrait concession at Fort Ord military base in Monterey, California, 1946–59. Bullock taught at the ID in 1967, filling in for Aaron Siskind while he was photographing in Rome. He also taught at the University of California at Santa Clara and at San Francisco State College. Known for his depictions of trees, nudes in nature, and moving water, Bullock in his work explores the philosophical realities of nature and challenges assumptions about perception. Bullock exhibited widely in the U.S. until his death in Monterey in 1975. LM

Barry Burlison

American, b. 1941. Barry Burlison was born in Norwich, New York, and earned a B.S. in art education at SUNY Buffalo, graduating in 1963. He spent a year at the University of Siena, Italy, and then attended the ID from 1966 to 1970, earning his master's degree in photography in 1970. After teaching in the New York public school system, Burlison taught photography and graphic arts at

Columbia College in Chicago, serving as chair from 1972 to 1978. He was a member of the photography department at Santa Monica College from 1982 to 1992, and taught at Mount Hood College, Oregon, from 1992 to 1998. He currently lives in Brush Prairie, Washington. LM

Harry Callahan

American, 1912–1999. A Detroit native, Callahan began photographing as an amateur and refined his skills at the Detroit Photo Guild, where he met Arthur Siegel and first saw Ansel Adams's photographs. Siegel, who became head of photography at the Institute of Design, recommended Callahan to László Moholy-Nagy in the summer of 1946. Callahan joined the fledgling program and taught photography at the school until 1961, with the exception of one year, 1957–58, during which he lived and photographed in France on a Graham Foundation fellowship. Callahan became the head of the ID photography department in 1949, and was instrumental in hiring Aaron Siskind and founding the master's degree program in 1951; together they formed a teaching partnership that is now legendary. During his time in Chicago, he explored subject matter that would define his photography – pictures of female pedestrians, abstract landscapes of weeds and grasses in the snow, architectural facades, and intimate portraits of his wife Eleanor and daughter Barbara – with techniques as varied as multiple-exposure, extreme contrast, and lengthy exposures. In 1961 Callahan left the ID to teach at the Rhode Island School of Design, in Providence, where he remained until his retirement in 1977. He began to photograph exclusively in color in 1977, focusing on beaches in Providence and throughout New England; in 1983 he moved to Atlanta, Georgia, and continued to photograph until he died there in 1999. The subject of numerous retrospectives and publications and the recipient of many awards, Callahan remains one of the most important photographers in twentieth-century America. ES

Alan Cohen

American, b. 1943. Alan Cohen, born in Harrisburg, Pennsylvania, attended North Carolina State University and studied thermodynamics at Northwestern University. He attended the ID from 1969 to 1972 and earned a Master of Science degree in 1972. His thesis project, "Slow Shutter: Painting with Light" or "The Nude Form: Energy and Structure," conducted under Arthur Siegel and Aaron Siskind, depicts a nude model in the landscape whose limbs merge with the sun-flooded ground, an effect achieved by extending the film development to increase the contrast between light and dark. Cohen currently teaches at The School of the Art Institute of Chicago, DePaul University, and Columbia College, Chicago, and exhibits

his photographs across the United States and Germany. His recent work documents wars of the twentieth century, political borders, and other sites of demarcation formed by nature. LM

Linda Connor

American, b. 1944. Born in New York City, Linda Connor studied photography with Harry Callahan at the Rhode Island School of Design, 1962–65, and with Aaron Siskind at the ID, 1966–69. She completed her master's thesis in 1969, which consisted of photographs within photographs. Connor's early work, produced while she was freelancing in San Francisco, consisted of collage-like photographic compositions and still lifes. A collection of early soft-focus lens photographs was published in her 1979 book, *Solos*. She has traveled extensively, taking photographs that explore relationships between the natural and civilized worlds and documenting spiritual artifacts and landscapes. She has exhibited her work broadly and was awarded a National Endowment for the Arts individual grant in 1976 and a Guggenheim Fellowship in 1979. Connor currently teaches at the San Francisco Art Institute. LM

Gordon Coster

American, 1906–1988. Born in Baltimore, Gordon Coster worked in Chicago for most of his professional life as a commercial photographer and photojournalist. Initially active in exhibiting in amateur salons – and winning awards for his pictorialist style – he later developed a documentary career photographing labor union activities, civil rights workers, and the peace and anti-fascism movements. In 1936 he opened his own commercial photography studio, which he operated until 1942, and throughout the 1940s he freelanced for *Life* magazine. Coster taught at the Institute of Design three separate times: during the 1946 "New Vision in Photography" summer seminar, in the 1950–51 school year, and again in 1960. Hired for his expertise in documentary photography, he focused in his classes on socially oriented themes and assignments. From the late 1940s on, he freelanced for *Time*, *Fortune*, *Holiday*, *Ladies Home Journal*, and *Scientific American*, before ceasing photographic work in 1964 and eventually retiring in 1982. ES

Eileen Cowin

American, b. 1947. Eileen Cowin was born in Brooklyn, New York, and attended SUNY New Paltz, from which she received her B.S. She earned a master's degree in photography at the ID in 1970, completing a thesis entitled "Plastic Environments," under Arthur Siegel. Cowin's narrative still photographs, which have been called "staged tableaux," explore the difference between the real and the photographed. Cowin was awarded a National Endowment for the Arts grant in

1974 and NEA fellowships in 1979 and 1982. She has had solo exhibitions throughout the United States, in Europe, and in Japan. She currently teaches at California State University, Fullerton. LM

Barbara Crane

American, b. 1928. A native of Chicago, Barbara Crane studied art history at Mills College in Oakland, California, where she was introduced to the work of László Moholy-Nagy and György Kepes at the Institute of Design. In 1948 she moved to New York, and completed her undergraduate degree at New York University in 1950. Having begun photographing in 1947, Crane got her first professional experience working as a portrait photographer for Bloomingdale's; she later continued portrait photography back in Chicago. In 1964 she showed a portfolio of her photographs to Aaron Siskind and began classes at the ID, receiving her master's degree in 1966 with a study of abstract nudes called "Human Forms." She taught photography at The School of the Art Institute of Chicago from 1967 to 1995, where she remains professor emeritus. Her many photographic series have been exhibited widely throughout the country. Crane has received two National Endowment for the Arts fellowships (1974, 1988), a Guggenheim Fellowship (1979), and a Polaroid Corporation Materials Grant (1979–1994), and has executed various public projects and commissions for the city of Chicago. ES

Margaret De Patta

American, 1903–1964. Known for her innovative jewelry designs, Margaret De Patta studied painting and metalworking in California and New York before opening a jewelry studio in San Francisco around 1935. She met László Moholy-Nagy during his 1939 visit to San Francisco, and, apparently inspired by that meeting, began making photograms that year. In the summer of 1940, she attended the School of Design's special summer session at Mills College, and decided to study at the school in Chicago during the academic year 1940–41. There she translated exercises in light modulators and photograms into jewelry with light-reflecting and magnifying properties. She also met faculty member Eugene Bielawski, whom she eventually married. The two returned to California, where she actively pursued jewelry making until 1958, and jewelry design thereafter until her death in 1964. ES

François Deschamps

American, b. 1946. A native of New York City, François Deschamps earned a master's degree in photography at the ID in 1972. His thesis under Arthur Siegel, "Spatially Ambiguous Photographs," consisted of "straight" photographs that experiment with point of view, lighting, or tonality to create

mysterious or ambiguous effects. He currently makes artist's books that juxtapose narrative elements with imagery. He received National Endowment for the Arts fellowships in 1983 and 1987 and has exhibited widely in the United States. Deschamps teaches in the photography department at SUNY New Paltz and divides his time between New York and Maine. LM

Jonas Dovydenas

American, b. Lithuania, 1939. Jonas Dovydenas was born in Lithuania and spent 1944 to 1949 as a refugee and displaced person in Germany. Arriving in the United States in 1949, his family settled in northwestern Pennsylvania. After serving in the U.S. Air Force, 1958–60, during which time he began to develop his own photographs, Dovydenas studied English literature at Brown University. There he met Harry Callahan and took a photography course at the Rhode Island School of Design before graduating in 1965. He moved to Chicago, attending the ID for a semester before joining the Department of Urban Renewal in 1966. He has worked as a freelance photographer since 1967 and is currently producing a series of photographs to illustrate a new edition of Edith Wharton's memoir *The Cruise of the Vanadis* (forthcoming 2002). He lives in Lenox, Massachusetts. LM

Robert Donald Erickson

American, 1917–1991. Born in St. Paul, Minnesota, Robert Erickson was interested in nature, sports, art, and music as a youth. After completing college degrees in science, mathematics, and art, he happened to read László Moholy-Nagy's *New Vision* and borrowed money to attend the School of Design in 1943. There Erickson attended every class offered, and received the school's first master's degree, awarded in 1945. At Moholy's invitation, he led the Saturday art classes for children until 1948, when he resigned to protest new director Serge Chermayeff's philosophy about the program. Beginning in 1945, Erickson taught at the University of Chicago Laboratory School and remained there until his retirement in 1978. He exhibited in local galleries, schools, and theaters, and focused on researching education, but he has also spent his time designing cameras, furniture, toys, and jewelry; lecturing and writing; painting, printmaking, drawing, and photographing; and singing and horn playing. ES

Andrew Eskind

American, b. 1946. Andrew Eskind was born and raised in Louisville, Kentucky. He graduated from Oberlin College in 1968 and earned his master's degree at the ID in 1973, studying with Arthur Siegel. His thesis, "Esthetic Effects of Light on Transparent Photographic Materials," focused on pattern and light. He left Chicago in 1973 to work at

George Eastman House in Rochester, New York, where he continues to work today. The many projects he has pioneered there include the computer management of large collections, the development of a database catalogue of the collection, and the first George Eastman House web site. Eskind continues to make photographs, particularly in digital media. LM

Antonio A. Fernandez

American, b. Cuba, 1941. Born in Havana, Cuba, Antonio Fernandez grew up in Miami and served two years in the U.S. Army. He attended the University of Florida in 1963, and spent two years in Panama as a Peace Corps volunteer before attending the ID from 1967 to 1970. While there, he worked part-time with emotionally disturbed children and drew upon this experience for his master's thesis, completed in 1970. Fernandez taught elementary school for five years and continued his studies at Michigan State University, where he earned a Ph.D. in elementary education and language arts in 1978. He returned to Miami and has taught education and photography at St. Thomas University ever since. In addition to landscape photography, Fernandez has been shooting pictures of local horse races. He continues to publish and exhibit his work and also teaches photography at the New World School of the Arts in Miami. LM

Lois Field

American, b. 1923. Born in New Jersey, Lois Field studied at the Newark School of Fine and Industrial Arts from 1945 to 1948. Inspired by press accounts of László Moholy-Nagy's revolutionary teaching method, she enrolled at the Institute of Design in 1948, graduating with a degree in visual design in 1952; while there, she studied with Arthur Siegel and produced photographs made with a variety of experimental techniques. During the 1950s Field taught in the Chicago Public Schools, and from the 1960s on she ran the Design Workshop, a firm she co-owned with her husband – and former ID graduate and faculty member – Myron Kozman. Committed to ID pedagogy, Field helps organize regular reunions of the school's alumni, and is working on a book chronicling the influence of the Bauhaus. ES

Len Gittleman

American, b. 1932. Born and raised in New York City, Len Gittleman began photography at age thirteen. He attended the ID from 1950 to 1954, receiving a B.S. degree. There he worked on the Sullivan project under Aaron Siskind, and made a film called The Press with John Wood and Michael Train (c. 1953). He collaborated with Train again on Whirligig, a film about an old carousel, which was screened at the Cannes Film Festival in 1959. Both films share a concern with the distinct form and beauty of inanimate

objects. Gittleman has taught at the Carpenter Center for the Visual Arts, Harvard University, 1963–75, and at the Rhode Island School of Design. He has also worked as a film photographer and exhibited both photography and graphic work across the United States, winning numerous awards. His series of lunar serigraphs were published in 1972 and recent work includes a time-lapse motion-picture study of the construction of Gund Hall at Harvard. He currently lives outside Boston, where he freelances as a multimedia and interactive media developer. LM

Milton Halberstadt

American, 1919–2000. Born in Boston, Milton Halberstadt worked as a studio photography assistant in the late 1930s and photographed for the WPA project in 1939-40. He received a scholarship to study photography at the School of Design from 1940 to 1941. There he assisted László Moholy-Nagy and György Kepes in the Light and Color workshops, overseeing the studio and darkrooms, and experimented with solarization, reflection, and repeated imagery. Because he also had earlier experience in commercial studios, he printed Moholy's photographs for the Museum of Modern Art to sell. His signature image, made while he was a student, is a triple-exposed portrait of Norm Martin (cat. 56) that was prized by Moholy, who kept a copy in his office and reproduced it in Vision in Motion. When Halberstadt returned for his second year, he found that the scholarship money had evaporated. He served in the U.S. Army from 1941 to 1945 and then moved to San Francisco, where he opened up a studio specializing in advertising photography, which he headed through 1973. Halberstadt continued to photograph and teach photography in San Francisco until his death in 2000. ES

Paul Hassel

American, 1906–1964. Born in Chicago, Paul Hassel was educated at the University of Pennsylvania and Northwestern University. While maintaining an interest in art and photography as an avocation, Hassel managed a family retail business in Chicago until he was in his early 40s. When he retired from the business in 1950, he resumed his education at the ID, studying with Aaron Siskind and Harry Callahan. In 1953 he moved to San Francisco and joined the staff at the School of Fine Arts (now the San Francisco Art Institute), where he became chairman of the photography department in 1958. He exhibited his work frequently and is included in the collections of the San Francisco Museum of Modern Art, the State Department, and the Oakland Museum of California. LM

Reginald Heron

American, b. France, 1932. Born in Marseilles, France, Reginald Heron earned his bachelor's and master's degrees at the ID in

1963 and 1966, respectively. His master's thesis, "The Group: A Photographic Study," addressed the choreography of crowds and the natural formation of groups. Heron taught at the ID from 1965 to 1966 and then joined the curatorial staff at the George Eastman House in Rochester, New York, where he focused increasingly on the technical craft of photography, and began photographing at night. Heron has shown his work in solo and group shows throughout the United States. After twenty-three years teaching at Indiana University, Heron retired in 1996. LM

Yasuhiro Ishimoto

Japanese, b. United States, 1921. Yasuhiro Ishimoto joined his Eastern sensibilities with photographic techniques learned at the Institute of Design to document both Chicago and Japan. Born in San Francisco and raised in Japan, Ishimoto returned to the United States to study agriculture, but he was detained at the Amachi Internment Camp during World War II. In 1945 he moved to Chicago to pursue the study of architecture. He joined the Fort Dearborn Camera Club (where he maintained darkroom privileges) and, after encountering György Kepes's Language of Vision and László Moholy-Nagy's Vision in Motion, enrolled at the ID in 1948. He studied photography under Harry Callahan and completed his bachelor's degree in 1952. While at the school, Ishimoto photographed extensively in local neighborhoods and made a short documentary film with Marvin Newman titled The Church on Maxwell Street. He returned to Japan in 1953, where he continued to photograph (including a series on the Japanese building complex Katsura Villa). The Japanese nation has named Ishimoto a "Person of Cultural Merit." But Chicago has always remained his second home: he returned to photograph on a fellowship from 1959 to 1961 and has presented his paean to the city in two books of photographs called Chicago, Chicago (1969, 1983). ES

Joseph D. Jachna

American, b. 1935. Born in Chicago, Joseph Jachna received a newspaper carrier's scholarship to attend the Institute of Design in 1953, but left after one year to work at the local Eastman Kodak lab. He returned to the school in 1955, studied with Harry Callahan, Aaron Siskind, and Frederick Sommer, and earned a bachelor's degree in art education in 1958. Deciding to focus on photography, Jachna worked for three years on his thesis, an in-depth photographic study of water. He received his M.S. in 1961, the same year that Aperture showcased his photographs in a special issue of five ID graduate students. After Callahan's departure in 1961, Jachna taught alongside Siskind until 1969, when he joined the faculty of the University of Illinois at Chicago Circle (now the University of Illinois at Chicago). He taught photography

there until his retirement in 2001. Jachna has photographed the natural environment of the Midwest and Iceland and has exhibited nationally; among his many awards are fellowships from the National Endowment for the Arts (1976) and the Guggenheim Foundation (1980). ES

Kenneth Josephson

American, b. 1932. Kenneth Josephson began taking photographs as a teenager in Detroit. He went to the Rochester Institute of Technology to study photography in 1951, earning an associate degree. After two years in the army (1953–55), he returned to RIT, where he worked with Beaumont Newhall and Minor White, and received his B.F.A. in 1957. In the fall of 1958 Josephson entered the Institute of Design's graduate program, studying under Callahan and Siskind. He completed his M.S. in 1960 with a thesis, "Exploration of the Multiple Image," that consisted of in-camera multiple exposures with changes of camera position, focus, time, and subject in order to discover new form; images from this thesis were included in the 1961 issue of Aperture on the ID. Following graduation, Josephson became a professor at The School of the Art Institute of Chicago, where – except for travel, sabbaticals, and visiting lectureships – he taught until his retirement in 1997. He was a founding member of the Society for Photographic Education. The recipient of numerous awards (including a Guggenheim Fellowship and two NEA fellowships), he has completed several extensive photographic series. ES

William Keck

American, 1908–1995. William Keck worked as an architect, designer, and photographer. Born in Watertown, Wisconsin, he earned a bachelor's degree in architecture at the University of Illinois in 1931. Keck joined the architectural firm of his brother George Fred Keck (1895–1980) in 1931 and worked with him until 1942. In 1933 their glass-and-steel design for a "House of Tomorrow" was featured in Chicago's Century of Progress Exposition. Keck attended the ID in 1939 and returned in 1941–42 to assist György Kepes in teaching the Light and Color workshops. After William served in the U.S. Corps of Engineers, 1942–43, and the Naval Reserve, 1944–45, the two brothers established the partnership Keck & Keck in 1946. They received numerous awards for their designs, which combined social and environmental concerns with innovative design and technology. LM

György Kepes

American, b. Hungary, 1906. Like his fellow Hungarian László Moholy-Nagy, György Kepes held a lifelong interest in light and color, as well as in photography, painting, typography, and design. In 1930 he joined Moholy in Berlin as his assistant, and

together they worked on set design and advertising. Kepes followed him to London, where he met and married Juliet Appleby, who became one of the first students at the New Bauhaus (and occasionally his model for photographs). When Moholy was invited to head the new school in 1937, he hired Kepes as the director of the Light Workshop. Kepes's course of instruction included photograms, photographs, and the manipulation of light through colored filters, prisms, and mirrors. In 1944, after leaving the school, Kepes summed up his teaching and philosophy of representation in Language of Vision, a book that would lead many students to the Institute of Design. A committed educator and artist, Kepes taught for thirty years at Massachusetts Institute of Technology, initiating and editing the interdisciplinary Vision + Value book series and continuing to study light as a creative tool. He has received honorary degrees and numerous awards, including a Guggenheim Fellowship (1959–60), and has exhibited his work widely. ES

Thomas Knudtson

American, b. 1939. A Chicago native, Thomas Knudtson studied at the ID over a span of ten years beginning in 1957. He earned his bachelor's degree in 1961 and documented Richard Nickel's removal of architectural ornament by Louis Sullivan at the Garrick Theater. In 1962 he began working as a photographer at Container Corporation of America, and completed a master's thesis under Aaron Siskind, titled "Four Exposures, a Photography Project," in 1967. Knudtson taught at what is now Virginia Commonwealth University, 1967–68, and at the University of Iowa, 1969. He returned to Chicago in 1969 and resumed photographing Chicago's architecture, publishing Chicago, The Rising City (1975). He later joined Chicago's Department of Planning and Development. Since his retirement in 1998, he has worked as a consultant on neighborhood economic development issues. LM

Cal Kowal

American, b. 1944. Cal Kowal was born in Oak Park and grew up in Chicago, where he studied art and architectural history at the University of Illinois. He completed a master's degree in photography at the ID, with the thesis "Light Wind, Light Snow, Light Sand" under Arthur Siegel in 1971. Kowal has shown his work in numerous exhibitions and publications, and has also curated and lectured extensively in the Midwest. His recent work experiments with compositions of juxtaposed elements. He currently teaches at the Art Academy of Cincinnati. LM

Myron Kozman

American, b. 1916. A lifelong artist and educator, Myron Kozman encountered the New Bauhaus by chance in its first year on Prairie Avenue, and László Moholy-Nagy encour-

aged him to enroll, offering a four-year scholarship. Kozman's photographic work, produced between 1937 and 1945, was influenced by his friend and teacher György Kepes, who encouraged the use of experimental techniques including "drawing" with photographic chemicals. Kozman became one of the school's first five graduates in the spring of 1942, and he received a master's degree in architecture in 1946. In Paris at the end of the World War II, he copublished the literary and art magazine Continuity, which reproduced the art and writings of such figures as Constantin Brancusi and Gertrude Stein. He later joined the Institute of Design as a faculty member and taught printmaking and visual design until 1954. He continued to apply the principles he learned at the New Bauhaus as a professor at the Layton School of Art, Milwaukee (1959–69); Webster College, St. Louis (1970–75); and Lindenwood College, St. Louis (1992–2000). Kozman resides in Webster Groves, Missouri. ES

Elsa Kula

American, b. 1918. Born in New York, Elsa Kula received a degree in drawing and illustration from the Pratt Institute in 1938, before designing window displays for Bonwit Teller. She attended a six-week summer session at the School of Design in 1939, and remained at the school through 1942, studying in the Light and Color workshops under László Moholy-Nagy and György Kepes; among her varied works from this period are collaborative photograms with fellow student (and later husband) Davis Pratt. In the early 1940s Kula worked as a graphic designer for the Works Progress Administration, a product designer for Lever Brothers, and an exhibit designer for the National Health Service. She returned to the ID in 1946 to teach visual design, specializing in typography and industrial, packaging, and advertising design. In 1948 she founded her own studio, serving such clients as Container Corporation, Schlitz Brewing, Allstate Insurance, and Playboy magazine. From 1957 to 1969 she taught design at Southern Illinois University; she now lives in Gainesville, Florida. ES

William Larson

American, b. 1942. Born in North Tonowanda, New York, William Larson attended SUNY Buffalo, earning a B.S. in art in 1964. He studied photography at the ID, and completed a master's thesis, "A Non-Classical Study of the Nude," in 1968. Larson continued to work in color photography, receiving National Endowment for the Arts fellowships in 1971 and 1979. He has worked as a freelance photographer in Philadelphia since 1968, and has taught at the Tyler School of Art. Larson's later work, such as his 1980 book of polaroids, Big Pictures, Little Pictures, focuses on the subject of photography itself, depicting studio equip-

ment and experimenting with lighting, focus, and color. He has exhibited widely in the United States, and lives in Collegeville, Pennsylvania, serving as director of graduate studies at Maryland Institute College of Arts, Baltimore. LM

Hubert Leckie

American, 1913–1993. A designer, typographer, and printmaker, Hubert Leckie was among the first students at the New Bauhaus in 1937–38, studying under László Moholy-Nagy, György Kepes, Hin Bredendieck, and Alexander Archipenko. He returned to the school in 1939 as its first lettering instructor (he also taught product design and the Basic Workshop), and he remained until 1942; in his class, students learned to create a new alphabet style. During the war, Leckie designed visual aids for the Navy and then joined a design cooperative. In 1952 he opened his own practice in Washington, D.C., and headed it until his death in 1993, specializing in brochures, exhibitions, and book cover design for clients from the Smithsonian Institution to *Interiors* magazine. Leckie applied New Bauhaus principles as a professor at American University, the Institute of Contemporary Arts, and the Corcoran School of Art. ES

Nathan Lerner

American, 1913–1997. Nathan Lerner studied painting at The School of the Art Institute of Chicago, and was a self-taught photographer before entering the first class of the New Bauhaus in 1937. There he studied under Alexander Archipenko, László Moholy-Nagy, György Kepes, and Henry Holmes Smith, and devised the "light box," a construction in which he could manipulate light for photographic studies. One of the school's five graduates from its first class, he was both student and teacher, assisting Kepes in the Light Workshop and teaching photography. Lerner returned to the Institute of Design in 1945 to head its Product Design Workshop, later becoming the dean of faculty and students and acting education director after Moholy's death. In 1949, he left the school and opened a design firm that he led through 1970; he returned to the ID as a visiting instructor in the 1950s. Lerner began working seriously again with a camera in the 1970s, photographing in Japan and Chicago, and exhibited for the first time many of his photographs from the 1930s. ES

Frank Levstik, Jr.

American, 1908–1985. Frank Levstik taught photography at the Institute of Design from 1939 to 1949. Born in Chicago, he attended art school early on and worked in various commercial photography studios throughout the 1930s, exhibiting widely in pictorialist salons. At the suggestion of Henry Holmes Smith, Moholy hired Levstik to assist György Kepes in the Light Workshop, where he

became a technician and instructor, often teaching the evening classes. Many of his photographs from this period were reproduced in Kepes's *Language of Vision*. From 1949 to 1955 Levstik taught photography and industrial design at the Layton School of Art, Milwaukee, and in 1956 taught at the Columbus College of Art and Design in Ohio. He exhibited his photographs in the Midwest as well as Houston and Washington, D.C. ES

Charles Lichtenstein

American, active 1940s–1950s. A native New Yorker, Charles Lichtenstein attended the Institute of Design from 1947 to 1950, studying under Harry Callahan and Arthur Siegel, and received a bachelor's degree in photography. He was also associated with the Photo League in New York. ES

Archie Lieberman

American, b. 1926. A Chicago native and one of the country's most prominent photojournalists, Archie Lieberman attended the Institute of Design from 1945 to 1948. Lieberman has worked as an independent photographer since 1961; his photographs have appeared in *Look*, *Life*, *Time*, *The Saturday Evening Post*, *Newsweek*, *London Illustrated*, *Paris Match*, and many other publications. Lieberman has written and illustrated numerous books, including *The Israelis* (1965), *Farm Boy* (1974), *Chicago* (1983) with Bob Cromie, and more recently, *Neighbors: A Forty-Year Portrait of an American Farm Community* (1993) taken in Scales Mound, the community in northwest Illinois where Lieberman lives today. LM

Nathan Lyons

American, b. 1930. Nathan Lyons is a curator, lecturer, photographer, and writer. A New York native, Lyons earned his B.A. at Alfred University and served as a photo-intelligence officer, newswriter, and photographer in the U.S. Air Force. From 1957 to 1969 Lyons worked at the George Eastman House, eventually becoming associate director and curator of photography. In 1963 he was a visiting lecturer in photography at the ID and also became a founding member of the Society for Photographic Education. He established the Visual Studies Workshop in 1969 and *Afterimage* magazine in 1972, where he served as editor until 1977. He is the author and editor of many books and anthologies, including *Photographers on Photography* (1966), *Photography in the Twentieth Century* (1967), and *Riding 1st Class on the Titanic!* (1999). He was awarded an honorary doctorate from the Corcoran School of Art, Washington, D.C., in 1995. LM

Ray Martin

American, b. 1930. Born in Chicago, Ray Martin attended the Institute of Design from 1949 to 1953 – except for a year spent in

the U.S. Marine Corps – and received his Bachelor of Science degree in visual design. He studied with Art Sinsabaugh, took a film class with Arthur Siegel, and produced a series of photographs on local storefront churches. An experienced printmaker, he then taught at the ID for a year and a half a class in letterpress printing and the making of artists' books as well as a course in drawing. Along with Aaron Siskind, he was a faculty advisor for the first *Student Independent* portfolio. Following a stay in Paris on a Fulbright Fellowship, Martin did commercial book design and made fine-print books. He currently lives and works in Oak Park, Illinois, where he continues printmaking and bookmaking. He teaches at The School of the Art Institute of Chicago, and exhibits prints and book art in Chicago and internationally. ES

Lyle Mayer

American, active 1950s–1960s. Lyle Mayer participated in the Institute of Design as both a student and teacher. As an undergraduate in the late 1940s, he photographed scenes of transient hotel fronts on north Clark Street, a Chinese-American laundry, and inhabitants of public-housing projects. He returned to the school to teach evenings in the mid-1950s, often teaming with William Rose, with whom he also operated a commercial photography studio. Mayer completed a master's degree in 1968 with a thesis on local antique stores. ES

Ray K. Metzker

American, b. 1931. Born in Milwaukee, Ray Metzker began photographing as a teenager, and studied art at Beloit College in Wisconsin. Following a two-year stint in the army (1954–56), he enrolled in the master's degree program at the Institute of Design, where he studied with Harry Callahan, Aaron Siskind, and Frederick Sommer and received his degree in 1959. His thesis, "My Camera and I in the Loop," comprised 119 photographs taken within the boundaries of Chicago's elevated transit that encircles downtown. More an investigation of the properties of photography than a documentary project on the Loop itself, the pictures were exhibited at The Art Institute of Chicago in the winter of 1959–60, and featured in the 1961 issue of *Aperture* devoted to the ID. Metzker has taught at the Philadelphia College of Art (1962–80), the University of New Mexico (visiting professor, 1970–72), and Columbia College, Chicago (1980–83). Among his many awards are Guggenheim fellowships in 1966 and 1979 and National Endowment for the Arts fellowships in 1974 and 1988; he has exhibited widely in the United States and Europe. Metzker no longer teaches full-time, but continues to travel extensively, photograph, and exhibit. ES

Wayne Miller

American, b. 1918. Wayne Miller served in the U.S. Navy during World War II as a member of Edward Steichen's Combat Photo Unit, and won two consecutive Guggenheim grants (1946–48) to document "The Way of Life of the Northern Negro" on the South Side of Chicago. He combined his skill in documentary photography with his interest in photographing human experience at the ID, where he taught one night a week for only one year (1948–49). While teaching at the ID and working on the Chicago project, Miller also freelanced for such magazines as *Life*, *Colliers*, *Ebony*, *Fortune*, and *Ladies Home Journal*. He later joined *Life* as a contract photographer, assisted Steichen on the 1955 *Family of Man* book and its exhibition at the Museum of Modern Art, New York, and gained membership to Magnum Photos, Inc., becoming its president in the mid-1960s. Miller has published several books, won many photojournalism awards, and has increasingly devoted himself to environmental causes. He lives in Orinda, California. ES

László Moholy-Nagy

American, b. Hungary, 1895–1946. A prolific artist in many media and a spirited educator, László Moholy-Nagy was associated with the Hungarian avant-garde before moving to Germany, where he was invited by Walter Gropius to teach at the Staatliche Bauhaus in 1923. He taught the Foundation Course at the Bauhaus until 1928, while experimenting with photography, light, and color in addition to painting, set design, and typography. It was at the Bauhaus that he published his landmark book *The New Vision*. Between 1928 and 1937, in Berlin, Amsterdam, and London, Moholy worked in and wrote widely on photography and film (with particular innovation in photograms, which he felt revealed the basic elements of photography), and he continued his experiments in other media. In 1937, upon the recommendation of Gropius, Moholy came to Chicago to head the New Bauhaus (subsequently the School of Design and Institute of Design), which he led until 1946. He worked tirelessly to support the school, lecturing and publishing about its pedagogy and devising novel ways to keep it afloat, while inspiring devotion from students and teachers. Moholy's interest in light and photography made the Light Workshop central to the school's program, and he continued to produce photographs and photograms while in Chicago. Moholy's posthumously published *Vision in Motion* summarized his educational philosophy and, with many examples of student work, provided a model for Bauhaus-derived education in America. ES

Marvin E. Newman

American, b. 1927. One of the first master's degree students in photography at the Institute of Design, Marvin Newman already had some experience with the medium, having taken classes at Brooklyn College with Walter Rosenblum and Berenice Abbott. Newman arrived at the ID in 1949, and studied under Harry Callahan. He often photographed the streets of Chicago with fellow student Yasuhiro Ishimoto (with whom he made the film *The Church on Maxwell Street*, documenting the sights and sounds of a revivalist church). His 1952 master's thesis, "A Creative Analysis of the Series Form in Still Photography," explored repeated forms in series of children's faces, people in similar positions and poses, and inverted human shadows on the sidewalk. Unlike many photographers trained at the ID, Newman did not go on to teach in a university, instead choosing the path of photojournalism: since 1953 he has been a contributing photographer for *Sports Illustrated*, and later photographed for *Life*, *Look*, and *Esquire*. He is the recipient of numerous photojournalism awards and has exhibited widely. ES

Richard Nickel

American, 1928–1972. A Chicago native, Richard Nickel found his calling in documenting and saving the work of Chicago architect Louis Sullivan. He began photographing while in the army, and upon his return in 1948 enrolled in the Institute of Design; after three semesters, he was recalled into combat, and worked as a military photographer in Korea. When he resumed courses at the ID, Aaron Siskind was leading students in the Sullivan project, photographing existing buildings by the noted architect. Nickel obsessively immersed himself in the research and photography, and after receiving his bachelor's degree in 1954, continued the project for his 1957 master's thesis. The study, which Nickel was planning (along with Siskind and Ben Raeburn) to publish as the definitive guide to Sullivan's architecture, was ultimately overshadowed by his urgent preservation work as buildings were being demolished. In the 1960s Nickel continued photographing, but he spent even more time rescuing ornament and attempting to save buildings from the wrecking ball. He was killed when a floor collapsed while he was on a salvage expedition inside the Chicago Stock Exchange Building in 1972. ES

Homer Gordon Page

American, 1918–1985. Born in Oakland, California, Homer Page first encountered the School of Design as a scholarship student at the school's Mills College summer session in 1940. He received additional funding to attend the school that fall, and studied photography and design alongside Milton Halberstadt and Margaret De Patta. In 1941 he returned to California and took a job in the Kaiser shipyards; shortly thereafter, he bought a Rolleiflex camera and began photographing seriously. In the late 1940s and 1950s he exhibited both locally and at the Museum of Modern Art in New York, where he was hired by Edward Steichen to assist on the 1955 *Family of Man* project. Page received a Guggenheim Fellowship in 1949, and the following year joined the photojournalist cooperative Magnum as its first non-founding member (through 1953). A photographer for *Life*, *Vogue*, *U.S. Camera*, *Look*, and *Fortune*, he traveled and photographed on assignment in over sixty countries in Africa, Asia, Europe and the Americas. ES

Thomas Porett

American, b. 1942. Chicago native Thomas Porett attended the University of Wisconsin, Madison, and completed a master's degree in photography at the ID in 1966. His thesis, "Introspective Landscape," under Joseph Jachna, involved slides, black-and-white prints, and film. He continued to make multimedia works, such as "Made in the USA," a collage of sound, altered photographs, and film. Porett has studied synthesizer techniques and electronic music composition as well as holography. He has presented his work extensively in the United States and Canada and works as a graphics and media consultant for computer design and technology. He currently teaches photography and electronic media at the University of the Arts in Philadelphia. LM

Davis Pratt

American, 1917–1987. Davis Pratt attended the School of Design in the early 1940s, where he collaborated on photograms with fellow student (and later wife) Elsa Kula. He also produced innovative plywood and tubular steel chairs that László Moholy-Nagy reproduced in his posthumously published *Vision in Motion*. After serving in World War II, Pratt returned to the school to teach product design. Best known as a furniture designer, Pratt won an award for his famous inflatable tube chair at the Museum of Modern Art's "International Competition for Low-Cost Furniture Design" in 1948. Along with fellow ID student Harold Cohen, he formed a furniture design and production company in 1952 called Designers in Production, which manufactured several original designs until 1957. That same year Pratt joined the faculty of Southern Illinois University, where he established a highly successful design department. ES

Max Pritikin

American, b. 1916. A beneficiary of the GI Bill (having served in World War II from 1942 to 1945), Max Pritikin studied at the ID from 1945 to 1948. He took classes with Arthur Siegel, Frank Sokolik, and Frank Levstik, and received his bachelor's degree in graphic design, with a minor in photography, in 1948. Although focusing on commercial art and design, Pritikin also experimented with

pinhole cameras, x-rays, and artificial negatives. Following his time at the school, he worked as a designer of industrial catalogues, a graphic designer, and a production artist, until his retirement in 1977. ES

Thomas Rago

American, b. 1926. Tom Rago attended the ID from 1953 to 1957, after serving in the U.S. Air Force as a trained photography lab technician, working in a professional portrait studio, and studying at a local art school, where he encountered László Moholy-Nagy's *The New Vision*. At the ID, his greatest influences were the Basic Workshop with Hugo Weber and Eugene Dana, and the photography courses with Harry Callahan and Aaron Siskind; he received a B.S. in photography and education in 1957. Following a year in Germany on a Fulbright Fellowship, 1957–58, Rago studied at Arizona State University, where he earned his master's degree in art history. He served as the civilian director of recreation for the U.S. Army in Europe from 1960 to 1989, during which time he traveled extensively, and exhibited and published his photographs in European galleries and magazines. In the 1980s, he photographed largely in color, and developed a process he calls photoseriography; he lives in Trenton, New Jersey, where creative writing is now his primary occupation. ES

Merry Renk

American, b. 1921. A war widow in 1946, and intrigued by an article she saw about the Institute of Design in the *Saturday Evening Post*, Merry Renk decided to come to the school to learn industrial design. During the year she attended (1946–47), she also took photography classes with Harry Callahan and experimented with the Foundation Course photography problems. In the spring of 1947, Renk, along with Mary Jo Slick and Olive Oliver, opened the 750 Studio, a gallery that exhibited and sold paintings, graphics, and crafts. The gallery presented fifteen exhibitions in the next year and a half (before closing in 1948), including Harry Callahan's first one-man show and a posthumous presentation of works by László Moholy-Nagy. A self-taught metalsmith, Renk has designed jewelry since 1947, much of it inspired by the exercises and problems she encountered at the Institute of Design. She lives and works in San Francisco. ES

Gretchen Schoeninger

American, b. 1913. Born in Ravinia, Illinois, and raised in Carmel, California, Gretchen Schoeninger attended the New Bauhaus in its first year, 1937–38. She studied with László Moholy-Nagy, György Kepes, Alexander Archipenko, and Henry Holmes Smith and experimented with such photographic techniques as negative exposure. Best known for her sculpture, which she began producing after her time at the New Bauhaus,

Schoeninger was included in several group exhibitions in the 1940s (at The Art Institute of Chicago, the Cincinnati Art Museum, the Metropolitan Museum of Art, New York, and the California Palace of the Legion of Honor, San Francisco), and received a two-person show with her husband (and fellow student) Alexander Corazzo at the San Francisco Museum of Art. She currently lives and works in Indiana. ES

Arthur Siegel

American, 1913–1978. Arthur Siegel sustained a forty-year association with the Institute of Design, beginning with his semester as a student at the New Bauhaus in the spring of 1938. When the school initially failed, he returned to his native Detroit, where he worked as a commercial photographer and, through the Detroit Camera Club, met Harry Callahan. Siegel photographed for several government organizations during World War II, until he was invited by László Moholy-Nagy to organize and head a four-year photography course. In 1946 Siegel inaugurated the new program with a six-week summer seminar, "New Vision in Photography," which featured top curators and photographers from around the country. As head of the program from 1946 until his resignation in 1949, he continued teaching photography through foundation problems, and introduced the school's first course in the history of photography. Siegel then focused on commercial work and photojournalism as well as his own color photography, became interested in Freudian analysis, and returned to teach at the school off and on throughout the 1950s and 1960s. In 1967 Aaron Siskind rehired him; Siegel was named chair of the photography department in 1971, and continued teaching until his death in 1978. ES

Bernard Siegel

American, 1916–1997. A native of Detroit, Bernard Siegel served in the U.S. Army for four years before following his older brother, Arthur, to the Institute of Design. There he studied photography under Harry Callahan, Frank Levstik, and his brother from 1945 to 1949. Siegel is best known for his self-titled "solargrams" – photographs made by exposing objects directly onto a piece of film and then printing – which he displayed in "Six States Photography," an exhibition held at the Milwaukee Art Museum in 1950, juried by John Morris, Arthur Siegel, and Roy Stryker. He continued to experiment extensively in color, and later worked in a photography lab in Detroit. ES

Arthur Reeder Sinsabaugh

American, 1924–1983. Art Sinsabaugh was one of the first students in the Institute of Design's four-year photography program. Beginning his courses in the summer of 1946 with the "New Vision in Photography" seminar, he eventually studied with Harry

Callahan, Frank Levstik, Arthur Siegel, and Frank Sokolik. After his graduation in 1949, Sinsabaugh remained at the ID as a teacher, heading the evening photography program until 1959. Sinsabaugh left the ID that year to direct the photography and cinematography department at the University of Illinois at Urbana-Champaign, where he taught until his death in 1983. He returned to the ID to conduct a master's thesis under Aaron Siskind, and received his degree in 1967. Early in his student years, Sinsabaugh turned his camera on Chicago, photographing the city from the tops of buildings. Where others saw skyscrapers, he found the city's innate prairie and in 1952 began cropping the foreground and sky out of his pictures to emphasize the horizon. In his two most well-known series from the 1960s, "Chicago Landscape" (commissioned by the Chicago Department of Development and Planning) and "Midwest Landscape," he employed a large-format banquet camera to portray the infinite detail of the horizon with almost peripheral vision. ES

Aaron Siskind

American, 1903–1991. A native New Yorker, Aaron Siskind taught English in the city's public schools from 1926 to 1947 and was active in the documentary-oriented New York Photo League between 1932 and 1941. As organizer of the League's Feature Group, Siskind led many social projects, including a collaborative cultural analysis and photographic series about Harlem. Siskind began experimenting with abstraction and exhibiting photographs in the 1940s; a founding member of "The Club," an informal cooperative salon of New York painters, he also became friends with many of the Abstract Expressionists. In 1951 Harry Callahan hired him to join the faculty of the Institute of Design, where he remained for twenty years until his departure for the Rhode Island School of Design in 1971. At the ID, Siskind directed and participated in student projects including a complete study of the architecture of Louis Sullivan; his own work in Chicago included a series on divers in Lake Michigan and a sustained, abstract exploration of walls. Siskind was a dedicated teacher, becoming head of the photography program in 1961 and helping to found the Society for Photographic Education. He was also an avid traveler, photographing often in Mexico and, on a Guggenheim Fellowship, in Rome. After his retirement from teaching in 1976, Siskind continued to produce, exhibit, and publish his photographs. ES

Lynn Sloan

American, b. 1945. A writer and photographer, Lynn Sloan earned a bachelor's degree in literature at Northwestern University before completing a master's degree in photography at the ID in 1971. Her thesis consisted of abstract forms from junkyard cars photographed on Chicago's South Side. She

has had solo exhibitions in the United States and London, and has participated in group shows in the United States, Australia, France, and Switzerland. Her solo exhibition "Faces of AIDS" was shown in New York, Chicago, and Boulder, Colorado, in 1990–91. Sloan teaches photography at Columbia College, Chicago, and also writes fiction. Since 1986 she has been the editor of *Occasional Readings in Photography*. LM

Henry Holmes Smith

American, 1909–1986. Henry Holmes Smith had studied art and dabbled in photography in school, but it was not until he read László Moholy-Nagy's *The New Vision* that he saw his own interests in design and education united. He moved to Chicago in 1937 to work in a portrait studio darkroom at Marshall Field's, and encountered more of Moholy's ideas through articles and a lecture. Smith's photographic work explored color and light, experimenting with cameraless imagery (even using light-refracting Karo syrup as a sort of photographic paint), and he wrote Moholy a letter about the potentials of color photography. Intrigued, Moholy invited Smith to set up the photographic laboratory at the New Bauhaus, and when György Kepes was delayed at the start of fall semester, Smith taught the Light Workshop. He presented light modulation and other problems using the curriculum proposed by Moholy but modified with his own interests and exercises. When the school failed to reopen in 1938, Smith took the opportunity to focus on writing; over the next fifty years, he would author numerous articles on photographic criticism, technique, and education. He also taught photography and the history of photography at Indiana University for thirty years, and was a founding member of the Society for Photographic Education. ES

Keith A. Smith

American, b. 1938. Born in Tipton, Indiana, Keith Smith grew up in Mansfield, Ohio. He served in the U.S. Army, 1960–63, and made his first photographs in Vietnam. Returning home, he attended The School of the Art Institute of Chicago from 1963 to 1967, and completed a master's degree in photography at the ID in 1968. Smith has continued to work in multiple media, including lithography, etching, engraving, and screen-printing, as well as photography. Particularly interested in artists' books, he has made over ninety one-of-a-kind books. Smith has won numerous awards and fellowships, and has exhibited his work nationwide. He lives in Rochester, New York, where he teaches printmaking at the Visual Studies Workshop. LM

Frank Sokolik

American, 1910–1984. Hired by László Moholy-Nagy, Frank Sokolik taught photography at the Institute of Design from 1943 to 1947 alongside Harry Callahan, Arthur

Siegel, and Frank Levstik. After leaving the ID, he became an instructor in bacteriology at the University of Chicago and the University of Illinois, but he continued to photograph – mostly children and humorous situations – in Chicago. He exhibited his pictures in shows at various universities and at the Chicago Public Library, and his photographs were published in the magazines *Popular Photography*, *Minicam*, and *Modern Photography*, as well as in Moholy's 1947 *Vision in Motion*. ES

Frederick Sommer

American, b. Italy, 1905–1999. Born Fritz Sommer in Angri, Italy, Frederick Sommer was educated in Germany, Rio de Janeiro, and São Paulo, before completing a master's degree in landscape architecture at Cornell University in 1927. After working with his father in landscape architecture and urban planning in Rio for three years, Sommer immigrated to the United States in 1931 (earning his citizenship in 1939). He worked as an independent painter and photographer, based in Prescott, Arizona, where he cofounded the Studio of Art School, Tucson, and lived from 1935 until his death. A friend of Max Ernst and other Surrealists, Sommer was interested in their theories of fragmentation, collage, and free association. He filled in as a lecturer at the ID when Harry Callahan was on sabbatical in 1957–58, and taught there again in 1963. Known as a brilliant and perfectionistic printer, Sommer was one of the few people actually to teach printing technique to the students at the ID. His emphasis on formalism and Surrealism added a new dimension to the ID curriculum. LM

Joseph Sterling

American, b. 1936. Joseph Sterling, a native of Texas, began photographing at age eleven. Inspired by a college professor and a photograph by Harry Callahan, he transferred to the Institute of Design in 1956, where he studied with Callahan, Aaron Siskind, and Frederick Sommer. He earned his bachelor's degree in 1959 and a master's degree in 1962. His thesis, "The Age of Adolescence," examined the world of Chicago teenagers and was featured in a 1961 issue of *Aperture* on the Institute of Design. Sterling worked as a magazine and corporate photographer from 1960 to 1990, during which time he traveled widely and also pursued personal photography; his commercial work has won numerous awards. He has taught photography at the Institute of Design (1966–68), The School of the Art Institute of Chicago, and Columbia College, Chicago, where he helped found the department. ES

Robert Stiegler

American, 1938–1990. A lifelong Chicagoan, Robert Stiegler studied photography under Harry Callahan and Aaron Siskind at the ID from 1956 to 1960, making photographs

largely of local bridges. He returned to the school to complete his master's degree in 1970 with a thesis in which he experimented with photo-silkscreening. His other photographic interests included street photographs, nature photography, and positive/negative abstractions, and he made several films as well using still-photography techniques. Stiegler taught at the University of Illinois in Chicago from 1966 until his death in 1989, with a hiatus to photograph in Egypt on a National Endowment for the Arts fellowship. ES

Charles A. Swedlund

American, b. 1935. Charles Swedlund grew up in Chicago and earned his bachelor's and master's degrees in photography at the ID in 1958 and 1961, respectively. His master's thesis, "The Search for Form: Photographical Experiments with the Human Figure," reflects what he considered the ID's emphasis on fundamental "straight" methods of photography. After teaching in Chicago and Buffalo, New York, Swedlund returned to teach at the ID from 1969 to 1971. He currently teaches cinema and photography at Southern Illinois University, Carbondale, and photographs names and drawings found in landscape and Native American sites, including Mammoth Cave, Kentucky. LM

Charles Traub

American, b. 1945. Charles Traub was born in Louisville, Kentucky, and attended the University of Illinois at Urbana-Champaign, 1963–67. He studied photography with Aaron Siskind at the ID, earning an M.S. in photography in 1971. His two-part thesis, "Landscapes" and "Mary and the Baby," reveals his interest in the transcendental nature of birth and landscape. His subsequent work documenting people and places explores both the voyeuristic nature of photography and the exhibitionist tendencies of people; a series of photographs taken at Oak Street Beach in Chicago was exhibited at the Art Institute in 1975. Traub has taught at Columbia College, Chicago, and helped found the Chicago Center for Contemporary Photography (currently the Museum of Contemporary Photography) in 1977. In 1978 he became director of Light Gallery, New York. He continues to live in New York, where he serves as director of the graduate department of photography at the School for Visual Arts. Traub also works as a freelance photographer documenting the social landscape. LM

Warren Wheeler

American, b. 1944. A native of New York, Warren Wheeler attended SUNY Buffalo and then earned a master's degree in photography at the ID in 1971. He completed his thesis, "Department Store Photographs," under Arthur Siegel. Wheeler's recent work, "Pressure Shadow Series," consists of triptych

groupings that challenge the notion of a singular photographic record and resist narrative interpretation. Wheeler works as a technical photographer at Colgate University in Hamilton, New York, and continues to exhibit his work. LM

Geoff Winningham

American, b. 1943. Born in Jackson, Tennessee, Geoff Winningham studied English at Rice University, Houston, and photography with Arthur Siegel at the ID from 1965 to 1968. He earned an M.S. in photography in 1968, with a thesis titled "Wells Street: A Search for a Documentary Method." Winningham worked as a freelance photographer for *Esquire*, *Atlantic Monthly*, *Life*, *Time*, *Newsweek*, and *Photo*, among others. The experimental and documentary methods he explored at the ID continue to preoccupy his work recording the people, customs, and environment of Texas. His late work, such as the film and photographs based on "Friday Night in the Coliseum," depicted the wrestling subculture in Houston and reveals his ongoing interest in "taking" photographs, rather than "making" (or arranging) them in the studio, as he did while studying at the ID. Winningham has published and exhibited widely, and has taught at the University of St. Thomas and at Rice University since 1969. LM

Diana (Dina) Woelffer

American, 1907–1990. Dina Woelffer attended the Institute of Design from 1946 to 1948, studying photography with Ferenc Berko, Harry Callahan, Wayne Miller, and Arthur Siegel, and participating in the "New Vision in Photography" summer session in 1946. Married to Emerson Woelffer, a painter and instructor at the Institute of Design from 1941 to 1949, Dina involved herself in both student and faculty activities. She taught photography at Black Mountain College in the summer of 1949, exhibited with Emerson at the Baldwin Kingery Gallery, Chicago, in 1948, and in "Six States Photography" at the Milwaukee Art Museum in 1950. She has also published her photographs in *American Annual of Photography* and *Black Mountain Review*. She traveled widely, photographing burial places in Europe and America; these pictures were exhibited in 1973 at the Jodi Scully Gallery, Los Angeles. ES

John Wood

American, b. 1922. Born in Turlock, California, John Wood studied at the University of Colorado, and, after serving in the U.S. Air Force from 1941 to 1945, earned a B.S. in visual design at the ID in 1954. He also made a film called *The Press* with Len Gittleman and Michael Train. Concerned with the integration of different types of images and media-making processes, Wood's work addresses relationships between nature and society, and has been shown widely in the United States. His recent book *Ozone Alert* (1995) recalls his ID training in visual design, juxtaposing documentary photographs of the cooling towers at Three Mile Island with the names of birds that include a color as part of their name. Wood taught printmaking and photography at the New York State College of Ceramics, Alfred University, from 1955 to 1989 and currently lives in Baltimore and Ithaca, New York. LM

CHRONOLOGY

Compiled by Elizabeth Siegel

1922

The Association of Arts and Industries is organized in Chicago on March 15.

1923–28

László Moholy-Nagy teaches at the Bauhaus in Weimar (1923–25) and in Dessau (1925–28) under Walter Gropius.

1930–37

György Kepes works with Moholy in Berlin (1930–34) and London (1935–37). English translation of Moholy's 1929 book *Von Material zu Architektur* is published in 1932 as *The New Vision: From Material to Architecture.*

1936

On January 5, the Association of Arts and Industries announces plans for a new school in Chicago.

1937

Through a series of negotiations during spring and early summer, the Association of Arts and Industries – on the recommendation of Walter Gropius – offers Moholy the position of director for its new school. Moholy accepts the post and names the institution the New Bauhaus. In his first lecture in the United States, given on September 23 at Chicago's Knickerbocker Hotel before an audience of 800 people, he outlines his educational plans for the school and points out its potential value to local industries. Advertisements and local and national press announce the formation of the New Bauhaus, which opens on October 18 in Chicago at 1905 South Prairie Avenue (the former Marshall Field mansion). The original class of thirty-three day students includes Nathan Lerner, and in the spring semester, Arthur Siegel; both later teach photography at the school. The total enrollment for the year is sixty-nine. Original faculty includes Moholy, director and head of the Basic Workshop; Norma K. Stahle, assistant director; György Kepes, head of the Light Workshop; Alexander Archipenko, head of the Sculpture Workshop; Hin Bredendieck, Basic Workshop; Andi Schiltz, assistant in the Basic Workshop; Henry Holmes Smith, assistant to Kepes in photography and lab manager; David Dushkin, music; Carl Eckart, physics; Charles W. Morris, philosophy; and Ralph W. Gerard, biology. Because Kepes is delayed in getting to the U.S., Smith initially teaches the Light Workshop. Cost of $325 covers tuition, registration, a locker, and workshop materials; Moholy offers several scholarships to talented students. Photography is featured as an essential part of the curriculum through the Light Workshop, which, in addition to the study of light itself, includes film, advertising, and typography.

The New Bauhaus is dedicated on November 9 with a dinner at the Palmer House hotel in honor of Walter Gropius, who lectures on "Education toward Creative Design." On December 2 Moholy brings an exhibition of abstract art to the New Bauhaus; it includes sculpture by Alexander Calder, Naum Gabo, Barbara Hepworth, and Henry Moore, and paintings by Piet Mondrian and Moholy.

1938

Spring semester classes begin February 8. The courses are as follows: Basic Workshop (Moholy, Bredendieck); modeling (Archipenko); music (Dushkin); lettering (Bredendieck, Kepes); life and analytical drawings (Kepes); geometrical drawing (Bredendieck); photography (Kepes and Smith); physical sciences (Eckart); biological sciences (Gerard); and intellectual integration (Morris). A circulating exhibition from the Museum of Modern Art, "A Brief Survey of Photography from 1839–1937" (a shortened version of Beaumont Newhall's landmark 1937 exhibit at MoMA), opens at the New Bauhaus on April 18 and runs through June; it includes four photographs by Moholy. On April 27, Moholy interprets the show with a lecture titled "Development of Photography." Classes end on June 24, and are followed the next day by a faculty critique of student work from the 1937–38 school year. A student exhibition of the year's work opens to the public on July 5, with strong reception in local, national, and British press, and remains on view through September.

In August Moholy is informed that the school will not re-open in the fall. Contributing factors include professional disagreements, financial troubles, and a lack of support from the founding organization, the Association of Arts and Industries. Though previously announced, all appointments of new faculty – Jean Helion (head of the Color Workshop), Herbert Bayer (head of the Light Workshop), and Xanti Schawinsky (head of the Stage and Exhibition Workshop) – are cancelled. In October Moholy sues the Association of Arts and Industries. The exhibition "Bauhaus 1919–1928," organized by Walter and Ise Gropius and Herbert Bayer, opens on December 6 at the Museum of Modern Art and includes work by New Bauhaus students.

1939

On January 1, Moholy publishes a letter in the *New York Times* explaining the closing of the New Bauhaus. The school reopens on February 22 as the School of Design in Chicago, on 247 East Ontario Street, in an abandoned bakery below the Chez Paree nightclub. Forty-seven students (eighteen day and twenty-nine evening students) attend; all faculty teach without pay the first semester. György Kepes remains the head of the Light Workshop, assisted by student Nathan Lerner. Moholy hires new faculty members George Fred Keck, an architect, and Robert Jay Wolff, a sculptor and painter. The six specialized workshops after the preliminary course are: wood and metal; textile (weaving, dyeing, fashion); color (murals, decorating); light (photography, motion pictures, light display, typography); modeling (glass, clay, stone, plastics); and stage (display, exposition architecture).

Summer sessions start on July 10 on rural property in Somonauk, Illinois, provided by Walter and Elizabeth Paepcke and continue until August 18. (Summer sessions are also held there in 1939, 1941, 1942, 1945, 1946, and 1947.) In the fall Frank Levstik, Nathan Lerner (while a student), and Leonard Nederkorn (part-time) are hired to assist in the teaching of photography, and George Barford and Eugene Bielawski are hired to teach the Basic Workshop. Barford collaborates with Moholy on a series of photograms. On December 14 Moholy presents an evening lecture titled "The New Vision and Photography." This same month *Popular Photography* publishes his essay and photograms in "Making Photographs without a Camera."

1940

A solo show of Moholy's work opens in January at Katharine Kuh's gallery in Chicago. Walter Paepcke becomes the primary benefactor of the school, and through personal donations, fund-raising, and grants from his firm, Container Corporation of America, helps ensure the financial stability of the School of Design. Spring semester begins on February 12 with two new faculty, Hubert Leckie (lettering) and James Hamilton Brown (assistant in the Light Workshop); Brown teaches evenings through 1946. A special summer session is held at Mills College in Oakland, California, from June 23 to August 3. Moholy, Kepes, and several other faculty members participate; over eighty students attend. A two-week showing of photographs and photograms by Moholy opens July 1 at the Pageant of Photography in the Palace of Fine Arts–Golden Gate International Exhibition, San Francisco. The fall semester opens on September 23 with 122 students enrolled, including Milton Halberstadt, Homer Page, and Margaret De Patta.

1941

Day and evening classes begin on February 3. The school's second summer session is held in Somonauk. In the fall William Keck becomes a technician for the Photography and Light and Color Workshops. Moholy, Kepes, and Lerner design a traveling exhibition of photograms by students and faculty of the school called "How to Make a Photogram." Circulated by the Museum of Modern Art, it opens at Phillips Academy Andover on November 15 and begins a six-year tour of schools and museums (traveling through winter 1947).

1942

Kepes publishes "Modern Design! With Light and Camera" in *Popular Photography* in February. In June the first class of five students graduates from the full four-year program: Juliet Kepes, Myron Kozman, Nathan Lerner, Charles Niedringhaus, and Grace Seelig. The Rockefeller Foundation donates $7500 to the school for photographic and motion-picture equipment, and a promotional color film based on the work of all the school's workshops is screened at the graduation ceremonies. Edward Rinker begins teaching part-time in the evenings in the fall and will continue to do so through summer 1945. Lerner teaches evening photography classes. Only 20 day students and 188 evening students are enrolled. The exhibition "How to Make a Photogram" is shown at the Museum of Modern Art from September 16 to November 2. On December 1 the school announces the opening of a new course in photography "especially designed to train women for the teaching of photographic courses in all branches of War Service."

1943

A new course in photography begins January 19 to train women and men over thirty-eight with 4F classification to teach in the War Service. Following a major disagreement with Moholy, Kepes leaves the School of Design in the spring. Johannes Molzahn is announced as the head of Light Workshop, replacing Kepes. A new course is offered, "Photography for War Services." A profile of Moholy and the work of students at the school is published in July in the *Saturday Evening Post*, expanding the school's influence and reputation outside of professional circles. Frank Sokolik joins the faculty in the fall to teach photography.

1944

Kepes publishes *Language of Vision* (written in 1942–43). In March the school changes its name to the Institute of Design and gains college accreditation. A new board is formed by Walter Paepcke and other industrialists to supervise school operations. Kepes has a solo exhibition at the Art Institute; most of the works shown are photograms.

1945

Moholy publishes "Photography in the Study of Design" in the *American Annual of Photography*; he has off-prints made and circulated widely for publicity purposes. A group of students in the motion-picture class, under the direction of Moholy, produces the experimental film *Do Not Disturb*. A press release dated February 2 announces a special course in photography for discharged veterans. In the spring the Chicago Camera Club exhibits work of ID faculty and students. As of March, there are twenty students enrolled in photography night classes, and eight in the Special Photography class for veterans. The School opens on September 24 at 1009 North State Street, on the corner of Rush Street, above a drug store. As a result of the influx of veterans taking advantage of the GI Bill, enrollment surpasses 450, mostly day students. In November Moholy is diagnosed with leukemia, but he maintains active involvement with the school and its programs.

1946

Returning World War II veterans increase student population and spark a commensurate increase in faculty. On January 15, Arthur Siegel is announced as the new head of the Department of Photography. He is hired to direct a four-year photography program and organize a summer workshop in photography. Other new faculty members include Myron Kozman and Hugo Weber. That spring a Department of Photography is created, separate from the Light Workshop. Special Photography students number thirty-four, all but two of whom are veterans.

Moholy and Siegel organize a six-week (July 8–August 16) photography summer symposium, "New Vision in Photography," to launch the four-year photography program. Participating are Berenice Abbott, Erwin Blumenfeld, Gordon Coster, Frank Levstik, Moholy, Beaumont Newhall, Ed Rosskam, Frank Scherschel, Siegel, Paul Strand, Roy Stryker, and Weegee (Arthur Fellig). The seminar consists of lectures, presentations, workshops with students, and film screenings, and receives national attention (*Life* magazine includes a spread with Weegee showing students how to photograph a corpse). In summer on Arthur Siegel's recommendation, Moholy hires Harry Callahan. Callahan works as a photographic assistant to learn the method of Levstik and Sokolik and studies the Foundation Course, but does not attend much of the seminar. Nathan Lerner and Henry Holmes Smith begin collaboration on an independent, encyclopedic study of light; the project continues through 1947. Art Sinsabaugh enters the first class in the new four-year photography depart-

ment. Moholy's health wanes during the summer; he participates with difficulty in the symposium.

In the fall the ID moves to 632 North Dearborn Street (a building formerly occupied by the Chicago Historical Society). Gordon Coster teaches part-time (and again in 1950). Siegel introduces a class in the history of photography as part of the Special Photography program. László Moholy-Nagy dies on November 24 of complications from leukemia.

1947

Newly appointed director Serge Chermayeff gives an inaugural address to 450 students in February and assumes his duties in March. Moholy's landmark book, *Vision in Motion*, is posthumously published (edited by Sibyl Moholy-Nagy). The book sums up Moholy's philosophy of education and showcases the work of students and faculty. Special Photography students number 106, most of whom are veterans. Frank Sokolik leaves at the end of the spring term. In March Merry Renk and Mary Jo Slick, two Institute of Design students, and Olive Oliver found the 750 Studio, a gallery that exhibits mainly student and faculty work, out of an apartment at 750 N. Dearborn Street. An exhibition of the work of Herbert Bayer is presented at the ID, the first exhibition in the new building. Memorial exhibitions on Moholy open on May 15 at the Museum of Non-Objective Art, New York and on September 18 at the Art Institute. Ferenc Berko teaches photography in the fall and continues on the faculty through 1948. "Harry Callahan: Exhibition of Photographs" is held at the 750 Studio (November 10–29); it is Callahan's first solo exhibition.

1948

"Exhibition of Student Work and Teaching Methods, Institute of Design, Chicago" is presented at Harvard University. Sometime around this date, Harry Callahan makes two films, *Motions* and *People Walking on State Street*. In spring Hillar Maskar is hired as a darkroom laboratory technician, and teaches part-time and evenings through 1952. March enrollment numbers 772; Special Photography students number 25. In summer Merry Renk sells the 750 Studio. That fall Victor Corrado begins teaching photography part-time in the evenings (and will continue though 1950). Wayne Miller teaches a documentary class and will do so again in spring 1949. Aaron Siskind visits the ID and meets Callahan and Siegel. Nathan Lerner resigns, effective at the end of the fall/winter term.

1949

Siegel resigns at the end of the spring term, as does Levstik. Art Sinsabaugh teaches as a student assistant, and graduates with his bachelor's degree. The school has an enrollment of 400 full-time and 300 evening students. In July an exhibition of work from the ID is held in London under the auspices of the Council of Industrial Design. Callahan becomes head of the Photography Department in the fall. Sinsabaugh is hired to assist Callahan in teaching photography. Aaron Siskind receives an official offer from Callahan to teach at the ID, but declines. In November the Institute of Design becomes part of the Illinois Institute of Technology.

1950

A one-hundred-print exhibition, "Student Work from the Institute of Design, Chicago" (organized by Arthur Siegel in 1949), is shown at the Photo League in New York in February and March. This show is intended to be in exchange for a similar one from the Photo League, but the complementary exhibition never materializes. Gordon Coster teaches part-time in the evenings in spring and will continue through 1951. Keld Helmer-Petersen teaches part-time in the fall and again in the spring of 1951. At the request of students who wish to continue further photographic study beyond the bachelor's degree, Callahan informally institutes the graduate program in photography.

1951

Serge Chermayeff resigns as director in the spring, and Crombie Taylor, a professor in the Shelter Design program, becomes acting director. Marvin Newman and Yasuhiro Ishimoto collaborate on a film, *The Church on Maxwell Street*. In summer Callahan, Siegel, and Siskind all teach together at Black Mountain College, North Carolina, following which Siskind begins teaching at the ID in the fall; he will remain at the school through 1971. Sinsabaugh switches to teaching photography in the evening program, which he heads through 1959. Siskind photographs the Adler and Sullivan Auditorium Building with students. The photography class is commissioned by the Chicago Housing Authority to document CHA life; other documentary group projects will follow under Siskind.

1952

The first graduate degrees in photography are awarded to Jordan Bernstein, Floyd Dunphey, and Marvin Newman; Newman's thesis is called "The Series Form in Photography." On April 16, the film *Chicago Morning* is shot between 4:00 a.m. and 9:45 a.m., produced by Boris Yakovleff with eleven students from the ID, and narrated by Studs Terkel. Siskind supervises a student documentary photography project on the architecture of Louis Sullivan. Yasuhiro Ishimoto graduates with a B.S. in photography.

1953

Students Len Gittleman, John Wood, and Michael Train collaborate on a film called *The Press*.

1954

In May, one hundred photographs from the Sullivan project are exhibited at the ID; organized by student Richard Nickel, the exhibition documents 75 of the 114 buildings by Sullivan then known to be standing. Robert Fine receives an M.S. in photography. Photographs by Siskind and students from the Sullivan project are published in the October issue of *Architectural Forum*. Siegel begins teaching again part-time and will continue through 1955; Lyle Mayer begins teaching evenings and will do so sporadically through the late 1960s.

1955

Jay Doblin, a designer with Raymond Loewy Associates, is named director in April. The faculty protests this appointment, made without their input, in a unanimous letter to IIT President J. T. Rettaliata. Leon Lewandowski receives an M.S. in photography. In fall the ID moves to the Crown Hall on the IIT campus, 3360 S. State Street, where it remains until 1990. Doblin begins as director in September. The Foundation Course, which began as a two-year program, is reduced to one year; students now have to specialize in the second year, leading more students to enroll in photography classes.

1956

Siskind and Callahan publish "Learning Photography at the Institute of Design" in *Aperture*, the premiere fine-art photography publication, in which they present the ID's four-year photography curriculum.

1957

Student Independent 2 is published, a student-produced portfolio in an edition of 483. This issue focuses on photography (unlike the first, devoted to graphics) and has an introduction by Siskind. The portfolio is showcased in a *New York Times* article by Jacob Deschin. M.S. degrees in photography are awarded in the spring to Joyce Lemensdorf and Richard Nickel; Nickel's thesis is on the buildings of Louis Sullivan. Callahan receives a Graham Foundation Fellowship and takes a fifteen-month leave of absence to work in Aix-en-Provence from fall 1957 to July 1958. Frederick Sommer teaches with Siskind during Callahan's sabbatical. A four-artist exhibition, "Abstract Photography: Aaron Siskind, Harry Callahan, Arthur Siegel, Art Sinsabaugh," is circulated in the U.S. in 1957–58 under the auspices of the American Federation of Arts.

1958

On January 16, a symposium, "Art and Photography," is held with George Cohen, Katharine Kuh, Arthur Siegel, Frederick Sommer, and Aaron Siskind. His sabbatical completed, Callahan returns to the ID in fall.

1959

Sinsabaugh leaves the ID in spring for the University of Illinois at Urbana-Champaign. Ray K. Metzker receives an M.S. in photography with his thesis, "My Camera and I in the Loop." In summer Siskind begins work on *Aaron Siskind: Photographs*, his first monograph; Sinsabaugh assists with the printing. Kenneth Josephson fills in teaching for some of Siskind's classes while the book is on press.

1960

In spring Kenneth Josephson receives his master's degree in photography with a thesis entitled "An Exploration of the Multiple Image." *Student Independent 3* is published featuring the photography of Joseph Jachna, Ray K. Metzker, Don Seiden, Joseph Sterling, Charles Swedlund, Robert Tanner, and Paul Zakoian.

1961

Aperture publishes an issue devoted to the graduate photography program at the ID, with an introduction by Siegel and photographs by Joseph Jachna, Kenneth Josephson, Ray K. Metzker, Joseph Sterling, and Charles Swedlund. An exhibition of the work of these five photographers circulates in conjunction with the issue. The ID Press publishes its first book, *The Multiple Image: Photographs by Harry Callahan*. Callahan leaves at the end of the spring term for the Rhode Island School of Design. Master's degrees in photography are awarded to Vernon Cheek, Robert Hilvers, Joseph D. Jachna (with a thesis on water), George Nan, and Charles Swedlund (with a thesis on multiple exposures with the figure). Siskind becomes the head of the Photography Department in fall, and Jachna begins teaching (through spring 1969).

1962

In spring Joseph Sterling receives an M.S. degree in photography with his thesis, "The Age of Adolescence."

1963

Frederick Sommer returns in spring to teach a workshop in conjunction with an exhibition of his photographs. Nathan Lyons is on the teaching staff this semester. Siegel teaches part-time (also spring 1964). Students begin work on his architectural guide, *Chicago's Famous Buildings*, published by the University of Chicago Press in 1965. Reginald Heron teaches evenings in the fall (as well as in fall 1965 and spring 1966). In November, the Society for Photographic Education holds its first annual meeting in Chicago. Founding members include Kenneth Josephson, Art Sinsabaugh, Aaron Siskind, and Henry Holmes Smith.

1964

Jay Doblin leaves for two years, and Lute Wassman becomes the director of the ID in his absence.

1965

In spring Beverly Capps and Joanne Marten receive M.S. degrees in photography.

1966

Barbara Crane (with a thesis on "Human Forms"), Reginald Heron, Roger Malloch, Thomas Porett, and George Strimbu all receive master's degrees in photography in spring. Siskind spends the summer in Rome, supported by a Guggenheim grant. While Siskind is away, Doblin returns as director and restructures the department, eliminating undergraduate majors; students may no longer specialize in photography. Joseph Sterling teaches basic photography in the fall term and will continue through spring 1968; Siegel returns to teach part-time.

1967

Wynn Bullock teaches one term in spring. Master's degrees in photography are awarded to Thomas Barrow, Donald Bulucos, Kurt Heyl, Thomas Knudtson, William Larson, Ronald Mesaros, John Seaholm, Art Sinsabaugh (with a thesis on the Chicago landscape), Judith Steinhauser, Karen Titel, and Jack Wilgus. In fall Siskind hires Siegel to teach full-time.

1968

Jay Doblin resigns in spring, and James Montague is named acting director. Siskind is made a full professor. The exhibition "Callahan–Siegel–Sinsabaugh–Siskind" opens at the Exchange National Bank, Chicago. Master's degrees in photography are awarded to Roslyn Banish, Barbara Blondeau, James Erwin, Brian Katz, Lyle Mayer, Ron Nameth, Carla Romeike, Roland Sinclair, Keith A. Smith, Peter Van Dyke, and Geoff Winningham.

1969

Jachna leaves at the end of the spring term for the University of Illinois, Chicago Circle. Master's degrees in photography are awarded to Jerry Aronson, Kenneth Biasco, Thomas Brown, Linda Connor, Edgar Dewell, Jr., Robert Frerck, Thomas Hocker, Charles Lyman, Hans Schaal, Thong-Hung Sung (Masuhiro So), Ronald Taylor, and Danae Voutiritsas. Charles Swedlund and Ken Biasco are hired in fall to teach photography. Students produce another *Student Independent* portfolio, featuring the work of Barbara Crane, Tom Knudtson, William Larson, and others.

1970

Without his agreement, Siskind is retired by the school at the end of the spring term. Master's degrees in photography are awarded to Christopher Ayres, Wayne Boyer, Constance Brenner, Richard Burd, Barry Burlison, John Church, Eileen Cowin, Joe Crumley, Marcia Daehn, Catherine Dawes, Antonio Fernandez, Ralph Fertig, Robert Florian, Patricia Jones, Nicolas Kolias, Bernard Krule, Elaine O'Neil, James Raymo, Judith Ross, Robert Stiegler, Tedwilliams Theodore, and Karin Vanek.

1971

Another *Student Independent* is issued, a portfolio of photographs by Douglas Baz, George Eastman, L. D. Foster, Douglas Gilbert, Jim Harrison, Lawrence Janiak, Cal Kowal, Mark Krastof, Dale Lehman, Bill Maguire, Mati Maldre, Robert E. Mosher, Joan Redmond, Darryl Schiff, Arthur Siegel, Aaron Siskind, Lynn Sloan, Robert Stiegler, Charles Swedlund, Charles Traub, and Warren Wheeler. In spring Siskind returns to teach one class, then moves to the Rhode Island School of Design, where he joins Harry Callahan. Swedlund leaves at the end of the term for Southern Illinois University. Siegel becomes the head of photography program and continues teaching through 1978. Master's degrees in photography are awarded to Cal Kowal, Mark Krastof, Roger Lundy, Gerald Moeller, Esther Parada, Joan Redmond, Lynn Sloan, J. Frederick Sway, Stuart Thomas, and Warren Wheeler.

CATALOGUE

1
Harold Allen
American, 1912–1998
Illinois and Franklin Streets, Chicago,
1950; gelatin silver print,
26.8 x 34 cm
The Art Institute of Chicago, restricted
gift of Mr. and Mrs. Charles Levy,
1971.75
pl. 88

2
David Avison
American, b. 1937
Under the Illinois Central 2, Hyde Park,
1970, printed 2001, from the series
"Longshots Before Camera"; gelatin
silver print, 25.8 x 80.7 cm
Courtesy of David Avison
pl. 165

3
Roslyn Banish
American, b. 1942
Untitled, 1968/69, from her thesis,
"Serial Imagery"; gelatin silver print,
11.6 x 32 cm
Courtesy of the Institute of Design,
Illinois Institute of Technology
pl. 177

4
George Barford
American, 1913–1998, and
László Moholy-Nagy
Untitled, 1939; gelatin silver print
(photogram), 11.9 x 16.8 cm
Collection of Barbara and Robert
Horwitch
pl. 21

5
Thomas Barrow
American, b. 1938
Untitled, 1964, from the series
"The Automobile"; gelatin silver print,
11.4 x 16.5 cm
Courtesy of Thomas Barrow
pl. 167

6
Thomas Barrow
Homage to E.P., 1968, from the series
"Television Montages"; gelatin silver
print, 22 x 34 cm
National Gallery of Canada
pl. 192

7
Ferenc Berko
American, b. Hungary, 1916–2000
Billboard Lights, New York, USA,
1950; gelatin silver print, 19.4 x 15 cm
Joel Soroka Gallery, Aspen
pl. 70

8, 9
Eugene Bielawski
American, b. 1911
Grid and Crystals (Diptych), 1947;
gelatin silver prints, positive and
negative, each 25.2 x 20.2 cm
The Art Institute of Chicago,
Photography Purchase Account Fund,
2001.402 a–b
pls. 15, 16

10
James P. Blair
American, b. 1931
Columbus, Ohio, 1956; gelatin silver
print, 34.4 x 22.9 cm
The Art Institute of Chicago, Horace W.
Goldsmith Foundation Fund, 2001.203
pl. 76

11
Barbara Blondeau
American, 1938–1974
Untitled, 1966/67; collage of positive
and negative gelatin silver prints,
19.3 cm diameter
Collections of the Visual Studies
Workshop, Rochester, New York
pl. 185

12
Barbara Blondeau
Untitled, 1968, from her thesis, "White
Photographs"; gelatin silver print,
5.6 x 78 cm
Courtesy of the Institute of Design,
Illinois Institute of Technology
pl. 180

13
Barbara Blondeau
Untitled, 1968, from her thesis, "White
Photographs"; gelatin silver print,
5.6 x 78.1 cm
Courtesy of the Institute of Design,
Illinois Institute of Technology
pl. 181

14
James Hamilton Brown
American, active in Chicago
1940s–1950s
Color Dream, c. 1940; selectively
toned gelatin silver print,
25.4 x 20.3 cm
Collection of Paul Berlanga, courtesy
of Stephen Daiter Gallery, Chicago
pl. 49

15
James Hamilton Brown
Untitled, 1940s; gelatin silver print,
34.1 x 41.3 cm
The Art Institute of Chicago, acquired
through a grant from the Lloyd A. Fry
Foundation, 2001.58
pl. 13

16
Wynn Bullock
American, 1902–1975
The Leaves, 1967; gelatin silver print,
22 x 18.2 cm
San Francisco Museum of Modern Art,
purchase, 69.59.1
pl. 154

17
Barry Burlison
American, b. 1941
Chicago, 1966; gelatin silver print,
18.4 x 14.3 cm
Courtesy of Barry Burlison
pl. 169

18
Harry Callahan
American, 1912–1999
Church Window, 1940s; gelatin silver
print, 19.6 x 19.3 cm
The Art Institute of Chicago, Peabody
Photography Purchase Fund,
1952.440
pl. 56

19
Harry Callahan
Light Abstraction, 1946; gelatin silver
print, 11.8 x 11.1 cm
Hallmark Photographic Collection,
Hallmark Cards, Inc., Kansas City,
Missouri, P5.008.303.99
pl. 57

20
Harry Callahan
Untitled (Lakefront Fence), c. 1947;
gelatin silver print, 27.3 x 26.7 cm
The Art Institute of Chicago, restricted
gift of Anstiss and Ronald Krueck in
honor of Sylvia Wolf, 1999.315
pl. 55

21
Harry Callahan
Untitled (Eleanor), c. 1947; gelatin
silver print, 8.3 x 11.1 cm
Collection of Joseph and Laverne
Schieszler
pl. 105

22
Harry Callahan
Untitled (Eleanor), c. 1947; gelatin
silver print, 8.3 x 11.1 cm
Collection of Joseph and Laverne
Schieszler
pl. 106

23
Harry Callahan
Untitled (Eleanor), c. 1947; gelatin
silver print, 8.3 x 11.1 cm
Collection of Joseph and Laverne
Schieszler
pl. 107

24
Harry Callahan
Weeds against Sky, c. 1948; gelatin
silver prints, each picture 5.7 x 5.5 cm
The Art Institute of Chicago, Peabody
Photography Purchase Fund,
1952.443–46
pl. 61

25
Harry Callahan
Untitled, 1948; gelatin silver print,
34.3 x 25.1 cm
The Art Institute of Chicago, 1959.885
pl. 130

26
Harry Callahan
Eleanor, 1948; gelatin silver print,
27.6 x 35.6 cm
The Art Institute of Chicago, Reva and
David Logan Foundation Fund,
1978.225
pl. 59

27
Harry Callahan
Chicago, 1950; gelatin silver print,
19.2 x 24.2 cm
The Art Institute of Chicago, Mary L.
and Leigh B. Block Endowment,
1983.65
pl. 62

28
Harry Callahan
Chicago, 1950; gelatin silver print,
24.2 x 34.8 cm
Courtesy of the Estate of Harry
Callahan and Pace/MacGill Gallery,
New York
pl. 111

29
Harry Callahan
Chicago, 1950; gelatin silver print,
23.2 x 34.2 cm
Courtesy of Madeleine and David
Lubar
pl. 109

30
Harry Callahan
Chicago, 1950; gelatin silver print,
21.3 x 31.6 cm
The Art Institute of Chicago, Sandor
Family Collection in honor of The
School of the Art Institute of Chicago,
1994.846
pl. 110

31
Harry Callahan
Portrait of Aaron Siskind, 1951;
gelatin silver print, 25.1 x 20.3 cm
The Art Institute of Chicago,
Arthur Siegel Memorial Fund,
1978.223
pl. 104

32
Harry Callahan
Untitled, 1953; gelatin silver print,
19.4 x 24.3 cm
The Art Institute of Chicago, Sandor
Family Collection in honor of The
School of the Art Institute of Chicago,
1994.866
pl. 60

33
Harry Callahan
Eleanor and Barbara, Chicago,
c. 1955; gelatin silver print,
17.2 x 16.7 cm
The Art Institute of Chicago, Sandor
Family Collection in honor of The
School of the Art Institute of Chicago,
1994.849
pl. 58

34
Alan Cohen
American, b. 1943
Untitled (Michele), 1971; gelatin silver
print, 6.6 x 9.4 cm
Courtesy of Alan Cohen
pl. 178

35
Linda Connor
American, b. 1944
My Mother with Heart and Thorns,
1967, from her master's thesis;
gelatin silver print, 11.8 x 9.5 cm
Courtesy of Linda Connor
pl. 206

36
Linda Connor
Chicago Homage, 1968, from her
master's thesis; gelatin silver print,
11.4 x 18.2 cm
Courtesy of Linda Connor
pl. 207

37
Linda Connor
Innocence, Soldiers, and Girl, 1968,
from her master's thesis; gelatin silver
print, 12.9 x 17.8 cm
Courtesy of Linda Connor
pl. 202

38
Linda Connor
Self-Portrait in the Badlands,
1968/69, from her master's thesis;
gelatin silver print, 17.6 x 22.3 cm
Courtesy of the Institute of Design,
Illinois Institute of Technology
pl. 203

39
Gordon Coster
American, 1906–1988
Chicago Motor Club, c. 1950; gelatin
silver print, 26.8 x 26.4 cm
The Art Institute of Chicago, restricted
gift of Bernard M. and Caryl H.
Susman, 2001.187
pl. 78

40
Eileen Cowin
American, b. 1947
Untitled (Desk), 1970; gelatin silver
transparency with turpentine-trans-
ferred ink on paper, 18.4 x 15.2 cm
Courtesy of Eileen Cowin
pl. 188

41
Eileen Cowin
Untitled (Waiting for Your Call), 1971;
gelatin silver transparency with tur-
pentine-transferred ink on paper,
11.4 x 16.5 cm
Courtesy of Eileen Cowin
pl. 187

42
Barbara Crane
American, b. 1928
Human Form, 1965/66, from her
thesis, "Human Forms"; gelatin silver
print, 17.1 x 23.5 cm
The Art Institute of Chicago, restricted
gift of Bernard M. and Caryl H.
Susman, 2001.185
pl. 155

43
Barbara Crane
Human Form, 1965/66, from her
thesis, "Human Forms"; gelatin silver
print, 20.3 x 24.1 cm
The Art Institute of Chicago, Barbara
and Lawrence Spitz Acquisition Fund,
2001.168
pl. 156

44
Barbara Crane
Untitled, 1969, from the series "Neon";
gelatin silver print, 25.3 x 18 cm
The Art Institute of Chicago, Living
Chicago Artists Fund, 2001.199
pl. 193

45
Barbara Crane
Untitled, 1969, from the series "Neon";
gelatin silver print, 26.3 x 17.2 cm
The Art Institute of Chicago, In
Chicago Portfolio Fund, 2001.200
pl. 194

46
Barbara Crane
Untitled, 1969, from the series "Neon";
gelatin silver print, 25.8 x 18 cm
The Art Institute of Chicago, In
Chicago Portfolio Fund, 2001.201
pl. 195

47
Margaret De Patta
American, 1903–1964
Untitled, 1939; gelatin silver print
(photogram), 17.3 x 17.2 cm
The Art Institute of Chicago, Mary and
Leigh Block Endowment, 1998.29
pl. 3

48
François Deschamps
American, b. 1946
Wisconsin, 1971; gelatin silver print,
10.4 x 15.5 cm
Courtesy of François Deschamps
pl. 162

49
Jonas Dovydenas
American, b. Lithuania, 1939
Ironworker, Chicago, 1969; gelatin
silver print, 18.8 x 18.6 cm
The Art Institute of Chicago, gift of the
artist, 1974.191
pl. 199

50
Robert Donald Erickson
American, 1917–1991
Self-Portrait, 1946; gelatin silver
print, 16.8 x 21 cm
Courtesy of Mrs. Robert Donald
Erickson (latser Cathline Erickson)
pl. 47

51
Robert Donald Erickson
Chicago El Shadow Patterns, 1946;
gelatin silver print, 17.2 x 16.6 cm
Courtesy of Mrs. Robert Donald
Erickson (latser Cathline Erickson)
pl. 48

52
Andrew Eskind
American, b. 1946
Untitled, 1971; gelatin silver print,
13.5 x 19.9 cm
Courtesy of Andrew Eskind
pl. 161

53
Antonio A. Fernandez
American, b. Cuba, 1941
Jeka H$_2$O, 1968, from his thesis, "A
Photographic Study of Emotionally
Disturbed Children, 1967–1969,
Chicago, Ill."; gelatin silver print,
9.5 x 14.3 cm
Courtesy of the Institute of Design,
Illinois Institute of Technology
pl. 153

54
Lois Field
American, b. 1923
Untitled, c. 1948; gelatin silver print
(photogram) with pen and ink drawing,
12.6 x 9.9 cm
The Art Institute of Chicago, Arnold
Gilbert Memorial Fund, 2001.196
pl. 63

55
Len Gittleman
American, b. 1932
Untitled (Carson's Facade), c. 1953;
gelatin silver print, 19.2 x 24.1 cm
Courtesy of Len Gittleman
pl. 128

56
Milton Halberstadt
American, 1919–2000
Norm Martin, 1940/41; gelatin silver
print, 39.7 x 31.8 cm
The Art Institute of Chicago, acquired
through a grant from the Lloyd A. Fry
Foundation; gift of Susan Ehrens and
Leland Rice, 1998.26
pl. 29

57
Milton Halberstadt
Untitled (Homer Page), 1940/41;
gelatin silver print, 34.1 x 26.6 cm
The Art Institute of Chicago, restricted
gift of Bernard M. and Caryl H.
Susman, 2001.191
pl. 27

58
Milton Halberstadt
Untitled (Margaret De Patta),
1940/41; gelatin silver print,
34.4 x 17 cm
The Art Institute of Chicago, Daniel L.
and Rosalind Benton Foundation Fund,
2001.405
pl. 50

59
Milton Halberstadt
Olga, Chicago, 1941; gelatin silver
print, 34.7 x 23.1 cm
The Art Institute of Chicago, Elizabeth
F. Cheney Foundation Fund, 1998.679
pl. 51

60
Paul Hassel
American, 1906–1964
Harry Callahan, c. 1950; gelatin silver
print, 24.5 x 19.1 cm
San Francisco Museum of Modern Art,
gift of Mrs. Virginia Ballinger in mem-
ory of Paul Hassel, 84.370
pl. 108

61
Paul Hassel
Chicago, 1950; gelatin silver print,
24.5 x 19.7 cm
San Francisco Museum of Modern Art,
gift of Mrs. Virginia Ballinger in mem-
ory of Paul Hassel, 84.380
pl. 71

62
Reginald Heron
American, b. France, 1932
Untitled, 1964, from his thesis, "The
Group"; gelatin silver print,
15.3 x 10.6 cm
Courtesy of the Institute of Design,
Illinois Institute of Technology
pl. 158

63
Reginald Heron
Untitled, 1965, from his thesis, "The
Group"; gelatin silver print,
10.7 x 16.2 cm
Courtesy of the Institute of Design,
Illinois Institute of Technology
pl. 160

64
Yasuhiro Ishimoto
Japanese, b. United States, 1921
Untitled, 1948/52; gelatin silver print,
23.7 x 18.8 cm
The Art Institute of Chicago,
Photography Gallery Fund, 1960.807
pl. 96

65
Yasuhiro Ishimoto
Untitled, 1948/52; gelatin silver print,
23.4 x 18.7 cm
The Art Institute of Chicago, gift of
Mary Morris Diamond Stein, 1960.812
pl. 95

66
Yasuhiro Ishimoto
Untitled, 1949/50; gelatin silver print,
20.8 x 20.4 cm
The Art Institute of Chicago, gift of
David C. and Sarajean Ruttenberg,
1992.1101
pl. 91

67
Yasuhiro Ishimoto
Untitled, 1949/50; gelatin silver print,
20.8 x 20.4 cm
The Art Institute of Chicago, gift of
David C. and Sarajean Ruttenberg,
1992.1143
pl. 100

68
Yasuhiro Ishimoto
Untitled, 1949/50; gelatin silver print,
20.8 x 20.4 cm
The Art Institute of Chicago, gift of
David C. and Sarajean Ruttenberg,
1992.1163
pl. 99

69
Yasuhiro Ishimoto
#4, Chicago, 1950; gelatin silver print,
20.5 x 20.3 cm
The Art Institute of Chicago, gift of
Yasuhiro and Shigeru Ishimoto,
1999.83
pl. 72

70
Yasuhiro Ishimoto
#75, Chicago, 1959/61; gelatin silver
print, 18.1 x 25.4 cm
The Art Institute of Chicago, gift of
Yasuhiro and Shigeru Ishimoto,
1999.112
pl. 93

71
Joseph D. Jachna
American, b. 1935
Untitled, 1958, from his thesis, "Water";
gelatin silver print, 15.8 x 12 cm
The Art Institute of Chicago, Horace W.
Goldsmith Foundation, 2001.73
pl. 140

72
Joseph D. Jachna
Untitled, 1958/61, from his thesis,
"Water"; gelatin silver print,
15.4 x 23.3 cm
The Art Institute of Chicago, gift of
Joseph Jachna, 1961.853
pl. 138

73
Joseph D. Jachna
Untitled, 1959, from his thesis, "Water";
gelatin silver print, 19.2 x 17 cm
The Art Institute of Chicago, Ernest
Kahn Endowment, 2001.204
pl. 139

74
Joseph D. Jachna
*Foam and Rocks, Slough Gundy,
Wisconsin*, 1967; gelatin silver print,
16.4 x 16.3 cm
The Art Institute of Chicago, gift of
Alvin J. Gilbert, 1979.1350
pl. 150

75
Joseph D. Jachna
Door County, Wisconsin, 1969; gelatin
silver print, 15.0 x 21.4 cm
The Art Institute of Chicago, gift of
Alvin J. Gilbert, 1979.1365
pl. 201

76
Kenneth Josephson
American, b. 1932
Trees, Chicago, 1959, from his thesis,
"An Exploration of the Multiple Image";
gelatin silver print, 19 x 19 cm
The Art Institute of Chicago, gift of
Jeanne and Richard S. Press,
2000.526
pl. 132

77
Kenneth Josephson
Chicago, 1961; gelatin silver print,
15.4 x 22.8 cm
The Art Institute of Chicago, gift of
Kenneth Josephson, 1976.219
pl. 136

78
Kenneth Josephson
Matthew, 1963; gelatin silver print,
30.5 x 20.1 cm
The Art Institute of Chicago, gift of
Ralph and Nancy Segall, 1998.634
pl. 200

79
Kenneth Josephson
Chicago, 1963 #63-2-8, 1963; gelatin
silver print, 10.2 x 17.8 cm
LaSalle Bank Photography Collection,
73.81.8
pl. 171

80
Kenneth Josephson
Stockholm, 1967, from the series
"Marks and Evidence"; gelatin silver
print, 15.4 x 22.7 cm
The Art Institute of Chicago, gift of
Ralph and Nancy Segall, 1998.620
pl. 168

81
Kenneth Josephson
Anissa, 1969, from the series "Images
within Images"; gelatin silver print
collage, 14.3 x 20.3 cm
The Art Institute of Chicago, gift of
Ralph and Nancy Segall, 1999.432
pl. 204

82
Kenneth Josephson
New York State, 1970, from the series
"Images within Images"; gelatin silver
print, 20.2 x 30.5 cm
The Art Institute of Chicago, gift of
Ralph and Nancy Segall, 1998.630
pl. 209

83
Kenneth Josephson
Michigan, 1970, from the series "The
History of Photography"; gelatin silver
print, 23 x 22.9 cm
The Art Institute of Chicago, gift of
Ralph and Nancy Segall, 1999.434
pl. 208

84
William Keck
American, 1908–1995
Untitled, 1940s; gelatin silver print
collage, 20.3 x 28.5 cm
The Art Institute of Chicago, restricted
gift of Anstiss and Ronald Krueck in
honor of Mark P. Sexton, 2001.205
pl. 23

85
György Kepes
American, b. Hungary, 1906
Untitled, 1937/43; gelatin silver print
(photogram), 50.4 x 40.3 cm
The Art Institute of Chicago, gift of
Mrs. Katharine Kuh, 1954.1340
pl. 5

86
György Kepes
Untitled, begun early 1930s with addi-
tions 1936/39; gelatin silver print
(photogram) with gouache,
23.2 x 18.1 cm
Museum of Fine Arts, Boston, Sophie
M. Friedman Fund, 1995.56
pl. 17

87
György Kepes
Juliet with Peacock Feather, 1937/38;
gelatin silver print with gouache,
15.2 x 11.6 cm
The Art Institute of Chicago, Maurice
D. Galleher Endowment, 1996.1
pl. 31

88
György Kepes
Juliet with Peacock Feather and Paint,
1937/38; gelatin silver print with
gouache, 11.6 x 8.7 cm
Collection of Eric Ceputis
pl. 32

89
György Kepes
*Untitled (Juliet with Peacock Feather
and Red Leaf)*, 1937/38; gelatin silver
print with gouache, 12.7 x 10.1 cm
Private collection
pl. 30

90
György Kepes
Solarization, c. 1938; gelatin silver
print, 32.9 x 28.2 cm.
The Art Institute of Chicago, Mary L.
and Leigh B. Block Endowment,
1994.320
pl. 24

91
György Kepes
Blue Woman with Vision, 1939; solar-
ized gelatin silver print, montage, with
gouache, 35.6 x 26 cm
Collection of Jane and Joel Rosenberg
pl. 25

92
György Kepes
Juliet's Shadow Caged, 1939, printed
1940; solarized gelatin silver print,
34.9 x 27.9 cm
Museum of Fine Arts, Boston, Sophie
M. Friedman Fund, 1984.147
pl. 26

93
György Kepes
Untitled (Photograph for Direction
Magazine*)*, 1939; toned gelatin silver
print with watercolor, 34.6 x 27 cm
Collection of Leland Rice and Susan
Ehrens
pl. 44

94
Thomas Knudtson
American, b. 1939
Barn Wall, Victor, NY, 1959; gelatin
silver print, 24.8 x 24.8 cm
Courtesy of Thomas Knudtson and
Stephen Daiter Gallery, Chicago
pl. 172

95
Cal Kowal
American, b. 1944
Untitled, 1968/69; gelatin silver print,
15.2 x 22.9 cm
Courtesy of Cal Kowal
pl. 191

96
Myron Kozman
American, b. 1916
Untitled, 1938; gelatin silver print,
20.3 x 25.2 cm
The Art Institute of Chicago, restricted
gift of Bernard M. and Caryl H.
Susman, 2001.193
pl. 41

97
Myron Kozman
Untitled, 1938; gelatin silver print,
20.3 x 25.2 cm
The Art Institute of Chicago, restricted
gift of Bernard M. and Caryl H.
Susman, 2001.194
pl. 42

98
Myron Kozman
Untitled, 1938; gelatin silver print,
20.3 x 25.2 cm
The Art Institute of Chicago, restricted
gift of Bernard M. and Caryl H.
Susman, 2001.195
pl. 43

99
Elsa Kula
American, b. 1918, and
Davis Pratt
American, 1917–1987
Untitled, c. 1943; gelatin silver print
(photogram), 23.9 x 18.7 cm
Collection of J. Donald Nichols, courtesy of Gary Snyder Fine Art, New York
pl. 34

100
William Larson
American, b. 1942
Still Films, 1967/70; color coupler
print, 5.7 x 45.7 cm
Courtesy of William Larson
pl. 183

101
William Larson
Figure in Motion, c. 1968, from his
thesis, "The Figure in Motion"; gelatin
silver print, 5.7 x 25.4 cm
Courtesy of William Larson
pl. 182

102
Hubert Leckie
American, 1913–1993
Untitled, c. 1940; gelatin silver print
(photogram), 36.8 x 28.6 cm
Collection of J. Donald Nichols, courtesy of Gary Snyder Fine Art, New York
pl. 18

103
Nathan Lerner
American, 1913–1997
Light Volume, Chicago, 1937, printed
1984; gelatin silver print, printed under
the artist's supervision by the Chicago
Albumen Works, 28.9 x 40.2 cm
The Art Institute of Chicago, gift of
David C. and Sarajean Ruttenberg,
1991.1119.6
pl. 9

104
Nathan Lerner
Eggs and Box, 1938; gelatin silver
print, 8.8 x 12.2 cm
Courtesy of Kiyoko Lerner
pl. 10

105
Nathan Lerner
Charley's Eye, 1940; gelatin silver
print, 23.3 x 18.5 cm
The Art Institute of Chicago, Edward
Byron Smith and John Bross Fund,
1992.101
pl. 11

106
Nathan Lerner
*Eye and Nails (Montage without
Scissors)*, 1940; gelatin silver print,
23.9 x 18.7 cm
Courtesy of Kiyoko Lerner
pl. 12

107
Nathan Lerner
*Montage without Scissors (Face and
Sandpaper)*, 1940; gelatin silver print,
24 x 19.1 cm
Courtesy of Robert Mann Gallery
pl. 28

108
Frank Levstik, Jr.
American, 1908–1985
Utility Shack Door, c. 1940; gelatin
silver print, 16.3 x 15.5 cm
The Art Institute of Chicago, restricted
gift of Bernard M. and Caryl H.
Susman, 2001.186
pl. 46

109
Frank Levstik, Jr.
Untitled (Bed Springs), 1945/46;
gelatin silver print, 19.1 x 18.7 cm
Hallmark Photographic Collection,
Hallmark Cards, Inc., Kansas City,
Missouri, P5.557.001.97
pl. 45

110
Charles Lichtenstein
American, active 1940s–1950s
Untitled, c. 1947; gelatin silver print,
19.4 x 19.3 cm
The Art Institute of Chicago, restricted
gift of Bernard M. and Caryl H.
Susman, 2001.190
pl. 92

111
Archie Lieberman
American, b. 1926
*Bill Hammer Jr. and Bill Hammer Sr.,
Jo Daviess County, Illinois*, 1955;
gelatin silver print, 22.9 x 29.4 cm
The Art Institute of Chicago, gift of
Focus/Infinity Fund, 1986.293
pl. 86

112
Archie Lieberman
*Bill Hammer Jr. and his son Jim,
Jo Daviess County, Illinois*, 1971;
gelatin silver print, 22.8 x 33.1 cm
The Art Institute of Chicago, gift of
Focus/Infinity Fund, 1986.297
pl. 87

113
Nathan Lyons
American, b. 1930
Untitled (Minneapolis), 1965; gelatin
silver print, 19.7 x 24.9 cm
Courtesy of Nathan Lyons
pl. 170

114
Ray Martin
American, b. 1930
Untitled, 1950s; gelatin silver print,
23.3 x 19.1 cm
The Art Institute of Chicago, RX
23247/12
pl. 94

115, 116
Lyle Mayer
American, active 1950s–1960s
Untitled, 1950s; gelatin silver prints,
positive and negative, each
9.5 x 11.8 cm
The Art Institute of Chicago, Daniel L.
and Rosalind Benton Foundation Fund,
2001.403–04
pls. 68, 69

117
Lyle Mayer
Untitled, 1951; gelatin silver print,
10.9 x 24.3 cm
The Art Institute of Chicago, restricted
gift of Bernard M. and Caryl H.
Susman, 2001.197
pl. 77

118
Ray K. Metzker
American, b. 1931
Chicago, 1957, from his thesis, "My
Camera and I in the Loop"; gelatin
silver print, 18.7 x 18.8 cm
The Art Institute of Chicago, Daniel L.
and Rosalind Benton Foundation Fund,
1998.222
pl. 131

119
Ray K. Metzker
The Loop: Chicago, 1958, from his
thesis, "My Camera and I in the Loop";
gelatin silver print, 19.1 x 19.1 cm
The Art Institute of Chicago,
Photography Gallery Fund, 1960.177
pl. 133

120
Ray K. Metzker
Chicago, 1958; gelatin silver print,
14.5 x 21.3 cm
The Art Institute of Chicago,
Photography Gallery Fund, 1960.189
pl. 134

121
Ray K. Metzker
Untitled, c. 1959, from his thesis, "My
Camera and I in the Loop"; gelatin
silver print, 18.2 x 18.2 cm
Courtesy of Ray K. Metzker
pl. 135

122
Ray K. Metzker
Untitled, c. 1959, from his thesis, "My
Camera and I in the Loop"; gelatin
silver print, 12.8 x 19.7 cm
Courtesy of the Institute of Design,
Illinois Institute of Technology
pl. 137

123
Ray K. Metzker
Composites: Philadelphia, 1966; com-
posite of gelatin silver prints, mounted
on masonite and wood, 171 x 77 cm
The Art Institute of Chicago, the
Goodman Fund, 1996.45
pl. 184

124
Ray K. Metzker
Atlantic City, 1966; gelatin silver print,
17.3 x 17.2 cm
The Art Institute of Chicago, Daniel L.
and Rosalind Benton Foundation Fund,
1998.219
pl. 151

125
Ray K. Metzker
Tall Grove of Nudes, 1966; composite
of 140 gelatin silver prints,
71.1 x 61 cm
LaSalle Bank Photography Collection,
70.57.2
pl. 186

126
Wayne Miller
American, b. 1918
Afternoon Game at Table 2, 1946/48;
gelatin silver print, 28.4 x 26.8 cm
The Art Institute of Chicago,
Horace W. Goldsmith Foundation Fund,
2001.349
pl. 84

127
Wayne Miller
Keeping Warm, Pool Hall, 1946/48;
gelatin silver print, 28.8 x 27 cm
The Art Institute of Chicago,
Horace W. Goldsmith Foundation Fund,
2001.350
pl. 89

128
Wayne Miller
Untitled, 1949; gelatin silver print,
27.1 x 34.1 cm
The Art Institute of Chicago, Daniel L.
and Rosalind Benton Foundation Fund,
2001.407
pl. 85

129
László Moholy-Nagy
American, b. Hungary, 1895–1946
Untitled, c. 1939; gelatin silver print
(photogram), 50.3 x 40.1 cm
The Museum of Modern Art, New York,
anonymous gift, 326.64
pl. 2

130
László Moholy-Nagy
Untitled, c. 1940; gelatin silver print
(photogram), 40.5 x 50.4 cm
George Eastman House, 81:2163:8
pl. 7

131
László Moholy-Nagy
Untitled, c. 1940; gelatin silver print
(photogram), 50.1 x 40.2 cm
The Art Institute of Chicago, gift of
George and Ruth Barford, 1968.264
pl. 1

132
László Moholy-Nagy
City Lights (Eastgate Hotel), 1939/46;
Kodachrome slide, 2.3 x 3.5 cm
Collection of Hattula Moholy-Nagy
pl. 38

133
László Moholy-Nagy
Billboard Detail, New York City, 1940;
Kodachrome slide, 2.3 x 3.5 cm
Collection of Hattula Moholy-Nagy
pl. 36

134
László Moholy-Nagy
Traffic Lights, early 1940s;
Kodachrome slide, 2.3 x 3.5 cm
Collection of Hattula Moholy-Nagy
pl. 37

135
László Moholy-Nagy
Untitled, 1941; gelatin silver print
(photogram), 27.3 x 11.8 cm
The Wolkowitz Collection
pl. 4

136
Artist unknown (student of
László Moholy-Nagy)
Untitled, c. 1940; gelatin silver print
(photogram), 20.3 x 25.4 cm
San Francisco Museum of Modern Art,
gift of the School of Design, Chicago,
Illinois, 40.8369.135
pl. 8

137
Marvin E. Newman
American, b. 1927
Third Avenue El, 1949; gelatin silver
print, 24 x 19 cm
The Art Institute of Chicago, Horace W.
Goldsmith Foundation Fund, 2000.155
pl. 90

138
Marvin E. Newman
Untitled, Chicago, 1950; gelatin silver
print, 23.1 x 16.3 cm
The Art Institute of Chicago, Horace W.
Goldsmith Foundation Fund, 2000.156
pl. 83

139
Marvin E. Newman
Chicago, 1951, from his thesis, "A
Creative Analysis of the Series Form in
Still Photography"; gelatin silver print,
17.8 x 23.5 cm
LaSalle Bank Photography Collection,
98.532.1
pl. 102

140
Marvin E. Newman
Untitled, 1951, from his thesis, "A
Creative Analysis of the Series Form in
Still Photography"; gelatin silver print,
18.6 x 23.7 cm
The Art Institute of Chicago, Smart
Family Foundation Fund, 1998.571
pl. 103

141
Richard Nickel
American, 1928–1972
*Untitled (Carson Pirie Scott and Co.
Store, detail of ornament on lower
stories)*, c. 1950; gelatin silver print,
printed by Patrice Grimbert in 1973,
35.3 x 45.2 cm
The Art Institute of Chicago,
Photography Department Exhibition
Funds, 1975.392
pl. 124

142
Richard Nickel
Untitled (Carson Pirie Scott and Co. Store), c. 1955; gelatin silver print, printed by Patrice Grimbert in 1973, 35.3 x 45.3 cm
The Art Institute of Chicago, Photography Department Exhibition Funds, 1975.398
pl. 125

143
Richard Nickel
Untitled (Demolition of Proscenium Arch, Garrick Theater), 1961; gelatin silver print, printed by Patrice Grimbert in 1973, 35.2 x 45.3 cm
The Art Institute of Chicago, RX19449/67
pl. 123

144
Homer Page
American, 1918–1985
Untitled, c. 1947; gelatin silver print, 19 x 24 cm
San Francisco Museum of Modern Art, gift of Christina Gardner, 92.442
pl. 97

145
Homer Page
Untitled, c. 1947; gelatin silver print, 21.2 x 19 cm
San Francisco Museum of Modern Art, gift of Christina Gardner, 92.439
pl. 98

146
Thomas Porett
American, b. 1942
Untitled, 1966, from his thesis, "Introspective Landscape"; gelatin silver print, 16 x 23.7 cm
Courtesy of Thomas Porett
pl. 159

147
Max Pritikin
American, b. 1916
Artificial Negative Greatly Enlarged, 1946; gelatin silver print from artificial negative, 25.4 x 17.8 cm
Collection of J. Donald Nichols, courtesy of Gary Snyder Fine Art, New York
pl. 19

148
Tom Rago
American, b. 1926
Snow Forms in Chicago, 1955/56; gelatin silver print, 24 x 19.2 cm
Courtesy of Tom Rago and Stephen Daiter Gallery, Chicago
pl. 118

149
Merry Renk
American, b. 1921
Untitled (Self-Portrait), 1946/47; gelatin silver print, 6.7 x 6.6 cm
The Art Institute of Chicago, Edward Byron Smith and John Bross Fund, in honor of Lisette Bross, 2001.408
pl. 80

150
Gretchen Schoeninger
American, b. 1913
Negative Exposure, 1937; gelatin silver print, 24.2 x 16.8 cm
The Art Institute of Chicago, restricted gift of Robert and Doris Taub, 2001.72
pl. 33

151
Arthur Siegel
American, 1913–1978
Photogram #72, c. 1937; gelatin silver print (photogram), 27.9 x 34.6 cm
Courtesy of Ubu Gallery, New York
pl. 6

152
Arthur Siegel
Right of Assembly, 1939; gelatin silver print, 34.1 x 27 cm
LaSalle Bank Photography Collection, 99.40.12
pl. 52

153
Arthur Siegel
Nude (Hand Shadow over Breasts), 1940; gelatin silver print, 21.6 x 32.1 cm
The Buhl Collection, New York
pl. 40

154
Arthur Siegel
Untitled, 1940s; gelatin silver print, 23 x 17.9 cm
The Art Institute of Chicago, Mary L. and Leigh B. Block Endowment, 2001.406
pl. 39

155
Arthur Siegel
Refugee, 1945; gelatin silver print, 21.6 x 24.1 cm
From the collection of Robin Woodhead, courtesy of Sarah Morthland Gallery
pl. 54

156
Arthur Siegel
Barbara (Double Portrait), 1947; gelatin silver print, 16.2 x 15.9 cm
Palmer Museum of Art, the Pennsylvania State University, 2000.41
pl. 81

157
Arthur Siegel
Photogram, 1948; gelatin silver print (photogram), 49.2 x 39.7 cm
Museum of Fine Arts, Boston, Sophie M. Friedman Fund, 1984.50
pl. 65

158
Arthur Siegel
Untitled (Barbara), 1949; dye imbibition print, 24.5 x 16.2 cm
The Art Institute of Chicago, restricted gift of Bernard M. and Caryl H. Susman, 2001.192
pl. 75

159
Arthur Siegel
Green Building, Red Door, 1950; dye imbibition print, 15 x 24.9 cm
The Art Institute of Chicago, Peabody Fund, 1954.1231
pl. 73

160
Arthur Siegel
Bra Window, 1951, from the series "In Search of Myself"; dye imbibition print, 25.7 x 17.5 cm
Hallmark Photographic Collection, Hallmark Cards, Inc., Kansas City, Missouri, P5.073.009.00
pl. 82

161
Arthur Siegel
Headlight, 1953; dye imbibition print, 25.7 x 20.7 cm
The Art Institute of Chicago, Peabody Fund, 1954.1229
pl. 74

162, 163
Arthur Siegel
Untitled, 1955; gelatin silver prints, diptych, 20.5 x 19.8 cm, 20.2 x 19.9 cm
The Art Institute of Chicago, Mary L. and Leigh B. Block Endowment, 2001.206a–b
pls. 66, 67

164
Arthur Siegel and
László Moholy-Nagy
Untitled, 1946; gelatin silver print
(photogram), 35.6 x 27.9 cm
Collection of Eric Ceputis
pl. 20

165
Bernard Siegel
American, 1916–1997
Solargram 10, 1949/50; gelatin silver
print (photogram), 50.8 x 40.6 cm
David Lusenhop Fine Art,
Cincinnati, Ohio
pl. 64

166
Art Sinsabaugh
American, 1924–1983
Midwest Landscape #4, 1961, from
the series "Midwest Landscape";
gelatin silver print, 11.4 x 48.2 cm
The Art Institute of Chicago, Joseph
and Helen Regenstein Foundation
Fund, 1963.1059
pl. 149

167
Art Sinsabaugh
Midwest Landscape #15, 1961, from
the series "Midwest Landscape";
gelatin silver print, 11.3 x 48.9 cm
The Art Institute of Chicago, restricted
gift of Leigh B. Block, 1983.62
pl. 148

168
Art Sinsabaugh
Midwest Landscape #34, 1961, from
the series "Midwest Landscape";
gelatin silver print, 7.6 x 48.3 cm
LaSalle Bank Photography Collection,
68.30.1
pl. 147

169
Art Sinsabaugh
Chicago Landscape #13, 1964, from
the series "Chicago Landscape";
gelatin silver print, 19.6 x 49.7 cm
The Art Institute of Chicago, restricted
gift of Edward Byron Smith, 1983.59
pl. 164

170
Art Sinsabaugh
Chicago Landscape #122, 1964, from
the series "Chicago Landscape";
gelatin silver print, 10.2 x 48.3 cm
LaSalle Bank Photography Collection,
69.30.8
pl. 166

171
Art Sinsabaugh
Chicago Landscape #205, 1965, from
the series "Chicago Landscape";
gelatin silver print, 29.5 x 49.5 cm
The Art Institute of Chicago, restricted
gift of Edward Byron Smith, 1983.60
pl. 163

172
Aaron Siskind
American, 1903–1991
New York 2, 1951; gelatin silver print,
41.5 x 33.5 cm
The Art Institute of Chicago, gift of
Mr. Noah Goldowsky, 1956.392
pl. 119

173
Aaron Siskind
Kentucky K7, 1951; gelatin silver
print, 33.1 x 41.5 cm
The Art Institute of Chicago, gift of
Mr. Noah Goldowsky, 1956.398
pl. 114

174
Aaron Siskind
North Carolina, 1951; gelatin silver
print, 34.1 x 23.6 cm
The Art Institute of Chicago, gift of
Judy Marcus, 1991.365
pl. 116

175
Aaron Siskind
Chicago 30, 1953; gelatin silver print,
26 x 33.8 cm
Courtesy of the Fogg Art Museum,
Harvard University Art Museums, gift
of Richard L. Menschel, P1978.59
pl. 113

176
Aaron Siskind
Chicago 224, 1953; gelatin silver
print, 34.5 x 34.5 cm
The Art Institute of Chicago, gift of
Mr. Noah Goldowsky, 1956.1269
pl. 112

177
Aaron Siskind
Walker Warehouse, 1953; gelatin
silver print, 34 x 25.1 cm
The Art Institute of Chicago, restricted
gift of David C. Ruttenberg, 1976.225
pl. 129

178
Aaron Siskind
Walker Warehouse, 1953; gelatin
silver print, 34.2 x 26.8 cm
The Art Institute of Chicago, gift of
Aaron Siskind, 1976.226
pl. 126

179
Aaron Siskind
Chicago, 1953/54; gelatin silver print,
34.7 x 25.8 cm
The Art Institute of Chicago, gift of
Richard L. Menschel, 1977.659
pl. 127

180
Aaron Siskind
*Pleasures and Terrors of Levitation
474*, 1954, from the series "Pleasures
and Terrors of Levitation"; gelatin
silver print, 39.3 x 38.2 cm
The Art Institute of Chicago, gift of
Dr. and Mrs. Irwin Siegel, 1992.802
pl. 122

181
Aaron Siskind
*Pleasures and Terrors of Levitation
491*, 1954, from the series "Pleasures
and Terrors of Levitation"; gelatin
silver print, 39.4 x 38.1 cm
The Art Institute of Chicago, gift of
Dr. and Mrs. Irwin Siegel, 1992.799
pl. 121

182
Aaron Siskind
Martha's Vineyard (UR 127B), 1954;
gelatin silver print, 33.5 x 41.7 cm
The Art Institute of Chicago, gift of
Mr. Noah Goldowsky, 1956.396
pl. 120

183
Aaron Siskind
Tenayuca (T-2'55/M4), 1955; gelatin
silver print, 34.4 x 41.8 cm
The Art Institute of Chicago,
Photography Collection Purchase
Fund, 1964.300
pl. 115

184
Aaron Siskind
Untitled (Self-Portrait), c. 1967;
gelatin silver print, 18.8 x 23.8 cm
Courtesy of the Fogg Art Museum,
Harvard University Art Museums, gift
of Carl Chiarenza and Heidi Katz,
P1999.76
pl. 205

185
Lynn Sloan
American, b. 1945
Untitled (G15/10), 1970; gelatin silver
print, 15.1 x 15.1 cm
Courtesy of Lynn Sloan
pl. 157

186
Henry Holmes Smith
American, 1909–1986
Untitled (Light Study), 1946; gelatin
silver print, 17.9 x 10.5 cm
Hallmark Photographic Collection,
Hallmark Cards, Inc., Kansas City,
Missouri, P5.132.002.97
pl. 35

187
Keith A. Smith
American, b. 1938
Untitled, 1965; gelatin silver print,
25.4 x 20.3 cm
Courtesy of Keith A. Smith
pl. 174

188
Keith A. Smith
Nude, 1966; Uratchi etching paper
with photographic emulsion and pencil
drawing, 15.7 x 8.3 cm
The Art Institute of Chicago, gift of
Hugh Edwards, 1986.1234
pl. 173

189
Keith A. Smith
Book 2, 1969; book of film-positives,
drawings, and watercolors,
27.9 x 34.3 x 2 cm
Courtesy of Keith A. Smith
pl. 175

190
Keith A. Smith
Book 11, 1969; book of film-positives,
drawings, and watercolors,
37.5 x 29.9 x 3.2 cm
Courtesy of Keith A. Smith
pl. 176

191
Frank Sokolik
American, 1910–1984
Untitled, 1940s; gelatin silver print,
18.8 x 22.5 cm
The Art Institute of Chicago, Smart
Family Foundation Fund, 1999.400
pl. 53

192
Frank Sokolik
Untitled, 1940s; gelatin silver print,
8.1 x 11.5 cm
The Art Institute of Chicago, restricted
gift of John A. Bross in memory of
Louise Smith Bross, 1999.402
pl. 22

193
Frederick Sommer
American, b. Italy, 1905–1999
Configurations on Black 5, 1957;
gelatin silver print, 34 x 26.6 cm
The Museum of Modern Art, New York,
purchase, 498.60
pl. 117

194
Joseph Sterling
American, b. 1936
Untitled, c. 1959, from his thesis, "The
Age of Adolescence"; gelatin silver
print, 19.1 x 17.8 cm
The Art Institute of Chicago, gift of
Joseph Sterling, 1961.415
pl. 143

195
Joseph Sterling
Chicago, 1959, from his thesis, "The
Age of Adolescence"; gelatin silver
print, 33.3 x 21.6 cm
The Art Institute of Chicago, gift of the
Illinois Arts Council, 1976.1254
pl. 141

196
Joseph Sterling
Untitled, 1964; gelatin silver print,
21.4 x 33 cm
The Art Institute of Chicago, gift of the
Illinois Arts Council, 1976.1255
pl. 142

197
Robert Stiegler
American, 1938–1990
Bridge, 1959; gelatin silver print,
22.9 x 22.9 cm
Courtesy of Anita David
pl. 79

198
Robert Stiegler
Untitled, c. 1965, printed 1974;
gelatin silver print, 39.4 x 11.4 cm
Courtesy of Anita David
pl. 179

199
Charles Swedlund
American, b. 1935
Multiple Exposure, c. 1957; gelatin
silver print, 19.1 x 24 cm
Courtesy of Charles Swedlund
pl. 146

200
Charles Swedlund
Untitled, c. 1961, from his thesis,
"The Search for Form: Studies of the
Human Figure"; gelatin silver print,
19.1 x 18.5 cm
Courtesy of Charles Swedlund
pl. 144

201
Charles Swedlund
Untitled, c. 1968; gelatin silver print,
19 x 18.9 cm
Courtesy of Charles Swedlund
pl. 145

202
Charles Traub
American, b. 1945
Meatyard, Kentucky, 1969; gelatin
silver print, 15.1 x 15.4 cm
Courtesy of Charles Traub
pl. 198

203
Charles Traub
Aaron, Chicago, 1971, from his thesis,
part 1, "Mary and the Baby"; gelatin
silver print, 15 x 15 cm
Courtesy of the Institute of Design,
Illinois Institute of Technology
pl. 197

204
Charles Traub
Neg Ice, 1971, from his thesis, part 2,
"Landscapes"; gelatin silver print,
21.5 x 28.9 cm
Courtesy of Charles Traub
pl. 152

205
Warren Wheeler
American, b. 1944
Trailer Light, 1971; toned gelatin
silver print, 15.3 x 22.9 cm
Courtesy of Warren Wheeler
pl. 190

206
Geoff Winningham
American, b. 1943
Tag Team Action, 1971, from the
series "Friday Night at the Coliseum";
gelatin silver print, 38.3 x 58.6 cm
Courtesy of Geoff Winningham
pl. 196

207
Dina Woelffer
American, 1907–1990
ID Problem, Chicago, 1946; gelatin
silver print, 18.1 x 22.2 cm
The Art Institute of Chicago, restricted
gift of Bernard M. and Caryl H.
Susman, 2001.188
pl. 14

208
Dina Woelffer
Chicago, 1947; gelatin silver print,
24 x 18.2 cm
The Art Institute of Chicago, restricted
gift of John A. Bross, Jr., 1998.28
pl. 101

209
John Wood
American, b. 1922
Birds and Bomber, 1965/68, from the
series "Gun in the Landscape"; gelatin
silver negative print/montage,
38.2 x 25.4 cm
Courtesy of John Wood
pl. 189

Appendix:
Related Exhibition Materials

A
Aperture 9:2 (1961)
The Art Institute of Chicago,
Department of Photography
Davis, fig. 15

B
Harry Callahan, *Untitled* (750 Studio
invitation); gelatin silver print on card,
15.2 x 25.4 cm
Collection of Leland Rice and Susan
Ehrens
Viskochil, fig. 3

C
Milton Halberstadt, schematic drawing
for his triple-exposure portrait of
Norm Martin, 1940/41, 50.6 x 40.6 cm
The Art Institute of Chicago, gift of
Hans, Eric and Piet Halberstadt,
2001.182
Engelbrecht, fig. 21

D
Institute of Design course catalogue,
fall 1957
Courtesy of Joseph Sterling
Davis, fig. 11

E
Institute of Design summer session
brochure, "New Vision in
Photography," 1946
The Art Institute of Chicago, Ryerson
and Burnham Libraries, Arthur Siegel
Collection
Engelbrecht, fig. 26

F
Institute of Design, *Photography*,
1940s; grey cloth three-ring binders
with gelatin silver prints mounted on
paper, pages 20.3 x 27.9 cm
Courtesy of the Illinois Institute of
Technology, Paul V. Galvin Library,
University Archives
Davis, fig. 7

G
Joseph D. Jachna and Bluhma Lew,
Photography Foundation Course,
early 1960s; handmade book with
gelatin silver prints, 24.8 x 39.4 cm
Courtesy of Joseph D. Jachna
Grimes, fig. 6

H
György Kepes, *Language of Vision*
(Chicago, 1944)
The Art Institute of Chicago, Ryerson
and Burnham Libraries
Engelbrecht, fig. 24

I
Nathan Lerner, reproduction of his
1937 "Light Box," made by Roger
Manley, 2000; wooden box with string
and other materials; lights, 61 x 95 x
75 cm
Courtesy of the North Carolina State
University, Gallery of Art and Design
Engelbrecht, fig. 16

J
László Moholy-Nagy, *Vision in Motion*
(Chicago, 1947)
The Art Institute of Chicago,
Department of Photography
Engelbrecht, figs. 12, 13, 17, 27

K
New Bauhaus course catalogue,
1937–38
The Art Institute of Chicago,
Department of Photography
Engelbrecht, figs. 2, 8

L
Marvin E. Newman, "A Creative
Analysis of the Series Form in Still
Photography," 1952; book of 122
gelatin silver prints, spiral bound,
approximately 25.4 x 76.2 cm
Courtesy of the Illinois Institute of
Technology, Paul V. Galvin Library
Davis, fig. 13

M
School of Design course catalogue,
1939–40
The Art Institute of Chicago, Ryerson
and Burnham Libraries
Engelbrecht, fig. 18

N
School of Design course catalogue,
1940–41
The Art Institute of Chicago, Ryerson
and Burnham Libraries
Engelbrecht, figs. 19, 20

BIBLIOGRAPHY

Compiled by Elizabeth Siegel

This bibliography is divided into primary and secondary sources. The primary sources, culled largely from magazines and newspapers of the period, are on file in the Department of Photography, The Art Institute of Chicago. Works listed here focus on the school's activities, curriculum, and photographic practice rather than on individual artists; important monographical works about individual figures are readily available elsewhere and therefore have not been included. Unpublished and archival materials on file in the Department of Photography, including taped or transcribed interviews, have also been excluded from this list, although many are cited in individual essays. Archives with a wealth of information on the Institute of Design and individual teachers and students include the Elmer Ray Pearson ID Collections and specific photographers' collections at the Chicago Historical Society; the Special Collections Department, University Library, University of Illinois at Chicago; the Arthur Siegel Collection at Ryerson and Burnham Libraries, The Art Institute of Chicago; the Paul Galvin Library, Illinois Institute of Technology, Chicago; Master's Thesis Archives at the Institute of Design, Chicago; photographers' archives at the Center for Creative Photography, University of Arizona, Tucson; the Sinsabaugh and Henry Holmes Smith archives at the Indiana University Art Museum, Bloomington, Indiana; Archives of American Art, Smithsonian Institution, Washington, D.C.; and the Bauhaus-Archiv, Berlin.

Primary Sources

"American School of Design to Open Here This Fall." *Chicago Daily News*, August 23, 1937, 11.

"Architecture at the Institute of Design." *Interiors* 108 (November 1948), 118–25.

"Bauhaus: First Year." *Time* 32 (July 11, 1938), 21.

"The Bauhaus Touch." *Art Digest* 12 (August 1938), 27.

"Bauhaus Will Open in Chicago in Fall." *New York Times*, Sunday, August 22, 1937, sec. 2, p. 6.

Benson, E[manuel] M[ervin]. "Chicago Bauhaus." *Magazine of Art* 31 (February 1938), 82–83.

———. "Wanted: An American Bauhaus." *Magazine of Art* 26 (June 1934), 307–11.

Bernsohn, Al, and DeVera Bernsohn. "Moholy-Nagy, Iconoclast." *Camera Craft* (August 1939), 357–64.

Bulliet, C[larence] J. "Around the Galleries: Of Bauhaus and the New Mousetrap." *Chicago Daily News*, July 9, 1938, 13.

Chancellor, John. "Institute of Design: The Rocky Road from the Bauhaus." *Chicago* (July 1955), 28–35.

Chermayeff, Serge. "Education for Modern Design." *College Art Journal* 6 (spring 1947), 219–21.

"Chicago: The New Bauhaus." *Art News* 36 (October 16, 1937), 18–19.

"Chicago's Bauhaus." *Art Digest* 11 (September 1, 1937), 20.

"Chicago's Sullivan in New Photographs." *Architectural Forum* 101 (October 1954), 128–33.

D., A. B. "School of Design on Threshold of Fourth Year." *Chicago Sun*, January 3, 1942.

"Design: Hungarian Professor Directs New School in Chicago." *News-Week* 10 (September 20, 1937), 36.

Doblin, Jay. "Graduate Study at IIT's Institute of Design." *Industrial Design* 10 (March 1963), 64–73.

Eckel, George. "Chicago Bauhaus Marks a Decade." *New York Times*, Sunday, August 31, 1947, sec. 1, p. 38.

Faherty, Robert. "The Institute of Design: Shapes of Things to Come." *Chicago Daily News Panorama*, March 23, 1963, 4–5.

Flavin, Genevieve. "Ideas? They're Plentiful at the Institute of Design." *Chicago Sunday Tribune*, December 2, 1945, pt. 3, pp. 1–2.

Ford, Phyllis. "Moholy-Nagy Brings Life of Future – Today." *Chicago Sunday Tribune*, August 1, 1943, pt. 3, p. 6.

F[rost], R[osamund]. "Form and Function: A U.S. Bauhaus." *Art News* 44 (August 1945), 23.

Gaunt, W. "The Great Design Experiment." *Art and Industry* 27 (August 1939), 37–39.

Holme, B. "Chicago." *The London Studio* 16 (November 1938), 268–69.

"The Institute of Design – A Laboratory for a New Education." *Interiors* 108 (October 1948), 134–39.

"Institute of Design Integrates Art, Technology and Science." *Interiors* 108 (September 1948), 142–51.

"Institute of Design Offers Summer Seminar." *Popular Photography* 19:1 (July 1946), 142.

Jewell, Edward Alden. "Chicago's New Bauhaus." *New York Times*, Sunday, September 12, 1937, sec. 11, p. 7.

Karr, S. P. "The Third Eye." *Art Photography* 4 (September 1952), 32–37.

Kepes, György. "Education of the Eye." *More Business* 3 (November 1938), 9.

———. *Language of Vision*. Chicago: Paul Theobald, 1944.

———. "Modern Design! With Light and Camera." *Popular Photography* 10 (February 1942), 24–25, 100–01.

Koppe, Richard. "The New Bauhaus, Chicago." In *Bauhaus and Bauhaus People*, edited by Eckhard Neumann; translated by Eva Richter and Alba Lorman, 234–42. New York: Van Nostrand Reinhold, 1970.

Kula, Elsa. "Institute of Design: The Student Must 'Learn for Himself.'" *Print* 14 (January 1960), 49–51.

"L. Moholy-Nagy and the Institute of Design in Chicago." *Everyday Art Quarterly* 3 (winter 1946/spring 1947), 1–3.

Martin, J. L[eslie]. "László Moholy-Nagy and The Chicago Institute of Design." *Architectural Review* 101 (June 1947), 224–26.

Millar's Chicago Letter 2 (August 5, 1940), special edition on the School of Design with articles by John H. Millar, László Moholy-Nagy, and Floyd B. Quigg.

Moholy-Nagy, László. "The Bauhaus in Chicago: Moholy-Nagy Explains." *New York Times*, Sunday, January 1, 1939, sec. 9, p. 9.

———. "Light: A Medium of Plastic Expression." *Broom: An International Magazine of the Arts* 4:4 (March 1923), 283–84.

———. "Light a New Medium of Expression." *Architectural Forum* 70 (May 1939), supp. 44–47.

———. "Make a Light Modulator." *Modern Photography* 2:7 (March 1940), 38–42.

———. "Making Photographs without a Camera." *Popular Photography* 5:6 (December 1939), 30–31, 167–69.

———. "New Approach to Fundamentals of Design." *More Business* 3 (November 1938), 4–8.

———. "The New Bauhaus, American School of Design, Chicago." *Design* 40 (March 1939), 19–21.

———. "New Education: Organic Approach." *Art and Industry* 40 (March 1946), 66–77.

———. *The New Vision: Fundamentals of Design, Painting, Sculpture, Architecture*. Translated by Daphne M. Hoffmann. New York: W. W. Norton, 1938. Revised edition of 1932 *The New Vision*.

———. "On Art and the Photograph: Recognized as a Visual Force and a Creative Medium as Well, Photography Gains in Capacity." *Technology Review* 47 (June 1945), 491–94, 518, 520, 522.

———. "Photography in the Study of Design." *The American Annual of Photography, Volume Fifty-nine, 1945* (Boston: American Photographic Publishing Co., 1944), 158–64.

———. *Vision in Motion*. Chicago: Paul Theobald, 1947.

Moholy-Nagy, Sibyl. "Moholy-Nagy: The Chicago Years." Lecture given at the Museum of Contemporary Art, Chicago, 1969. Reprinted in Richard Kostelanetz, ed., *Moholy-Nagy* (New York: Praeger Publishers, 1970).

"New Approach to Design: Creative Methods of Chicago Institute Influence Modern Living." *Pictures, St. Louis Post-Dispatch*, Sunday, January 28, 1951.

"The New Bauhaus." *Architectural Forum* 67 (October 1937), supp. 22, 82.

"The New Bauhaus, American School of Design." *The Chicago Guild of Freelance Artists Bulletin* 4 (November 1937), [1–2].

"New Bauhaus for Chicago." *Sunday Times* (Chicago), October 10, 1937, 53.

"New Bauhaus School Closes; Director Sues." *Chicago Sunday Tribune*, October 16, 1938, 18.

"New in Old." *Time* (October 25, 1937), 41.

"Open House: Institute of Design in 1952." *Arts and Architecture* 69 (July 1952), 16–33.

Pearson, Ralph M. "The School of Design, the American Bauhaus." In *The New Art Education*, edited by Ralph M. Pearson, 198–205. New York: Harper and Brothers, 1941.

"Photography by the New Bahaus [*sic*] School." *Townsfolk: Society, Sports, Travel and the Fine Arts* 20:5 (June 1938), 18.

"Reunion in Chicago: An Investigation into the Work of L. Moholy-Nagy." *Minicam Photography* (January 1945), 64–71.

Sagendorph, Kent. "Functionalism, Inc." *Coronet* (October 1941), 107–10.

"School of Design is Given $10,000 'For Pioneering.'" *Chicago Daily News*, February 7, 1940, 17.

Siskind, Aaron, and Harry Callahan. "Learning Photography at the Institute of Design." *Aperture* 4:4 (1956), 147–49.

"Speaking of Pictures . . . Weegee Shows How to Photograph a Corpse." *Life* 21 (August 12, 1946), 8–9.

Stephens, Louise. "Institute of Design Seeks to End Prejudice." *Chicago Defender*, February 21, 1948, 17.

"Student Exhibits." *New York Times*, February 19, 1950.

Thorpe, Max, and Jane Bell Edwards. "From a Student's Notebook." *Popular Photography* 21:6 (December 1947), 53–56ff.

"Unique School of Design." *Architect and Engineer* 140 (January 1940), 70.

Weisenborn, Fritzi. "Design Students hold Annual Show." *Chicago Times*, June 23, 1940.

White, Minor, ed. "Five Photography Students from the Institute of Design, Illinois Institute of Technology." *Aperture* 9:2 (1961), 247–90.

Yoder, Robert M. "Are You Contemporary? Work of Moholy-Nagy." *Saturday Evening Post* 216 (July 3, 1943), 16–17, 89.

Secondary sources

Allen, James Sloan. "Marketing Modernism: Moholy-Nagy and the Bauhaus in America." In *The Romance of Commerce and Culture: Capitalism, Modernism, and the Chicago–Aspen Crusade for Reform*. Chicago: University of Chicago Press, 1983, 35–77.

Barrow, Thomas. "Moholy-Nagy and the Chicago Bauhaus." In *Experimental Vision: The Evolution of the Photogram since 1919*. Niwot, Colo.: Roberts Rinehart Publishers in association with the Denver Art Museum, 1994.

Betts, Paul. "New Bauhaus and School of Design, Chicago." In *Bauhaus*, edited by Jeannine Fiedler and Peter Feierabend. Cologne: Könemann, 2000.

Boxer, Adam J, ed. *The New Bauhaus, School of Design in Chicago: Photographs, 1937–1944*. New York: Banning and Associates, 1993.

Bredendieck, Hin. "The Legacy of the Bauhaus." *Art Journal* 22 (fall 1962), 15–21.

Buckland, Gail. *The Photographer and the City*. Chicago: Museum of Contemporary Art, 1977.

Coke, Van Deren. "The Art of Photography in College Teaching." *College Art Journal* 19 (summer 1960), 332–42.

Cook, Jno. "Photography: The Chicago School." *Nit & Wit, Chicago's Arts Magazine* (January/February 1983), 30–31.

Daiter, Stephen. *Light and Vision: Photography at the School of Design in Chicago, 1937–1952*. Chicago: Stephen Daiter Photography, 1994.

Engelbrecht, Lloyd C. "The Association of Arts and Industries: Background and Origins of the Bauhaus Movement in Chicago." Ph.D. diss., University of Chicago, 1973.

Fiedler, Jeannine. "Das New Bauhaus Chicago im Bauhaus-Archiv Berlin." *Museums Journal* 6 (July 1992), 62–63.

Findeli, Alain. "Design Education and Industry: The Laborious Beginnings of the Institute of Design in Chicago in 1944." *Journal of Design History* 4 (1991), 97–113.

———. "Bauhaus Education and After: Some Critical Reflections." *Structurist*, no. 31/32 (1991/1992), 32–43.

———. *Le Bauhaus de Chicago: L'Oeuvre pédagogique de László Moholy-Nagy*. Sillery, Québec: Éditions du Septentrion, 1995.

Gallery 312. *Together Again: Ishimoto, Jachna, Josephson, Metzker, Sterling, Swedlund*. Introduction by David Travis. Chicago: Gallery 312, 1996.

Gaskins, W. G. "Photography and Photographic Education in the USA." *Image* 14 (December 1971), 8–13.

Grimes, John. "The Role of the Institute of Design in Chicago." *Photographies* (Paris) 3 (December 1983), 122–26.

Grundberg, Andy. "Photography: Chicago, Moholy and After." *Art in America* 63 (September 1976), 34–39.

Grundberg, Andy, and Julia Scully. "Currents: American Photography Today – The Legacy of the German Bauhaus." *Modern Photography* 42 (November 1978), 116–19.

Hahn, Peter, and Lloyd Engelbrecht, eds. *50 Jahre New Bauhaus; Bauhausnachfolge in Chicago*. Berlin: Argon Verlag, 1987.

Karmel, Pepe. "Photography Under Moholy's Eye." *Art in America* 68 (October 1980), 39–41.

Krannert Art Museum, University of Illinois. *The New Spirit in American Photography*. Urbana-Champaign: Krannert Art Museum, 1985.

Longmire, Stephen. "Callahan's Children: Recent Retrospectives of Photographers from the Institute of Design." *Afterimage* 28 (September/October 2000), 5–8.

Lusenhop, David. *Experimental Vision: Photography at the New Bauhaus and Institute of Design*. Cincinnati: David Lusenhop Fine Art, 1988.

Margolin, Victor. "Design for Business or Design for Life? Moholy-Nagy." In *The Struggle for Utopia: Rodchenko, Lissitzky, Moholy-Nagy, 1917–1946*, 215–50. Chicago: University of Chicago Press, 1997.

Meline, Caroline. Review of "New Vision: Forty Years of Photography at the Institute of Design." *Afterimage* 8 (November 1980), 15.

Moholy-Nagy, Sibyl. *Moholy-Nagy: Experiment in Totality*. 2nd ed. Cambridge, Mass.: MIT Press, 1969.

Morrison, C. L. "Chicago Dialectic." *Artforum* 16 (February 1978), 32–39.

Moynihan, Jeanne Patricia. "The Influence of the Bauhaus on Art and Art Education in the United States." Ph.D. diss., Northwestern University, 1980.

Pohlad, Mark B. "A Photographic Summit in the Windy City: The Institute of Design's 1946 'New Vision in Photography' Seminar." *History of Photography* 24:2 (summer 2000), 148–54.

Rice, Leland D., and David W. Steadman. *Photographs of Moholy-Nagy from the Collection of William Larson*. Claremont, Calif.: The Galleries of the Claremont Colleges, 1975. Includes essays by Lloyd Engelbrecht and Henry Holmes Smith.

Selz, Peter. "Modernism Comes to Chicago: The Institute of Design." In *Art in Chicago, 1945–1995*, edited by Lynne Warren, 35–52. Chicago: Museum of Contemporary Art and New York: Thames and Hudson, 1996.

Shaw, Louise, Virginia Beahan, and John McWilliams, eds. *Harry Callahan and His Students: A Study in Influence*. Atlanta: Georgia State University Art Gallery, 1983.

Solomon-Godeau, Abigail. "Armed Vision Disarmed: Radical Formalism from Weapon to Style." *Afterimage* 19 (January 1983), 4–14.

Suhre, Terry, ed. *Moholy-Nagy: A New Vision for Chicago*. Springfield: University of Illinois Press and Illinois State Museum, 1990.

Traub, Charles, and John Grimes. *The New Vision: Forty Years of Photography at the Institute of Design*. Millerton, N.Y.: Aperture, 1982.

Walley, John E. "The Influence of the Bauhaus in Chicago, 1938–1943." In *Selected Papers: John E. Walley, 1910–1974*, 74–87. Chicago: Department of Art, College of Architecture and Art, University of Illinois at Chicago Circle, 1975.

Wingler, Hans M. *Bauhaus in America: Resonanz und Weiterentwicklung/ Repercussion and Further Development*. Berlin: Bauhaus Archiv, 1972.

———. "The New Bauhaus/School of Design in Chicago/Institute of Design." In *The Bauhaus: Weimar, Dessau, Berlin, Chicago*, translated by Wolfgang Jabs and Basil Gilbert. Cambridge, Mass.: MIT Press, 1969.

ACKNOWLEDG- MENTS

The organization of the first comprehensive exhibition of photography at the New Bauhaus, School of Design, and Institute of Design has been a collaborative and rewarding effort. Although the exhibition is historical in nature, the school and its impact are very much alive. That the Institute of Design inspired such innovative photographic work as well as the need to share its teachings and principles with future generations of students is its lasting and ongoing legacy.

We want to begin first of all by thanking LaSalle Bank, sponsor, lender, and long-standing Chicago institution, who offered both patience and inspiration as the project expanded beyond its initial scope. We thank Thomas Heagy, Chief Financial Officer of ABN AMRO North America and Vice Chairman of LaSalle Bank, for his continuing involvement with the Art Institute. We would also like to recognize the contributions of LaSalle's Community Affairs staff: Brad Ballast, Mary Anderson, and Molly Conneen.

Numerous ID participants have shared their memories and collections with us, reminding us that, in the words of one graduate, "It wasn't a school of art, it was a school for life." First-hand recollections are invaluable to the researcher, and as a generation departs, it is all the more important to preserve their stories. Among the many ID participants who generously painted a portrait of the school for us in formal interviews are Harold Allen, Ferenc Berko, Eugene Bielawski, Eleanor Callahan, Alan Cohen, Barbara Crane, Eudice Feder, Richard Filipowski, Len Gittleman, Milton Halberstadt, Olga Halberstadt, Joseph D. Jachna, Kenneth Josephson, Brian Katz, Juliet Kepes, Myron Kozman, Maryann Lea, Leon Lewandowski, Mel Menkin, Ray K. Metzker, Marvin E. Newman, Irene Siegel, Joseph

Sterling, David Windsor, and Emerson Woelffer. Many others filled in details about the school's character (and characters), including Peter Coster, Mrs. Robert Donald Erickson, Lois Field, Christina Gardner, Linda Grunsten, Keld Helmer-Petersen, Reginald Heron, Martin Hurtig, Yasuhiro Ishimoto, Larry Janiak, John P. Keener, William Kessler, Dan Kuruna, Kiyoko Lerner, Bobbi Mate, Wayne Miller, Allen Porter, Max Pritikin, Thomas M. Rago, Merry Renk, Ted Smith, Masuhiro So, Julie Stone, and Bea Takeuchi. In addition, John Alderson, Seymour Goldstein, Lewis Kostiner, John Miller, John Vinci, and Jay Wolke joined us in group lunches over the past few years to discuss certain teachers at the ID.

This exhibition would have been impossible were it not for the pioneering work of those who paved the way for our efforts. Dealers have been the most intrepid explorers of this underrecognized terrain, locating photographs, contacting participants and families, and scrupulously recording dates and events. Stephen Daiter early on discerned the importance of the Institute of Design and, with the help of Paul Berlanga and Michael Welch, brought many previously unknown photographers and works to light; Leland Rice and Susan Ehrens introduced us to the careers of many ID participants now in California; and David Lusenhop has helped locate numerous works and artists from the school's early years. All four have provided invaluable resources including photographs, artists' biographies, and general history of the school, and their ongoing assistance has been gratefully appreciated. Other dealers who have taken a special interest in finding, preserving, and documenting the work of the school include Jack Banning, Adam Boxer, Keith de Lellis, Carol Ehlers, Alex Novak, and Stephen Wirtz, and we are

indebted to their careful work. Along the way, numerous scholars – several of whom we convinced to write for this catalogue – have fielded our questions of all varieties. We offer our sincere thanks to Richard Cahan, Carl Chiarenza, Keith F. Davis, Lloyd C. Engelbrecht, John Grimes, Deborah Martin Kao, Mark Pohlad, Charles Traub, Larry Viskochil, and Steve Yates. In particular, we thank Hattula Moholy-Nagy, who from the very beginning of this project has most generously shared information from the extensive research she has conducted on the New Bauhaus and Institute of Design.

We have also been blessed with extraordinary assistance from a number of gifted archivists, librarians, and curators, who helped us navigate important collections. At the Art Institute's own Ryerson and Burnham Libraries, thanks are due to Jack Brown, Susan Perry, and Mary Woolever, and especially Marcy Neth and Lauren Lessing for their persistence and patience. Mary Ann Bamberger and Gretchen Lagana guided us through the Special Collections treasures at the University of Illinois at Chicago, and Cynthia Matthews, Matthew Cook, and Usama Alshaibi all helped with the collections, especially films, at the Chicago Historical Society. At the Illinois Institute of Technology, Patricia Pompa, Deb Tocco, and Stanton Moore helped track down names, Vincent Golden and Anita Anderson assisted with library collections, and Catherine Bruck, University Archivist at the Paul Galvin Library, went beyond the call of duty, uncovering surprising and wonderful ID materials. John Grimes, Associate Director of the Institute of Design, kindly pulled boxes of master's thesis photographs off the shelves at the ID on several occasions. Sarah McNear, former curator of the LaSalle Bank Photography Collection, has also been extremely

helpful throughout the project. Out-of-town archives also played generous host to us; at the Indiana University Art Museum, Bloomington, Nan Brewer guided a path through the Sinsabaugh archives, and at the Center for Creative Photography at the University of Arizona, Tucson, we were graciously assisted by Amy Rule, Leslie Calmes, Marcia Tiede, and Tim Troy. Michelle Harvey at the Museum of Modern Art Archives, Tricia Van Eyck at the Museum of Contemporary Art, Chicago, and Dr. Peter Hahn, Director of the Bauhaus-Archiv, Berlin, all helped find important information and answer queries.

The numerous lenders to this exhibition attest both to the wide impact the school has had and to the fact that this material, now so dispersed, needed to be reunited for viewing and study. We are indebted to the many institutions and individuals who generously agreed to make these photographs available, including Ubu Gallery, New York; the Buhl Collection, New York; Stephen Daiter Gallery, Chicago; the Fogg Museum, Harvard University Art Museums; Gallery of Art and Design, North Carolina State University; George Eastman House; Hallmark Photographic Collection, Hallmark Cards, Inc.; Paul Galvin Library, Illinois Institute of Technology; the Institute of Design, Illinois Institute of Technology; LaSalle Bank Photography Collection; David Lusenhop Fine Art, Cincinnati; Robert Mann Gallery, New York; Museum of Fine Arts, Boston; Museum of Modern Art, New York; National Gallery of Canada; Pace/MacGill Gallery, New York; Palmer Museum of Art, The Pennsylvania State University; San Francisco Museum of Modern Art; Joel Soroka Gallery, Aspen; and the Visual Studies Workshop, Rochester, New York. We are grateful to all the curators and collections managers of these institutions who allowed us entry into their collections and shared their knowledge with us. Many artists and private collectors also agreed to lend their treasured works, and we offer our sincere gratitude to David Avison, Thomas Barrow, Paul Berlanga, Barry Burlison, Eric Ceputis, Alan Cohen, Linda Connor, Eileen Cowin, Anita David, François Deschamps, Mrs. Robert Donald Erickson (latser Cathline Erickson), Andrew Eskind, Len Gittleman, Barbara and Robert Horwitch, Joseph Jachna, Cal Kowal, William Larson, Kiyoko Lerner, Madeleine and David Lubar, Nathan Lyons, Ray K. Metzker, Hattula Moholy-Nagy, J. Donald Nichols (courtesy of Gary Snyder Fine Art, New York), Richard Nickel Committee, Thomas Porett, Leland Rice and Susan Ehrens, Jane and Joel Rosenberg, Joseph and Laverne Schieszler, Lynn Sloan, Keith Smith, Charles Swedlund, Charles Traub, the Wolkowitz Collection, Robin Woodhead (courtesy of Sarah Morthland Gallery), Warren Wheeler, Geoff Winningham, and John Wood. We would also like to thank the San Francisco Museum of Modern Art and the Philadelphia Museum of Art for hosting this exhibition after its showing at the Art Institute.

Over half of the works included in the exhibition and reproduced in this catalogue come from the Art Institute's permanent collection, a remarkable number of which are recent acquisitions. The generous patrons of the Photography Department have allowed us to make the Art Institute a destination for the study and appreciation of the school's photographic innovations, and have ensured that these photographs will be available for future generations of scholars. In particular, we would like to acknowledge the generosity of the Daniel L. and Rosalind Benton Foundation, the Horace W. Goldsmith Foundation, Anstiss and Ronald Krueck, Jeanne and Richard S. Press, Ralph and Nancy Segall, the Smart Family Foundation, Edward Byron Smith and John A. Bross, Jr., Barbara and Lawrence Spitz, Robert and Doris Taub, and especially Bernard M. and Caryl H. Susman, who purchased a large number of photographs toward the end of the project. We also wish to thank the Committee on Photography for their ongoing support of departmental acquisitions and programming.

The staff at the Art Institute of Chicago has been helpful and supportive in innumerable ways. In the Department of Photography, Sylvia Wolf and Stephanie Lipscomb provided important information on Kenneth Josephson, Colin Westerbeck and Jennifer Jankauskas shared their scholarship on Yasuhiro Ishimoto, Riva Feshbach volunteered early research assistance, and Tom Arndt gave his time and enthusiasm. Doug Severson and Sylvie Penichon provided conservation counsel on photographs; Jim Iska and Ginger Wolfe expertly matted and framed the pictures; Kristin Merrill and Nora Riccio assisted us with permanent collection objects; and Lisa D'Acquisto graciously helped with any and all administrative matters. Martha Sharma, Assistant Registrar, coordinated loans from over fifty separate lenders. The Imaging Department was more than patient with our repeated requests, for which we thank Alan Newman and his staff, especially photographer Greg Williams. Clare Kunny and the Museum Education Department produced inventive programming ideas for the exhibition, and Lyn Delli-Quadri and her staff in Graphic Design and Communication Services helped design a clear and compelling exhibition space and supporting materials. For their support and management of various aspects of the project, we also wish to thank Dorothy Schroeder, Assistant Director for Exhibitions and Budgets; Neal Benezra, Deputy Director; Robert E. Mars, former Executive Vice President for Administrative Affairs; Edward W. Horner, Executive Vice President for Development and Public Affairs, and Lisa Key, Director of Foundation and Corporate Relations; Eileen Harakal and John F. Hindman of Public Affairs; and Anders Nyberg of Visitor Services. Most of all, we thank James N. Wood, Director and President of The Art Institute of Chicago, for his early and consistent appreciation of this important endeavor.

The catalogue was a collaborative effort, as evidenced not only by the multiple authors but also by numerous contributors behind the scenes. Susan F. Rossen, Executive Director of Publications, lent her support to the project from the start. Robert V. Sharp, Associate Director of Publications, served as the able editor of the catalogue, and he has helped craft every page of the book with his experience and talent; he was assisted by Lisa Meyerowitz, whose attention to detail and research skills have been greatly appreciated. Sarah Guernsey skillfully guided the production process from start to finish. Carol Parden of Image Resources, Karen Altschul, and Jessica Kennedy obtained photographs and permissions, and Cris Ligenza typeset manuscript corrections. Cheryl Towler Weese, Matt Simpson, and Gail Wiener of studio blue, Chicago, designed the dynamic catalogue, capturing the spirit of ID innovation, and Pat Goley of Professional Graphics, Inc., ensured that all of the photographs look as good in the catalogue as they do in person.

Finally, we would like to close by thanking the over seventy-five artists included in the exhibition and catalogue for their inspired work and teachings. The ID proved to be such fertile ground for photographic exploration that its products can only be captured here as a sample. Many photographers passed through the school and made important works, either as students or later when their careers flourished. Although we cannot show the complete range of photography in the school's magnificent history, we hope that this exhibition and catalogue reflect the profound influence of the Institute of Design.

David Travis and Elizabeth Siegel
Department of Photography
The Art Institute of Chicago

CONTRIBUTORS

Keith F. Davis

is the Fine Art Programs Director at Hallmark Cards, Inc., Kansas City, Missouri, where he has worked since 1979. Davis has curated and written extensively about the history of photography and also holds the position of Adjunct Professor of Art History at the University of Missouri-Kansas City. His most recent book is the revised and expanded second edition of *An American Century of Photography: From Dry-Plate to Digital* (1999).

Lloyd C. Engelbrecht

is Professor Emeritus of Art History at the University of Cincinnati and author of a forthcoming biography of László Moholy-Nagy. He earned his Ph.D. at the University of Chicago after completing undergraduate studies at San Francisco City College and the University of California, Berkeley. He wrote a prize-winning biography, *Henry C. Trost: Architect of the Southwest* (1981), in collaboration with his wife, June-Marie.

John Grimes

is currently Associate Director of the Institute of Design, Illinois Institute of Technology, where he has been a faculty member since 1975. He teaches photography, digital media, and interaction design. His work in digital imaging has been widely shown and he has written about the relationship between art and technology and the history of photography, including several publications about the Institute of Design.

Hattula Moholy-Nagy

is a Mesoamerican archaeologist. For the past three decades, however, an additional research interest has been the life work of her father, László Moholy-Nagy, and the history of the Institute of Design when it was under his direction. She lives in Ann Arbor, Michigan.

Elizabeth Siegel

is Assistant Curator of Photography at The Art Institute of Chicago. She is completing her doctorate in art history at the University of Chicago, with a study of nineteenth-century family albums.

David Travis

is Curator of Photography at The Art Institute of Chicago, where he has directed photographic acquisitions and exhibitions since 1972. A specialist in the modernist period, he has organized a number of shows and contributed to the catalogues that accompanied them, including *Starting with Atget: Photographs from the Julien Levy Collection* (1977), *André Kertész: Of Paris and New York* (1985), *On the Art of Fixing a Shadow: One Hundred and Fifty Years of Photography* (1989), and most recently *Edward Weston: The Last Years in Carmel* (2001).

Larry Viskochil

is a historian, consulting archivist, and an appraiser of fine art and historical photographs. He is the former research librarian (1967–77) and curator of prints and photographs (1978–95) at the Chicago Historical Society. He holds bachelor's degrees in social science and photography and master's degrees in history and library science.

PHOTOGRAPHY CREDITS

All photographs of works of art in the collections of The Art Institute of Chicago illustrated in this catalogue are © The Art Institute of Chicago, photographed by Robert Hashimoto and Greg Williams in the museum's Imaging Department, Alan B. Newman, Executive Director. All other photography credits are listed below, including material supplied by other institutions, agencies, or individual photographers. Wherever possible photographs have been credited to the original photographers, regardless of the source of the photograph. All works of art in this catalogue are protected by the expressed copyright of the individual artists. In addition, The Art Institute of Chicago and The University of Chicago Press, as publishers, recognize the following copyrights: all works by Wynn Bullock © 2001 Wynn Bullock, Bullock Family Photography LLC; all works by Harry Callahan © the Estate of Harry Callahan; all works by László Moholy-Nagy © 2001 Artists Rights Society (ARS), New York/VG Bild-Kunst, Bonn; all works by Arthur Siegel © the Estate of Arthur Siegel. The following credits apply to images for which separate acknowledgment is due.

Pages 1, 6–7, 10, 12–13, 16–17, 68–69, 152–53, 208–09, 214–15, 224–25, 272: Photographs by studio blue, Chicago.

Essays
Moholy-Nagy
1: Courtesy of Keith de Lellis. 2: Courtesy of Chicago Historical Society, Arthur Siegel Collection, ICHI-15840.

Engelbrecht
1: By permission of University Archives, Paul V. Galvin Library, Illinois Institute of Technology, Chicago. Reproduction without permission prohibited. © Romeo Rolette. 2: Arthur Siegel Collection, Ryerson and Burnham Libraries. 3, 4, 5, 9, 14, 24, 25, 27: By permission of University Archives, Paul V. Galvin Library, Illinois Institute of Technology, Chicago. Reproduction without permission prohibited. 6: Photograph by David Heald © The Solomon R. Guggenheim Foundation, New York. 7: Photograph by Vories Fisher, courtesy of Hattula Moholy-Nagy. 10: By permission of University Archives, Paul V. Galvin Library, Illinois Institute of Technology, Chicago. Reproduction without permission prohibited. Photograph by Daniel Humeston. 11: © Corbis. 16: Courtesy of the North Carolina State University, Gallery of Art and Design. 18: University of Illinois at Chicago, The University Library, Department of Special Collections, Institute of Design Collections ID neg. 147. 21: The Art Institute of Chicago, gift of Hans, Eric and Piet Halberstadt, 2001.182.

Davis
1: Arthur Siegel Collection, Ryerson and Burnham Libraries. 3: Photograph by Robert M. Schiller, courtesy of Stephen Daiter Gallery. 4: Courtesy of Chicago Historical Society, Elmer Pearson Collection, ICHI-32510. 7, 13: By permission of Special Collections, Paul V. Galvin Library, Illinois Institute of Technology, Chicago. Reproduction without permission prohibited. 8: Courtesy of Elisabeth Sinsabaugh. 9: Courtesy of Howard Greenberg. 10: © 1995 Center for Creative Photography, The University of Arizona. 12: Courtesy of Chicago Historical Society, Elmer Pearson Collection, ICHI-32509. 14: Courtesy of Chicago Historical Society, ICHI-32479.

Grimes
1: Courtesy of Charles Swedlund. 2: Courtesy of Chicago Historical Society, ICHI-32508. 3: Courtesy of Joseph Sterling. 4: Courtesy of David Avison. 5: Courtesy of Joseph Sterling, photograph by Steve Hale. 6: Courtesy of Joseph Jachna. 7: Courtesy of Chicago Historical Society, photograph by Adam Zipkin, ICHI-15925.

Viskochil
1: Courtesy of Chicago Historical Society, photograph by M. J. Schmidt, ICHI-32492. 3: Collection of Leland Rice and Susan Ehrens.

Siegel
1, 3–5: Courtesy of Chicago Historical Society. 6: Courtesy of Marvin Newman. 7: Courtesy of Kenneth Josephson.

Grimes, Epilogue
1: Courtesy of David Avison.

Plates
2: Digital image © 2002 The Museum of Modern Art, New York. 4: Courtesy of Stephen Daiter Gallery. 7: Courtesy of George Eastman House. 17, 26, 65: © 2001 Museum of Fine Arts, Boston. 34, 64: Courtesy of Tony Walsh photography. 35: © Smith Family Trust. 70: © Ferenc Berko Estate. 113: Photographic services © President and Fellows of Harvard College. 117: © 2002 The Museum of Modern Art, New York. 192: National Gallery of Canada, Ottawa. 205: Photo by Allan Macintyre © President and Fellows of Harvard College.

INDEX

This catalogue was published in conjunction with the exhibition "Taken by Design: Photographs from the Institute of Design, 1937–1971," organized by The Art Institute of Chicago.

This book and the exhibition it accompanies were sponsored by LaSalle Bank.

Exhibition itinerary:

The Art Institute of Chicago
March 2–May 12, 2002

San Francisco Museum of Modern Art
July 20–October 20, 2002

The Philadelphia Museum of Art
December 7, 2002–March 2, 2003

First edition

Printed in Italy

06 05 04 03 02 9 8 7 6 5 4 3 2 1

Published by The Art Institute of Chicago, 111 South Michigan Avenue, Chicago, Illinois 60603–6110

Trade edition published by The University of Chicago Press, 1427 East 60th Street, Chicago, Illinois 60637

Produced by the Publications Department of The Art Institute of Chicago, Susan F. Rossen, Executive Director

Edited by Robert V. Sharp, Associate Director of Publications, and Lisa Meyerowitz, Special Projects Editor

Production by Sarah E. Guernsey, Production Coordinator

Photo research by Karen Gephart Altschul, Special Projects Photo Editor, and Carol Parden, Image Resources, Chicago

Designed and typeset by studio blue, Chicago

Separations by Professional Graphics, Inc., Rockford, Illinois

Printed and bound by Amilcare Pizzi, S.p.A., Milan, Italy

Front cover:
Nathan Lerner
Charley's Eye, 1940 (detail)
Gelatin silver print
The Art Institute of Chicago, Edward Byron Smith and John Bross Fund, 1992.101
Cat. 105, pl. 11

Back cover:
Harry Callahan
Chicago, 1950 (detail)
Gelatin silver print
Courtesy of the Estate of Harry Callahan and Pace/MacGill Gallery, New York
Cat. 28, pl. 111

Library of Congress Cataloging-in-Publication Data

Taken by design: photographs from the Institute of Design, 1937–1971 / edited by David Travis and Elizabeth Siegel; with essays by Keith F. Davis ... [et al.].
 p. cm.
 Catalogue of an exhibition organized by the Art Institute of Chicago.
 Includes bibliographical references and index.
 ISBN 0–226–81167–0 (alk. paper)
 1. Photography, Artistic—Exhibitions. 2. Institute of Design (Chicago, Ill.)—History—Exhibitions. I.Travis, David, 1948– II. Siegel, Elizabeth, 1969– III. Davis, Keith F., 1952– IV. Art Institute of Chicago.

TR645.C552 A78 2002
770'.71'177311—dc21

2001056465